Writing on the Wall

Writing on the Wall

GRAFFITI AND THE FORGOTTEN JEWS OF ANTIQUITY

Karen B. Stern

Princeton University Press
Princeton and Oxford

Published by Princeton University Press,
41 William Street, Princeton, New Jersey 08540

In the United Kingdom: Princeton University Press,
6 Oxford Street, Woodstock, Oxfordshire OX20 1TR

press.princeton.edu

Jacket image: Carving of menorah from a doorway inside a burial cave in the
Necropolis of Beit She'arim, Israel. Photo by Ezra Gabbay

ISBN 978-0-691-16133-4

Library of Congress Control Number 2018936572

British Library Cataloging-in-Publication Data is available

Publication of this book has been aided by a grant from the von Bothmer
Publication Fund of the Archaeological Institute of America

This book has been composed in Adobe Garamond Pro and Gotham

Printed on acid-free paper ∞

Printed in the United States of America

10 9 8 7 6 5 4 3 2 1

For my mother Barbara
and
For Ezra

CONTENTS

ILLUSTRATIONS

MAPS

PREFACE

Hidden within sprawling catacombs of the Middle East, Italy, Malta, and North Africa, enfolded by cliffs throughout Egyptian and Arabian deserts, and degrading along walls of a synagogue secreted in Damascus, are vestiges of markings—graffiti—once written by ancient Jews and their neighbors. Contents and locations of these graffiti are as erratic as they are disparate. Some consist only of texts, which record writers' names and solicit the attentions and remembrances of passersby; others depict images, including those of obelisks, enshrouded skeletons, horses, birds, menorahs, ships, and concentric circles. Dismissed by the archaeologists and explorers who discovered them as random and incidental scribbles, these graffiti are only briefly noted in excavation records and compendia. Given their general obscurity, it is no wonder that so few people know that they exist at all.

But these graffiti do exist and they number in the hundreds to thousands. And it is for the very same reasons that they have been neglected for so long that they are of consummate importance in the historical record. Unlike other forms of commissioned and monumental writing or decoration, or the well-edited literary treatises that shape the histories of their eras, these graffiti document otherwise unknown activities of religious devotion and commemoration, expressions of identity, belonging, and belief, of the long-forgotten people who produced them. The artists who created them were ancient Jews and their neighbors, who inhabited diverse regions of the Mediterranean, southern Europe, Egypt, Mesopotamia, and Arabia from earlier through later antiquity. They carved their drawings and personal dedications during visits to places of worship, family graves, pilgrimages, work trips, sports competitions, theatrical displays, and dealings in local marketplaces. These faint traces of daily life are largely overshadowed by the ocean of words produced by intellectual elites of the day: the feverish sectarian writings of the Dead Sea Scrolls, the treatises of privileged

authors such as Josephus and Philo, and the elaborate legal discussions of the Mishnah, Tosefta, and Talmuds. My purpose in writing this book was to heed these written messages and drawings, to consider how their examination might reveal information about ancient Jews, whose stories have otherwise disappeared from the literary and historical records.

The sheer ubiquity of graffiti associated with ancient Jews singlehandedly begs for their collective evaluation. Archaeologists have identified graffiti of Jewish cultural provenance in significant archaeological sites: around the interiors of the famed synagogue of Roman Dura-Europos, throughout the extensive necropolis of Beit Shearim and in burial caves elsewhere in Roman Palestine, and inside the storied catacombs of Rome, Naples, and Malta. These graffiti also pervade public spaces dedicated to pagan worship, including Egyptian sanctuaries for local gods, points along Arabian desert-highways, and the once-bustling theatres, streets, and markets of Tyre, Miletos, Sardis, and Aphrodisias. Scholars have exhaustively investigated the literatures, laws, monumental architecture, inscriptions, and art discovered in and around many of the same places in order to learn more about regional Jews. Shifting the focus of study to neglected examples of vernacular texts and pictures encourages more nuanced analyses of how Jewish individuals and communities, as agents, used their acts of writing and drawing to manipulate the built and natural (those not originally created by human hands) environments that surrounded them. This heretofore under-considered body of material therefore sheds new light on some of the most elusive features of ancient history—the daily lives and activities of individuals—documented in raw and unedited form.

When approached from a locally comparative perspective, contextual readings of these graffiti, from such diverse places, periods, and contexts, can fundamentally transform what we *think* we know about Jews and Judaism throughout the ancient world. Only graffiti, for example, reveal that some Jews invoked deity in spaces designed for pagan worship and that their acts of carving graffiti constituted devotional experiences for some Jews, inside pagan sanctuaries, along open cliffs, and in synagogues alike.[1] Only recurring appearances of graffiti in burial caves throughout the Mediterranean suggest that many Jews engaged in the same types of mortuary activities as their peers, even if those behaviors defied rabbinic record or subsequent prohibition. Graffiti alone can illuminate the functional coexistence of Jews and Christians in late ancient towns where contemporaneous writers consistently report Jewish and Christian antipathy. And finally, the study of graffiti can offer more nuanced insights into local and regional diversities in Jews' relationships with their pagan, Christian, and early Muslim neighbors. Analyses of graffiti cannot fill in all the gaps of our historical knowledge, but they can add to it significantly; they challenge current understandings of ancient Jewish life, by offering

new information about how Jews and their neighbors prayed, mourned, celebrated, loved, worked, and played.

The need for such a study responds to a sober reality confronting most historians interested in all numerical minority populations, including Jews, from antiquity: a dearth of evidence for their everyday lives and experiences. Roughly two millennia, countless geographic divides, and unfathomable cultural shifts separate modernity from the world Jews inhabited in earlier through later antiquity in disparate corners of the Mediterranean and the deserts beyond. And however rosy (or positivistic) one's perspective, the ancient sources on which most historians rely for the extrapolation of Jewish history are considerably more opaque than they initially appear. Ornate tractates of religious jurisprudence redacted by Palestinian and Babylonian rabbis, alongside fiery treatises composed by Christian writers throughout the Mediterranean, and revelations from the Qurʾān, constitute the majority of relevant literary discussions on the subject; as has long been acknowledged, the diverse polemical agendas of related editors and authors sometimes remain impenetrable for the purposes of historiography. Evidence from the monumental archaeological record, likewise, skews toward the documentation of exceptional events and behaviors, conducted by wealthier members of society. In light of these realities, pursuit of the ordinary and the quotidian sometimes seems futile, at best.

Systematic readings of ancient graffiti, this book argues, circumvent challenges such as these, by offering new insights into the activities Jews once performed on a daily or periodic basis, which otherwise evade literary documentation. The chapters that follow draw attention to these graffiti, as well as to the social, political, economic, and religious dynamics and activities associated with their production. Close regard for patterns in the contents and locations of graffiti and their comparisons with local analogues (often produced by non-Jews), informed by theories of anthropology, landscape, and visual studies, ultimately illuminate the fundamental connections between Jews' activities of writing and drawing and the architectural spaces in which they performed them, whether along the Mediterranean coastline or throughout the open deserts of Egypt and Arabia.

Underlying this study is a reality that resonates strangely in modernity—the fact that many ancient people viewed built and natural spaces as appropriately mutable, interactive, and open to modification. Ancient writers of graffiti, for instance, did not necessarily regard buildings (whether pagan temples, synagogues, burial caves, or civic structures) as finished products when their construction and formal decoration ceased. As graffiti writing indicates, rather, many people viewed their built environments as plastic and processual, even years after the setting of mortar and plaster upon building stones and the final applications of mosaic, paint, or fresco to their surfaces. Similar perspectives governed interactions with natural

spaces, which visitors equally viewed as appropriately violable. Graffiti thus represent the mutual and continuous inextricability of humans from the built and natural environments they created and traversed.

Related vantages advance well-documented observations that ancient Jews, just like their neighbors, engaged in ongoing acts of writing and drawing just about everywhere—whether in urban or rural landscapes along the Mediterranean coasts, farther inland in Italy, Malta, North Africa, Macedonia, Greece, Asia Minor, or the Levant, or throughout the desert expanses of Egypt, Mesopotamia, and Arabia. They painted, engraved, and even buried examples of their words and pictures wherever they lived, visited, and traveled. Assessments, such as those that follow, thus offer a rare and comparative means to vivify the activities ancient Jews performed on a daily basis, alongside their peers, outside of literary frameworks and within their variable built and natural environments. And while vast cultural chasms separate the world of antiquity from that of modernity, more careful attention to relationships between image and space, artist and viewer, permits the reclassification of these ancient activities of writing and decoration for their meaningful and collective assessment.

The imperative to address these graffiti, however, responds as much to practical as to intellectual concerns. Total numbers of graffiti, which I have collected in databases and analyze below, represent only a fraction of those which once existed. Patterns of passive and active destruction explain their rapid and recently accelerated disappearance. Most graffiti remain unprotected in situ and thus as vulnerable today to environmental damage (from moisture, erosion, and exposure), as they are to vandalism. Recent political and religious upheavals throughout the Levant, Mesopotamia, and Arabia, in places like modern Syria, Lebanon, and Iraq, as well as Tunisia, Egypt, and parts of Arabia, have exacerbated the ongoing processes of their destruction and effacement. Graffiti (like so many other types of archaeological evidence) are important, if rapidly diminishing resources, whose stories ought to be told before they vanish entirely and it is too late.

In recent years, graffiti have assumed more prominent roles in the scholarship of ancient Egypt and classical antiquity. Considerations of graffiti have not been integrated into narratives about ancient Jewish history in the same way, but they deserve to be. Only analyses of media, such as graffiti, can ultimately apprise us of the diversities of Jewish life throughout the Mediterranean, which should appear fuller and stranger to us than is commonly acknowledged.[2] This study thus opens up to scrutiny new ways of looking at old materials, as scholars continue to reconsider the dynamics, political and cultural shifts, regionalisms, eccentricities, particularities, and conventionalities of Jewish life in centers and peripheries of the Hellenistic, Roman, and Byzantine empires.

ACKNOWLEDGMENTS

Completion of this book owes profoundly to the institutions and people who generously supported my years of research in the field and writing. What formally began, nearly one decade ago, as a proposal to study the Beit Shearim catacombs for a residential National Endowment for the Humanities Fellowship at the Albright Institute for Archaeological Research, unexpectedly metamorphosed into a book, whose subjects ultimately spanned multiple geographic and chronological divides.

Government and private granting institutions made research for this book technically possible. During a residential NEH fellowship at the Albright in Spring 2011, I initiated my field research and designed databases for the project. A Whiting Award for Teaching Excellence at Brooklyn College CUNY, which I used in Fall 2011, also afforded me an additional semester away from teaching to advance my fieldwork in Israel, and to complete initial drafts of Chapters 1 and 2. One year-long research grant from the NEH, which I used from January 2013 to December 2014 to support twelve months of writing, enabled me to draft Chapter 3 and transform and consolidate fuller drafts of Chapters 1 and 2. The generous Leonard and Clare Tow Faculty Travel Award at Brooklyn College of City University of New York facilitated my travel and purchases of photographic and digital equipment necessary for documenting graffiti in the field. This award, along with the PSC-CUNY Research Fund Travel Award and an award from the Brooklyn College New Faculty Fund subsidized expenses associated with travel and acquisitions of research materials. The generosity of the Memoria Romana Research Award, through the Max Planck International Cooperation with the University of Texas at Austin, supported my efforts to document graffiti in the Jewish catacombs of Rome. Due to logistical problems with access to the catacombs, that project remains ongoing and its fruits are only partially represented here. An award from

the van Bothmer Publication Program of the Archaeological Institute of America and a supplementary award from the CUNY Office of Research Book Completion Award Program jointly supported inclusions of additional maps and images in the book, for which I am extremely grateful.

Specific institutions and individuals require additional acknowledgement. I owe great debts of gratitude to the History Department at Brooklyn College of CUNY and to sequential Chairs David Troyansky and Christopher Ebert; they encouraged me to pursue research and award leaves, despite the demanding teaching responsibilities at the College. I also appreciate the generosity of Sy Gitin and Matthew Adams and the Albright Institute of Archaeological Research, where I served as a Senior Fellow between 2011 and 2015; the entire manuscript benefited from my access to the Albright library and from my interactions with a rotating and vital cast of colleagues at the Institute, from whom I learned so much. Additionally, I deeply thank Revital Weiss, the director of Beit Shearim National Park, and Tzvika Tsuk, the director of the Israel National Parks Authority, for their ongoing support of this project and for facilitating my research at Beit Shearim.

Sections of this book were presented in earlier stages in other publications and in lectures at multiple conferences and symposia. Portions of "Vandals or Pilgrims? Jews and the Temple of Pan in Egyptian El-Kanaïs" (*BJS*, 2013); "Tagging Sacred Space in the Dura-Europos Synagogue" (*JRA*, 2012); and "Working Women: Professions of Jewish Women in the Late Ancient Levant" (*BJS*, 2014) are reprinted in Chapters 1 and 4; permissions to print these here are gratefully acknowledged. I presented other sections of the book, in initial form, in seminars, symposia, and conferences in Providence, Jerusalem, San Antonio, Haifa, Tel Aviv, New York, Helsinki, Oxford, and Erfurt, and I thank colleagues for their comments and suggestions. My participation in "Scribbling through the Past: Symposium on Egyptian Graffiti and its Broader Geographic, Social, and Religious Contexts," by invitation and organization of Chloë Ragazzoli and Elizabeth Frood at Baliol College, Oxford, in September 2013, requires special mention, because it constituted a watershed moment in this project. Through my encounters with the fine scholars at the symposium, I learned much; I particularly thank Michael MacDonald and Frédéric Imbert for their introduction to and willingness to discuss (and share work concerning) Arabian graffiti.

Other colleagues offered critical assistance during every phase of the project and significantly impacted its outcomes. Many do not know how lasting were their impressions and contributions. These include Emma Maayan Dror, who helped me to make initial contacts with the administration of Beit Shearim, and Yonatan Ben-Dov, who connected me to Emma and encouraged me to visit Elijah's Cave for the first time. Jonathan Price

offered support and collegiality in the exploration of matters graffiti-related. Boaz Zissu accompanied me, multiple times, to descend rickety ladders into burial caves in the Judean Shefelah in order to inspect graffiti; these caves would have been otherwise entirely inaccessible without his time, patience, and remarkable spelunking skills. I also thank Angelos Chaniotis for his generosity in sharing his time, information, and photographs from his ongoing research in Aphrodisias. Ms. Sylvie Krapiwko at the Rockefeller Museum facilitated my work in the Mandatory Archive, and I am grateful for her assistance.

I owe hours of repayment, in kind, to friends and colleagues who supported this project. Those who carefully read and commented on sections of the manuscript in its various iterations include Katherine Ulrich, Molly Swetnam-Burland, Gil Klein, Marcy Brink-Danan, and Deena Aranoff, and two anonymous readers of drafts of the book manuscript. All of the improvements are owed to your insights, dedication, and extremely close readings and recommendations. I also thank the research assistants who worked on the project during different phases, including Sandy Levinn, then a student at SUNY Binghamton, who assisted me as a Hebrew University/ Albright Institute Intern in Spring 2011; and Vallerie Trachsler and Avi Toiv, my Kurz Research Assistant and Mellon Transfer Research Fellow at Brooklyn College in Spring 2017. In addition, I am perpetually grateful to those who offered miraculous combinations of intellectual and emotional support. From the bottom of my heart, I thank Saul Olyan, Erich Gruen, and Tessa Rajak, who, as mentors, colleagues, and friends, encouraged me to push through with this book even in the most challenging of moments.

Finally, I can only begin to thank my amazing husband, Ezra Gabbay, a talented physician who, when asked, moonlights as a remarkable field photographer and editor. I could never have completed this book without his participation, contribution, collaboration, encouragement, and ballast. His ability to capture so sharply, with a simple digital camera, spidery lines on stone, has only been surpassed by his unrivaled support. Conducting field study, let alone writing the book in its various iterations, would have been impossible without him. One phase of the project is now over, but I look forward to continuing the adventure in the years ahead.

ABBREVIATIONS

ALA	Roueché, Charlotte, and J. M. Reynolds. *Aphrodisias in Late Antiquity : the late Roman and Byzantine Inscriptions including Texts from the Excavations at Aphrodisias Conducted by Kenan T. Erim.* London: *Journal of Roman Studies,* 1989.
ala 2004	Roueché Charlotte, *Aphrodisias in Late Antiquity: The Late Roman and Byzantine Inscriptions,* revised second edition, 2004; accessed electronically <http://insaph.kcl.ac.uk/ala2004>.
ANRW	*Aufstieg under Niedergang der römischen Welt: Geschichte und Kultur Roms im Spiegel der neueren Forschung*
BS I	Mazar, Benjamin. *Beth She'arim; Report on the Excavations during 1936–1940.* New Brunswick, NJ: Rutgers University Press on behalf of the Israel Exploration Society and the Institute of Archaeology, Hebrew University, 1973.
BS II	Schwabe, Moshe and Baruch Lifshitz, *Beth She'arim. Volume II: The Greek Inscriptions.* New Brunswick, NJ: Rutgers University Press, 1974.
BS III	Avigad, Nahman. *Beth She'arim, Report on the Excavations during 1953–1958. Volume III: Catacombs 12–23.* New Brunswick, NJ: Rutgers University Press, 1976.
CIIP	Cotton, Hannah, et al. ed. *Corpus Inscriptionum Iudaeae/Palaestinae: A Multilingual Corpus of Inscriptions from Alexander to Muhammed.* Berlin: De Gruyter, serial.
CIJ I	Frey, Jean-B. *Corpus Inscriptionum Judaicarum.*
CIL	*Corpus Inscriptionum Latinarum*
CIS	*Corpus Inscriptionum Semiticarum,* serial.

CJO	Rahmani, L. Y., and Ayala Sussmann. *A Catalogue of Jewish Ossuaries: In the Collections of the State of Israel.* Jerusalem: Israel Antiquities Authority, 1994.
HA–ESI	*Hadashot Arkheologiyot—Excavations and Surveys in Israel*
Haggag	Negev, Avraham. *The Inscriptions of Wadi Haggag, Sinai.* Jerusalem: Institute of Archaeology, Hebrew University of Jerusalem, 1977.
Hoftijzer/ Jongeling	Hoftijzer, Jacob, Karel Jongeling, Bertold Spuler, and Hady R. Idris. *Dictionary of the North-West Semitic Inscriptions.* Leiden: Brill, 1995.
JAJ	*Journal of Ancient Judaism*
Hoyland	Hoyland, Robert. "The Jews of the Hijaz in the Qurʾān and in their inscriptions," in *New Perspectives on the Qurʾān: The Qurʾān in its Historical Context 2,* ed. Gabriel Said Reynolds. New York: Routledge, 2011, 91–116.
IEJ	*Israel Exploration Journal*
IJO I	Noy, David, Alexander Panayotov, and Hanswulf Bloedhorn, eds. *Inscriptiones Judaicae Orientis. Vol. I: Eastern Europe.* Tübingen, Germany: Mohr Siebeck, 2004.
IJO II	Ameling, Walter. *Inscriptiones Judaicae Orientis. Vol. II: Asia Minor.* Tübingen: Mohr Siebeck, 2004.
IJO III	Noy, D. and H. Bloedhorn. *Inscriptiones Judaicae Orientis. Vol. III: Syria and Cyprus.* Tübingen: Mohr Seibeck, 2004.
Aph2007	Reynolds, Joyce, Charlotte Roueché, Gabriel Bodard, *Inscriptions of Aphrodisias* (2007); accessed electronically: <https://insaph.kcl.ac.uk/iaph2007>.
JIWE I	Noy, D. *Jewish Inscriptions of Western Europe. Vol. I: Italy (excluding the City of Rome), Spain and Gaul.* Cambridge, Cambridge University Press, 1993.
JIWE II	Noy, D. *Jewish Inscriptions of Western Europe. Vol. II: The City of Rome.* Cambridge, Cambridge University Press, 1993.
JRA	*Journal of Roman Archaeology*
JRS	*Journal of Roman Studies*
JSJ	*Journal for the Study of Judaism in the Persian, Hellenistic, and Roman Period*
JSNab	Jaussen, A. R. Savignac and H. Vincent. *Mission archéologique en Arabie.* 5 vols. Paris: Leroux Geuthner, 1909-1914.
KAI	Donner Herbert and Wolfgand Röllig, eds. *Kanaanäische und Aramäische Inschriften.* 5th ed. Weisbaden: Harrassowitz Verlag, 2002.

Langner	Langner, Martin. *Antike Graffitizeichunungen: Motive, Gestalung, und Bedeutung.* Wiesbaden: L. Reichert, 2001.
Lexicon	Ilan, Tal. *Lexicon of Jewish Names in Late Antiquity. Part II: Palestine 200–650.* Tübingen: Mohr Siebeck, 2012.
Littmann	Littmann, E. *Greek and Latin Inscriptions in Syria. Division III. Section A, Southern Syria, Part 3, Umm Idj-Djimal.* Leiden: Brill, 1913.
MILET	Kleiner, G. *Das römische Milet,* Wiesbaden: Steiner, 1970.
NEA	*Near Eastern Archaeology*
Noja	Noja, S. "Testimonianze epigrafiche di Giudei nell'Arabia settentrionale," *Bibbia e Orientale* (Brescia) 21 (1979): 283–316.
PAT	Hillers, Delbert Roy, and Eleonora Cussini. *Palmyrene Aramaic Texts.* Baltimore: Johns Hopkins University Press, 1996.
PEQ	*Palestine Exploration Quarterly*
RB	*Revue Biblique*
SCI	*Scripta Classica Israelica*
SEG	*Supplementum epigraphicum graecum*
SSI 3	Gibson, J. C. L. *Texbook of Syrian Semitic Inscriptions. Vol. 3: Phoenician Inscriptions.* Oxford: Clarendon, 1982.
SWP	Condor, C. R. and H. H. Kitchener. *Survey of Western Palestine I. Memoirs of the Topography, Orography, Hydrography, and Archaeology. Vol I: Galilee.* London: Palestine Exploration Fund, 1881.
ZPE	*Zeitschrift für Papyrologie und Epigraphik*

Writing on the Wall

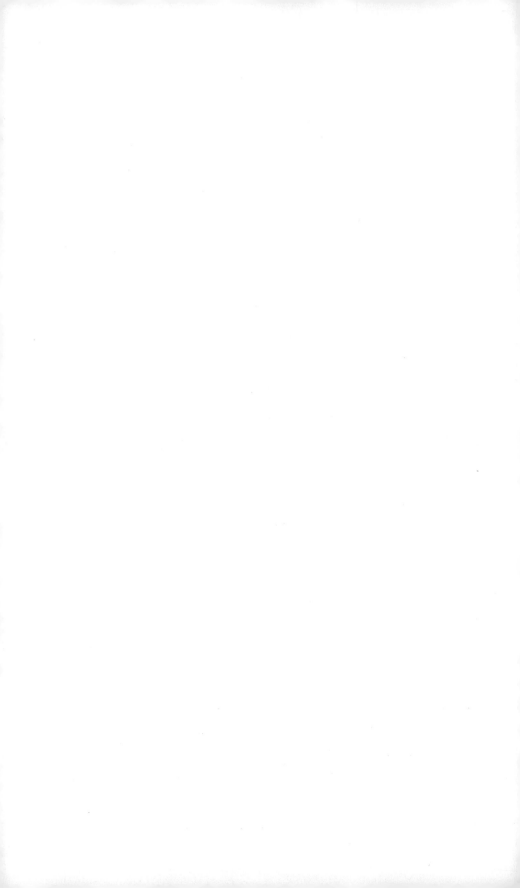

Graffiti, Ancient and Modern

One day in the middle of the third century, a man grasped a nail and scratched his name, "Ḥiya," in large Aramaic letters along a doorway inside a synagogue in Roman Syria. Roughly two hundred years later, someone ducked inside a catacomb in Roman Palestine and grabbed a sharpened stick to scrawl the Greek message, "Good luck in your resurrection!" along the smoothed stone surface framing the cave's entrance. Spectators of entertainments, perhaps a century after that, used a knife to energetically hack the Greek phrase, "The old Jews for the Blues!" into the stone seats of a public building in Byzantine Asia Minor. To modern audiences, these acts of writing might seem to have little in common other than their apparent inappropriateness. Today, after all, most people would classify acts of scratching one's name onto a synagogue doorway as vandalism, if not sacrilege; writing messages around tombs as outrageous displays of disrespect, if not desecration; and carving enthusiastic messages into the seats of municipal buildings as illegal tampering with public property. But these interpretations of such writings, however intuitive they might seem to contemporary sensibilities, demonstrate how differently the same activities resonated in antiquity. Ancient people viewed applications of messages, such as those above, quite distinctly—as desirable, even normal activities inside of their respective environments. Their writers did not apply their words to deface or to defy, but rather, to exhibit their devotions to deity, their imperatives to comfort or protect dead ancestors, and their factional and civic pride.

Decades of exploration and excavation have exposed graffiti associated with Jews from far corners of the ancient world, from the shores of the

Black Sea to the eastern and southern portions of the Mediterranean littoral, through the deserts of Egypt and Arabia to the eastern stretches of Mesopotamia, in areas of modern Crimea, Macedonia, Greece, Croatia, Italy, Turkey, Syria, Lebanon, Jordan, Israel, Egypt, Saudi Arabia, south to Malta, Tunisia, Rome, and Sardinia (Map 1a, 1b). These markings encrust surfaces of ancient synagogues, pagan temples, passageways along desert shrines, byways, and cliffs of ancient harbors; doorways and burial beds in underground tombs and cemeteries; theatres, a hippodrome, an imperial palace, private homes, and marketplaces. Their chronologies of deposit also span more than a millennium, with the earliest examples associated with Iron Age Judah (c. sixth century BCE) and the remainder from periods of Hellenistic, Roman, and Byzantine hegemony through the Arab conquests (the fourth century BCE through the seventh/eighth centuries CE). Locations, contexts, and chronologies of these vernacular writings and drawings might seem impossibly diverse, but many share a surprising number of common features, which implicate broad ranges of human behaviors from domestic practices to public and private worship, commerce, recreation, and commemoration.

But as indicated by the introductory examples above, the task of evaluating ancient graffiti proves to be a challenging one. For a start, consider two conflicting modern judgments about graffiti writing. The recent opening of Galleria Varsi in Rome, a space devoted entirely to international street art, reflects the evolving respect, among cultural elites, for graffiti artists and their works.[1] Glossy coffee table books document the oeuvres of urban artists, whose graffiti emblazon public spaces throughout the United States, Europe, and the Middle East.[2] The ubiquity of stories about graffiti in the popular press and in film, which eagerly locate and analyze the most recent "hits," whereabouts, and identity/ies of the elusive British artist Banksy, exemplifies how relevant and increasingly newsworthy are graffiti and their creators.[3] Banksy, along with other artists, known by professional aliases such as Broken Fingaz and Lady Aiko, earn renown as visual commentators, whose works boldly confront societal ills and urban realities and advocate social, economic, and political change (figure I.1). The past decades, in short, offer plenty of witnesses to a positive cultural reception of graffiti and street art.[4]

Yet such esteem has not entirely erased older views of graffiti writing. One could equally point out that longstanding prejudices entrench views that graffiti are forms of defacement and constitute only marginal and "low" forms of self-expression. Despite recent revolutions in the reception of street art, for instance, graffiti and comparable media commonly retain pejorative connotations in the United States and parts of Europe. To some observers, the word "graffiti" might evoke esteemed acts of social and political activism, while to many others, it indicates illegal acts of vandalism that

deface the surfaces of public or private buildings. In urban environments in the United States, where strategically placed markings (tags) on houses, stores, or street corners territorialize gang affiliations, graffiti often signify juvenile delinquency or gang membership. In Europe and the Middle East, graffiti more commonly manifest religious, political, and social activism and dissent (figures I.2 and I.3).[5] Graffiti can serve common functions, globally, as a means to inspire terror: spray paintings of swastikas on public structures, including playgrounds, intimidate and anger viewers by evoking fear and outrage.[6] These features of graffiti writing are among their most potent and to some, their most pernicious. One might reasonably ask, therefore, whether employing an anachronistic category, such as graffiti, which simultaneously evokes associations ranging from political activism to gang violence or racism, would detract from efforts to examine any ancient texts and images, including those produced by Jews.

The capaciousness of graffiti, as a category, might resound strangely to students of the ancient world for additional reasons. Indeed, if a single word, "graffiti," conventionally classifies so many different media (including spray-painted, painted, or carved writing) with such discrepant contents, and if examples of graffiti reflect such diverse objectives of their creators (from self-advertisement, to architectural appropriation, to defacement, to terror) and inspire such conflicting emotional responses in their audiences (whether of esteem, appreciation, disgust, or fear), one might reasonably ask whether the category remains too broad to be meaningful in any context. Use of the same term to describe tags outside bodegas in New York City; voodoo symbols drawn by devotees on a New Orleans tomb; and anti-Nazi slogans on public walls in Germany, reinforces this point. Aside from their obvious visual and locational differences, such markings betray vastly distinct media, cultural impulses, and individual intentions and responses. Objections might multiply when using the identical category of graffiti to classify different types of ancient markings. Someone who incised a message of well-wishes to the deceased in a burial cave would likely deny any connection between her act of writing and that undertaken by someone else, who carved letters deeply into the stone backings of civic theatre seats, in order to mark them as reserved seating for "the old Jews." Using graffiti and cognate terms to describe both types of writing thus might appear to be more distorting than helpful; it would, moreover, artificially unify data and associated actions, which ancient writers and viewers likely regarded as entirely distinct. Such critiques are cogent, partly because the term (graffiti) is not an internal or ancient one.

This book confronts such logical challenges by magnifying them. Indeed, the very anachronism and capaciousness of the term "graffiti" should not be explained away, because both features are instrumental for reexaminations of ancient Jewish life. The remainder of this chapter and this book

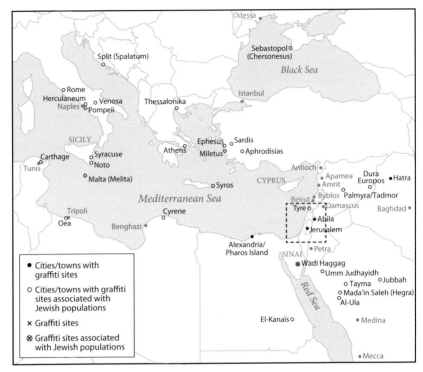

Map 1a. Locations of graffiti associated with Jews and neighboring populations throughout the Mediterranean (S. Kelley).

as a whole demonstrates why and how this is so. Well-worn terms, such as "religion" and "race," among several others, have no precise analogues in antiquity, but scholars commonly deploy them to gain greater insights into the dynamics of the ancient world.[7] Highlighting the artificiality and the obvious anachronism of the category of "graffiti," as well as the dissonance and consonance between its modern and ancient applications, ultimately facilitates its productive and responsible use for the discussion of the permeable boundaries between ancient writings and images and their relationships to the daily activities of their creators. Distilled views of graffiti, when informed by methods developed in the fields of anthropology, spatial, landscape, visual, and liturgical studies, demonstrate how graffiti assume roles as creative and powerful agents in antiquity as well as modernity: they can advertise the names and affiliations of their authors, advocate political change or resistance, recast and appropriate the spaces they adorn, and inspire wildly ranging emotions in their audiences. Subsequent chapters are devoted to considering related activities and understandings

Map 1b. Detail of area in dashed box shown in Map 1a (S. Kelley).

to emphasize the inextricability between the activities that dominated the everyday lives of ancient people, and vernacular writing and drawing. Collective evaluation of graffiti thus harnesses their potential to change the face of ancient Jewish historiography.

One could ask how and why graffiti, among all other available ancient media, might serve such potent roles in generating insights into the ancient world. One answer is that graffiti retain information that most other genres of textual or documentary evidence distinctly lack. Even today, studies of ancient Jewish history remain disproportionately reliant on the words of the few (rabbis of the Mishnah, Tosefta, and Talmuds) to consider the lives of the many ("ordinary" Jewish men and women of the time). Scholars conventionally view this type of dependency on literary texts as inevitable, as many continue to use rabbinical writings to frame discussions of daily life and the archaeological and inscriptional evidence produced by Jews who were outside rabbinic circles. Yet this hermeneutic is by no means inevitable, for a simple alternative exists: prioritizing the evidence produced by the "many" over that produced

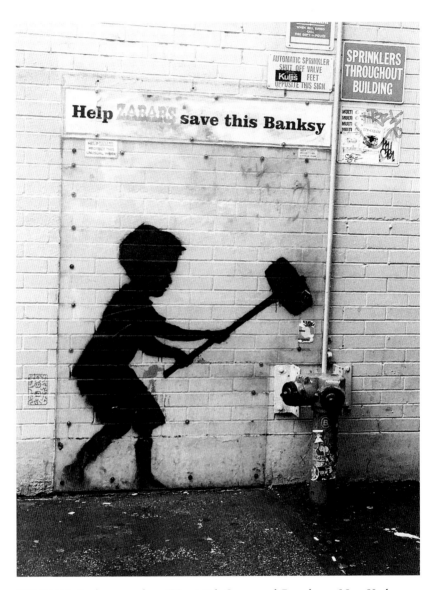

FIGURE I.1. Banksy mural on West 79th Street and Broadway, New York City, USA. Zabar's Market has installed plexiglass over the mural to protect it from wear and vandalism; March 2017. Photo by the author.

FIGURE I.2. Political stencil from Jaffa, Israel; August 2017. Photo by the author.

FIGURE I.3. Anti-Nazi graffiti on wall in downtown Erfurt, Germany; June 2017. Photo by the author.

(nearly exclusively) by the "elite." By drawing attention to genres of archaeological data more suitable for the discussion of Jewish daily life (including graffiti) and by challenging the hegemony of rabbinical texts for their interpretation, this book demonstrates what is at stake: the possibilities and expanded scope of ancient Jewish historiography when one emphasizes vernacular data and uses local and regional analogues (often produced by non-Jews) to interpret them—outside of literary texts and outside of twenty-first-century expectations. The following chapters, which distinctly consider features of ancient graffiti from diverse locations and contexts, thus open up new ways to interpret Jewish life, as it bridged perceived ethnic and cultural boundaries and theological, practical, chronological, and geographic divides.

PURSUITS OF THE EVERYDAY

The elite Roman historian Ammianus Marcellinus once described historiography as an enterprise that conventionally concerns "the highpoints of affairs," rather than "the minor details of unimportant circumstances"

(*Roman History* 26.1.1).[8] Comparable methods of reading formal material, from Herodotus and on, have yielded intellectual, political, and social histories that prioritize exceptional circumstances and people. This has also held true, somewhat inadvertently, in studies of ancient Jews, even if such approaches to the past have begun to shift only in recent years. Beginning in the 1980s, theorists, such as Michel de Certeau, and historians of the *Alltagsgeschichte*, transformed the study of the everyday in present and past time; refinements in these methods have encouraged scholars of early Jewish history, classics, art history and visual studies, archaeology, and anthropology to advance ongoing scrutinies of "unimportant circumstances" and overlooked data to better illuminate the quotidian activities that occupied the majority of people's lives, also revealing differences in class, status, and gender.[9] A cursory review of traditional approaches to writing about Jewish "everyday" history reveals how limiting the disproportionate reliance on rabbinic sources and monumental archaeology for these purposes can be, and why careful examinations of graffiti can generate substantially improved insights into the daily lives of Jews in earlier and later antiquity.

When approaching a study of ancient Jewish life, at first glance, rabbinic sources seem like the most natural and productive places to turn. Rabbinic editors from Palestine and Babylonia shaped their expansive collections of the Mishnah, Tosefta, Talmuds and other midrashic works, from the second through the seventh centuries CE. Even if the rabbis do not explicitly describe graffiti writing (with exceptions detailed in Chapter 2), few other aspects of daily life, in fact, seem too mundane or humble for their extensive and detailed deliberations. Meticulous descriptions of agriculture, trade, craftsmanship, architecture, family life, marriage, sexuality, and other features of daily existence in the Mishnah and Talmuds invite the historian to rely on their fastidious accounts to reconstruct the quotidian activities of Jews in antiquity. So, to take but a few examples, rabbinic texts preserve exhaustive debates about appropriate postures for daily prayers; chronicle, in painstaking detail, arguments concerning which pack-camels get priority to pass in narrow lanes; and enthusiastically debate how a polygamist's estate should be divided appropriately among his multiple widows.[10] The richness and occasional eccentricity of such discussions promise unanticipated insights into the existence and activities of Jews, who inhabited regions stretching from the Mediterranean basin to Arabia and Mesopotamia. But it is through keen awareness of the inward focus of rabbinic literature and of how the editorial agendas of the rabbis shape the selection and description of popular behaviors and sentiments that one can appreciate their limitations as historical resources.

Scrutiny of rabbinic writings, first of all, cannot singlehandedly recreate the worlds of "non-rabbinic," non-Roman-Palestinian, and non-Babylonian Jews. As many argue today, in fact, the "triumph" of rabbinic Judaism,

which inclines scholars to favor their texts for historiography, was never a foregone conclusion in antiquity.[11] Many ancient Jews (at least until the medieval period) lived outside of rabbinic textual cultures, and most diaspora populations never once set foot in Palestine or Babylonia, the places associated with rabbinic learning and textual production.[12] Furthermore, as scholars consistently caution, the rabbis did not redact the Mishnah, Talmuds, and other works for the purposes of internal historiography, nor for twenty-first-century historians, but for myriad other interests, including the preservation of rabbinic methods of argumentation and reasoning, as well as consolidations and transmissions of rabbinical authority.[13] Particularly in light of the fact that rabbinic editors were elite men of similar circles, as discussed additionally below, historians' pervasive dependence on the Mishnah and Talmuds to generalize about Jewish life throughout antiquity remains fundamentally problematic.[14]

But archaeological evidence, which often appears to serve as a vital counterbalance to the elite bias and polemic in many literary sources, bears its own limitations. Architecture, art, and formal inscriptions discovered in synagogues, cemeteries, and tombs, in their highest densities in Roman Palestine and elsewhere along the Mediterranean littoral, initially promise more direct types of information about the everyday lives of Jews, found outside of the rabbinic orbit and sometimes outside of Palestine or Mesopotamia, which are otherwise absent from rabbinic texts. Scholars interrogate the architectural styles and urban locations of ancient synagogues, for instance, to postulate about the social positions of Jews in their surrounding societies. Pictorial arrangements in mosaics and on murals from synagogues, furthermore, offer important clues for how some Jews interpreted their Bible, integrated distinctly pagan and Christian imagery into spaces for worship, engaged in euergetism, and buried their dead.[15] Monumental inscriptions, too, retain critical information, documenting the names some Jews conferred upon their children, the languages they preferred to write in (but not necessarily speak!), institutional hierarchies within synagogues, and the selective involvements of women in them. Some inscribed texts record portions of liturgies or biblical interpretations, and demonstrate various degrees of enmeshment between Jews and their neighbors, among other things.[16]

But these complementary sources for historiography are beset by additional limitations. First, they often retain a situational bias: most known objects and structures (with the exception of rare data from domestic contexts in earlier periods) are associated with synagogues or mortuary environments. This fact limits the study of Jewish life in other spatial and practical contexts.[17] Second, archaeological data, such as those described above, largely reflect and reinforce the historical interests and priorities of ancient Jewish elites. Only wealthier Jews could afford to build, decorate, and renovate

synagogues, as donor plaques attest. Only wealthier Jews, likewise, could afford to hire artisans to construct monumental tombs and to inscribe elaborate epitaphs for their deceased.[18] Moreover, while inscriptions exacted on stone and in mosaic, such as donor plaques and epitaphs, retain critical information about patterns in naming and honorific titles and practices, their semantic contents are often formulaic and bereft of more specific details about the lives and experiences of those whom they commemorate.

Finally, considerations of many features of synagogues and burial complexes are limiting for historiographical purposes for another fundamental reason: they only occasionally record substantive information about what people actually *did* inside surrounding spaces.[19] For example, one could parse the iconography of a synagogue mosaic from Roman Palestine to conjecture about the cosmology of its patron(s), but the same data can more rarely assist speculations about the myriad activities once conducted by those who trod on that decorated floor.[20] Mortuary architecture, likewise, manifests contemporaneous customs and aesthetics, and documents methods of burial, but cannot reveal information about the activities mourners might have conducted tomb-side. Centuries of looting and partial record keeping in early archaeology compound the problem by depriving the archaeological record of the smallest finds (bits of bone, wood, fragmented plaster), which otherwise might have afforded invaluable clues to reconstruct the activities conducted inside associated structures (including those of commensality, lamp-lighting, anointing, etc.).[21] With rare exception, most of the evidence for the behaviors Jews conducted during their day-to-day lives—whether in synagogues or cemeteries, at home, or in the marketplace or theatre—has disappeared from the archaeological record.

Equally problematic are the conventional models historians and other scholars use to interpret these data. As Martin Goodman once aptly assessed, the isolation and abstraction of monumental features of the archaeological record inevitably lead to their interpretation through available literary texts, which, as indicated above, have no obvious historical link to the populations who produced the same inscriptions or monuments.[22] Equally distancing are the research questions historians commonly apply to ancient texts and objects: efforts to pinpoint the etiologies for the ultimate "triumph" of the rabbis over non-rabbinic Jewish cultures, or to investigate historical antagonisms between early Jewish, Christian, and Muslim populations, often (if necessarily) impose and reify a medieval, if not twentieth- and twenty-first-century cast on the available data for Judaism in antiquity.[23] Daily activities of ancient Jews, let alone the tenors of their relationships with their neighbors, appear to be serially distorted, if not lost, in translation.

Historians thus clearly possess critical information from rabbinic and monumental archaeological sources for the discussion of ancient Jews and

their neighbors. But intrinsic limitations in available data, paired with conventional reliance on entrenched genres of literary evidence for their interpretation, have inadvertently perpetuated historians' disproportionate emphases on specific genres of evidence, produced by exceptional individuals, which they interpret through words of interested authors. Access to broader ranges of Jewish activities, read outside of the gazes of rabbis (let alone of pagan or Christian writers, as discussed in Chapter 3), remains a desideratum.

In antiquity, after all, most Jews did not exclusively devote their waking hours to debating arcane marital laws, considering ways to manage unruly camel traffic, drawing plans for constructing new synagogues and their mosaics, murals, or foundations, designing monumental display tombs, or even contemplating their essential similarities to their distant relatives living across the Mediterranean Sea. Their daily lives were disproportionately consumed with the mundane activities that sustained them, including: buying or selling wares in the market, growing crops, tending animals, preparing food, eating, working, praying, caring for the sick or the dying, chatting with their family members and with their Jewish and non-Jewish neighbors, traveling briefly for business, spending time with loved ones, and dedicating moments to remembering those who had passed away.[24] Occasionally, they might have taken time to enjoy the horse races or go to the theatre. Analysis of these everyday activities requires attention to different types of evidence, more obscurely represented in features of the literary and archaeological record.[25]

This book demonstrates that evidence for these types of activities and for the participation of individuals in them is available and comes in the form of graffiti. This heretofore under-considered body of material ultimately sheds new light on some of the most elusive features of ancient history—the activities that some Jews (including non-elites and non-males) conducted during their day-to-day lives, which required extensive exchanges with other Jews and non-Jews.[26] They document social practices of convocation and prayer, travel, work, commerce, recreation, and occasional and periodic commemorations of the dead. Of equal significance is the fact that unlike many other categories of artifacts and inscriptions found in secondary contexts, graffiti are usually discovered *in situ*, which means that they document ancient individuals' uses of spaces and landscapes that surrounded them, inside their original spatial as well as practical contexts. Systematic review of graffiti thus serves as a type of "missing link" in Jewish historiography by constituting evidence for Jews' devotional, commemorative, social, and economic behaviors, fully situated within their broader societies and landscapes. This evidence can even challenge traditional readings of ancient texts on comparable subjects. And it is to the parameters of these graffiti and to methods of their analyses that this chapter now turns.

DEFINING GRAFFITI

The following discussion of graffiti associated with ancient Jews requires a preliminary disaggregation of centuries of accrued presumptions about textual and pictorial production. Common uses of the word "graffiti" in modernity reflect the legacy of eighteenth-century tourists in Pompeii, who applied the Latin-derived Italian term *sgraffiato* (to scratch) to label the ancient drawings and writings found carved into the walls of the famous ancient town.[27] In this book, the meanings of "graffiti" (in the plural) and "graffito" (in the singular) specifically draw from the ancient Greek verb "to write" (*grapho*), more than the Italian use, to indicate modes of writing or decoration that are done by hand—whether on walls, in tombs, or on vessels.[28] Modern graffiti can be stenciled, written in magic marker, copied, or applied from projections ("projection bombing"), or rendered freehand with spray paint ("throw-ups"). This category, when applied to ancient examples, likewise encompasses multiple media, including markings that are painted (conventionally described as *dipinti*) and/or those which are engraved (*graffiti*). The media chosen for these expressions (painted versus carved) remain significant, because they betray different dialogical registers and modes of use.[29] While the practical features of their application are important to consider, modern assumptions about their "illicitness" should be set aside, as they distract from the distinct moralities of graffiti writing in antiquity.[30] As is argued throughout the pages to follow, graffiti making was in many cases unexceptional or even expected; its examination underscores the agency of the graffiti makers whose hands scratched or painted their messages (and also the agency of the graffiti itself, which circumscribed the actions of their audiences, directing them toward taking certain seats or saying certain prayers).[31] Yet additional aspects of these markings qualify them specifically as graffiti, as discussed below.

If it is not an illicit circumstance that defines a marking as a graffito, then neither are its aesthetics, which can be particularly deceiving when classifying ancient inscriptions and images. Many commissioned texts or images, for instance, might appear to be of poorer quality to the modern eye, particularly when produced by non-elites of the Roman provinces.[32] The Beit Shearim catacombs of Roman and Byzantine Palestine offer hundreds of examples of this pattern: the rough-hewn paleography of many epitaphs from the site is nearly indistinguishable from markings found nearby, which scholars differently classify as graffiti. Inscriptions from Pompeii, Ostia, and elsewhere in Italy often demonstrate the opposite possibility: they deploy elegant paleography (as well as classically attested poetic and grammatical forms), but scholars still consider them to be graffiti, rather than monumental texts.[33] While markings' appearances should factor into their interpretation, their apparent elegance (or lack thereof)

cannot singlehandedly classify "hits" of writing as graffiti, as opposed to something else.

Lexical or semantic contents, likewise, cannot independently differentiate graffiti from more monumental texts.[34] For example, as discussed in the following chapter, identical phrases of commemoration, such as *dkyr* and *zkyr lṭb* ("be remembered for good") recur frequently in ancient Hebrew and Aramaic inscriptions. Some texts that include this formula, such as those embedded in mosaic pavements from Palestinian synagogues, are accurately described as monumental inscriptions (texts commissioned specifically for prominent display) (figure I.4), while other synagogue inscriptions that include identical sentiments, also found nearby, are appropriately classified as graffiti. Contents alone cannot distinguish between associated types: only enhanced attention to their additional and interrelated features, including those of display, authorship or commission, chronology of deposit, and use, can differentiate the activities that produced them.

Modes of display remain particularly significant, because they commonly link to the agency, status, and preliminary financial transactions of authors or commissioners. For example, conventions of monumental epigraphy (whether in devotional, mortuary, or civic contexts) predict that those who commissioned prominently displayed writing or decoration *purchased* the rights to do so; either people legally *owned* the spaces in which artisans recorded their names, or they donated significant amounts of money to fund features of the surrounding space.[35] Prominently positioned texts or images, including dedicatory, foundation, or mortuary inscriptions, might advertise generous acts of men and women, private citizens, freed-people, or civic authorities, who funded the construction, renovation, or decoration of markets, theatres, hippodromes, smaller-scale synagogues, or burial caves around the eastern, western, or southern Mediterranean.[36] In mortuary settings, likewise, monumental inscriptions might label an individual's final resting place inside a tomb and document the preliminary purchase of the plot by the deceased or her family.[37] In many such cases, these types of commemorative inscriptions, which identified the dead or expressed legal ownership over surrounding spaces, were carved, tessellated, or painted by paid professionals, scribes, or artisans. The production of these and other monumental texts thus often relies upon two financial transactions: donors both purchased the rights to commission writing or decoration inside a space and paid professionals to exact their work. Display of such modes of writing in prominent locations thereby serves multiple functions in reflecting, advertising, and reinforcing the social, economic, and political means and legal holdings of the individuals they name.

Unlike monumental texts and art, applications of graffiti are not necessarily contingent upon creators' preliminary acts of financial exchange and

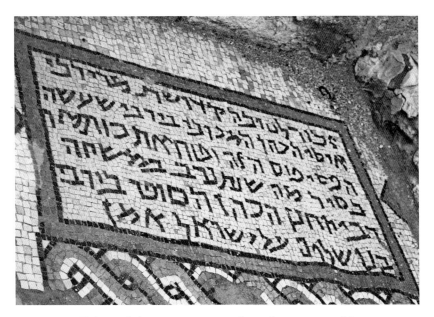

FIGURE I.4. Hebrew dedicatory inscription from floor mosaic of Susiya Synagogue in Susiya, West Bank; January 2011. Photo by Ezra Gabbay.

commission.[38] Regardless of whether they are anonymous or boldly advertise the names or identities of inscribers, lexical contents of graffiti reflect distinct purposes and manners of application. All, indeed, result from their creators' *sui generis* and individuated actions of writing, likely performed without preliminary permission or purchase. Angelos Chaniotis articulates this distinction in a complementary way. He declares that graffiti (unlike donor inscriptions) are: "always of unofficial character."[39] While ancient examples abound for the pattern, a modern one from the Mahane Yehuda market in Jerusalem clearly demonstrates this point. In 2015, a young local street-artist, Solomon Souza, began to spray-paint portraits of rabbinic sages and Israeli historical figures onto storefront shutters throughout West Jerusalem's *shuk* (old market), which are only viewable at night when the storefronts are shuttered (figure I.5). His images employ techniques and materials (freehand spray-painting) that resemble those conventionally used in graffiti or street art. But since the municipality formally permitted and encouraged Souza to undertake this project, his resulting work is better classified as monumental art than as graffiti—albeit that which follows a street-art aesthetic.[40] This example manifests what Chaniotis underscores: despite all appearances, "official" versions of commissioned work cannot be graffiti at all.

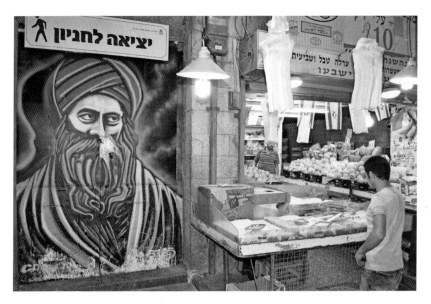

FIGURE I.5. Shutter portrait of Rabbi Yosef Ḥayim ben Eliyahu of Baghdad (a.k.a. Ben Ish Ḥai), painted by Solomon Souza in Maḥane Yehudah market, Jerusalem, Israel; June 2015. Photo by Ezra Gabbay.

Functionality also plays a role in determining which examples of writing and decoration are best classified as graffiti. Martin Langner, for instance, emphasizes the friction between the functions of graffiti and the intended uses of the spaces that surround them. To Langner, graffiti are "images engraved on a space that did not primarily serve this function"—that is—the space was not created specifically for the display of graffiti.[41] This perspective is useful, in many ways, because it emphasizes the potential dissonance between certain acts of writing and decoration and those activities conventionally conducted inside a surrounding space. But Langner's definition, however illustrative, embeds vestigial expectations about graffiti writing as, somehow, subversive to normative uses of surrounding spaces and landscapes. Closer spatial analyses of ancient graffiti reveal, by contrast, that some visitors to buildings or natural landscapes *anticipated* the appearance of graffiti, even if individuals had not specifically and originally designed surrounding spaces for the purposes of their display. A Latin graffito from Ostia, for example, whose writer promises to physically violate ("bugger") those who write on a surrounding wall, simultaneously reflects the strident objections of the wall's legal owner and anticipates its subsequent and potentially irreverent use by unauthorized authors and artists.[42] Considerations of diverse modes of writing and decoration can

thus better illuminate concurrently competitive, dissonant, and complementary uses of writing on identical surfaces and spaces.

Chronology, too, remains a determining factor. Graffiti are iterative and additive; their presence signifies the ongoing use and modification of the built and natural landscapes that surround them. For instance, artisans often cemented monumental texts into the tesserae of floor mosaics (figure I.4) or brushed them into wet plaster before it hardened into fresco. Applications of graffiti, by contrast, frequently postdate the final construction and decoration of surrounding wall and floor surfaces.[43] Indeed, their writers often carved them, incrementally and diachronically, to explicitly respond to the monumental decoration and writing permanently displayed nearby.[44]

Graffiti, moreover, are social enterprises. Tendencies of graffiti to "cluster" demonstrate this point. Archaeologists just as rarely discover a single graffito along the Sinai rock desert, as do pedestrians scrutinizing abandoned storefronts in New York City (figure I.6). This is because one graffito often serves as an invitation for other passersby to contribute their own work. Whether on decorated walls inside domestic spaces in Pompeii, or in south central Los Angeles, therefore, people often draw graffiti beside other examples to engage in graphic responses to previous writers or artists, in exchanges that could continue over years and decades (in some instances, even centuries!).[45] In many cases, therefore, graffiti appear to be as intrinsically social, dialogical, and participatory as they are a means of self-expression or communication—and it is partly for this reason that they are so useful for the discussion of social and cultural history.[46]

Graffiti also encompass images as well as texts. Traditional studies of ancient Jews, for multiple reasons, tend to favor textual rather than pictorial evidence.[47] A more comprehensive study of ancient behaviors, such as graffiti writing, however, substantively heeds Roland Barthes' frequently cited assertion that images, gestures, and other types of data should merit equal scholarly attention ("I read texts, images, cities, faces, gestures, scenes, etc.").[48] After all, images (just like Barthes' gestures and faces), can often express sentiments and emotions as well as, if not better than, their literary counterparts; not to mention the fact that, as discussed below, ranges of literacy were somewhat more limited in antiquity than today, which would make the number of people who could "read" images far greater than those who could identify or vocalize letters, words, or complex phrases in texts.[49] Recent scholarship in visual studies advances and transforms this perspective, particularly emphasizing the significance of the visual and its inextricability from other modes of communication, expression, and experience. In his discussion of the juncture between piety and visual experience, for example, David Morgan summarizes how: "language and vision, word and image, text and picture are in fact

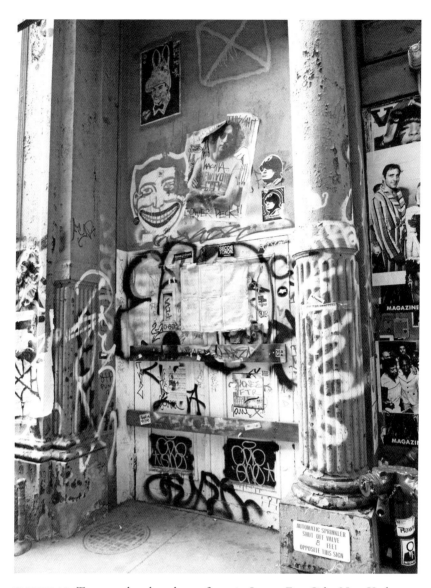

FIGURE I.6. Tags on abandoned storefront in Lower East Side, New York City; November 2010. Photo by the author.

deeply enmeshed and collaborate powerfully in assembling our sense of the real."[50] Efforts to assess ancient "senses of the real," to correspond with Morgan's interrogation of modern data, require the consideration of all available sources of information, including textual or visual features. The discussion below expands this view.

Words and pictures are sometimes inextricable—whether in graffiti or other media—as many other comparisons reveal. As Juliet Fleming notes in her study of graffiti in England, for example, early modern copyists rendered certain poems in graffiti, including posies ("forms of poetry . . . written on something"), to configure images, including nets or axes.[51] Ancient writers occasionally inscribed texts in similar ways to conform to visual patterns that represented, reinforced, or interpreted their literary content (an example would be a poem about a fish whose words were configured to look like a fish).[52] Readings of graffiti, which are sensitive to such possibilities, whether manifested in burial caves, synagogues, or theatres, may reveal comparable mergings of the visual, the textual, and the architectural, to permit consideration of their potential interaction. These possibilities demonstrate how the ever-elusive meanings of writings often related directly to their visual display and to their spatial and geometric relationships to other texts and images nearby on neighboring surfaces. Recent studies of Pompeiian graffiti demonstrate these points robustly.[53] Collapsing categories of "pictures" or "texts" into the broader rubric equates the historical value of pictorial and textual expressions, draws attention to their potential interplay or elision, and considers how inscribers, in diverse ways, used modes of writing and drawing more broadly, to manipulate the totality of the spaces that surrounded them.[54]

Texts and images, nonetheless, are obviously not the same. Acts of writing with letters, words, or pictures reflect a host of diverging contingencies and imperatives, ranging from the literacy skills and personal inclinations of individual writers, to the elusive expectations of what media were considered particularly appropriate, preferable, most effective, or most esteemed, for the precise contexts in which the author wrote.[55] Inscribers' decisions about whether or not to make their writings decipherable to an audience merit commensurate attention; at times, some ancient writers intentionally inverted words or rendered letters in obscure ways that appear as "nonsense" to the modern viewer. Presentations of alphabet lists, sometimes in retrograde, demonstrate such patterns—whether around doorways of tombs in Beit Shearim, or in burial caves of the Judean Shefelah.[56] Associated decisions therefore reflect the strategies of ancient writers as much as their skill sets. Subsuming different types of writing (whether retrograde, legible, or purposely or accidentally illegible) under the rubric of graffiti, therefore, does not erase but rather highlights these constituent differences and

variegations, which collectively point to the power of writing in antiquity, in all of its iterations, for its creators, agents, and audiences.[57]

My working definition of graffiti emerges from this preliminary review of ancient writings and drawings and contemporary theoretical perspectives: graffiti are those markings (whether words, images, or both) applied in an "unofficial" capacity and in social and dialogical ways, regardless of whether their applications were anticipated, lauded, or denigrated by their audiences. Graffiti include a variety of media applied to diverse types of spaces (e.g., devotional, mortuary, recreational, professional, commercial, or civic) and surfaces (e.g., walls, ceilings, or doorways), for what was likely an equally diverse set of reasons, though any statements about reasons must remain speculative. What most distinguish graffiti from other types of writing, therefore, are the precise relationships between their contents, modes of display and presentation, authorship and authorization, spatial, chronological, and social settings, and ostensible functions—not their paleography or perceived aesthetic value. These relationships are dynamic and shift according to the precise contexts (spatial, practical, chronological, and geographic) in which they are found; for this reason I often refer to them as vernacular forms of writing and image making. Thus, while all textual graffiti can be classified as inscriptions, and all pictorial graffiti might be distilled as "images," or "art" of some kind, not all inscriptions or images are properly classified as graffiti.[58] This perspective on graffiti necessarily breaks with operative moralities of graffiti writing in modernity, because ancient types of writing constituted neutral or desirable activities, as the chapters below indicate.

Graffiti ultimately remains an anachronistic category. The definition offered here thus does not pretend to be a universal taxon, but a neutral one, which specifically responds to the data and research questions at hand. The following chapters thereby emphasize relationships between graffiti and their diverse modalities and *uses* of surrounding spaces. Such markings have, can, and should continue to be analyzed and defined in distinct ways elsewhere.

READING GRAFFITI IN SOCIETY, SPACE, AND LANDSCAPE

Graffiti associated with Jewish populations might appear to be more challenging to "read" or interpret for historiographical purposes than are many other types of archaeological information, because of their brevity, frequent anonymity, and their lack of clear social contexts (let alone in overlapping cultic, political, or economic ones). Some graffiti are nameless and anonymous, while others consist only of signatures (personal names). Still other types are limited to abstract pictures of freestanding quadrupeds,

obelisks, boats, menorahs, X- and V-shapes and lines, tree branches, and of men brandishing weapons. In light of these obstacles, the gravitational pull of traditional methods of interpretation, so reliant on fuller texts and epigraphic and aesthetic frameworks for the explication of these abstract markings, seems ever more alluring.[59]

But this book argues that it is possible to interpret graffiti, just like other types of data, independently of such well-worn approaches. The following consideration of one genre of modern graffiti, known as tags, demonstrates how particular modes of reading can generate distinct insights about associated cultures and social dynamics, whether in modernity or antiquity. Tags, as they are known, commonly record the personal or street names of artists or collectives (tagging teams or gangs) on walls, trees, apartment buildings, or storefronts in urban and rural spaces. Sometimes they render names in encoded and obscure ways, while at other times they are deliberately legible, for distinct effect. In the United States, tags dominate walls throughout gang-ridden streets of south central Los Angeles as much as the contested upper stories of buildings along the Bronx-Queens Expressway in New York City. Tags, in these cities and others, manifest peculiar inversions of conventional dynamics of economic, political, and social agency. Taggers associated with gangs, including the Crips, Bloods, Sureños, Wah Ching, or Mexican Mafia, have no legal claims to the buildings they hit and may lack the desire or economic resources to purchase apartments or spaces inside of them. When armed with sharpies or cans of spray paint, a steady hand, and years of practice, however, taggers can do something even more powerful than attain home ownership: by writing on walls, they aggressively and strategically territorialize their surfaces to stake claim to contiguous buildings, neighborhoods, and urban landscapes for themselves or for their gang.[60] Tagging singlehandedly demarcates territory by implicitly threatening consequences when associated markings go unheeded by rival gangs. Indeed, writing a "diss" (a counter-tag) over the previous one, or defying the boundaries imposed by tags, can provoke outbreaks of gang violence.[61]

Graffiti marking, read in this way, is an activity—one with creative and real import. Taggers' activities of applying words and pictures, to modify the approach of Stanley Tambiah, actually change the urban landscapes that encompass them—their buildings, streetscapes, and neighborhoods.[62] These changes are technically superficial, because tags conform to preexisting contours of walls, buildings, or doorways, and rarely alter them in any structural way. But such markings aggressively modify urban landscapes, to different degrees, by drawing intersecting social, political, and economic boundaries, at least for the purposes of urban gang dynamics. And tags, if unmodified, remain durable—they continue to send their messages as long as they are visible to passersby. Indeed, tags, just like other types

of graffiti, ultimately function as agents on behalf of their artists and associated gangs, by superseding the territorial claims of previous taggers or legal owners of buildings (and threatening subsequent infringements upon them).[63]

One could study the official governance of cities by looking at the records of elected officials and their platforms, or investigate their seamier undersides by poring through updated crime blotters. Direct consideration of graffiti, however, offers striking insights into the "real" politics that govern life on the streets and features of an informal, but equally real, political, and even religious economy. When regarded with attention to activity, space, gang politics, and landscape, spatial and geographic analyses of tags speak to, as Morgan described it, the "sense of the real" (perhaps, as opposed to the sense of the "official") in modern cities, in confronting links between texts, pictures, and matrices of economic and cultural life. Associated ways of reading graffiti, which draw upon local comparisons and modern theories of picture and text production, human activity, the social, and the phenomenology of space and landscape, offer useful models for interrogating ancient examples in vastly distinct chronological and practical contexts. Just as modern graffiti constitute snapshots of city dynamics that differ from the pictures derived from crime blotters or urban policy, so too do the ancient graffiti, even indirectly, reveal the quotidian workings of ancient cities (or synagogues or burial complexes) that are rather different than the seemingly official viewpoints, which Josephus, the rabbis of the Mishnah and Talmuds, and Christian writers espouse.

Reading Graffiti as Actions or Agents

Conceptual frameworks that support interpretations, such as those above, draw considerably from Alfred Gell's discussions of art in *Art and Agency: An Anthropological Theory*.[64] Two decades ago, Gell critiqued anthropologists' common approaches to art, which evaluated "art-objects" as products of human action (things) and assessed their values according to aesthetic criteria. Art-objects, in Gell's view, were not "things"—they were active and did something for their artists and creators.[65] Gell directed attention instead to behaviors of art-production, defined as "system[s] of action," and declared that art-objects, which those actions produced, ultimately functioned independently (at least on a theoretical level) as "social agents" for their creators. This move is a logical and relevant one, as clusterings of modern and ancient graffiti independently suggest the sociality that their applications entail.

This latter aspect of Gell's work offers a useful model for framing more productive discussions of graffiti, particularly for the purposes of historiography. Regarding graffiti (in place of art) as a type of *action*

(not solely as a *product* of action), foremost, situates graffiti writing as a behavior, which can be located historically, within broader and identifiable practical, cultural, topological, geographic, and chronological contexts. And graffiti, just like Gell's "art-objects," similarly function as "social agents" (or political or religious ones). Long after their writers have passed on, they remain durable and potent stand-ins for the activities and agencies of their original creators. In antiquity, forms of art and writing were not passive, but often assumed strident and interactive qualities of their own; Gell's approach particularly assists analyses of graffiti in both modern and ancient settings, because it permits attention to such qualities and possibilities.[66] Examination of multiple types of graffiti (regardless of whether examples are textual or pictorial), from these vantages, moves their study from one of observation or collation toward one of contextualization of human agency and activity—even when related behaviors respond to divine beings or to the deceased.

Social (and Spatial) Dimensions of Graffiti

Graffiti (including tags) index people's preexisting views of the spaces they adorn and simultaneously transform them for their writers and their audiences. Spatial dimensions of graffiti writing, therefore, remain critical for situating the actions of ancient, as well as modern, artists. Placements of ancient graffiti are strategic and deliberate: recurring patterns in their locations demonstrate how purposefully their artists carved, painted, and smudged them in specific if diverse architectural, practical, and spatial settings. Theories of Henri Lefebvre, among others, help to draw attention to these simultaneously social and spatial aspects of graffiti-production for their writers and for their audiences.[67]

To Lefebvre, humans, as social beings, use various strategies to circumscribe the spaces that surround them, whether urban streetscapes or sandstone cliffs. Lefebvre's succinct claim that "(Social) space is a (social) product"[68] distills a more fundamental argument that "in reality, social space 'incorporates' social actions, the actions of subjects both individual and collective who are born and who die, who suffer and who act."[69] People write graffiti in different places for variable reasons, but once they do, the idea of neutral or natural space becomes even more impossible as "practical activity writes upon nature, albeit in a scrawling hand, and . . . this writing implies a particular representation of space."[70] These approaches to spatiality, its dialogical mapping, and its social uses are advantageous for analyzing graffiti.[71]

Powerful and implicit social rules, in conjunction, prescribe "appropriateness"—individuals' beliefs about which activities are considered to be desirable or acceptable in particular spaces, places, and times. Modern

taggers, for example, tend to write on designated surfaces of buildings, walls, or even trees, in specific media, because they know that is "what one does" for a chosen effect. Generalized applications of Bourdieusian "habitus" highlight how, through social and cultural inculcation, individuals acquire and reproduce such types of "system[s] of generative schemes objectively adjusted to the particular conditions in which it is [they are] constituted,"[72] which serve as "both the collection of schemes informing practice and the generative source of new or modified practices."[73] *Habitus* works through its largely subconscious direction of human behavior ("the construction of the world that one takes for granted"), because "it provides the range of conscious and unconscious codes, protocols, principles and presuppositions that are enacted" in human practices.[74] These conscious and subconscious codes, for instance, could both indirectly inspire a person to write his name on a shrine around a cult statue of Artemis (because that is what one respectfully does when one visits such a place!), or could indirectly deter him from doing the same thing (because what type of person would commit a sacrilege of such a kind, in such a space?!).[75] Scarce evidence exists to reconstruct the implicit rules that governed the day-to-day behaviors of most ancient people, including Jews and their neighbors. Sufficient evidence, moreover, indicates that free will and independent proclivity played some role in determining individuals' actions (outside of routines and expectations).[76] Analyses of repeated patterns in the contents and spatiality of graffiti writing (whether in pagan temples, burial caves, or elsewhere), nonetheless, offer crucial insights into otherwise unknown dispositions, including particularly local and regional ones, such as those that governed common practices of daily life (and graffiti production) in antiquity.[77]

Reading Graffiti in Space and Landscape

Phenomenological approaches of landscape theorists, such as Christopher Tilley, situate these preceding views within a broader environmental and experiential frame.[78] By describing as inextricable and dialogical the relationships between humans and their sensory and physical worlds, Tilley and others isolate how people's kinetic activities (including graffiti writing and viewing) simultaneously conform to and modify physical features of their environments (whether built or natural). Enhanced attention to details of landscapes, so frequently overlooked, thus inspire additional insights into the activities of graffiti writers and their effects.[79] These include the qualities and sources of light and air, temperature, humidity or aridity, as well as the fabrics, textures, cleavages, and angles of surfaces available for human modification (for acts of chiseling, sanding, carving, or painting). Consideration of such elements, whenever associated data

are available, situates the parameters of activities of graffiti writing and graffiti viewing. By serving as "both medium *for* and outcome *of* action," landscapes can also record evidence (so crucially for these purposes) of "histories of action"—activities undertaken in past time.[80] Such perspectives ultimately historicize how graffiti manifest relationships forged between writers, their audiences, and the built and natural environments that surrounded them.

Closer examination of evidence for the sensory dimensions of graffiti environments additionally advances phenomenological assessments of graffiti writing (for their writers) and viewing (for their audiences).[81] As diverse approaches from liturgical and visual studies remind us, small kinetic acts, such as writing or drawing (or assuming deliberate bodily postures, lighting lamps, or burning incense, for that matter) can profoundly impact the senses and experiences of those who perform them and the audiences who witness (or touch or smell) their effects. As discussions below indicate, acts of carving graffiti do the same. For instance, in the middle of the third century CE, Durene Christians chiseled messages around the baptistry in the Christian building in Syrian Dura-Europos. In multiple and tangible ways, therefore, these writers physically changed the baptistry (and thereby the building) through their actions.[82] By cutting into the friable plaster, they performed physical acts that expressed and reinforced their own devotional fervor. But, in doing so, they altered the appearance of the baptistry, specifically the textures of its surfaces, and expanded the functionality of the space to include its serving as a place for writing one's name as well as for conducting baptisms. This example demonstrates what the following chapters reveal in greater detail—the myriad and distinct ways that graffiti engage and transform the spaces and senses of their agents (writers) and audiences (viewers), to adjust their senses of reality.[83]

The following chapters draw from and expand these preliminary approaches to agency, spatiality, landscape, and sociality, to inspire insights into the historical activities associated with graffiti writing. This is true, despite the awareness that the "actual" experiences of ancient graffiti writers, let alone of their audiences, necessarily remain elusive.[84] As Rachel Neis notes in her study of the visual world of the ancient rabbis, for instance, while it remains impossible to reconstruct *what* ancient people, including ancient Jews, once saw (or heard, or felt, or smelled, or tasted, for that matter), it is possible to conjecture about *how* they did so, based on information derived from textual or archaeological records.[85] Variable approaches summarized here assist comparable efforts to draw evidence from graffiti to speculate about *how* ancient people (whether Jews or their neighbors), as agents, used activities of writing and drawing to engage, change, and experience the spaces, landscapes, individuals, and societies that surrounded them.[86]

CONNECTING GRAFFITI WITH FORGOTTEN JEWS

Significant technical features of data selection and interpretation inform the following case studies, which associate specific archaeological data (graffiti included) with ancient Jews. And graffiti, of course, cannot be "Jewish," because graffiti are not people.[87] They are scratches or paintings that people (some perhaps Jewish and others perhaps not) applied to surfaces or objects. Decisions concerning how to identify archaeological materials and associate them with Jewish populations, in turn, inevitably and significantly shape related conclusions about graffiti, Jews, and the activities they undertook in their broader cultural environments.

In the discussion below, graffiti merit association with Jews if they exhibit one or more diagnostic features. Some textual graffiti include personal or second names (*signa*) of biblical, Judean, or Jewish origin or association (Moses, Judah, Judas, Jeremiah, Annanias, etc.).[88] Others include explicit identifying terms, such as *Ioudaios*, *Hebraios*, *Iudaeus*, or variants of *Yehuda'i*, either in Greek, Latin, Aramaic, or Nabataean, which are commonly translated into English as "Judean," or "Jew."[89] Appearances of Hebrew or Aramaic scripts in graffiti, in many cases, also indicate Jewish language use. Still other graffiti incorporate pictures of the architecture and appurtenances of the Jerusalem Temple, including the menorah (seven-branched candelabrum), ethrog (citron), lulab (palm frond), or shofar (ritual horn).[90] Associated images were particularly evocative for Jews after the Roman destruction of the Jerusalem Temple, even if Christians developed similar ones for their own purposes, in later periods of antiquity.[91] In some cases, however, connections between Jews and graffiti remain more indirect. Some graffiti, for instance, include no diagnostic markers, but were discovered in spatial contexts particularly known to be associated with Jews, such as synagogues or burial complexes where the majority of burials were clearly marked with Jewish names, symbols, or vocabulary.[92] Such factors cannot prove incontrovertibly that graffiti writers were necessarily Jews. At minimum, however, as discussed additionally below, the lack of erasure of such markings suggests that Jews who used these spaces considered them to be sufficiently acceptable or tolerable to maintain them.

Deployments of identical images or textual patterns, of course, need not predict more substantive similarities in the self-identifications and beliefs of their creators.[93] Even if Jewish graffiti inscribers and artists conferred similar names to their children, or drew comparable pictures of menorahs, not all of them retained equivalent cosmologies, practiced similar forms of devotion, or sustained unified theologies.[94] What the designation of "Jew" or "Jewish" meant, furthermore, necessarily varied among graffiti inscribers, whether they inhabited the same village or disparate towns throughout the Mediterranean.[95] Graffiti evidence, indeed,

often demonstrates significant practical and cultural diversities among their Jewish creators, and their commensurately varied relationships with their neighbors, which, in turn, fluctuated according to the precise cities, neighborhoods, or even the city streets they once inhabited. [96] Partly for these reasons adoptions of "fixed criteria" for associating epigraphic and archaeological data with Jews remain highly problematic.[97] Related occlusions in studies of material remains of Jews, including those presented here, remain unavoidable and sometimes appear to be tautological. Nonetheless, without another route available, one hopes that more sensitive examinations of the archaeological record, as demonstrated below, ultimately offer more locally and spatially nuanced ways to interpret evidence for Jews in regionally variable contexts, outside of preexisting expectations or traditional methods of association.

Methods of determining the antiquity of individual graffiti, in comparable ways, vary according to their precise archaeological contexts and contents. Few examples of graffiti associated with Jews include exact dates or regnal years, which might better assist their accurate dating. In certain cases, however, the stratigraphic record offers important clues for establishing chronologies of graffiti written by or around Jews. Graffiti from the Dura-Europos synagogue, for example, were discovered in a sealed archaeological context that predated the destruction of the building sometime between 255 and 257 CE.[98] In this case, we have a useful *terminus ante quem* for their ancient application.

Other graffiti deposits pose greater challenges for establishing patterns of relative dating. Graffiti in Beit Shearim, Palmyra, or along cliffs in deserts of Egypt, Sinai, and Arabia are located inside spaces that sustained ongoing reuse; this might prompt questions about their antiquity.[99] While it remains impossible to establish secure dates for every graffito and dipinto discovered throughout these sites, considerations of regional customs, language, and iconographic typology help to better situate their chronology.[100] Although methods of dating textual graffiti through paleography remain as tenuous as is dating pictorial art through patterns in iconography, deployments of Greek and Latin (and in some cases, Aramaic, Hebrew, and Nabataean) in graffiti may assist their dating to similar periods of Hellenistic, Roman, and Byzantine hegemony, which predate the early medieval period.[101] Tombs throughout Judaea and Palestine, additionally, often contain multiple examples of textual or pictorial graffiti, which replicate those on identical portions of tombs with more secure dating (inside vestibules, around doorways, etc.) located nearby. Similarities in these elements (same types of drawings or sentiments, positioned in the same places, on the same architectural features of tombs) suggest the contemporaneousness of their applications. Methods of rigorous typological comparisons, such as these, often serve as the

only means of positing chronologies for three-dimensional artifacts, such as ceramic lamps and vessels, similarly discovered in looted and reused burial caves in Israel, Egypt, Jordan, and Syria. Thus, while practices of ascribing dates to graffiti based on analogy are not foolproof, they are, in the end, most comparable to the methods commonly employed elsewhere in archaeological scholarship. What one can say most definitively is that many of the deposits of graffiti discussed below were accrued throughout years, decades, and centuries in periods of antiquity.

One might wish to ascertain additional information about the ancient contexts and the social histories of individual graffiti inscribers. For instance, one might desire to map precisely where graffiti artists fell along spectra of literacy.[102] Abundance of written material throughout Arabian cliffs and Palestinian burial caves, indeed, suggests that many more people of these regions than traditionally assumed were at least capable of copying their names or brief messages into rocks or onto walls, even if they could not do much else. And recurrences of carved invocations to "remember" certain individuals inside buildings and along rocks throughout the Levant and Arabia equally suggest, as discussed in the following chapter, that many writers anticipated that significant numbers of viewers would be able to read their messages—perhaps even out loud. Unfortunately, writers' expectations (or hopes!) about the reading capabilities of their audiences cannot speak definitively to comprehensive assessments of ranges and modes of literacy (necessarily varying according to time and place) among Jews and their neighbors in antiquity.[103] Attention to graffiti, nonetheless, can play an important role in initiating and advancing more nuanced discussions of regional patterns of literacy, even if it cannot offer definitive conclusions.

Likewise, one might also wish to determine the classes or statuses of Jews who inscribed graffiti. Graffiti writing, of course, was not just a strategy or an activity of the lower classes, as many might infer from modern stereotypes. Throughout the Hellenistic and Roman world, rather, abundant examples indicate that hegemonic and indigenous elites wrote graffiti, just as non-elites did.[104] While most graffiti exclude elite status markers that individuals enjoyed flaunting, this still does not preclude elite authorship: graffiti sometimes attest to conversational registers and features of daily life, so they might reflect a distinct type of discourse, in which status-flaunting might have taken different forms (such as, occasionally, being able to write at all, or being capable of inscribing a graffito on a particular feature or part of a building). Some Jewish graffiti inscribers, therefore, might have enjoyed higher status within broader imperial frameworks, even if it is hard to imagine that many of them counted among the elites of the Roman Empire—the unusual one percent (or fewer!) of the population, who retained economic capital, freeborn

status, military position, and public offices (*ordines*) that inspired the awe and appreciation of others.[105]

Other Jewish graffiti writers were not elites of imperial frameworks, but more certainly enjoyed elevated status in the eyes of their Jewish peers.[106] Hayim Lapin uses postcolonial approaches to draw attention to such possibilities, as he speaks of ancient rabbis, who operated among circles of rabbinic textual production, as "indigenous elites"—those who did not occupy higher status or class within a hegemonic (imperial) framework, but did so among their peers in Palestine and elsewhere. Such a category is eminently useful and equally extends to members of the priestly classes before (and, to varying degrees, after) the Roman destruction of the Temple in 70 CE.[107] So circumscribed, evidence does exist to link indigenous elites and graffiti production. For instance, in the 1960s, Nahman Avigad discovered pictures of a menorah and a showbread table scratched into fragments of wall plaster from an elite home in Jerusalem dating to the Herodian period. He argued that its artist might have visited the Temple while it still stood and carved elaborate pictures of its implements (including the menorah and showbread table) into surfaces of his own family's opulent residence (figure I.7).[108] The corresponding section of plaster, now displayed in the Israel Museum, thus demonstrates one known case from Judaea in which indigenous elites (or at least someone from a high status household, priestly or otherwise) wrote graffiti inside their domestic spaces (albeit for private viewing).

Multiple factors, nonetheless, predict that many, if not most, Jewish graffiti inscribers were among non-elite or ordinary classes, however those are defined. This is likely true, whether examining graffiti produced during periods of Hellenistic, Roman, or Byzantine hegemony. Tax lists indicate that some Jews fell among lower economic classes in Egypt during Hellenistic rule.[109] And, until 212 CE, when Caracalla's Antonine Constitution extended citizenship throughout the Empire, few Jews would have been Roman citizens at all—let alone qualifying among the most highly regarded of the Empire's constituents. Whenever information about inscribers' class or status (let alone gender) can be deduced from the evidence available, I draw attention to it. In the meantime, the possibilities are expansive, partly because designations of class and status are quite difficult to estimate anywhere in the Hellenistic and Roman worlds, let alone throughout the Roman provinces.[110] While both imperial and indigenous elites were no doubt responsible for some graffiti, non-elites surely carved most of the others.[111] Perhaps more important and definitive, however, is the degree to which graffiti attest to a culture of writing that was pervasive and performative, with places for a wide range of people, throughout antiquity.

FIGURE I.7. Menorah and showbread table depicted in graffiti from an elite home in Roman Jerusalem, displayed in the Israel Museum in Jerusalem, Israel; May 2015. Photo by the author. Reproduced with permission of Israel Antiquities Authority.

ORGANIZATION

As the foregoing has shown, graffiti have great potential for opening the lives of ancient Jews to our scrutiny in new ways. But the nature of this evidence also requires us to approach it with meticulous attention to the contents of graffiti and the settings in which they are discovered. Productive evaluations of vernacular texts and images necessarily require a preliminary

thick description—multiple levels of contextualization with respect to graffiti's precise contents (whether pictorial, literary, or onomastic), settings (whether in synagogues, catacombs, theatres, etc.), chronology, spatial orientation, and regional find contexts. Presentations of background information, at times, might appear to be both technical and ranging as each chapter introduces case studies from wildly discrepant environments and cultural milieus: one chapter requires preliminary assessments of trade networks throughout the Egyptian desert and language practices in Roman Syria; another considers urban and cultural landscapes in Asia Minor under Byzantine rule; still another assesses evolving relationships between topography and Levantine tomb decoration. The differences between these treatments remain necessary to produce interpretations of graffiti that are sensitive to their spatial and geographical locations and practical contexts, to avoid the pitfalls of essentialist methods (which presuppose a monolithic Jewish culture throughout these regions and across time). The diversity of the approaches used in this book ultimately aims to facilitate a more accurate narrative for the discussion of graffiti and the reassessment of ancient Jewish life.

Chapters include case studies from multiple regions and assess connections between graffiti writing and the devotional, commemorative, and civic activities conducted by Jews and their peers. Chapter 1, "Carving Graffiti as Devotion," argues that ancient Jewish populations inscribed and painted graffiti as one method of communicating with and about the divine. Spatial analyses of graffiti carved in multiple locations, including the Dura-Europos synagogue from Roman Syria, a sanctuary to Pan in Hellenistic Egypt, and the open deserts of the Sinai Peninsula and Arabia, reveal something surprising: that some ancient acts of writing and drawing are best classified as devotional behaviors. No ancient literary texts mention graffiti writing as a devotional practice associated with Jews or their neighbors; only careful attention to the archaeological record reveals that this is so. Graffiti writing, this chapter suggests, should be considered alongside other activities more commonly associated with Jewish acts of worship, such as communal prayer, recitations of liturgy, and interpretations of scripture. More than this, however, evaluations of patterns in graffiti deposits help to expand common definitions of prayer, by demonstrating how capacious were some types of devotional activities that Jews and their neighbors once conducted independently and alongside each other.

While Chapter 1 shows how Jews painted and carved graffiti as a means of communicating with and about the divine, Chapter 2, "Mortuary Graffiti in the Roman East," focuses on graffiti making as a way to communicate with and about the dead by examining graffiti discovered in cemeteries and burial caves throughout Palestine during the Hellenistic, Roman, and Byzantine periods. This chapter argues three interrelated points. First and foremost, recurrences of graffiti in Jewish mortuary contexts suggest that

acts of carving them were systematic and deliberate exercises, undertaken by Jews inside cemeteries and burial caves throughout the ancient Levant: at minimum, they constitute otherwise unknown mortuary activities. At times, the ancient rationales for these behaviors remain obscure, because resulting markings are opaque for our interpretation, but at other times, they are suggestive about common acts and even beliefs concerning death, the afterlife, and the perceived ritual power of tombs. But closer examination reveals a second point—Jews and neighboring populations of pagans and Christians behaved similarly, in these specific respects, when visiting their deceased. By drawing attention to graffiti making as common, if unnoticed, regional "languages" of mortuary writing and decoration, this chapter offers tangible evidence for broader cultural continuities among the populations who created them. This last point, in turn, leads to a third conclusion: that even in Beit Shearim—a cemetery with strong and documented links to populations of rabbis (whether of Talmudic, alternative, or complementary orientation)—works of Jewish commemorators and inscribers reflect understandings about death, corpse contagion, and commemorative practice with closer ties to regional non-Jewish behavior than to rabbinic textual prescriptions. These perspectives, in turn, permit a rare reversal of scholarly practice: a rereading of rabbinic texts in light of archaeological findings.

Chapter 3, "Making One's Mark in a Pagan and Christian World," interprets graffiti associated with the public lives of Jewish populations from Tyre and Asia Minor. Scholars historically debated whether Jews attended public entertainments in the Greco-Roman world, such as theatre performances or gladiatorial contests.[112] Graffiti in this chapter incontrovertibly demonstrate that they did. These graffiti, which included explicit symbols like menorahs and words like *Ioudaioi* or, in later periods, *Hebraioi*, were found in the hippodrome in Tyre, the Byzantine market in Sardis, in the Roman theatres of Miletos and in municipal and commercial buildings in late Roman and Byzantine Aphrodisias. These types of graffiti, cut into civic spaces, attest to Jewish participation in public entertainments and to relationships, publically exhibited and reinforced, between Jews and their non-Jewish neighbors. More than this, however, these graffiti demonstrate that during periods of escalating anti-Jewish legislation and religious polemic, Jews inscribed menorahs where they sold their wares in public markets or attended public entertainments, applied graffiti to reserve their own seats in the theatre and assembly halls, and acclaimed their collective support for empire-wide factions like the "Blues." Examples of graffiti from these regions, unlike those examined in previous chapters, were discovered in distinctly public spaces. Textual graffiti from Tyre and Asia Minor thus substantively embody Jews' individual and collective engagement with all sorts of civic and economic activities and their

willingness to mark their physical environments to distinguish themselves in public settings.

The final chapter of the book, "Rethinking Modern Graffiti through Ancient," advocates reconsidering modern graffiti through a reformed understanding of ancient examples. Adjusting notions of what qualifies as a source for the historiography of ancient Jewish populations, this chapter suggests, impels an expansion of information available for enquiry in the ancient or modern world. This chapter concludes that attention to vernacular data associated with Jews and other numerical minority populations throughout the classical and postclassical worlds singlehandedly shifts readings of the complexity and dynamism of local, regional, and cross-regional Mediterranean, as well as Syrian, Egyptian, and Arabian desert-cultures, in addition to modern connections between visuality, piety, and graffiti.

As its organization indicates, this book does not constitute an exhaustive compendium of graffiti, offer a traditional historiography, or provide an archaeological, art historical, or epigraphic treatment of related media. The application of cross-disciplinary methodologies, which draw from fields of religious studies, classics, archaeology, and art history, combined with those of sociology, anthropology, linguistics, landscape, and spatial studies, rather, yields something else: a historiography of past actions. Questions central to the following chapters include: Did ancient inscribers want others to read their graffiti? If so, who were their intended audiences? Did individuals scratch names or sentiments in obscure corners of buildings, or did they write in places more easily visible to the general public? How do graffiti found in structures that Jews built and used, such as synagogues or burial caves, compare to examples discovered in neighboring structures of comparable genre? When ancient Jews carved or painted graffiti in non-Jewish contexts, were their actions analogous to the graffiti making of non-Jews? Even if Jews and non-Jews carved the same thing on the wall of a pagan sanctuary ("thanks be to god!") or on a stadium seat ("Go Blues!"), might there have been different affects behind those acts? These questions cannot produce extensive biographies of individual Jews who traveled, lived, and worked throughout the Mediterranean or Arabia, but they can generate improved insights into the cultural diversities, experiences, and contexts of Jews throughout the ancient world. By treating graffiti as material vestiges of individuals' behaviors, the resulting analysis thus emphasizes the variable ranges of activities once considered acceptable among ancient Jews, rather than the precise (and often unknowable) social historical conditions that yielded them.[113]

Undergirding these evaluations are specific procedures of data collection and analysis. Whenever and wherever possible, I have directly examined and measured graffiti, discussed below, in situ. When political circumstances unexpectedly impeded my direct autopsy of graffiti, as recurred with unfor-

tunate frequency during the years I conducted active field research for the project (2011–2015), my means of data collection necessarily included the most recent excavation records, publications, notes, and photographs. When examining painted writings and pictures, furthermore, I consistently augmented the visible information with various digital technologies, including Image J and D-stretch digital enhancement software.[114] These methods augment the data available for mapping, measuring, and comparing graffiti written by Jews and their neighbors across multiple and diverse regions. Final assessments of these graffiti relying on such methods ultimately yield more accurate evaluations of their geographic and practical scope.

Ensuing analyses, in turn, contribute in two principal ways to discussions of the cultural dynamics of ancient Judaism and of the Roman and Byzantine Mediterranean. Applications of practical categories to evaluate graffiti, from the outset, advance understandings of the daily activities of ancient Jews, which varied according to location, context, and region. Scholars continue to debate questions concerning Jewish "universalism" or "particularism" to assess the social and cultural cohesiveness (or lack thereof) of those who designated themselves as Jews throughout the Greek, Roman, Byzantine, and Mesopotamian worlds.[115] Graffiti, when read within their practical, local, and regional contexts, thus accelerate and nuance these efforts. They offer tangible evidence for cultural continuities and discontinuities between Jews and their neighbors; they inspire renewed consideration of degrees to which Jews' behaviors were shaped by local and regional environments, as well as by internal notions of "Jewish" difference, or practice.

In complement, these discussions contribute to ongoing conversations about the dynamics of Mediterranean culture writ large. Examinations of graffiti associated with ancient Jews facilitate more nuanced discussions about how numerical minority, local, and regional cultures related to hegemonic cultures of the Greek East, Rome, and Byzantium, and ultimately, of earliest Islam. Jews, alongside Greeks, Egyptians, Romans, Syrians, Nabataeans, and many others, rapidly found themselves dispersed throughout the expanse of a shifting Mediterranean, Arabian, and Mesopotamian world; their experiences are as much a part of that world as are the perspectives of the well-trained and better-known authors and editors from Carthage, Rome, Constantinople, and Babylon, whose literary treatises shape common understandings of these periods and places. Evaluation of unprivileged archaeological data from one minority population thus intends to recover what is otherwise lost—insights into the everyday lives of ordinary men and women in antiquity.

Carving Graffiti as Devotion

Deep in the heart of the Old City in Jerusalem, pilgrims travel daily to the Church of the Holy Sepulchre—revered by many Christians as the site where Jesus was crucified and buried. During high pilgrimage seasons, pedestrian traffic slows to a shuffle inside the Church vestibule, where the faithful lie prostrate and rake their fingernails through oil lubricating the stone that marks the place of Jesus's crucifixion. Farther on, women clutching their headscarves strain to decipher paintings blackened by centuries of smoke; beyond, processionals snake toward the medieval Aedicule, which ensconces the reported site of Jesus's burial. Whispers, footsteps, and chanted prayers swell into a hum as light from dusty sunbeams and faltering candles flickers off icons and metallic threads of vestments. Smoky air, redolent of frankincense and candle-wax, filters slowly through the nostrils and lungs. Over the centuries, pilgrim accounts document their authors' departures from this environment as changed people; dramatic encounters with its relics, prayers, light, smells, colors, and tastes effected their profound physical and emotional transformations. And while the architecture of the Church has metamorphosed during its 1500-year history, the interior of the building feels timeless.

But during the past six hundred years, pilgrims have modified considerably this venerated space. Devotees have chiseled thousands of crosses, crests, and cryptograms, alongside lists of names and prayers in Greek, Latin, Arabic, Armenian, Syriac, Ethiopic, and Georgian, into the structure's exterior façade, portals, stairways, and altars. To many pilgrims, these markings might remain strangely invisible, despite their prominent locations. When prompted to recall their time in the Church, visitors rapidly recount their

sensory experiences: the warmth of bodies pressed together during Vespers; the slipperiness of the oleaginous stone of the anointing; the taste of the particulate air, opaque with centuries of dust and burnt incense; and the overwhelming sensations of joy and wonder at having fulfilled lifelong dreams of visiting this place. Quite rarely do pilgrims equally remark on scribbles around the building, rendering names, prayers, and geometric shapes, carved and painted in seemingly random places.[1]

But these paintings and carvings blanket the surfaces of the Church. And while Church officials rigorously control and maintain the surrounding areas, these types of markings document one of the only ways that visitors have individually modified surfaces of the architectural space. Visitors' graffiti, which render sacred symbols, requests for remembrance, personal signatures, and prayers in multiple languages, do not constitute marks of defacement. They serve, rather, as physical vestiges of pilgrims' devotions, permanently tattooed onto surfaces of one of the holiest sites in Christendom (figures 1.1 and 1.2).[2]

. . .

Why begin a consideration of ancient Jews by examining the workings of a Levantine pilgrimage church, so significant to Christians of various denominations? One might easily dismiss this as a poor decision. Comparisons between the devotional spaces and practices associated with modern and premodern Christians and those performed by ancient Jews could indeed reflect implicit and irresponsible collapses of time, space, place, belief, and custom, barely sustained by hierarchical and reductive understandings of religious experience. When reconfiguring discussions of ancient Jewish devotional practices, some might suggest that modern synagogues would offer better places to turn for inspiration.

But, for targeted reasons, the Church of the Holy Sepulchre can serve as a particularly useful tool when beginning to rethink ancient Jewish activities associated with prayer. The availability of the Church of the Holy Sepulchre for visitation is critical in this regard. Visits to the modern Church remind us of what we wish we knew about ancient Jews' devotional spaces, even if we lack such information. Entering its expanse reminds us of how profoundly sensory information shapes supplicants' experiences in devotional environments, from associated sounds, smells, textures, tastes, and degrees of illumination.[3] And watching Christians of all denominations and origins congregate in the same church remains equally instructive—it reminds us of how demographically diverse devotional spaces can be.

Such observations, in turn, can inspire new questions about the sensory, socially, and spatially circumscribed realities of Jews in their ancient devotional environments. For instance, we might ask whether Jews only prayed in designated places, such as synagogues, or whether they might have prayed in other

FIGURE 1.1. Memorial dipinti and graffiti in Latin and Arabic scripts upon columns of the external façade of the Church of the Holy Sepulchre in Jerusalem, Israel; December 2014. Photo by Ezra Gabbay.

FIGURE 1.2. Graffiti of crosses from the stairway to St. Vartan's Chapel in the Church of the Holy Sepulchre; May 2013. Photo by Ezra Gabbay.

types of environments more broadly conceived? How densely populated were such spaces at times of communal prayer? What did ancient synagogues smell like? What, if anything, could you see inside of them—were they brightly illuminated through second-story windows, or was the darkness inside them barely permeated by lit wicks of oil-lamps?[4] What did people wear when they prayed? Did synagogue officials or rabbis don distinctive clothing, and did other Jews modify their attire (with particular vestments, head-coverings, or veils) when they entered synagogues? Did all Jews pray alongside similarly minded Jews, or also beside and with Jews of different backgrounds, theologies, and beliefs—or even beside non-Jews? Raising questions such as these highlights how woefully incomplete are our understandings of the sensory, spatial, and demographic dimensions of ancient synagogues (let alone of the alternative spaces in which ancient Jews might have prayed), without tangible evidence for associated sights, sounds, smells, and textures.

Most known ancient synagogues are preserved only as stone foundations and tiles, broken and empty shells, largely devoid of their original fabrics, paint, or upper stories (whose presence might indicate modes of illumination through window locations). Yet these absent features were likely critical in shaping the experiences of Jewish devotees for associated activities of communal gathering, reciting and translating biblical scripture, and repeating liturgical prose and poetry.[5] Regard for "living"

examples of devotional spaces, including that of the Holy Sepulchre, may encourage us to use our imaginations to ask new questions about ancient structures, their experiential features, and their collective impact on activities of prayer—whether conducted by Jews, Christians, or pagans within them.

Yet a second feature of the Church—its ubiquitous graffiti—offers another useful prompt to imagine potential ranges of Jewish devotional practices in antiquity. Closer evaluation suggests that the locations and contents of the Church graffiti are less random than they might initially appear. Patterns emerge: signature graffiti and written requests for blessings and remembrance proliferate particularly around the portals (figure 1.1), while christograms and abstract figural graffiti dominate stairwells leading to specific shrines (figure 1.2). Locations and lexical contents of these writings, moreover, often exhibit surprising similarities to thousands of comparably neglected examples, scratched by ancient peoples from the same region, including Jews, as well as pagans, Christians, and the earliest followers of Muḥammad.

Jews and their neighbors once carved graffiti, such as these, nearly everywhere, including interiors of ancient synagogues, pagan sanctuaries, and shrines, in Syria and Judaea/Palaestina and throughout the deserts of Egypt, the Sinai Peninsula, and Arabia. These markings, just like those in the Church of the Holy Sepulchre, are often patterned, as inscribers positioned similar types of messages and pictures in consistent portions of buildings and landscapes. They recorded their names and, occasionally, those of family members, their offerings of thanksgiving or divine blessing, and their solicitations of remembrance and favor for themselves and for their families. And these markings, associated with ancient Jews and their neighbors throughout the eastern Mediterranean, Mespotamia, and northwest Arabia, beg for attention as much as do their early modern Christian counterparts.

In this chapter, I argue that certain acts of graffiti writing, such as these, should be properly classified as modes of prayer conducted by Jews and their neighbors alike. Associated behaviors, including physical and sensual acts of carving, painting, and smudging, indeed, were intimately connected to the spatial and temporal contexts in which people performed them. The ensuing analysis of graffiti writing ultimately reveals another point, equally obscured in Jewish historiography: that ancient Jews prayed in a variety of built and natural environments. They sometimes did so only beside other Jews, and, at other times, alongside their pagan, Zoroastrian, and Christian neighbors. Contributions of these observations are manifold, as they challenge and expand conventional understandings of devotional experience, activity, sanctity, exclusivity, sociality, and spatiality among Jews and their neighbors in antiquity.

DENATURING PRAYER

This analysis requires the preliminary denaturing of common assumptions that govern studies of ancient Jewish prayer. Prayer is often understood as a specifically verbal act—a vocalized or internal production or repetition of words or sentiments to communicate with the divine and, perhaps, with other worshippers.[6] As Uri Erlich and Rachel Neis have recently argued, however, ancient Jewish prayer also entailed bodily and visual components.[7] Closer attention to graffiti suggests that, in antiquity, acts of scratching texts into stone or plaster, or of painting images onto a wall, equally constituted acts of prayer. My working definition of prayer, then, accommodates this possibility by imagining it as a general type of communication—directed by humans toward the divine—which may be planned or spontaneous, individuated or rote, singular or repetitive. This communication might be verbal or written, silent, spoken, or gestural. Its expressions might include divine praise and thanksgiving; requests of favors or blessings for supplicants, their families, or their communities; express appeals to the divine, and/or allude to sacred events or history.[8] Prayer(s) might be proffered in isolation or communally. Such conceptions of prayer expand, still further, toward the end of this chapter, after consideration of graffiti nuances current approaches to ancient devotion—and particularly among ancient Jews.

Attention to the spatial, physical, and local dimensions of prayer remains critical to this approach. Ancient and modern sources frequently discuss Jewish prayer as an activity substantively disembodied from its surroundings. This understanding is not accidental, but, as some suggest, reflects a deliberately crafted rabbinic response to the destruction of the Jerusalem Temple in 70 CE. Biblical texts often describe the Jerusalem Temple as God's one dwelling place on earth, where Israelites, Judahites, Judeans, and Jews diachronically offered their prayers (and sacrifices) to the divine.[9] For this reason, some rabbis advocated visualizing scenes from the Temple during prayer, regardless of their actual surroundings (*b. Yoma* 54a–b). As long as Jews did not pray beneath or beside idols, in fact, they could pray (whether for the Sabbath or on weekdays) in multiple environments (*t. Šabb.* 18:1; *b. Šabb.* 149a; *Exod. Rab.* 12:5).[10] But as the remains of elaborately decorated synagogues demonstrate, the contours of Jewish prayer environments mattered a great deal to their constituents. Whether Jews offered prayers in built spaces or in natural ones (those which humans did not wholly construct using tools), their devotional acts, just like those of their neighbors, were inextricably related to the particular environments in which they conducted them; their precise *locations* within places or sites (and with varying degrees of precision) remain as critical to their interpretation as are their lexical contents.[11]

Some questions, largely unanswerable, but inspired by conversations in spatial discourse and landscape theory, thus remain useful here to

reimagine acts of ancient Jewish devotion. How did devotees, for example, position themselves to pray inside their chosen spaces? Did they offer prayers in obscure corners of buildings, or in central locations alongside other people, where their presence was apparent and their recited prayers were more audible to passersby? And, of equal importance, how do modes of devotion associated with Jews and identifiably Jewish contexts compare to analogues among neighboring populations? Did Jews deliberately pray differently (with respect to location, posture, comportment, or semantic contents) than their neighbors did, or not? These sorts of questions situate verbal and written devotional activities as points along a continuum and facilitate their improved evaluation as vestiges of actions once conducted in specific times, spaces, places, and landscapes.

This analysis relies on a simple and practical fact: that graffiti, unlike countless verbal prayers once offered by Jews and their neighbors throughout antiquity, are documented archaeologically. Their texts and drawings often appear crude, but when available, remain etched into the same stone and plaster into which they were originally applied. And they specifically qualify here as potentially "devotional" graffiti for reasons of context and/or content. Some graffiti are found in places in which other types of devotional activities took place, including those of communal gathering, liturgical recitation, storage and recitation of holy texts, the conduct of sacrifice, or maintenance of relics (whether in synagogues, pagan sanctuaries, shrines, or the like). Other markings include diagnostic content (they explicitly name a divine audience, offer thanks, request blessings, favors, etc.). All of these types of graffiti merit collective and integrated consideration here.[12]

Finally, we know that certain graffiti were minimally acceptable as forms of expression in devotional environments, because other users of the same spaces did not efface them, even if they did not necessarily laud their application. If the presence of a graffito had been intolerable to patrons or visitors to a building or sanctuary, for example, others might have scratched or painted over them. While some graffiti might have disappeared through deliberate erasure, known examples of graffiti associated with Jewish populations (unlike some of their monumental and decorative counterparts), found in sanctuaries, temples, and desert cliffs, bear no overt signs of subsequent defacement.[13] Extant graffiti thus represent acts of physical engagement with communal spaces, whose survival reflects their sufficient acceptability to other inscribers and viewers.

Contexts and settings vary considerably among known graffiti of these types. Some proliferate in distinctly Jewish devotional contexts, such as the seventy documented examples of textual and figural graffiti found inside the synagogue of Roman Dura-Europos in Syria. Devotional carvings, in the forms of written signatures and liturgical symbols associated with Jews, also appear inside spaces designed for cultic use by pagans, Christians, and others,

whether a late Hellenistic sanctuary of Pan in the eastern Egyptian desert or a pagan shrine subsequently dedicated to the prophet Elijah on Mt. Carmel in modern Haifa. Ongoing excavations throughout the Sinai Peninsula and archaeological surveys along Nabataean trade routes in modern Saudi Arabia, moreover, continue to reveal additional and comparable examples.[14] These graffiti, which have never been reviewed collectively, conform to at least three subcategories of devotional activity. Serial and synthetic analyses of these genres of graffiti ultimately help to forge a narrative, quite different from that preserved in rabbinic texts or dedicatory inscriptions, about the variety and capaciousness of Jewish prayer in antiquity.

JEWS PRAYING IN THEIR OWN SPACES

Jews wrote graffiti in devotional environments throughout the Mediterranean. Many surviving examples of them, however, remain particularly difficult to interpret. Isolated texts and pictures have been found inside and upon ancient synagogues and other buildings in modern Macedonia, Croatia, Greece, Turkey, Syria, and Israel: these include renderings of solitary menorahs or other appurtenances from the destroyed Jerusalem Temple, and, more occasionally, individual letters or words.[15] The proportional rarity of these graffiti, particularly when compared to more abundant examples of monumental decoration and dedicatory inscriptions preserved from the same sites, remains striking.

One might fairly ascribe the scarcity of synagogue graffiti to the fact that graffiti writing was not actually a popular practice in antiquity. But diminished records for synagogue graffiti and dipinti likely also relate to other factors, including environmental exposure and excavation methods. For example, plaster is the fabric of choice for many attested graffiti throughout the Mediterranean, from Judaea to Rome and from Pompeii to Hatra.[16] This is true for practical reasons: plaster is more durable than wood, but much softer and therefore easier to carve than are many stone surfaces. But ancient building plaster rarely survives, partly because it succumbs to the serial ravages of moist Mediterranean winters, and partly because early excavators lacked the desire, funds, or technologies to properly preserve it. Only the most remarkable circumstances could permit the survival of plastered walls and associated graffiti from ancient buildings. Luckily, extraordinary conditions are responsible for the unprecedented conservation of the walls and graffiti from the synagogue in the Syrian town of Dura-Europos.

The unusual preservation of graffiti from the Dura synagogue is connected to the history and demise of the city that once surrounded it. For over five centuries of its existence, Dura-Europos had occupied a strategic position on the Euphrates River, between modern Syria and

Iraq. During the period in which Dura flourished, beginning in the fourth century BCE, populations of Arab, Roman, Palmyrene, Parthian, Syrian, and Greek traders, manufacturers, and soldiers flooded the town. We know this, because the archaeological record preserves diversities in local linguistic, onomastic, artistic, and cultic practices.[17] The cultic and religious climate of the city fluctuated through time, corresponding with the municipal restructurings that followed sequential periods of Parthian and Roman conquest. Durenes built temples dedicated to local and regional manifestations of deities (such as Azzanthkona and the Aphlad), beside those constructed for the veneration of Hellenistic, Palmyrene, Roman, Christian, and Jewish divinities (Map 2).[18]

Third-century invasions of Sassanian Persians ultimately shattered the life of this Syrian town.[19] The Sassanids ultimately overtook the city sometime around 256 CE, though the details of their attack and destruction of Dura remain obscure.[20] Attempts to defend Dura, however, preserved the remains of the city for posterity in a remarkable way. In anticipation of the Persian attack, local Roman soldiers (mostly of Syrian descent) filled the buildings that abutted the city defense walls with sand, to transform them into a series of fortified earthworks that might resist the battering rams of the enemy. Long after the city's destruction and depopulation, then, the buildings that were incorporated into the defensive earthen embankment, such as the local synagogue, continued to resist collapse. This explains why, even if Dura's population did not survive the Sassanid invasion, many of the painted and inscribed walls of the synagogue did, until their discovery in the early twentieth century.

Clark Hopkins discovered the synagogue in the sixth excavation season of Yale University's expeditions in Dura (1932–1933). Due to its location just beside the city wall and its full integration into the defensive embankment, the degree of preservation of the structure was superb and unprecedented among other buildings in Dura (let alone among ancient synagogues theretofore discovered). Excavations revealed that ancient Durenes had converted the synagogue from a domestic building and imposed multiple stages of renovation on it. Decoration of the final iteration of the structure, called a *bayita* ("house") in its Aramaic dedicatory dipinti, was completed sometime around 244/245.[21] The synagogue floors were apparently unadorned. But excavators discovered the walls of the assembly hall, largely intact and dramatically decorated with more than seventy panels depicting narrative texts from the Hebrew Bible, replete with painted and labeled images of Moses, Aaron, and other biblical figures (figure 1.3).[22] Portions of the fancifully decorated and inscribed ceiling were also preserved; so too were architectural elements of the multiple construction phases of the synagogue, and a liturgical papyrus.[23]

Inscriptions discovered throughout the structure, on its ceiling, walls, and architectural features, contained writing in multiple languages, including Greek, Aramaic, Pahlavi, and Middle Persian. Some of these inscriptions

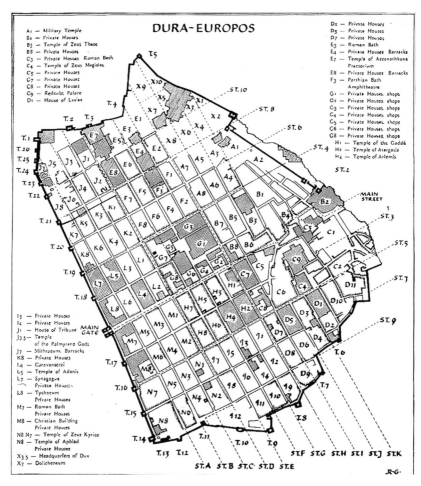

Map 2. Plan of Dura-Europos, Syria. Map courtesy of YUAG.

recognized the works of synagogue donors, others labeled images on the walls, while still others, composed in Pahlavi and Middle Persian, commemorated multiple visits paid by Persian scribes to the space. The unusual degree of conservation of the synagogue, its decoration, and its polyglossic epigraphic remains, in all cases, pointed to a rich cultural environment and a cosmopolitan population of visitors. Discovery of the building, for such reasons, rapidly transformed the study of Jewish populations of the Roman world and offered a three-dimensional example of how culturally and demographically continuous was one Syrian Jewish population within the complex world that surrounded it.[24]

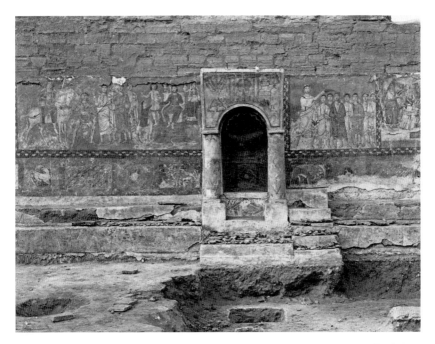

FIGURE 1.3. Photos of the *aedicula* and west wall of the Assembly Hall of the Dura-Europos synagogue in Syria, as uncovered *in situ*; c. 1932–1933. Image courtesy of Yale University Art Gallery (YUAG).

The remarkable preservation of components of the Dura synagogue has justified continued reliance on its architecture, murals, and associated finds for postulations about the history of Jewish populations inside Dura and elsewhere in the ancient Mediterranean. But certain of the synagogue's elements, including its most abstract figural and textual graffiti, have largely eluded scholarly attention.[25] Excavators reported discoveries of various types of graffiti on architectural features from every stage of the building's construction and use: from its earliest documented phases (c. 150–240 CE), embedded in fill and etched onto the decorated walls of the final assembly hall (c. 240–255/7 CE), and scratched onto fragments of doorjambs, lintels, and walls throughout the building. Final excavation reports noted the presence of figural images in graffiti, but the majority of associated markings are textual: roughly 35 percent of all graffiti discovered in the synagogue contain pictures.[26] Most of these roughly-applied pictorial and textual markings include simple renderings of personal names, remembrance requests and miniature portraits, and even words of divine praise and commendation, which usually seem so clumsily rendered, amateurish, and slightly odd that they appear to justify their serial neglect.[27]

אנצ'וֹת'וא

עמ'חה ס''ו

בר שׁמאנל

FIGURE 1.4. Aramaic signatures of Hiya and Ḥananī son of Samuel from the Dura-Europos synagogue; drawn from the original. Scanned drawing from R. Du Mesnil de Buisson, *Les Peintures*, 162.

Closer evaluation of these graffiti, however, reveals sufficient consistencies in their contents and placements to suggest their significance inside the Dura synagogue, both for their inscribers and for their audiences.

Carvings of names (signatures) are among the most common types recovered on plaster fragments and walls from multiple phases of the synagogue. These account for one quarter of the identified examples.[28] Some signature graffiti simply declare: "I am so-and-so," in Aramaic ('*n*' and personal name) and appear, most commonly, on or around the synagogue doorways. One portion of a doorjamb discovered on the embankment above the synagogue Assembly Hall, for example, reads in three lines: "I (am) Ḥiya . . . | I (am) Ḥananī son of Samuel" (figure 1.4),[29] while another piece of a doorjamb includes three comparable lines of Aramaic graffiti to document a certain "Ḥiya" multiple times: "Ḥiya, son of . . . | I Ḥiya, son of . . . (am) their father/chief | Yo[ab?/I]".[30] Graffiti associated with Ḥiya might commemorate the work of similarly named individuals or, more likely, demonstrate the zeal of one individual (or a smaller number of identically named individuals) to carve his name, multiple times, throughout the building.[31]

Still another modification of the simple signature graffito emphasizes the importance of writing one's own name with one's own hand. In a graffito that declares: "This is the inscription which Mattenai wrote," the author (Mattenai) emphasizes his having carved his own name directly into the synagogue wall (Syr83). Boasting of carving one's own name is an epigraphic cliché, commonly attested in inscriptions throughout Dura and elsewhere in the Roman world. But the precise sentiment, however stylized in form, could reflect its true significance for the writer, either as an expression of pride in the ability to write his own name, and/or the degree to which the act of writing his *own* graffito (rather than asking a more skilled friend for the favor) made the message more efficacious for him (its agent).[32] We shall return to the latter point below.

Another common expression also names individuals, but additionally requests that they "be remembered" or, "be remembered for good" (*dkyr* or *dkyr ḷṭb*). Clusters of this type of graffito also adorned doorjambs, including one example which reads: "By your leave; Ḥanani and Dakka

FIGURE 1.5. Greek memorial graffito from the Dura-Europos synagogue. Scanned drawing from de Buisson, *Les Peintures*, 162.

and Naḥmani, may he be remembered," and another, which beseeches: "May Minyamin be remembered, the *apothecarius*."[33] While most of these phrases are in Aramaic, others use equivalent expressions in Greek, such as the term *mnēsthē* (figure 1.5).[34]

Other graffiti clusters incorporate pictures of male heads and torsos into textual requests for remembrance.[35] One example of this pairing appears on a plaster fragment, likely from the synagogue assembly hall, which includes six or more lines in Aramaic. The text reads: "Aḥiah son of . . . of the sons of Levi. May he be remembered for good before the Lord of Heaven. Amen. This is a memorial for good."[36] The text nominates someone (Aḥiah, descended from Levi), and requests that he be remembered for good (*dkyr lṭb*) and before (*qdm*) a specific named deity (restored as *[mry š]my*'). But beneath the final line of the text also appears an additional element: an image of a male torso with a circle on the left breast, a head without hair, and dot-like eyes. The relationship between the picture and the text remains unclear, but the image of the man, so similar to another example carved around a different memorial graffito discovered nearby (Syr82), may graphically portray the individual (Aḥiah) named in the adjacent text (figure 1.6).

What are these different types of inscriptions, and what accounts for their recurrences within the Dura synagogue? Traditional explanations focus on their textual and lexical contents. Similarities between phrases in the Aramaic graffiti and those found in monumental inscriptions, on walls and mosaic floors of Syrian and Palestinian synagogues, for instance, have led scholars to conclude that their functions are equivalent. The Durene examples, according to these readings, serve as abbreviated dedicatory inscriptions, which would solicit the remembrance of individuals who had given some form of gift to the synagogue.[37]

Attention to the precise syntax of the Dura graffiti, their variety, their exact placement in the building, and the media of their applications,

FIGURE 1.6. Aramaic memorial dipinto of Aḥiah and picture from the Dura-Europos synagogue; drawn from the original. Scanned drawing from R. Du Mesnil de Buisson, "Sur quelques inscriptions juives," 170.

FIGURE 1.7. Greek dedicatory inscription of Samuel, son of Saphara (Bar Saphara) painted onto ceiling tile from the Dura-Europos synagogue, which requests "may he be remembered [who] founded these things thus" (Syr87). YUAG open access catalogue number 1933.257.

nevertheless, collectively challenge this otherwise reasonable explanation in several ways. First, with the exception of the rough-hewn dedicatory text(s) found on the Torah niche and those more elegantly painted on the ceiling, each of which explicitly describes acts of donors or donated objects,[38] none of the signature or remembrance graffiti from the Dura synagogue—whether upon walls or architectural features—explicitly name gifts or imply that the nominated individuals donated any. Second, neither the graffiti preserved *in situ*, nor those preserved on architectural fragments *necessarily* adorn donated objects. Though the presumption that the graffiti were intended to accompany gifts makes intuitive sense, it embeds an

underlying presumption about the nature and function of such modes of writing based on common donor models; understanding these texts as handwritten versions of dedicatory inscriptions casts them implicitly as "hasty" or "slapdash," suggesting a lesser degree of care taken to form them than other dedicatory inscriptions. Yet, as their examinations indicate, these modes of writing may not be the same, and I return to this point more directly below. Third, if these graffiti constitute dedicatory inscriptions, why might multiple names of donors be crowded onto identical architectural features, like doorjambs? Perhaps this practice would indicate that multiple individuals contributed at different times to fund the creation or renovation of an identical architectural feature, such as a doorjamb, even if such a choice seems somewhat odd to modern sensibilities.[39] Fourth, the link between some of the Durene graffiti and surrounding pictures seems strange. While these carvings could have been applied incidentally or independently, the figural portraits are applied consistently enough beside these texts to suggest a possible connection between them. Upon closer review of spatial and syntactical patterns in these graffiti, the hypothesis that these texts are donor inscriptions seems less convincing.

One of the strongest arguments *against* reading these graffiti from the Dura synagogue as dedicatory inscriptions is that both their contents and contexts largely mimic other genres of graffiti consistently discovered elsewhere in Dura and throughout the surrounding region, which bear no evidence of being dedicatory at all.[40] To this point, nearly 1400 graffiti have been collected throughout Dura-Europos.[41] Signatures and remembrance formulas account for a large percentage of these; Jennifer Baird has suggested that remembrance graffiti, written in Greek and usually beginning with the acclamation "*mnēsthē*" (remember!), account for at least 12 percent of the total number collected.[42] While Greek versions of the expression are most common in Dura, equivalents in Semitic languages and scripts recur in surrounding regions. As discussed below, texts that include Aramaic, Palmyrene, Syriac, and Nabataean equivalents for remembrance formulas (rendered respectively as *dkyr* or *zkyr*) are common throughout regions of modern Lebanon, Syria, Israel, Palestine, Egypt, and Saudi Arabia. These formulas are ubiquitous but do not necessarily signify any associated acts of gift giving in religious or cultic contexts.

Additional similarities between graffiti from the synagogue and elsewhere in Dura also discourage their interpretations as second-class or more sloppily carved dedicatory inscriptions.[43] For instance, examples of signature and remembrance graffiti abound in local temples and devotional spaces. Signature and remembrance graffiti, incised directly inside shrines and altars, constitute roughly 78 percent of the textual graffiti reported in the Durene Aphlad Temple, where the Greek formulation for remembrance is so common that most instances of the word are abbreviated to the initial

Greek letter *mu* (for *mnēsthē*).[44] Comparable patterns emerge in the Greek graffiti in the so-called Temple of Azzanathkona, where the majority of textual graffiti include signature and remembrance inscriptions; these appear most frequently (over 53 percent of the total published number) around cultic images, shrines, altars, and architectural niches.[45] While pictorial graffiti appear in all contexts throughout the city, clusters of name and remembrance graffiti, occasionally with portrait-like elements, appear most commonly in temple precincts and, particularly densely, upon and around altars and cultic niches. These signature and remembrance graffiti are usually in Greek and conform to a category independent of the dedicatory inscriptions themselves, which otherwise explicitly describe acts of donation, nominate gifts given to temples, or directly label donated objects like votive statues, altars, and cultic reliefs.[46]

How best, then, to interpret Aramaic and Greek signature and remembrance graffiti in the synagogue and elsewhere in Dura? Answers relate both to their lexical contents and to their placement. As Joseph Naveh argues, Semitic graffiti that include signatures and remembrance requests, and thus maximally include only the first half of typical dedicatory formulas, read more like written prayers than dedications.[47] According to Naveh, inclusions of names in this genre of graffito, of which thousands of examples appear on caves, rock surfaces, and public spaces throughout Mesopotamia, the Roman East, and Arabia, need not signify associated acts of dedication at all. He suggests that they express written requests that passersby memorialize the writer of the graffito, by reading his name out loud—often before a specific god or set of deities. A name or remembrance inscription, unlike a dedicatory one, thus would serve as a type of petition, permanently documented in plaster or stone.

Phrases in comparable graffiti from regional cultic contexts substantiate such readings of Durene graffiti. A more complete Aramaic graffito from an *iwan* in a temple complex in nearby Hatra, for example, explicitly compels passersby to vocalize the name(s) it records before the local deities, including the god Māran,[48] by cautioning: ". . . The curse of [Māran] against anyone who reads this inscription [and does not say, 'Remembered] for good and excellence before Māran be. . . . this [this *NŠRYHB*]'."[49] The agencies of the viewer and the reader, in this case, overshadow that of the inscriber, even if the viewer and reader play pivotal roles in activating the agent's original invocation for remembrance before the divine; the writer's threat against recalcitrant passersby underscores this relationship.[50]

Signature and remembrance graffiti, therefore, when viewed from the perspective of the Māran prayer above, do not merely serve as declarative writings. Instead, they are dialogical and coercive and work as agents on behalf of their inscribers. Viewers' responses to them (either through silent or vocalized repetition), moreover, determine their efficacy.[51] Inscribers' acts

of writing, combined with vocal repetitions of their sentiments, indeed, might doubly assure a named individual's remembrance, both by humans and by a resident or proximate deity.[52] Rare but explicit invocations of curses for those who read a graffito, but do not recite its contents out loud, underscore the writers' dependency on their audiences, whose subsequent responses and activities determine the efficacy of writers' requests, whether inside the synagogue or temples in Dura, or those farther east in Hatra.[53]

These types of graffiti-petitions can be understood as prayers, on multiple levels. First, the act of inscribing one's name and/or requesting remembrance for good could document one's efforts to communicate directly with a divinity. Second, these acts of writing solicited an audience of passersby from a community of like-minded (or similarly located) devotees, who served as witnesses to the writers' supplications. An audience's response to the graffito, furthermore, could play an additional and vital role for its inscriber. Perhaps the original writer, whether he recorded his name or requested remembrance, expected passersby to read his name or acclamation out loud whenever they viewed it.[54] Perhaps, in such a case, the vocalization of an individual's name or remembrance request served to activate an associated message and its devotional function. Analogues for this expectation abound in discussions of objects and prayers of ritual power, particularly in the consideration of Aramaic amulets and incantation bowls found throughout the region in later periods.[55] Finally, the spatial dimension of the graffito shaped its role as an imprecation, in a different way: its precise placement might have reflected an inscriber's additional wish that his name or prayer be recited out loud in that exact spot. This could be in a particular architectural or natural feature where a god was thought to dwell, or in the liminal space of the doorway, positioned halfway between the realm of a god (directly around an altar, or inside an assembly room) and that of the human or mundane (less privileged portions of these buildings).[56]

The locations and visibility of graffiti from the Dura synagogue support these hypothetical interpretations, foremost, because writers drew them so that viewers could read or see them easily. Letter sizes and pictures of extant examples of memorial graffiti are relatively large. And while neither the Greek nor Aramaic graffiti are elegantly carved, due to the medium of their application (rendered with a stylus or some other sharp implement, into hard-to-carve and friable plaster, inscriptions incised in this way *necessarily* won't look so good), the act of inscription itself, in addition to the basic legibility of their markings to audiences, appear to have taken priority over the appearances of the texts. Moreover, the locations of these carvings are significant: writers carved their words and pictures on prominent architectural features. Most extant Aramaic graffiti from the synagogue, for example, appear on elements of its doorways, which likely predicted and accommodated patterns in pedestrian traffic. If one sought an audience for

one's message, the placement of signatures around a highly trafficked door to the central assembly-hall of the synagogue would seem like a strategic decision. Other factors, however, might explain why synagogue visitors wanted their names (and perhaps, their associated pictures) to be seen and, perhaps, to be read out loud, in these particular places.

Comparisons with examples found in neighboring buildings are illustrative in this regard. In the Durene temples of the Aphlad and Azzanathkona, as well as the Mithraeum and Christian building, visitors also wrote their names and remembrance requests in large scripts at eye level and in consistent and prominent locations. But signatures and remembrance requests, in those buildings, are clustered somewhat differently; their greatest densities are directly around cultic scenes, appurtenances, divine statues and images, and around architectural features, such as shrines, where sacrificial or anointing rituals were performed (inside shrines and around altars).[57] This curious distribution is telling: it suggests that devotees situated their graffiti-prayers strategically, in the places where they could be most effective, where their intended audiences—whether gods or other devotees—were most physically present and, potentially, most receptive to them.[58] Patterns in the spatial distribution of graffiti are therefore significant: they suggest that writers did not position their requests at random, but carved and painted them deliberately in the precise locations where they could most efficiently communicate with their intended and multiple audiences.

Juxtaposition of the spatial distribution of the synagogue graffiti with other local analogues, nonetheless, yields a puzzling result. If most signature and remembrance graffiti in Durene temples are clustered in the most sacred spaces of the buildings, such as altars and shrines, or in the case of the Christian building, the baptistry, why are nearly 70 percent of the same types of graffiti from the synagogue more unusually clustered on architectural features such as stone trim, lintels, and doorjambs, rather than on other areas (such as the aedicula), often assumed to be the spaces of greater sanctity?[59] One might argue that the disproportionate presence of graffiti around synagogue doorways might respond to inscribers' desires for their visibility, as suggested above, or to accidents of preservation. Architectural features like lintels and doorjambs, whether in plaster or stone, remain more durable than other parts of buildings, like wall plaster; this fact predicts the disproportionate survival of associated markings, even after a building's partial collapse. But this logic does not account for the dearth of graffiti surrounding the spaces often presumed to be most sacred in synagogues, such as spaces where the Torah scrolls were stored or displayed.

A more convincing explanation might relate to the intrinsic significance of doorways in biblical and broader regional traditions.[60] Biblical injunctions to write words of divine commandments "on the doorposts of your house and on your gates" (Deut 6:9) were interpreted literally among Levantine

Jewish, Samaritan, and Christian populations from earlier through later antiquity, who carefully carved such quotations directly into their stone doorposts and lintels.[61] Many examples of this are recorded in Palmyra, and subsequent Jewish traditions of emplacing *mezuzahs* on doorposts respond to the same biblical directives.[62] Discoveries of deposits of incantation bowls, bones, and lamellae beneath the doorways of Mesopotamian homes (when documented), within the door sockets leading to the assembly hall of the Dura synagogue itself, and embedded within thresholds of Palestinian synagogues, collectively reinforce complementary points: Jews and their neighbors considered doorways to be powerful places, where amulets, wishes, or prayers might be most effective.[63] To inscribers, entrances to the synagogue assembly hall, just like doorways of the earlier synagogue and cultic niches in other Durene buildings, could be places where the inscription of names, their spoken repetition, and associated invocations of a writer's memory might be particularly potent for multiple reasons, including their visibility, their architectural significance, and their direct connection to divinity. Tagging doorways with one's signature or portrait, or requesting remembrance, did not necessarily commemorate acts of donation, but in all cases constituted acts of agency, self-advocacy, and personal prayer inside the synagogue.

Graffiti found throughout Dura, whether in the synagogue, the Christian building, or the Temple of Azzanathkona thus demonstrate something consistent: they do not appear to violate laws of sanctity as they would if they were carved or painted onto houses of worship in the United States or Western Europe. The ubiquity of these examples, rather, suggests something entirely unexpected: that these graffiti were carved most densely in places of intensified holiness, upon the precise architectural features where devotees offered sacrifices (whether animal, vegetable, or metaphorical) to the divine, or directly anticipated divine presence or connection.[64]

Supplementary attention to the ways that non-Durenes (and probably non-Jews), also wrote on surfaces in the synagogue offers additional regional perspectives on associated practices. In the 230s CE and following, Persian visitors to the synagogue also applied messages to portions of the decorated walls of the assembly hall in Pahlavi, Parthian, and Middle Persian scripts. Despite the linguistic differences in their writings, their appearances, lexical contents, and locations betray similarities in certain respects. Scribes painted their writings carefully, if not reverentially, along the natural contours of specific painted figures (figure 1.8).[65] Several include the personal names of individuals, self-identified as scribes; they record the precise dates of their visits to the synagogue and words of praise for the quality and appearance of the surrounding murals.[66] Persian writers, indeed, were aware of the functionality of the space they visited: one text explicitly pronounces that Jews worshipped their god(s) in the building (". . . and this servant of the

FIGURE 1.8. Detail of writings that Persian scribes painted onto mural of panel depicting the Triumph of Mordechai, from the assembly hall of the Dura-Europos synagogue; date of photo unknown. Image courtesy of YUAG.

Jews to his edifice of the god [of] the gods of the Jews came. . . .").[67] A small number of these dipinti, moreover, took advantage of the devotional nature of the space by directly appealing to divinities through expressions of divine praise.[68] Two Middle Persian texts, painted onto the panel depicting Ezekiel in the Valley of Dry Bones (NC1), for instance, include expressions such as ". . . to the gods give thanks!" and "Make this be known: be joyous and hear the gods' voices! Then well-being will be upon us!"[69]

Identifications of the Persians who wrote these dipinti and graffiti and explanations for their presence in the synagogue remain unresolved. Some argue that the scribes were Jewish Persians, even if multiple elements of the inscriptions suggest that they were probably not.[70] The medium, phrasing, and locations of many of these writings, indeed, differ from others discovered in Dura and in the synagogue itself, partly because they follow distinct devotional, linguistic, spatial, and cultural conventions—presumably Persian (and Zoroastrian) ones.[71] When taken together, however, their presence demonstrates the engagement of some Persian scribes with locally and regionally normative practices, including writing on the surfaces of special buildings, to invoke, praise, or appeal to gods, under various guises, inside the synagogue and elsewhere.

What can interpretations of some of these graffiti, whether written by Durenes or visiting Persians, contribute more generally to our understanding of devotional behaviors in ancient Dura and its environs? First, in all cases, individuals who applied these types of graffiti did so as (semi-)public acts. They boldly carved and drew pictures to be seen, both by their peers and also by the divinities involved (and believed to be resident or proximate) in surrounding spaces. The placement and syntax of multiple messages demonstrate the latter point. Second, in the case of local Jews, the synagogue graffiti demonstrate something else: substantive evidence that Jews in Dura were behaving in many of the same ways as were their neighbors (both locally and cross-regionally) in their devotional spaces. Writing names and drawing self-portraits inside buildings of devotional significance, in a similar idiom, medium, syntax, and form as did their peers, demonstrates important continuities in the devotional and cultural practices of all Durene populations—pagans, Jews, and Christians included—and of those who visited Dura from afar. These behaviors reflect local and regional norms, rather than particularly pan-Mediterranean Jewish ones.

In recent decades, scholars have used multiple features of the Dura synagogue to prove that local Jews, traditionally assumed to be intrinsically culturally isolated, maintained high levels of interactivity with their Durene neighbors. Arguments about the deployment of common artisans and architects for decorating, designing, and inscribing the synagogue and other local buildings support such claims.[72] But graffiti constitute evidence

for a more fundamental and, I would argue, substantive cultural continuity—not just for the *interaction* of Jews with their neighbors, but for their enmeshment in and inextricability from Durene society. Jews drew graffiti—both textual and pictorial—to pray like other Syrian Durenes, because they *were* (it seems) Durenes.[73] They lived with and next to other Durenes and were, accordingly, quite aware of devotional propriety—what one should do (and presumably, should not do) in cultic and religious spaces—just as were their neighbors. Thus graffiti demonstrate something otherwise unknown: Jews in Dura offered some of their prayers, through acts of drawing and writing, just like their neighbors did. And, Persian scribes, in isolated cases, even joined their devotional conversations.

Local analogues, however, demonstrate something distinctive about Jewish prayer practices in Dura. Comparisons with graffiti from other Durene buildings illustrate the nuanced ways that devotees in the synagogue, just like those elsewhere in Dura, commonly adjusted the languages, vocabulary, and scripts in their graffiti to respond to their precise devotional contexts and the deities associated with them. Graffiti from the temples of the Aphlad and Azzanathkona are all in Greek, the best-attested epigraphic language in Dura, and follow common formulas for signature graffiti and acclamations throughout the Greco-Roman east. Graffiti from Dura's Mithraeum largely deploy Greek scripts, but sometimes modify the *mnēsthē* expression with that of the term *nama* (which possibly means "blessings!"), to conform to the particular liturgical vocabulary of that cult.[74] Variations in graffiti-contents in each building reveal imperatives to speak to gods in the liturgical languages, scripts, and terminologies most appropriate for them. This makes sense, because one of the presumed goals of writing the graffiti included facilitating the most effective communication with a specific deity (or associated worshippers).

In this respect, semantic contents of graffiti from the synagogue resemble those from other Durene buildings, except for their script and language: they are mostly scratched in Aramaic. As there were Greek dedicatory dipinti in the ceiling and several mural labels in Greek, it appears that Greek was also considered an appropriate language for monumental display in the synagogue. The dominant use of Aramaic for the synagogue graffiti, then, might suggest a degree of context-dependence. Either graffiti inscribers were more comfortable inscribing Aramaic graffiti than Greek, or, alternatively, they believed that Aramaic was the most suitable language for communicating with other worshippers and/or directly soliciting the Jewish God in this particular medium. Persian scribes may have felt the same way about their messages to their own gods, whether transcribed in Parthian, Pahlavi, or Middle Persian.

Of course, graffiti writing and viewing comprised only one aspect of the multifaceted experience of visiting the Dura synagogue. Designers

of the building had ensured that, on multiple levels, a visit to the space would have entailed a temporal and symbolic re-orientation. Vibrant wall paintings, which portrayed the history of the Israelites, the rapturous visions of their prophets, and the past glory of the Jerusalem Temple, encircled viewers with representations of a glorious Jewish past, sustained through acts of divine intervention, faithfulness to the divine, and collective perseverance. Overhead, the roof of the building served as a constructed heaven to remind viewers of the exceptionality of the space below: hundreds of polychromatic ceiling tiles projected fantastical images of mythical creatures, smiling women's faces, abundant fruits, and violent assaults on the evil eye.[75] Between the decorated walls and ceiling of the assembly hall, erratic sounds and intense smells were likely trapped inside the still air, thickened by smoke from the burning wicks of lamps. Light from the clerestory windows above selectively illuminated the space. The dazzling impression of these features is well documented: it inspired visiting Persians to praise the resulting and exemplary nature of the synagogue's interior and to write their own prayers and expressions of thanksgiving directly on the assembly hall walls.[76] Like the modern Church of the Holy Sepulchre, then, the aggregate experience of the synagogue's structural, decorative, and sensory aspects (including illumination, sounds, smells, and textures) successfully achieved dizzying effects by transporting visitors to a different sensory world, dedicated to experiences and encounters with the divine.

Beneath, beside, and inside more opulent features of the synagogue's decoration, other visitors additionally personalized and shaped their exceptional environment—by drawing their own messages and pictures. They deeply scratched their names and remembrance requests around doorways and walls, and carved supplementary images into its commissioned paintings. Attention to these features demonstrates why scholars should not view the Dura synagogue, or analogues elsewhere in the ancient world, as mere buildings in which esteemed activities, such as communal convocation and liturgy recitation, occasionally took place. A more precise description would be of a four-dimensional space, whose decoration and inscription evoked events of the past, present, and anticipated future. Worshippers and visitors appreciated and asserted their places in this chronological and spatial continuum, by viewing, smelling, and hearing elements inside the building. But they also touched them, painted and carved into them, felt them, and thereby transformed them. Only graffiti can attest to this process. As Lindsay Jones argues, sacred architecture must also be studied from the perspective of its reception.[77] Graffiti from the synagogue push this recommendation further by offering abundant data for audiences' receptions, but also transformations of selectively sacred architecture within the synagogue: they constitute rare records of visitors' participation in its sensory, architectural, and devotional environment.

General studies of the ancient synagogue have burgeoned in recent years. Scholars have plumbed literary accounts and archaeological remains to investigate multiple activities associated with synagogues, including those of assembly, prayer, charity giving or donation, vow-making, social consolidation and organizational hierarchies, gender stratification, liturgical and textual recitation, commensality and hospitality, and visual and narrative methods of interpreting biblical texts.[78] Recent advances in literary theory, as well as archaeological discoveries, encourage increasingly refined interpretations of rabbinic accounts of these spaces, documentary evidence for their uses, and the social and devotional practices they encompassed. More comprehensive studies, such as those Steven Fine has written and edited, have also considered the ways that Jews carefully curated their synagogues as "sacred realms"; they used multiple strategies to filter expressions of sanctity and effect the spatial reorientations of their audiences.[79]

But, in several respects, analyses of graffiti confront a missing link in discussions of the lived experiences of visitors to synagogues—albeit through a single case study from an exceptionally well-preserved synagogue in one ancient Syrian town. While modern observers would consider graffiti inside synagogues and churches to constitute acts of defilement or defacement, ancient evidence suggests the opposite: these acts served, in this synagogue and contemporaneous buildings, as regionally conventional media of devotional expression. They constitute bold and desirable acts of communication and devotion that attest to diverse modes of participation in synagogue life.[80]

One might also begin to speculate how these modes of devotion intersected with questions of class, status, and demography in the synagogue. Perhaps only donors to the synagogue, prominent individuals with the funds to perform good works, possessed the rights to commission donor inscriptions or to directly inscribe surfaces of the building at will, in the form of graffiti. Alternatively, perhaps graffiti were the work of less-moneyed visitors, who did not possess the means to donate significant funds (otherwise documented formally in donor inscriptions), but took matters into their own hands, by writing their signatures directly around the building's interior. Whoever was responsible for these writings and drawings, whether the wealthy or the (relatively) poor, whether Durene Jews, or Persian Jewish or non-Jewish visitors, their works collectively achieved a potent effect: they changed the building's interior and, thereby, interacted with, reshaped, and personalized the communal spaces that surrounded them.

Perhaps these types of writing indeed should be regarded as gifts unto themselves. In recent years, scholars of early Christian spaces, such as AnnMarie Yasin, have argued convincingly that certain monumental inscriptions in Christian contexts should be properly viewed as gifts in their own rights.[81] Anne Katrine de Hemmer Gudme has argued for

similar points in her discussion of votive inscriptions throughout the Levant and northern Arabia.[82] While graffiti might not be associated with preliminary donations or monumental display, Jews who wrote them alongside more monumental examples might have understood their behaviors in complementary ways. Graffiti writing thus could encompass activities that benefited the synagogue space and its worshippers through their contributions of permanently documented appeals to the divine.[83]

JEWS PRAYING IN SHARED ENVIRONMENTS

One might imagine that acts of scratching messages and pictures into synagogue walls and doorways manifested a quirky local habit among Jews in Dura, where associated traditions of writing messages inside sanctuaries were quite strong. But examples of writing and drawing from the Dura-Europos synagogue represent only a fraction of the many examples of graffiti, applied by Jews, in places of cultic activity throughout the Levant and Egypt, from the Hellenistic period through the Arab conquest. Jews wrote graffiti, in multiple cases, in varied devotional environments, including those which were predominantly used, visited, and inscribed by neighboring pagans, Christians, or followers of Muḥammad. Attention to graffiti from these shared cultic environments additionally expands our understanding of modes of devotion among ancient Jews.

Nineteenth-century explorers discovered the earliest datable examples of devotional graffiti written by Jews in a spot of distinctly pagan association, in the eastern Egyptian desert sanctuary of Pan/Min in El-Kanaïs (figure 1.9). Graffiti throughout the site were inscribed roughly five to six hundred years before the use of the Dura synagogue, sometime in the third century BCE. Particularly during the Ptolemaic period, El-Kanaïs flourished as a way station along one of the most prominent regional trade routes to the Red Sea. But El-Kanaïs was more than just a way station—it was an outdoor sanctuary dedicated to an elided manifestation of the gods Pan and Min. While the foundation of the first local temple can be traced to the nineteenth dynasty of the New Kingdom (c. 1294–1279 BCE), only after Alexander's conquests of the region and through periods of Ptolemaic rule did a more extensive infrastructure develop to support regional trade through El-Kanaïs from Cyrenaica and the Levant, which led to the edification of the local shrine.

During the Hellenistic period, Ptolemaic rulers rededicated the El-Kanaïs temple to venerate a merged form of Pan (a Greek god associated with desert spaces and the wilderness) and Min (the local Egyptian god, who was particularly associated with the eastern desert).[84] This Paneion, just like others along regional trade routes, offered water, resources, and shelter to weary travelers.[85] Many textual graffiti found inside the shrine and along

FIGURE 1.9. Photo of Paneion and desert landscape of El-Kanaïs, Egypt; date of photo unknown. Scanned from André Bernand, *Le Paneion D'El-Kanaïs*, 1970, Pl. 5.2.

the surrounding cliffs serve as abbreviated travelogues; they emphasize writers' far-flung origins (in Macedonia, Crete, and Cyrene); chronicle their inscribers' survivals in the face of extreme dangers of travel, war, brigandage, deprivation, and general violence; record the number of times they had visited the sanctuary; and express gratitude to god for their safe arrival at El-Kanaïs.[86] Some inscribers explicitly credit Pan for their salvation.[87]

Jews, too, followed suit. Three out of the ninety-two published Greek texts from the site are particularly associated with *Ioudaioi*, a term variously translated by scholars as either "Judeans" and/or "Jews."[88] One such graffito, which follows many of the conventions of surrounding texts, reads: "Bless God. Theodotos son of Dorion the Jew (*Ioudaios*) returned safely from overseas (figure 1.10)."[89] A second graffito to include the designation "*Ioudaios*" appears similarly on the northern face of a rock on the western side of the temple precinct. It reads: "Praise the God. Ptolemaios, son of Dionysios, Jew (*Ioudaios*) (a/the Jew or Judean)."[90] A final inscription, traditionally ascribed Jewish authorship, reads: "I, Lazarus, came for the third time (?)."[91]

The first two inscriptions share several lexical, decorative, and locational features. They were each scratched deeply inside rectangular borders and appeared on the north face of the westernmost rock surface on the hill surrounding the Paneion. Each, additionally, records conventional Hellenistic names and patronymics (father's names)—in one case *Theodotos* and *Dorion*, and in the other, *Ptolemaios* and *Dionysios*. Theodotos' graffito, in a locally typical way, also triumphantly details some of the perils the author faced en route (a presumably difficult journey from the sea).[92] Both texts,

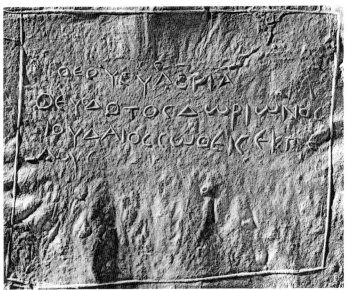

FIGURE 1.10. Theodoros inscription on rock face within the sanctuary of Paneion in El-Kanaïs, Egypt; photo of inscription *in situ* (top) and squeeze impression of inscription (bottom); date of photos unknown. Scanned from Bernand, *Le Paneion,* 1970, Pl. 37.2; and 37.1.

in comparable ways, call praise upon "the god" or "the God."[93] And, following the fathers' names appears the adjective *Ioudaios*, thus demarcating the geographic origin or *ethnē* of the writers.

Scholars, to this point, have primarily emphasized the locally unusual features of each of these texts. In the case of the first two inscriptions, these traits include inscribers' explicit identifications (of themselves or of their fathers) as *Ioudaioi*, and their comparable exhortations (*eulogei ton theon/theou eulogia*), which command passersby to join in praising or blessing "(the) god," but not Pan himself.[94] Non-literary features of these inscriptions have also inspired interpretation. André Bernand declared that the encasement of the *Ioudaios* graffiti in rectangular frames and their distance from the Pan shrine constituted a physical and stylistic mechanism to separate them from other graffiti carved nearby (figure 1.10).[95] Few comment extensively on the Lazarus text, whose principal distinction from neighboring graffiti is limited to the personal name of its inscriber, which is drawn from the Hebrew Bible and whose application almost certainly predates Christian use.[96]

Scholars' general discomfort with the idea that Jews inscribed graffiti in the precinct of the Paneion has informed somewhat exaggerated distinctions between these graffiti and neighboring examples. Renewed examination of these graffiti, in fact, reveals significant ways in which they resemble other local analogues and demonstrate their authors' direct engagement with the broader graffiti-discourse at El-Kanaïs. First, to emphasize the term *Ioudaios* as a marker of difference remains somewhat misleading. Inclusion of the term *Ioudaios* distinguishes a graffito writer's origin (in Hellenistic *Judea*), his associated kinship group and ethnicity (as a *Judean/Jew*), and, perhaps, his god-beliefs (presumably, his belief in one god, whose Temple stood in Jerusalem).[97] But the word can also simply designate a region (*Judea*), just like the 40 percent of all other graffiti from El-Kanaïs, in which individuals from Cyrene, Macedonia, and Crete declared their *ethnai* and places of origin.[98] Travelers and traders passing through the region were necessarily a cosmopolitan lot, who enjoyed boasting about their distant travels and far-flung origins. Authors' self-designations as *Ioudaioi* at El-Kanaïs, therefore, certainly mark differences in writers' origins and cultural contexts, but in ways conventional for local travelers' graffiti.

Previous assessments have been somewhat misleading in other ways. Scholars commonly isolate the *Ioudaios* graffiti from other local examples, partly because their entreaties to bless an abstract *T/theon* differ from those that explicitly invoke the god Pan. A frustrating lack of supplementary evidence impedes an improved interpretation, however, because it is unclear whether these texts implicitly refer to Pan through their address of a single abstract god (transliterated accordingly, as *theon*—one among many gods), or whether they designate a singular and exclusive God—a Jewish god (transliterated

accordingly, as *Theon*—the one and only God)—who is merely evoked in the sanctuary of another deity. Even more significant is the fact that many graffiti from the site (nearly half!) omit any mention at all of Pan.[99] The Lazarus text, among others of the same type, only records the numbers of visits a writer had made to the precinct; other visitors' signatures are also bereft of additional information about their theological beliefs.[100]

Traditional arguments that emphasize the physical distancing of *Ioudaios* graffiti from neighboring examples are similarly problematic. The alleged spatial and stylistic isolation of the Theodotos graffito, for example, which Bernand uses to illustrate its author's desire for "discretion" within the pagan space, remains unfounded: the text is not isolated from other inscriptions, but appears just below another graffito that explicitly praises Pan.[101] The rectangular shapes incised around *Ioudaios* graffiti, likewise, need not have served as borders to create physical boundaries against messages written by Pan-worshippers, as Bernand similarly declared. Several other graffiti in the precinct, which exclude evidence of Judean/Jewish authorship, were similarly encased in square and rectangular partitions of comparable sizes (figure 1.10).[102] Efforts to draw outlines around graffiti might have served to isolate their contents, but these borders are not exclusive to the *Ioudaios* texts and cannot support hypotheses that inscribers deliberately used them to create a physical separation from other graffiti. Presumably they could have been an artistic or aesthetic flourish, much like a *tabula ansata* used later in the Roman period, as we will see below.[103]

Equally unconvincing is the argument that the *Ioudaios* and Lazarus texts were necessarily scratched *outside* of the temple building to distance their contents from spaces associated with the god Pan. The three texts were inscribed in the north and eastern rocks around the Paneion, but the vast majority of Greek graffiti were also discovered on the rocks of the temple precinct, rather than inside the temple itself. The precise locations of the *Ioudaios* graffiti, too, are locally typical. North-facing rocks on the west and east of the temple were conventional places to scratch graffiti, for *Ioudaioi* and non-*Ioudaioi* alike, because their surfaces were most accessible to inscribers and offered greater shelter from the desert sun.[104] Incisions of *Ioudaios* graffiti in the rocks of El-Kanaïs conform to patterns exemplified by neighboring texts explicitly directed to Pan.

Visitors may not have considered the rocks surrounding the Paneion to be as sacred to Pan as the rooms within the temple itself, because degrees of sanctity varied throughout natural landscapes as much as they did in built structures throughout the ancient world.[105] As *leges sacrae* throughout the Mediterranean indicate, however, the sanctity of temples and shrines was not necessarily confined to their physical structures, but also pervaded the landscapes (sands, cliffs, and upwelling water sources) that encompassed them. Uses of inscribed boundary stones, in Greek and later Roman contexts,

reinforce this point.[106] Several local graffiti explicitly announce, for example, that inscribers considered Pan to be the protector of desert wanderers and the wilderness that surrounded them; he thus presided over the entire landscape and its visiting populations, as much as his shrines. Travelers exhibited this understanding by clustering their thanksgiving graffiti on the surrounding rocks, as well as within the constructed shrine of the Paneion. In most respects, then, *Ioudaioi* wrote in ways locally conventional for their authors' particular social, cultural, and environmental contexts. Absences of specific invocations to the god Pan do not singlehandedly distinguish their graffiti.[107] Just like authors of neighboring texts, some of these bless the divine and enjoin passersby to do the same.

Ioudaios graffiti, most significantly, conform to the rules of engagement in local graffiti discourse; they obey standards of content, placement, and respect for other inscriptions and thereby demonstrate their authors' awareness of conventions of the genre. Their messages are repetitive, both in placement and in syntax; their authors scratched them close to, but not over other texts, as was customary elsewhere in the Hellenistic and Roman world.[108] Whether graffiti artists identified themselves as traders, soldiers, miners, or hunters, and whether they announced that their birthplaces were in Punt, Crete, Macedonia, or Judea, they all participated in a common feature of travel-culture: they carved graffiti, in a sanctuary for desert wanderers—to praise god and celebrate the improbability of surviving harsh climates and lengthy voyages. It does not much matter, according to this perspective, to which precise god, or to which precise aspect of a god, writers attributed their survival by offering prayer, praise, or words of blessing. Rock faces of El-Kanaïs, in every instance, constituted appropriate and effective places to record one's gratitude and to praise and thank deity, for *Ioudaioi* and non-*Ioudaioi* alike.

The positions of all graffiti-prayers in El-Kanaïs, moreover, suggest that writers did not carve their markings to communicate with selective audiences. Unlike Durene devotional graffiti, which appeared inside cultic and religious environments with limited viewers, these markings were displayed, in full view, in a shrine of the open wilderness. And also unlike Durene graffiti, they exhibit slightly different types of prayer, invocations of thanksgiving, or documentations of presence, which correspond with local convention. Rachel Mairs has emphasized how acts of inscribing graffiti, of similar content, in the rocks of the desert (the territory of the god Pan) constituted independent, if public rituals, whereby writers interacted directly with the desolate terrain and anticipated the responses of passersby.[109] *Ioudaios* graffiti from the Paneion of El-Kanaïs, likewise, exhibit how some people, who self-identified as *Ioudaioi*, exacted this type of prayer by participating in these overlapping practices of inscription, prayer, and display within the natural and human landscape. The Paneion was presumably not a final

destination for desert travelers, but served as a critical way station. Travelers' dire practical needs thus demanded their presence in a sacred setting, which simultaneously invited their expressions of gratitude through graffiti.[110]

But numbers matter, and there are only two to three graffiti attributable to Jews or Judeans from the site. Some might argue, therefore, that only marginal *Ioudaioi* would engage in activities such as carving graffito-prayers in a Pan sanctuary. In such cases, both the anonymity of the wilderness shrine and perhaps its distance from Judea proper would have protected inscribers from the chastisement of their compatriots. Such an explanation, however, necessarily implies that there was something bad or untoward about Jews or Judeans writing devotional graffiti inside a Paneion. But these graffiti writers exhibit no compunction about identifying themselves as *Ioudaioi* in their texts. They, like many of their neighbors, proudly record their origins and their personal names; they found it desirable to simultaneously identify as *Ioudaioi* and to thank a deity (*T/theon*) inside Pan's sacred precinct. While rereading the content, decoration, and placement of the *Ioudaios* graffiti cannot elucidate the precise contours of inscribers' god beliefs, their reassessment in light of regional travel-culture can illuminate the degree to which some *Ioudaioi* actively participated in the common devotional and social discourses of their peers in a numinous space.

Perhaps, additional individuals with non-diagnostic names, who would also consider themselves to be *Ioudaioi*, also engaged in similar practices in the Paneion or in Pan shrines elsewhere in the eastern desert; we would have no way of discerning. But unusual markers in specific graffiti demonstrate that some Jews, just like their neighboring travelers and traders passing through El-Kanaïs, used portable tools, such as chisels, nails, rocks, or pointed objects, to carve prayers of thanksgiving and entreaties of divine blessing into the cliffs. They used a conventional medium and devotional language to do so.[111]

Elijah's Cave

Jews also wrote graffiti in shrines shared by pagans and Christians in periods of later antiquity. Elijah's Cave preserves evidence of this pattern. Positioned halfway up the northern side of Mt. Carmel in Haifa, in modern Israel, the built platform outside of the cave's mouth offers a magnificent view of the Mediterranean Sea. The interior of the cave is spacious and carefully hewn, with four smoothed sides and square corners, punctuated by niches and natural fissures in the rock.[112] Today, Jewish pilgrims visit the cave daily to beseech the prophet Elijah to help resolve their personal problems, including challenges associated with weight loss and frustrated searches for suitable spouses (figure 1.11). The interior walls of Elijah's Cave, however, attest to its complex ancient and medieval history; hundreds of names and messages are scratched onto its walls and along the modern partition at its center. Several carved niches inside may

have originally held cult statues, while a larger domed niche on the southern wall may have served (alternatively or serially) as a *miḥrab* or as a Torah shrine, in later periods; it faces both Mecca and Jerusalem.[113] While the populations visiting the cave have changed considerably over the past two thousand years, the hundreds of ancient texts found along its interior walls, combined with medieval and early modern literary records for the shrine, suggest that it may be one of the oldest ongoing pilgrimage sites in the region.[114]

Origins of the cave and associated worship practices remain unclear. During the Iron Age and perhaps through the Hellenistic period, the top of Mt. Carmel likely housed a cult for the worship of Baʿal. The Hebrew Bible links a cave on Mt. Carmel with Elijah (1 Kgs 18:16–45), but only by the twelfth century does the traveler Benjamin of Tudela speak definitively about Elijah's cave in his travelogue; following this period, the cave may have been converted to a synagogue.[115] In the absence of corroborating literary testimony until nearly 1400 years after the redaction date of the biblical text, however, one may conclude that the attraction of Elijah to this precise cave (with the support of the biblical story) may be retroactive.[116]

Some of the story about the cave, however, likely relates to a series of dedicatory inscriptions, carved in the center of the southwestern wall. One prominent six-line Greek inscription, set within a deeply carved *tabula ansata* on the southwestern wall of the complex, reads: "Remembered Elios the Greatest, Decurion (of the) Col(onia) Pto(lemais), with his son Cyr<i>llus . . . the place."[117] The central placement and relative size of the text suggests that it is foundational, if not originally dedicatory, and forms the visual and spatial nexus of the southeastern wall of the cave. Tal Ilan argues that this text might owe its preservation (lack of overwriting) to its inclusion of the name "Elios," which some Jewish readers of Greek subsequently associated with the local veneration of Elijah himself.[118]

While none of the cave's monumental inscriptions clearly identify the names of the god(s) originally worshipped in the space, scholars have suggested its ancient association with Pan and Eros, as well as goddesses such as Hestia.[119] Cult images, however, once appeared inside niches around the cave;[120] one Greek text identified and read by Asher Ovadiah credits an original cult statue to the donation of a certain Theodorus.[121] Pictorial notations on the northern wall of the cave, yet unpublished, may additionally allude to the use of the cave for activities of veneration or supplication. These finely drawn images, which resemble architectural cultic niches, may represent and reinforce the devotional nature of the surrounding space, as do analogues in other contexts.[122]

Evidence more ambiguously points to early Christian use of the site. As Tal Ilan has argued, the absence of inscribed christograms and explicit Christian iconography among the Greek textual graffiti contraindicates ancient Christian use of the shrine. My recent application of digital enhancement

FIGURE 1.11. Modern prayer space and furniture in Elijah's Cave on Mt. Carmel, Haifa, Israel; March 2014. Photo by Ezra Gabbay.

technology to photos of the walls, however, has revealed a painting of a large red ochre christogram on the northwestern wall of the cave (figure 1.12).[123] This image overwrites several inscriptions, but is overwritten, in turn, by others; this might associate its application with periods of late antiquity, rather than early modernity.

Several dedicatory inscriptions and graffiti from the site more clearly document Jewish use of the cave as early as the second through fifth centuries CE. Tal Ilan and Olaf Pinkpank have restored one Greek text, which is set within a *tabula ansata* and positioned close to the "Elios" foundation inscription to read: "Remem[bered. . . .Juda[h]. . .] Cla[udia's vow [. . .]."[124] The mention of a vow and its carving within a carefully rendered tabula ansata probably identifies it as a dedicatory inscription, even if the personal name, *Iouda* or *Ioudas*, is distinctly associated with Jewish, rather than pagan or Christian use in late antiquity.[125] But other non-monumental texts from the cave walls are better classified as graffiti; these include more idiosyncratic personal names, conventionally associated with Jewish populations. One large and loping Greek graffito is restored to read: "Ioananos and Onia and . . . [r]embered Nomas of Emmaus [. . .] Beth (house!) [of] [. . .] Ēlio[s]."[126] The orthography, joint presentation, and clustering of these names, as Tal Ilan argues, bolsters its association with Jewish inscribers. She suggests that *Ioananos* remained a prescribed spelling in Jewish, rather than Christian contexts in late antiquity for the name Iohanan. Inclusion of the Greek name Onias in the same graffito (equivalent to the personal name *Ḥoni* particularly attested in rabbinic texts), in tandem, may reinforce the Jewish association of the inclusive message.[127] Appearances in other texts of personal names with biblical connotations, restored as Abiathar and Onias, also suggest Jewish authorship.[128]

FIGURE 1.12. Red ochre painted christogram overlying Greek graffiti and inscriptions in Elijah's Cave; March 2014. Photo by Ezra Gabbay and digital enhancement of painting using D-stretch/ImageJ.

Iconographic elements in graffiti also attest to ancient Jewish use of the space. Symbols that resemble stylized menorahs appear on the southwestern wall of the complex, and two badly worn but clear examples of menorahs appear on the northern side of the cave.[129] Next to a large rendering of the word *mnēsthē*, moreover, appear two additional menorahs. One of these has been overwritten by an Arabic inscription, "[In the] name of Allah the merciful" (figure 1.13).[130] While the date of the successive applications of the menorah and the Arabic inscription could be medieval, Ilan suggests that the decline in the regional popularity of the menorah in the Middle Ages points to a late ancient date of application for the menorah and its subsequent overwriting.[131]

Several aspects of the periodization of the cave and its use remain obscure and prompt many questions.[132] Was the cave, then, a sacred place that Jews, pagans, Christians, and Muslims ultimately shared, with some joint veneration of an esteemed prophet Elijah, who may have retained a heroized or divinized aspect among earlier pagan populations, as Ilan suggests?[133] Or, alternatively, was the story a different one, such that pagans and, ultimately, Jews and Christians wrote graffiti in the cave to be remembered before a god/prophet, but then Jews (then perhaps Christians, then perhaps Muslims, then Jews again) subsequently appropriated it? Little

FIGURE 1.13. Graffiti of menorahs and Greek and Arabic inscriptions in Elijah's Cave in photo (top) and tracing (bottom); March 2014. Photo by Ezra Gabbay.

supplementary information can support one hypothesis or chronology over another. Textual, iconographic, and architectural evidence suggests that pagans, Jews, Christians, and Muslims used the cave sequentially. But they also could have done so simultaneously.

What is clearest, then, is that the cave served as a spot of ongoing veneration among regional populations, beginning in the second century, which visitors subsequently decorated with inscriptions and graffiti. At some point in antiquity, Jews seem to have joined the devotional and graphic conversation: records of their signatures, remembrance requests, and menorah carvings suggest this. When ancient Jews wrote in the cave, furthermore,

they did so in the same languages and idioms as their neighbors, suggesting that they could, at the very least, read the messages of pagan devotion that were also carved nearby. Elijah's cave thus demonstrates differently what has been observed elsewhere: that some Jews were willing to share devotional spaces with their pagan (and Christian) neighbors. Here, they prayed through writing (if not also through speech), to supplicate the prophet Elijah, among others. This pattern is an important one, because it illustrates how some Jewish devotees acceptably requested blessings and remembrance in shrines that pagans, Christians, and Muslims variously and visibly used for prayer and worship.

JEWS PRAYING IN OPEN SPACES

Tens of thousands of graffiti associated with regional nomadic and semi-nomadic populations have been identified in the open deserts of northwestern Arabia. Graffiti written by Jews appear among these. Nomads and travelers carved markings on Arabian rocks and cliffs since earliest antiquity, and Jews, who also traversed and inhabited the region through the dawn of Islam, engaged in these written and devotional dialogues. While these types of texts pose particular challenges for interpretation, they constitute a distinct category of graffito, whose function corresponds to its application in different areas of natural landscapes and otherwise unworked spaces.

Throughout antiquity (as well as early modernity) economic, linguistic, environmental, demographic, ethnic, and political ties bound the southern Negev, Sinai Peninsula, and Northwest Arabia. Nomadic and settled Nabataeans maintained their distinctive cultural effects, including languages and scripts, architecture, pantheon, burial, and cultic practices, through Rome's regional conquests in the second century CE and the reign of Philip (244–249 CE) decades later.[134] Despite the harshness of its arid climate, moreover, Arabia lured many, including Jews, to settle and trade throughout its expanse,[135] because resources from the Sinai Peninsula and Northwest Arabia were coveted throughout the Mediterranean.[136] The incense trade, in particular, sustained a robust regional transport economy, whereby caravans carried frankincense and myrrh, mined in Arabia Felix in the south, northward for export to Rome and elsewhere in the Empire, where they were instrumental in cultic contexts. Extraction of mineral resources in the Sinai (copper and turquoise) and their accompanying trade supported local semi-nomadic and nomadic populations and drew others to the region, including Jews, to participate in their lucrative trade and transfer.[137]

All understandings of regional demographics are challenged by the overarching fact that most Arabian populations—whether Jews or other ancient peoples—remain somewhat enigmatic to historians.[138] Rabbinic and early

Islamic literary accounts are useful, in some respects, by locating Jews in the Hijaz and Northwest Arabia.[139] Whenever the rabbis describe Arabia and Arabian Jews, however, their geographic designations remain murky: they could refer to Jews visiting and originating in regions farther north in modern Jordan.[140] Texts of the Qur'ān, likewise, describe encounters between Muḥammad, his followers, and Arabian Jews, but such attestations are usually somewhat stylized and polemically charged.[141] Archaeological discoveries thus remain crucial to advance literary suggestions about Jewish presence in Arabia. Epitaphs from towns, such as ancient Hegra (modern-day Madā'in Ṣāliḥ), where excavators discovered a monumental tomb of Shubaytu, son of Aliu, the *yhwdy'* (Jew or Judaean), document the presence of wealthier Jews in such places.[142] And supplementary graffiti, which include distinctive Jewish names, iconography, symbols, and scripts, correspondingly attest to the diachronic presence of Jews throughout the region.

Graffiti carved by nomads and travelers pervade the cliffs and rocks bordering the trade routes of Arabia and the Sinai Peninsula and it is a small percentage of these which index Jewish authorship.[143] Most known textual examples derive from Hegra and from 'al-Ulā (ancient Dedan), nearly 20 km to its south. Both cities constituted important regional stops along the *Via Odifera*, which facilitated the transport of incense and other goods from Africa and Asia.[144] Such graffiti are preserved, beside many others, on stone cliffs and outcroppings. Most markings associated with Jews are carved in local Nabataean Aramaic scripts and are only identifiable through their inclusion of regionally unusual names, often associated with biblical or Jewish traditions, or through their incorporation of distinct imagery, such as their integrations of drawings of menorahs or Temple-related symbols.[145]

Some signature graffiti include personal names closely associated with Jewish populations, such as one from Wadi I-Qura, which reads, "Levy" (*lwy*), in Nabataean Aramaic (Hoyland, no. 13).[146] Others include more diagnostic patronyms as well as personal names.[147] An Aramaic or Hebrew text from 'al-Ulā, with an uncertain date, reads: "This is Abisalo(m?) son of Susannah" (*dh 'byšlw[m?] br šwšnh*; Hoyland, no. 19), while other signatures, containing biblical names, precede or follow the word *šlm* (greetings/farewell), such as a Nabataean Aramaic text which reads: "greetings/farewell (*šlm*) Joseph son of 'Awiyu" (Hoyland, no. 12). *Šlm* (variously vocalized as *shalom*, or *shlam*) is a common acclamation in regional Nabataean graffiti, so it is not diagnostic of Jewish usage in this region.[148] A graffito limited to the word *šlm*, which appears next to a large carving of a menorah along the roads through the Wadi Umm Sideira in the Sinai (second to fourth centuries CE), however, demonstrates other ways to modify Nabataean graffiti patterns through inclusions of images of particularly Jewish association.[149]

More extensive Nabataean Aramaic graffiti, which contain names more conventionally associated with Jews in similar periods, request that named

individuals be remembered or remembered well/for good. One example includes an unedited graffito from Hegra in Nabataean Aramaic, which Robert Hoyland dates to the third to fifth centuries CE and reads: "May Jacob son of Samuel be remembered well!"[150] Still another from Wadi I-Qura reads: "May Laḥmu son of Yehūdā be remembered well," (*dkyr lḥmw br yhwd' b-ṭb*) (Hoyland, no. 17).[151] The latter graffito employs paleography and syntax that replicate those of neighboring examples on the surrounding rocks (*dkyr* PN *br* PN *b-ṭb*).[152]

But additional categories of textual graffiti in Hebrew and Aramaic specifically request blessings. These include a late ancient graffito from 'al-Ulā ("Blessing to 'Atur son of Menahem and Rabbi Jeremiah") written in a merged dialect of Hebrew and Aramaic.[153] Blessings graffiti associated with Jews are also found along Christian pilgrimage routes in Ein Hudeira, in Sinai; these include Hebrew scripts, record names such as "Samuel, son of Hillel," and drawings, which include large menorah symbols.[154] Requests for blessing and protection recur in Ein Hudeira and surrounding areas in Nabataean, Byzantine Christian, and Arabic graffiti. Some of their placements also correspond with the pilgrimage routes through Wadi Haggag in the Sinai.[155] Such graffiti, carved deeply into the white sandstone hills, are found interspersed with many Byzantine crosses, as well as with some menorah carvings (figure 1.14).[156]

Several other inscriptions, more unusually carved in Hebrew scripts, directly invoke divinity. In Jubbah, near Ha'il in modern eastern Jordan, two joined texts in Hebrew script declare: "Blessed be the name of my Lord,"[157] while another, from 'al-Ulā, reads in Arabic in a Hebrew script, "Naim/Nuam son of Isaac trusts in God. He has written (this)."[158] Still another Hebrew graffito from 'al-Ulā is restored to read, "God be blessed/ Bless God."[159] While the first graffito elicits anonymous words of praise and divine blessing, the second occupies a devotional function: the writer proudly declares his trust in God and, as we have seen elsewhere, emphasizes that he has written the message himself. Perhaps inscribers of these graffiti were Arabic speakers, who merely knew how to write the Hebrew alphabet and wished to demonstrate this. Alternatively, and more likely, they might have been Jews, visiting or inhabiting the region, who were well versed in the declarations of faith proffered by their Muslim neighbors in speech or in graffiti. If writers of these graffiti indeed identified themselves as Jews, their uses of Hebrew scripts to render statements of blessing and praise indexed their individuated cultural contexts, origins, or god beliefs.

Michael MacDonald advocates more minimalistic readings of graffiti such as these. Instead of emphasizing the significance of the lexical contents of these writings, he argues that they should largely be read as expressions of entertainment. These graffiti, he suggests, manifest the general efforts of regional nomads or sojourners to undertake efforts to learn and master the skills of writing their names and a few additional words, simply as a

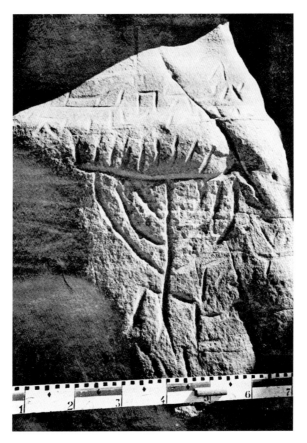

FIGURE 1.14. Graffito with menorah from Ein Hudera, Sinai; date of photo unknown. Scanned from B. Rothenberg, "An Archaeological Survey of South Sinai," 1970, Pl. IX, courtesy of Palestine Exploration Fund.

means to pass the time.[160] This minimalistic explanation is an attractive one, which supports reading these graffiti as iterations of the more recent and oft repeated: "Kilroy was here."[161] The endless sands of the desert might have held few attractions for their inhabitants and journeymen; regarding these writings as forms of entertainment, or as sheer demonstrations of esteemed sets of practiced skills, offers a reasonable explanation for their recurrence.

But certain features of the graffiti suggest why such theories might fall a bit short, at least in specific cases. For example, efforts to pass the time might inspire people to scratch their names on rocks along desert cliffs and byways. But what about the requests to be remembered and remembered

for good, carved into natural walls along desert passageways? And what about the graffiti that specifically solicit and offer divine blessings, and explicitly include symbols associated with particular theological beliefs and worship practices (such as menorahs, crosses, or façades of the destroyed Jerusalem Temple), or proclaim the greatness of the divine? Few of these types of texts necessarily or exclusively fit into the "passing time" category.[162]

To some inscribers, of course, graffiti writing might have served as an activity of entertainment. But the precise semantic contents of certain of these writings, including remembrance and blessing requests, should factor more significantly in their interpretations. Applying graffiti, indeed, might have served another complementary purpose: as offerings of prayers to the divine or as documented expressions of faith. These types of graffiti carvings in Arabia, indeed, might have performed functions, much like those of abbreviated prayers, similar to those found throughout Dura, El-Kanaïs, and on Mt. Carmel.[163] This can be true even when Arabian examples appear outside of distinctive architectural or environmental contexts explicitly associated with devotional activities, such as pagan temples or sanctuaries, synagogues, or churches. The open sky served as the most suitable canopy for devotional acts in the desert, since the fixedness of monumental structures (including temples) made them impractical for nomadic existence. Prayers on desert rocks and cliffs, just like those in synagogues and temple shrines, served as the documented prayers of the everyday, among Jews and non-Jews alike.

Equally suggestive are the ways that regional idioms informed Jews' devotional expressions in these graffiti, whether in the Sinai Peninsula or Arabia. For example, most Arabian graffiti containing Jewish names replicate the languages, scripts, syntax, and forms of neighboring examples, in kind. Even the transliterated declarations of faith in God, from Jubba, mimic the language and sentiments embedded in contemporaneous regional graffiti from late antiquity, in which inscribers wrote their declarations of faith to Allah. Similar patterns appear in the Sinai Peninsula, where some graffiti that incorporate images of menorahs are carved just steps away from etchings of christograms paired with Christian confessions. Whatever the actual beliefs of ancient Jewish writers and whatever the precise chronologies of their graffiti deposits, their inscriptions in Nabataean Aramaic, Lihyanite, or Arabic largely replicate regional modes of devotional expression and practice throughout Arabia, the Sinai Peninsula, and elsewhere.[164] Jews wrote their prayers directly beside their neighbors, who were doing the same thing—in earlier ancient periods, explicitly invoking the goddess 'Allat and, in later periods, Allah. To modify the terminology of Alfred Gell, these prayer graffiti, still visible throughout these regional desert climates, ultimately served as devotional agents (as well as "social agents") that continue to advocate for the memories, interests, dreams, and hopes of their writers, even today, hundreds to thousands of years after they originally carved them.

One might wonder why, in the vast expanses of the desert, individuals chose these particular places to write their prayer graffiti. Did they do this deliberately, or at random? Proliferations of graffiti around cliffs and on rocks throughout Arabia suggest that most individuals wrote graffiti wherever rock surfaces were available and other examples were already found; presence of one graffito might have tempted others to carve markings nearby. Evidence from graffiti, however, might prompt another possible interpretation: that some individuals, including Jews, wrote graffiti in specific places that held some significance to them, but whose identification otherwise eludes documentation. Thus, prayer graffiti might appear in designated devotional contexts (Dura synagogue, El-Kanaïs Paneion, or Elijah's Cave), in seemingly "neutral" places (any number of Arabian sites), or, alternatively, might document loci of otherwise unrecognized importance to individuals or groups, where peoples of many cultures prayed in words and in writing. Perhaps some graffiti clusters throughout Arabia and the Sinai implicate specific but heretofore unrecognized locales where individuals particularly wished to thank God for their good fortune, places which were known for miracles, for their awe-inspiring natural beauty, or for their numinous qualities. In these places, Jews, along with their neighbors and just like them, saw fit to write, draw, and pray. Even in the desert graffiti writing could simultaneously constitute a social and devotional experience in these ways.

RETHINKING DEVOTION FROM GRAFFITI

Graffiti, when reviewed continuously, tell a broader ongoing story—about how some Jews used informal and physical acts of writing and decoration, as did their neighbors, to communicate with the divine and with each other. Just as modern pilgrims rarely "see" or notice graffiti in modern churches throughout the region designated as the Christian Holy Land, scholars rarely "see" or consider these ancient graffiti. But they exist. And they benefit from their comprehensive and continuous evaluation here.

To this point, reliance on evidence from rabbinic texts and monumental dedicatory inscriptions has led scholars to treat devotional practices of ancient Jewish populations as fundamentally different—both with respect to modes of expression and semantic content—from those of their pagan and Christian neighbors. Such conclusions often relate to expectations about Jewish distinctiveness and about the role biblical scripture and interpretation play in shaping early modern Jewish liturgies and associated prayer acts. But examinations of graffiti as prayers, foremost, facilitate renewed discussions of Jews' devotional behaviors and their fundamental inextricability from those of their neighbors.

An approach such as this highlights how, in many respects, Jews in Syria, Egypt, Judea, Palestine, the Sinai, and northwest Arabia offered written prayers, which were only selectively distinguishable from cognate examples of the corresponding genre. Whether Jews wrote remembrance requests inside their synagogues, or along open cliffs, or invoked divine blessings on the walls of shared and open sanctuaries, the scripts, vocabulary, media, and placement of their scratches largely resembled those of their peers. Attention to this phenomenon augments understandings of connections between Jews' acts of piety and their broader cultural experiences. Consideration of devotional graffiti—however diffuse and varied—thus offers fuller insights into the dynamics of Jewish prayer in antiquity and highlights the degree to which devotional practices of neighboring populations shaped regional Jewish behaviors in the variably Hellenized and Romanized East and the Arabian West.

These continuities might encourage scholars to think differently, moreover, about the most productive approaches to Jewish devotional activity in late antiquity. Many studies of ancient Jewish prayer rely principally on texts (biblical or rabbinic) to "fill in the blanks" of our understandings of ancient Jewish practice. Patterns in graffiti suggest why vernacular evidence from regional churches, pagan temples, and Arabian byways offer equally reasonable places to turn.[165]

Attention to deposit patterns of graffiti, moreover, reinforces other observations about the heterogeneity of landscapes suitable for Jewish prayer in antiquity. Certain graffiti, such as those from the Dura synagogue, suggest that some Jews conducted their prayers inside designated prayer halls or houses of study, specifically among other Jews, as rabbinic texts often imply or recommend. But some graffiti demonstrate that other Jews comfortably prayed in ways that some rabbis explicitly and implicitly forbade: they did so by making pilgrimages to loci of pagan and Christian worship and wrote inside of them (cf. *b. 'Abod. Zar.* 17b; *t. Šabb.* 18:1). They did this in open spaces and enclosed shrines, surrounded by others who did the same thing. Clusters of graffiti, when examined in their spatial contexts, thereby demonstrate a long-suspected, but largely undocumented fact—that some ancient Jews prayed to their God anywhere, with and beside anyone—whether in sumptuous built environments, deep wadis, or beneath the awe-inspiring limestone cliffs that bisected them. Indeed, writing graffiti might have constituted an important form of communal and devotional experience among Jews, but also between Jews and their non-Jewish neighbors. While the heterogeneity of these communal activities evades discussion (if not proscription) in literary sources, evidence for their conduct expands current notions of the broader social dimensions of Jewish prayer to include non-Jewish as well as Jewish populations.

Equally illuminating, however, are the degrees to which Jewish modes of writing sometimes differ from those of their peers. Select devotional graffiti, for example, appear in spatial contexts particularly associated with Jews, such

as the synagogue in Roman Dura-Europos. Others appear in areas shared by pagans, Christians, and Muslims, but carved in scripts and languages which are regionally unusual, such as Hebrew or Aramaic, which inscribers might have considered more appropriate for communicating with their own God (or with other Jews). Different graffiti appear in common regional languages and scripts, such as Greek, but could include distinctive vocabulary, toponyms and identifiers (such as *Ioudaios*), or sets of images that differentiate their writers' origins or cultural context. Finally, some graffiti contain personal names—likely conferred to people at birth—which mark their owners as being of Jewish or Judean origin. These indices are significant because of the rare information they retain about the precise cultural contexts of the latter types of graffiti inscribers. These types of differences, nonetheless, do not detract from the broader pattern: Jews consistently engaged in written prayer practices, informed by those of their neighbors, even if they modified those acts (whether deliberately or inadvertently) in targeted ways.

But graffiti-prayers were also physical ones. Rabbinic texts occasionally speak of the corporeal dimensions of Jewish prayer, which Uri Ehrlich describes as a "gestural system." This encompasses the adoption of selected postures, such as raised or clasped hands (*b. Šabb.* 10a), a standing or prostrated body (*y. Ber.* 1:1, 4a), or a direction of one's eyes or face during recitations of prayer.[166] Ehrlich additionally details the significance of these "nonverbal" elements, which may include one's attire (*b. Šabb.* 10a), footwear (*m. Ber.* 9:5), and time of day (*b. Ber.* 26b) in shaping a supplicant's devotional experience. Rachel Neis, in complement, illuminates the significant role of visuality in rabbinic descriptions of devotional experience. Prayer, indeed, might entail reciting or reading specific sentiments while envisioning particularly sacred scenes or objects.[167] These perspectives are essential in drawing attention to the important, if neglected, bodily and sensory dimensions of ancient Jewish prayer. This chapter suggests, however, that carving graffiti into plaster and rock should be added to such a list. Graffiti writing also served as a different and physical, if heretofore unidentified type of prayer, whereby Jews and their neighbors used rudimentary tools, such as rocks or knives, to aggressively carve messages to divinities who presided over surrounding natural and built landscapes. Performances of such prayers did not constitute mental or verbal exercises, but rather, entailed writers' deliberate, occasionally violent, and indelible modifications of their environments. These types of prayers also required degrees of corporal contortion and artistic aggression, as well as many types of sensory engagement, inside surrounding natural and built landscapes.

After considering these dimensions of graffiti writing, we might ultimately rethink our working definition for prayer. After all, graffiti require consideration not as an alternative *type* of prayer, but as a component (or subdivision) of verbal and visual prayer. If prayer is a communicative act with the divine, albeit (often) with a social dimension, perhaps we can imagine that acts of

carving, scratching, writing, and painting served as gestures continuous with selective offerings of supplication and chanting, utterances, and processes of visualization. These activities are not all the same, to be certain, but they form a continuum, which extends and expands upon common notions of prayer as an "expressive system."[168] Transforming conventional notions of prayer, in turn, collapses hierarchies that implicitly govern traditional understandings of devotional behavior. Instead of conferring primacy to literary and redacted forms of prayer, as is common, this approach imagines the complementary and compounding power, agency, and efficacy of each.

But what about the emotional dimensions of graffiti writing? What motivated Jews and their neighbors to write graffiti prayers, and did they believe that their acts of writing were, somehow, effective? For example, on one end of the spectrum, did writers apply graffiti as expressions of "true" piety? That is, did they carve markings as a result of beliefs that their acts of writing might reflect, reinforce, or express their devotion toward deity? If this were the case, did they believe that a deity might hearken and respond directly to their messages? Alternatively, and on the other end of the spectrum, did others apply graffiti for more social than theological reasons? As a means to pass the time? Or to copy what others typically did in similar places and spaces? One might imagine that inscribers must have possessed any range of intentions and beliefs along this spectrum. Attention to different types of graffiti carved into diverse geographic and practical locations, regardless, offers more definitive grounds for speculations about ancient Jewish piety and cultural behaviors.[169]

Prayers, in all cases, could be a dirty business. Painting with pigments would indelibly stain precious clothing and skin. Acts of carving drawings and texts into plaster or stone would surely be even messier, let alone more painful: powders and fragments would cover one's face and fill one's lungs with dust; hardened dirt, rock, and plaster could push back and split fingernails; and carving implements, including metal nails, blades, and stones, surely drew blood when the lighting faded or surfaces grew unwieldy. Composition of a proper message, furthermore, required time, diligence, steadfastness, and a degree of pain tolerance. Inscribers might have indeed viewed these types of laboriousness and ensuing degrees of pain as intrinsic components of their prayer experiences.[170] By drawing attention to these physical dimensions of devotional practice, examinations of these graffiti thus encourage a more holistic approach to Jewish acts of prayer in antiquity, which fully engaged—and occasionally scarred—the body as well as the mind. Consideration of graffiti highlights the physicality, creativity, filth, dynamism, sociality, and interactivity of ancient devotional behaviors. Whether writers carved their messages in states of euphoria, hope, desperation, piety, boredom, solidarity, or pragmatism, their markings illustrate the holism, capaciousness, cultural normativity, and distinctiveness of Jewish forms of devotion in the ancient world.

Mortuary Graffiti in the Roman East

Any trip to the tomb of Marie Laveau in New Orleans might shock the uninitiated. Visitors have been paying homage at the tomb of Laveau, New Orleans' legendary "Voodoo Queen," for more than two centuries. What they deposit graveside seems irreverent for any cemetery, let alone for the rather Spartan-looking tract of St. Louis Cemetery No. 1: half-used tubes of lipstick and cosmetic vials, plastic beaded jewelry, melted candles, money, and garlands of plastic flowers. Laveau's weathered and white-washed tomb suffers to an equal degree: visitors have drawn hundreds of X-shapes around its door and external walls, and, more recently, shellacked the tomb with bubble-gum-colored latex paint (figure 2.1). The ensuing picture is a decidedly gaudy and messy one, which more closely resembles an abandoned festival site than a cemetery.

Insights gleaned from oral and written legend reveal that many of these seemingly kitschy gifts and sloppy paintings are offered with sincerity and deliberation. Certain visitors believe that by drawing an X on the surface of Laveau's tomb, turning about three times, knocking on the tomb, and shouting their wishes out loud, they can wake Laveau to do their bidding. If wishes are granted, supplicants are obligated to return to the monument, place an offering beside or upon it, and draw a circle around their original X-shape.[1] For those who understand and follow the proper protocol, the grave simultaneously serves as a place of visitation, interaction, and manipulation—a locus of mortuary and ritual power—which enables the weak or hapless to achieve agency to obtain their desired ends in life, love, and finances. Beyond a mere resting place

FIGURE 2.1. Restored tomb of Marie Laveau in St. Louis Cemetery No. 1, New Orleans, LA, USA; May 2017. Photo by Elhanan Lazar.

for the dead, then, Laveau's tomb is a site the living use variously and energetically on a daily basis.

In the context of the modern United States, Laveau's memorial constitutes an unusual case. Spending time in the world of the dead, after all, is only rarely considered to be an integral part of everyday life in most spheres of American society. Cemeteries, at least in the United States and Western Europe, are generally visited on exceptional occasions, including funerals, memorial days, birthdays, anniversaries, or holidays. Modern mausolea and cemeteries, moreover, are often topographically and geographically removed from urban centers; efforts to visit them underscore the spatial, as well as existential, divides between the living and the dead. But the cemeteries of New Orleans are interspersed throughout the modern city, which expanded outward, years ago, from its earliest core. And the activities that take place around Laveau's tomb bespeak something unexpected—the use of a mortuary space, in the course of daily life, for purposes other than burial or episodic commemoration.[2]

This chapter considers tombs from times and places as far removed as one can imagine from modern New Orleans—those of Roman and Byzantine Palestine—where operative understandings of death and mortuary commemoration are commensurately distinct. Many of these monuments are encrusted with markings, which look surprisingly similar to those found on Laveau's. These include inscribed and drawn texts, pictures, hatch-marks, circles, and even X-shapes, sometimes surrounded by circles and squares. To this point, archaeologists and historians have ignored such additive features of ancient Jewish burial caves, or have considered them to be incidental and irrelevant—just as patterns on Laveau's tomb might appear to the uninformed. For example, Binyamin Mazar, the first official excavator of Beit Shearim, the largest necropolis associated with Jews in the ancient Levant, once noted the preponderance of mortuary graffiti from the site, but claimed that "some of the drawings and graffiti as well as inscriptions painted or incised by the relatives of the deceased or by visitors, lack any preplanned order and are carelessly executed . . ."[3] Such dismissals of these markings, classified here as graffiti, have justified their protracted neglect. But closer attention to the surfaces of burial caves and cemeteries throughout the region—whether from Beit Shearim, farther north in Beirut, in Lebanon; or farther south in regions of Roman and Byzantine Judea and Palestine, and in Alexandria in Egypt, reveals that these types of writings and drawings were widespread in antiquity (Map 1). Moreover, many of the associated markings, which strangely resemble those found on Laveau's tomb, exhibit sufficient consistencies of lexical content and placement to indicate their correspondence with systematic sets of behaviors, which individuals once conducted inside and around regional tombs. Consideration of these graffiti and the patterns in their application

contributes surprising insights into how the living used mortuary spaces in the courses of their daily lives.

This chapter argues three interrelated points. First and foremost, recurrences of graffiti in Jewish mortuary contexts suggest that acts of carving them were deliberate exercises, undertaken by Jews inside larger cemeteries and smaller burial caves throughout the ancient Levant: at minimum, they constitute otherwise unknown mortuary activities. At times, the ancient rationales for these behaviors remain obscure, because the resulting markings are opaque for our interpretation, but at other times, their features attest to common acts and beliefs concerning death, the afterlife, and the perceived ritual power of tombs. But closer examination reveals a second point: that Jews and neighboring populations of pagans and Christians behaved similarly, in specific respects, when visiting their deceased. By drawing attention to graffiti as common, if unnoticed, practices of mortuary writing and decoration, this chapter offers tangible evidence for broader cultural and behavioral continuities among the populations who created them. This last point, in turn, leads to a third conclusion: that even in Beit Shearim, a cemetery with strong and documented links to populations of rabbis and patriarchs (whether of Talmudic, alternative, or complementary orientation), works of Jewish commemorators and inscribers reflect understandings about death, corpse contagion, and commemorative practice with closer ties to regional non-Jewish behavior than to rabbinic textual prescription.[4]

Why do any of these points matter? First, because they broaden current understandings of ancient Jewish commemorative practices. Rabbinic texts outline activities considered appropriate for funerals, mourning, and burial, but not for diachronic activities to be conducted on or around tombs; in fact, they generally discourage spending excessive amounts of time around the dead, in places like cemeteries.[5] In tandem, pervasive disruptions to the stratigraphy of ancient burial caves and cemeteries, through pillaging, reuse, or vandalism, impede efforts to understand how living populations once used and reused the spaces associated with the dead. By considering graffiti as rare data, preserved *in situ*, that document these behaviors, this chapter thus contributes entirely new information for discussions of mortuary activities (including commemorative ones) once performed by regional Jews inside cemeteries and around graves. Second, rabbinic texts often underscore the differences between contemporaneous Jews and their neighbors in the Levant and elsewhere.[6] Basic similarities between many Jewish and non-Jewish practices of mortuary carving and writing, by contrast, serve to demonstrate yet another case in which normative and non-Jewish regional practices largely framed, shaped, or informed behaviors also conducted by Jews. These types of continuities bear non-mortuary cultural corollaries, as discussed further

below. Finally, such observations offer insights into the relationships between regional Jews and contemporaneous rabbis, who may or may not have followed common practices relating to death and commemoration. The lack of compunction of regional graffiti inscribers, including Jews (regardless of whether they were otherwise engaged with rabbinic cultures of textual production of the Mishnah, Tosefta, and Talmuds), to spend extended amounts of time inside burial caves to create elaborate textual and pictorial graffiti, implicitly contradicts some rabbinic notions about death, corpse-contact contagion, and associated impurities. This last point engages ongoing debates about rabbinic culture and its dominance (or lack thereof) in Roman Palestine and elsewhere in the incipient phases of late antiquity.[7]

The core of this chapter considers the necropolis with the highest density of graffiti associated with late ancient Levantine Jewish populations—that of Beit Shearim. While the cemetery is sometimes described as being regionally exceptional, it exhibits many features (with respect to burial architecture, personal names of the deceased, iconography, and language use), entirely conventional for contemporaneous Levantine mortuary complexes.[8] A critical mass of graffiti from this space, therefore, offers a useful starting point to consider associated media from a regional and diachronic perspective.

Different approaches govern each of the three sections of this chapter. The initial discussion is largely descriptive: it provides an introduction to the graffiti inside the mortuary landscape of Beit Shearim by offering a cursory "tour" of portions of the catacombs where graffiti appear. This approach, which echoes that of landscape theorist Christopher Tilley, encourages closer attention to the spatial and experiential dimensions of texts and images carved throughout the catacombs, and, in turn, facilitates a more continuous mapping of inscribed surfaces.[9] Subsequent portions of the chapter draw attention to recurring patterns in these graffiti deposits, which largely resemble those found in burial caves and catacombs in Nazareth, Jerusalem, Bethphage, the Judean Shefelah (lowlands), Palmyra and Beirut in Roman Syria, Petra in Arabia, and Alexandria in Egypt. The final portion of the chapter reads these findings collectively, in light of pertinent rabbinic discussions of corpse-contact contagion and acceptable commemorative behaviors.

The ensuing evaluation prompts new readings of the cultural matrix of burial populations at Beit Shearim, but also generates insights into Jewish life (and death) in the late ancient Roman East. No comprehensive studies exist that consider late ancient mortuary graffiti; this examination thus illuminates an overlooked but widespread component of ancient mortuary culture, as one facet of daily life in the eastern and southeastern Mediterranean.

BEIT SHEARIM AND ITS GRAFFITI

No discussion of Jewish populations in the late Roman world would be complete without consideration of the finds from the ancient city of *Besara*, or Beit Shearim, situated by the modern town of Tivon in the southwestern Galilee of modern Israel. Excavations of the area revealed a late ancient settlement with a synagogue and domestic structures, but the retroactive fame of Beit Shearim owes exclusively to its necropolis. Subterranean catacombs, carved into the hills just below the ancient town, are among the most visually arresting of their period and region. Arched gates decorate several cave entrances (figure 2.2). Entryways are guarded by elaborate stone doors, which mimic wooden analogues and still pivot in their original sockets. Subterranean chambers of the cemetery burrow through two acres of limestone and sandstone and contain the mortuary remains of hundreds, if not thousands of individuals. Indeed, one of the most impressive features of the necropolis remains its potential geographic scope; some speculate that more than two-thirds of the cemetery remains unexcavated beneath Tivon's rolling hills (Map 3).

Earliest formal explorations of ancient Beit Shearim, or Sheikh Abreikh in Arabic, began in the late nineteenth century. British Lieutenants Condor and Kitchener surveyed and sketched some of the associated caves, which they first published in their *Survey of Western Palestine I* in 1881. Partly due to contingencies of international and regional politics, however, the Beit Shearim necropolis grew increasingly prominent after its rediscovery during the British Mandate period in Palestine in the 1930s. In 1936, the British initiated official excavations of the site, which Benyamin Maisel (Mazar) directed in the 1930s and Nahman Avigad led in the 1950s.[10] Both surveyors and archaeologists collectively identified thirty-three burial caves in the area, which contained the largest concentration of human remains from the region and period. Many features of the explored and excavated caves have been published in the three-volume report on the site, but considerable percentages have not. Photographs from and descriptions of several unpublished caves are included in the assessment below.[11]

Textual and archaeological information dovetailed in the original identification of the necropolis. Early discovery of a Greek epitaph, which named *Besara* as the place of interment for the deceased, rapidly facilitated the identification of the surrounding cemetery with the ancient town (Beit Shearim) described in Aramaic texts of the Mishnah and the Talmuds.[12] Beit Shearim, according to various rabbinic texts, served as a seat of the esteemed Sanhedrin (the rabbinical council of seventy-one members) under the leadership of Rabbi Judah the Prince, the famed redactor of the Mishnah.[13] Even in antiquity, however, the area was best known for its necropolis. Recent and renewed excavations on the hill just above

FIGURE 2.2. Façade of Catacomb 20 in Beit Shearim, Israel; March 2011. Photo by Ezra Gabbay.

the catacombs support hypotheses that burial (stone carving, inscribing, and hewing) was likely the town's central industry from the late second century through the Byzantine period.[14] In the absence of explicit markers of pagan or Christian presence (and without hope of additional formal excavation in the foreseeable future inside the cemetery), moreover, the Beit Shearim necropolis conclusively contains the highest concentration of burials associated with Jewish populations in the Levant from the Roman and Byzantine periods.[15]

Architecture within the complex, however, remains maddeningly and, at times, impenetrably variegated. Some catacombs from the site include pit burials (*fossae*), while others include smaller intramural arches in which ossuaries (bone boxes) were placed for the secondary burial of human remains. *Loculus* or *kokh* tombs, rectangular spaces (c. 1.3 m in length) excavated to accommodate placements of ossuaries or fully extended corpses, appear in several catacombs. The large hewn caves that comprise Catacomb 20, on the other hand, were filled with massive stone sarcophagi (over 120 of them), many of which were elaborately decorated and painted and, occasionally, carved with epitaphs.[16] Perhaps the most common architectural feature associated with burials throughout the complex, however, was the *arcosolium* (*arcosolia* in the plural), a canopied burial bed carved into the rock, whose flattened base contained rectangular troughs to accommodate one, two, or multiple inhumations. The latter style of burial architecture

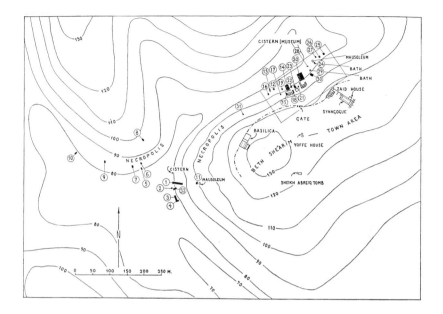

Map 3. Map of Beit Shearim with encircled numbers indicating locations of corresponding catacombs. Scanned from BS III, 5; reproduced courtesy of the Israel Exploration Society.

is particularly associated with later periods. Various burial styles were often employed in identical catacombs, however, which makes their chronology (often determined by their assemblages of architectural features) somewhat challenging to reconstruct.[17]

Research on the necropolis generally falls into two basic categories. The first responds to the main interests of scholars in the social history and demography of late ancient Palestine and seeks to identify historical individuals once buried inside the complex. Painted and bilingual epitaphs from Beit Shearim famously nominate rabbis, such as Gamaliel and Ḥanina, whose names also appear in rabbinic and even Christian literatures.[18] Textual references to the local burial of Rabbi Judah the Prince led excavators and scholars to assume that he, too, was buried in this cemetery (y. Kil. 9:3, 42; b. Ketub. 103b).[19] Presumed connections between literary and inscriptional data continue to fascinate scholars, as debates intensify concerning the possible connections between rabbis described in the Mishnah and Talmuds and those nominated in epitaphs as rabbis and interred at Beit Shearim.[20]

Questions about the geographic origins of the Beit Shearim dead equally dominate related discussions of the complex. While most epitaphs from the necropolis include locally determined names and titles, roughly 20 percent

include toponyms that suggest more far-reaching origins of its dead in regions like Beirut, Sidon, Palmyra, Messene (Babylonia), and Himyar (Southern Arabia).[21] Some epitaphs record the transportation of bones from abroad for re-interment in Beit Shearim.[22] Excavators extrapolated from these texts, as well as from those in rabbinic literature, that Jewish elites throughout the eastern Mediterranean and Arabia consistently conveyed the remains of loved ones to Beit Shearim for reburial beside the tombs of its illustrious rabbis.[23] Certain scholars, such as Hayim Lapin, Tessa Rajak, and Seth Schwartz, have offered alternative and more skeptical readings of related inscriptions, but the general impression of Beit Shearim as an international destination cemetery for Jews in late antiquity persists.[24] Continued dominance of these arguments possesses significant and broader implications, however, as they, in turn, bolster assertions about the ascendancy of rabbis and patriarchs in Roman Palestine and about the centrality of the land of Palestine to Jewish populations in the ancient diaspora.

Little supplementary information is available to support definitive hypotheses about the demography of the cemetery and of the populations who used it. Higher densities of epitaphs containing toponyms (such as those of Sidon and Palmyra) in particular catacombs suggests that certain areas of the cemetery contained the remains of people who traced their descent to common regions of the Mediterranean littoral and Syria. Other epitaphs indicate that the bones of the dead were transferred posthumously to Beit Shearim. Abruptions to the archaeological record, however, systematically impede improved insights about the demography of burial populations. Each of the exposed catacombs had been thoroughly pillaged before excavation; archaeologists reported that only one burial (a sarcophagus from Catacomb 20) out of hundreds remained un-breached.[25] This fact additionally confounds efforts to investigate the origins of those buried inside the cemetery.

Comparisons between archaeological features of the site, including the monumental sarcophagi, with those found elsewhere in the region, offer some information about cultural contexts of local burial communities, but cannot fill gaps in our understandings of regional populations' day-to-day lives, mortuary activities, or death beliefs. Small finds, such as ceramic jars, containers, and oil-lamps, whose placements might have otherwise testified to aspects of the cemetery's ancient use, were lost, disinterred, or stolen from their original find spots, long ago. Thus, all that remain of the site are its bare bones; most traces of its residents have been lost to the vagaries of time, theft, or deliberate vandalism. Moreover, exclusive focus on the site as a city of the dead has distracted scholars from considering the living populations, who also visited and used the necropolis. To this point, the relatively limited state of the evidence, paired with current schol-

arly methods and approaches, have painted a picture of Beit Shearim that underscores its importance but remains incomplete. It is in part for this reason that the graffiti are so vital for giving us an impression of ancient human activity: they document the last remaining vestiges of the visits of family members, of distinct ritual activity, and even of commemorative practice. By mapping local graffiti according to their practical, spatial, and cultural contexts, this chapter offers a fresh perspective on a significant and often undervalued archaeological site.

Graffiti in Their Mortuary Landscape

More than 250 examples of ancient graffiti from the excavated caves from Beit Shearim are published in the final reports. While some caves include no obvious graffiti at all, other caves are graffiti-rich, and thus document clustered activities of writing and drawing, which multiple individuals conducted during their visits. Many markings have suffered in the decades since their discovery and publication: iconophobic vandals deliberately effaced several, which depicted human faces and figures.[26] My field study at the site, however, has revealed additional, unpublished examples of graffiti (mostly pictorial) from areas of excavated caves and inside surveyed, but unexcavated, caves. While the following description summarizes lexical contents and distributions of representative examples of graffiti throughout the complex, it is not comprehensive. More complete records for graffiti discovered throughout the cemetery will be published, in database format, in the years ahead.

Catacomb 20. Today, Catacomb 20, which commands one of the grandest façades at Beit Shearim, serves as a type of "museum" cave for tourists to visit (figure 2.2). More than 120 carved and painted stone sarcophagi were discovered inside its twenty-six rooms, and the back chambers of the catacomb soar to heights greater than 4 meters. Three carved doorways punctuate its triple-arched façade, but only the central door currently offers access to the cave. Graffiti encrust the northeastern entrance to the catacomb, but these remain lost in the darkness, as the associated doorway, while still in its original position, is closed to visitors. The graffiti carved around this entrance are among the most diverse and dense in the entire necropolis, however, and require review in light of their original modes of use and illumination.

To attempt to reconstruct the experience of an ancient visitor to Catacomb 20, one begins by imagining how the northeastern entryway was used in antiquity. Both the functionality of the door and wear on the doorjamb attest to its ancient use.[27] Whenever that door, which still rests in its original socket, pivoted inward, it would illuminate the surrounding space, with raking light, particularly from its right side (when facing the door from the outside). This, in turn, would highlight inscribed surfaces and clusters

of textual and figural graffiti, which already scored the interior of the cave. The catacomb faces due west, so the light would most directly penetrate the entryway at evening, when the sun was closest to setting. Perhaps this would be the time that graffiti were easiest to behold and also to carve.

One's route into the catacomb, from this northern point, would neither be straight nor entirely obvious. The passageway inside, for instance, continues for only a few meters before forcing the visitor to turn (somewhat inexplicably) to the right, to merge with the anteroom beside the catacomb's large central entrance. The northeastern entryway, therefore, is flanked by two parallel walls, canopied by a low, arching ceiling, and terminates in a wall facing the entrance. Upon entry, the most visible graffito appears straight ahead on this facing wall. Positioned at eye-height, above a niche carved for a lamp, it is carved irregularly in three lines, in Greek letters, to read: "Be of good courage, pious parents! No one is immortal!" (figure 2.3).[28] On the closed side of the passage (on the left side, facing), yet another message appears in Greek, wrapping onto the wall from the edge of the low ceiling. It wishes: "Good luck in your resurrection!" (figure 2.4).[29] The precise tone of these anonymous writings remains debatable (do they reflect their authors' sincerity, or morbid senses of humor?), and their disparate paleography suggests that different hands incised each one.[30]

But tens of additional markings, largely unpublished, also appear nearby. Just beneath the "resurrection" inscription, on the northernmost wall of the complex (on the left side of the passage, when entering), pictorial graffiti abound. Human figures recur with box- or net-like bodies, bearing abstract facial features. Their hair stands on end; stick-like fingers and toes protrude from their hands and feet (figure 2.5). A small set of carved archways, which mimics the arcade-like façade of the same catacomb, appears beside the figure closest to the entrance (figure 2.5). Other shapes also appear, whose sizes range from 2 to 10 cm in height and width: these include grid-like boxes, nets, X-shapes, and rectangles. Outlines of pillars, covered with cross-hatching and terminating in pyramidal shapes, are carved beside striated domes (figure 2.6).[31] On the opposite side of the doorway also appear faint traces of designs and objects, including a menorah, a quadruped, and cross-hatching marks. Just like the neighboring texts, these markings are found several meters away from the closest sarcophagus or burial niche. But unlike those writings, these figures betray fewer obvious connections with their surrounding mortuary environment.

Excavators and scholars have discussed the texts from the entryway to the exclusion of the images. This is somewhat understandable, given that the writings are decipherable while accompanying pictures inside the entrance to Catacomb 20 appear impenetrably abstract. Comparisons within and outside of Beit Shearim, however, recommend reviewing all of these markings, collectively, as a "group," whose contents, spatial context,

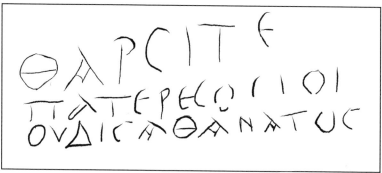

FIGURE 2.3. Greek message to "Be of good courage, pious parents, no one is immortal!" inside entryway to Catacomb 20 in Beit Shearim in photo (top) and tracing (bottom); March 2011. Photo by Ezra Gabbay.

and interplay relate specifically to their mortuary environment, as we shall see below.

Catacomb 25. Catacomb 20 dominates studies of Beit Shearim, but its grandeur remains somewhat anomalous within the necropolis. Catacomb 25, for example, situated just meters up the hill and northeast from the northern door of Catacomb 20, is significantly smaller than its neighbor and remains relatively typical, with respect to architecture and size, of many other caves

FIGURE 2.4. Greek message, "Good luck in your resurrection," carved into the ceiling and wall of the entryway into Catacomb 20 in Beit Shearim in photo (top) and tracing (bottom); May 2014. Photo by Ezra Gabbay.

at Beit Shearim. Most elements in the catacomb are unpublished, and site maps label it according to the name of an individual buried inside ("Cave of Itzak Zaira son of Shimon").

One accesses the catacomb through a sharp descent to a courtyard platform below. To enter the cave (one of several which extend from

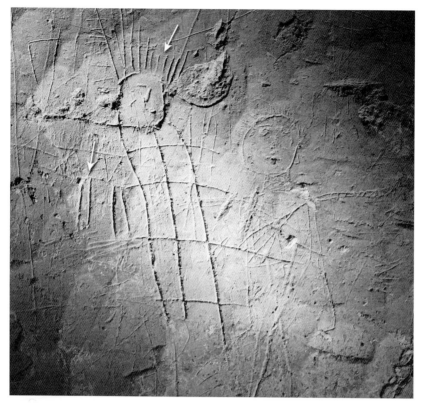

FIGURE 2.5. Figural and architectural graffiti (locations indicated by arrows) at the northeastern entrance to Catacomb 20 in Beit Shearim; June 2014. Photo by Ezra Gabbay.

the same courtyard), a visitor could pull on a metal door ring, still embedded in its original setting, before applying pressure to the stone door. When a visitor opens the door in this way, light pours into the cave's interior, which is most brightly illuminated in the afternoon or early evening. The rectangular room is designed symmetrically: two arcosolia are carved into the northern and southern sides of the room, and a single arcosolium is hewn into the eastern wall of the cave, which faces the entrance (five arcosolia in total). Readily visible, too, are pictographic and textual graffiti, which cluster directly around burial beds on the right and left sides of the cave (facing). Between and beneath two arcosolia on the right appears a dense cluster of drawings. Some of these render ships of various styles, shapes, and degrees of elaboration. Three are large and shallowly carved in between the arcosolia: each is

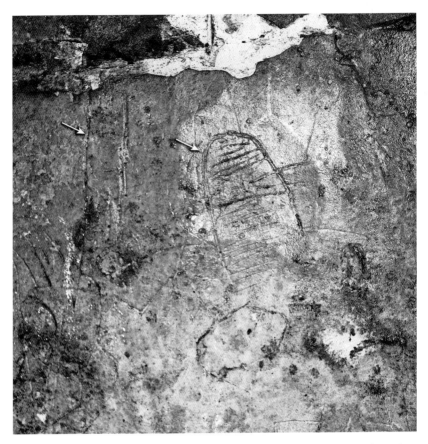

FIGURE 2.6. Abstract structural and architectural graffiti (locations indicated by arrows) at the northeastern entrance to Catacomb 20 in Beit Shearim; June 2014. Photo by Ezra Gabbay.

rendered with a curved hull and a mast; one is rendered with billowing sails, and others are festooned with streamers (figure 2.7). A more abstract ship appears slightly beneath the shelf of the arcosolium on the southeast side (left side, facing). Oars and anchors extend from most of these. A simple carving of a bird and a grid appear at eye-height between the arcosolia, and a tiny abecedary, or sequence of Hebrew letters in alphabetical order, is carved against the eastern edge of the arcosolium positioned closest to the entrance (figure 2.8).

On the opposite side of the same room, more abstract pictorial graffiti appear between burial beds. Grid-shapes, X-shapes, and carved box-shapes recur beside and between the two arcosolia. In the absence of a distinct

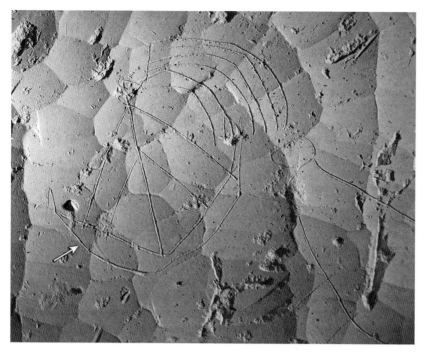

FIGURE 2.7. Ship graffito (unpublished) located between arcosolia in Catacomb 25, Beit Shearim; July 2016. Photo by Ezra Gabbay.

internal vestibule or antechamber, most graffiti images and writings from this cave directly surround the burial beds, and none are visible around the doorway itself.

Catacombs 12 and 13. If a visitor exits Catacomb 25 and travels back toward the main access road to the site, Catacombs 12 and 13 appear to her left. Catacomb 12 is only selectively open to the public and, like Catacomb 25, is accessed by descending stairs, which lead to a small external platform. The cave presently contains four larger sections, which extend from this original courtyard. Today, Catacomb 12 is linked with Catacomb 13 artificially through a robber's trench, but both caves are known for their associations with northern cities; they house remains of Jews who traced their origins to northern Levantine towns, including Antioch, Byblos, Beirut, Sidon, and Tyre.[32] Most known graffiti derive from the hall on its eastern side, which excavators labeled on their map as Hall A.

Current conditions impede the admission of natural light into the catacomb. Torchlight, however, illuminates several carvings and dipinti inside. After descending two steps into the cave, a first cluster of graffiti appear around a doorway to the immediate left. On the western doorjamb of this

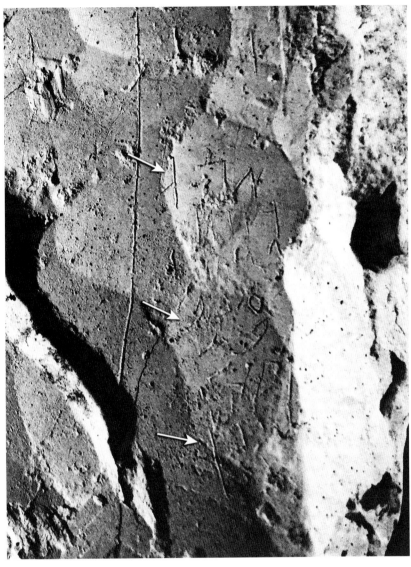

FIGURE 2.8. Hebrew alphabet carved beside arcosolium from Catacomb 25 in Beit Shearim; July 2016. Photo by Ezra Gabbay.

arched passage, on the side of the entryway (between rooms designated as I and II), appears an elaborately drawn eagle or vulture, at hip height and below (35 cm above the ground; figure 2.9). Light but careful lines depict the bird standing, with its head turned in profile toward the entryway. The artist took pains to etch individual feathers on the bird's body and head, but the figure's beak and facial features are somewhat effaced.

Just around the corner on the interior and west side of the doorjamb, however, appear multiple, less elaborate markings, carved at eye-height (on average, 1.5 meters above the ground). These include large seven-branched menorahs and X-shapes. Several letters also appear, which render an indecipherable Hebrew or Aramaic phrase. On the opposite doorjamb, at the same height, are several additional images and letters; on the interior of the jamb appears a Greek textual graffito, which terminates at the corner of the jamb (figure 2.11).[33] While the readings of the Greek and Hebrew texts remain obscure, they may replicate the same sounds in each independent alphabet.[34] Around the corner, and on the opposite doorjamb from the eagle, is a small menorah, which is cut precisely and faces the central room of this section of the cave (room I; figure 2.10).[35]

Scratched pictures appear elsewhere in the catacomb. In the room to the right of the catacomb entrance (Room III), another drawing appears on the interior northeast jamb. This depicts a quadruped of nondescript identification, whose image (and record) remains unpublished (figure 2.12).

Rich textual dipinti also recur around and inside a burial bed from the same room (III) on its western side, parallel to the central doorway (arcosolium 3); (figure 2.13). These Greek and Aramaic writings are painted in red ochre. An Aramaic dipinto, applied to the upper portion of the semicircular interior wall of the arcosolium, faces the room and cautions: "Anyone who shall open this burial upon whomever is inside it shall die of an evil end" (figure 2.13, detail).[36] A Greek dipinto painted on the outer and upper left wall beside the same arcosolium reads: "Nobody shall open in accordance with divine and secular law" (figure 2.13, detail).[37] It remains unclear whether or not the application of these curses was originally a coordinated effort. Rendering curses in two languages around and inside the same arcosolium, in any case, suggests that those who applied the texts hoped that potential tomb robbers were sufficiently literate, in one of the languages, to read and heed the repeated warnings. Regardless of the rates of literacy among tomb violators, the warnings certainly went unheeded: a robber's trench, which artificially connects the cave to Catacomb 13, pierces through the trough of this arcosolium.

These types of curses against grave disturbance appear elsewhere, both in Catacomb 12 and in Catacomb 13. The beginning of an additional curse appears in Aramaic above a single loculus, or *kokh*, carved into the southeastern corner of Room VIII ("Anyone who shall open . . ."). Beside

FIGURE 2.9. Elaborate graffito of bird (possibly a vulture or eagle) on the doorjamb in Catacomb 12 in Beit Shearim in photo (top) and tracing (bottom); May 2013. Photo by Ezra Gabbay.

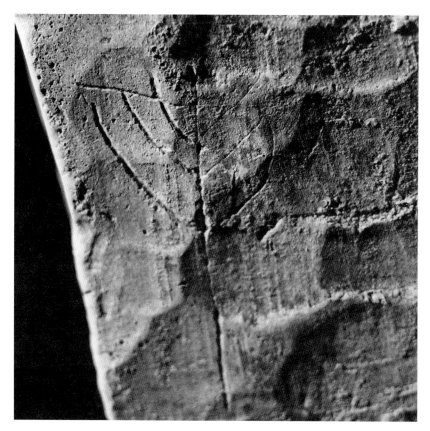

FIGURE 2.10. Menorah graffito on the doorjamb in Catacomb 12 in Beit Shearim; March 2011. Photo by Ezra Gabbay.

it is painted an epitaph, which embeds an oath to promise "an evil end" to anyone who disturbs the associated tomb of Shimʿon, the son of Yoḥanan ("Whoever opens this tomb will die a bad death!").[38] The latter texts are also applied in Aramaic in red ochre.

Painted curses also mark tombs in the adjacent catacomb.[39] One Greek dipinto, curving around the right upper edge of an arcosolium in Catacomb 13 and similarly painted in red, reads: "Anyone who changes this lady's place (i.e., the woman buried in this grave), He who promised to resurrect the dead will Himself judge (him)" (figure 2.14).[40] This curse appears along the northwestern side of Catacomb 13 (Hall D, Room II, arcosolium 1) and remains visible from the southern entrance to the hall—both due to the rich color of the ochre and the open design of the main hallway.

FIGURE 2.11. Greek writing carved into doorjamb in Catacomb 12 in Beit Shearim; March 2011. Photo by Ezra Gabbay.

Catacomb 1. The necropolis extends well beyond the area that encompasses the preceding catacombs; several additional catacombs have been excavated farther to the southwest, across the modern access road (Map 3). Archaeologists generally consider this southernmost section of caves, which includes the excavated catacombs 1, 2, 3, 4, 7, 8, 11, and 32 (and explored but mostly unexcavated catacombs, including 6, 9, and 10, which remain largely unpublished), to be somewhat older than the other portion of the complex (that including Catacombs 12, 14, 20, and so on). The internal architecture of these caves is erratic, and many portions have suffered collapse; these realities impose greater challenges for identifying and mapping graffiti inside. Nonetheless, graffiti from this area are abundant.

A visit to Catacomb 1 requires extensive climbing. One scrambles up a diverse system of ancient stairways to access a warren of rooms, which extend from upper and lower corridors. The effort is quickly matched with results: one can identify at least seventy examples of extant graffiti, carved and painted around the surfaces and hallways associated with the space. One such example appears directly inside a tomb. Just inside a cave entrance, accessed from the lower corridor (between halls excavators labeled

FIGURE 2.12. Graffito of quadruped (unpublished) on internal doorjamb in Catacomb 12 in Beit Shearim; May 2011. Photo by Ezra Gabbay.

as C and D, in Room I), appears a striking figural graffito, carved into the back section of an arcosolium, hovering at a level just above the trough into which a corpse would have been placed (figure 2.15).[41] Its gender is indeterminate, though excavators have described her as a woman. She has no hair, and deeply incised eyes and brow bone. Her legs are obscured by plant growth inside the cave, but her arms are extended unevenly; her left one (facing) is poised higher than the right. Three stick-like fingers extend from each hand. Her rectangular-shaped torso is decorated with cross-hatching. The position of the graffito would have made it exceptionally difficult to carve—it would have required its artist to stand on the grave to do so.

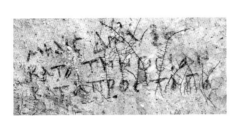
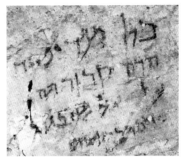
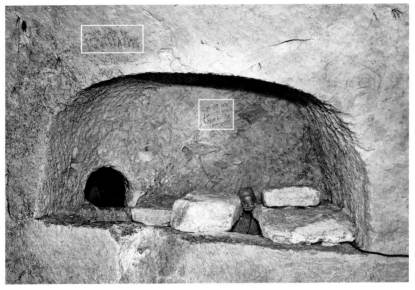

FIGURE 2.13. Greek and Aramaic curses surrounding tomb in Catacomb 12 in Beit Shearim as indicated *in situ* (bottom) and with detail of the Greek (top left) and Aramaic (top right) texts; March 2013. Photos by Ezra Gabbay.

Multiple additional graffiti remain visible in the caves that extend from the corridors of the catacomb. Some in its lower section include concentric circles, incised and traced with green paint on the ceiling. Menorahs are also carved in passageways around Room IV (of Hall I). More figural graffiti appear, farther west in this lower corridor, in the area excavators designated as Hall G. On the extended jambs between Rooms II and III appears a sculpted monumental image and graffiti of menorah symbols, alongside other images equally associated with the destroyed Jerusalem Temple, including a shofar. Just meters away, in another passageway, the word *shalom* is written, multiple times, in Hebrew scripts. Drawings of ships

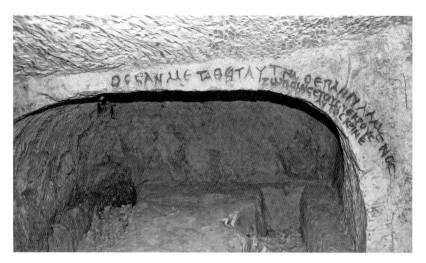

FIGURE 2.14. Painted curse threatening, "Whoever changes this lady's place," above arcosolium in Catacomb 13 in Beit Shearim; January 2014. Photo by Ezra Gabbay.

also appear, particularly around burial beds in Halls A (Room I) and G (Rooms I, II). In the upper portion of the catacomb, two ships are carved around arcosolia in Room V of Hall O, and in Room IV, below burial beds in section P. An architectural drawing, which resembles a set of arches, also appears. Additional inscriptions of so-called abecedaries are also recorded in the upper portion of this cave. A carving of the first eight letters of the Greek alphabet (*alpha* through *theta*, if not *iota*) appears in a passageway of Hall N (between Room II and IV).[42] Some have reported the presence of additional Hebrew abecedaries in the catacomb; their precise find spots are difficult to ascertain.[43]

 Catacomb 2 and Mugharet el-Jehennem. If one exits Catacomb 1 and proceeds to the southwest, the area of Catacomb 2 appears roughly 15 meters to one's left. Most of this catacomb collapsed long ago. Excavators recall many dipinti and graffiti, including elaborately designed concentric circles on portions of the cave ceiling, as well as menorah graffiti and an image of a ship (Hall B, Room I, arcosolium 2).[44] The most accessible remains belong to the underlying cave designated as Mugharet el-Jehennem, so named because Arabic-speakers in the area once described it as being the gaping entrance to hell (Jehenna). Today, one can visit parts of this cave, carved into soft sandstone, but much of the area is fenced off, due to fears of additional collapse. The portion of the cave that is open for visitation may have served as a vestibule or housed a small number of

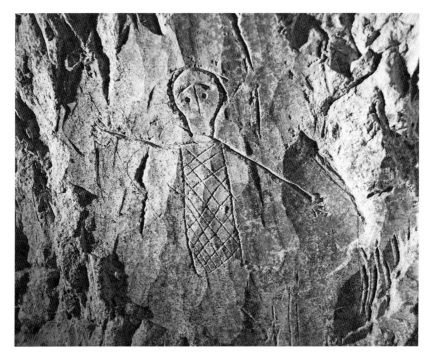

FIGURE 2.15. Human figure or skeleton carved above arcosolium in Catacomb 1 in Beit Shearim; March 2011. Photo by Ezra Gabbay.

burials. It is flanked by two clearly rendered images of ships (figure 2.16). These are elegantly drawn and carefully and deeply incised. One resembles an Egyptian barque or ferry, with a striated hull and cabin on-deck; the other resembles a seaborne vessel with full sails.[45] Due to their position and to their appearances beside decorative installations carved into the stone, it remains unclear whether the latter images were part of a broader monumental decorative program in antiquity, or whether they are more appropriately classified as graffiti.

Catacomb 4. Farther to the southwest appears Catacomb 4, also accessed through a series of descents. The cluster of rooms is divided into four portions (labeled by excavators as Halls A through D), each accessed through stairs descending from a central courtyard. Entries to these caves are typical of those on the other side of the necropolis; their façades are unadorned, with the exception of their carefully carved stone doors.

One of the easiest sections to access from the courtyard, Hall A, contains some of the most vivid decoration found in the entire complex.[46] The ceiling's design includes elaborately painted red ochre lines, abstract squiggle-like patterns, and radiate circles. When one enters this portion of

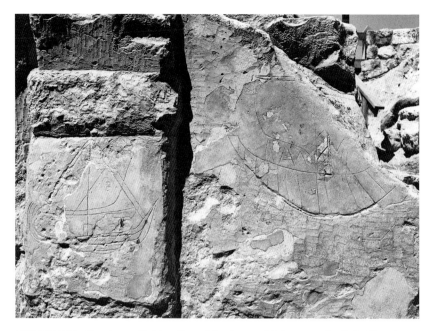

FIGURE 2.16. Carvings of ships from Mugharet el-Jehennem in Beit Shearim; March 2011. Photo by Ezra Gabbay.

the cave, the decoration on the ceiling carries one's eyes vertically through two sequential rooms beyond, to the section that terminates with an ornate tomb structure. Etched into the tombs are high reliefs of human figures and lions in an architectural frame, and a profile of a man's head with nested V-shapes, now effaced.[47]

But if one immediately turns to the left upon entry and walks to the end of Room II (northward toward wall 2), one sees carvings of two human figures, stacked one above the other, inside the right frame of the tomb's arch (figure 2.17). These bold forms possess basic facial features, including carved and straight mouths, defined eyebrow lines, eyes, and noses; their midsections are etched with crosshatching. Their arms are extended; the outward-facing direction of their feet might suggest movement away from the tomb. The figure on top appears to have been carved and painted in multiple stages. Application of D-stretch technology to digital photos highlights what is only faintly visible to the naked eye—the top figure is holding some form of a staff, painted in red ochre. Ancient artists would have needed to considerably contort their bodies, or squat upon the frame of the grave itself, to apply these drawings, so nestled into the interior corner of an arcosolium.

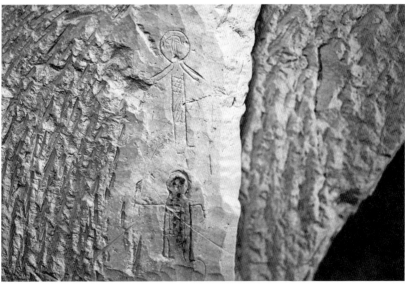

FIGURE 2.17. Stacked human figures carved and painted inside arcosolium of Hall A in Catacomb 4 in Beit Shearim as indicated *in situ* (top) and in detail (bottom); March 2011. Photo by Ezra Gabbay.

If one exits Hall A and turns sharply to the south, one accesses Hall C, which contains several more carvings. One must duck one's head considerably to enter the space, because the entrance is significantly lower than the previous one. The two rooms of this hall contain a high density of graffiti. Several clusters of markings surround the first arcosolium on the left (facing) in the first room, which bears a painted Greek epitaph, dedicated to "Germanos [son] of Isak the Palmyrene" (Room I, arcosolium 1).[48] To the upper left edge of the arcosolium, roughly 1.5 meters above the ground and relatively close to the entrance, appears a deeply etched standing figure (c. 15 cm high), depicted as hairless, with deeply carved eyebrows, eyes, nose, and mouth. His thighs bared, he is dressed in a military tunic with a belt and boots. He grasps a spear in both hands, which he points directly toward the tomb opening (figure 2.18).[49] To his upper left appears another figure, more sparsely drawn, similarly pointing a spear toward the adjacent tomb.[50]

A second cluster of graffiti appears to the lower right of the same arcosolium between this grave and the arcosolium to its right (south). Unlike the previous images, this cluster includes two armed figures that appear to interact directly with one another (figure 2.19). The figure on the left (facing) is carved with two eyes and a mouth. He wears some sort of oversized headgear, or a net, which his combatant has cast upon him; perhaps he holds a shield. He brandishes a sword in his right hand, which he points menacingly toward his opponent. The net-like feature of his attire has inspired some to classify the figure as a Roman *retiarius*, or "net-thrower"—a gladiator type commonly clad in fisherman's gear.[51] The figure to his right displays more elaborate facial features, including deeply incised eyes, a nose, furrowed eyebrows and, perhaps, eyelashes. His hairs, like his eyelashes, stand on end. He wears a tunic or belt that bares his thighs, but no protective helmet. He points his feet and a spear toward his neighbor and toward the tomb to the viewer's left.

Beneath both arcosolia on this eastern wall appear many other types of scratches. Some resemble X-shapes, while others mimic the Roman letter or number "V." While four or five clusters of these markings appear beneath the tomb closest to the entrance, nearly twenty examples are carved into the space between the burial bed and the floor of the neighboring arcosolium (south). Systems of grid-shapes also appear, which resemble boxes formed through intersecting lines. Each of these markings would have required inscribers to crouch low on the floor to carve them.

Still other graffiti of men and animals appear in the same cave on the smoothed rock surface of a south wall facing the entrance, positioned between eye and knee height (figure 2.20).[52] Three types of images are carved in combination: humans, animals, and human busts or statues. Most of the human figures are depicted upside-down, diving in the direction of the floor. The central "diver" is very carefully etched; his eyes, eyebrows,

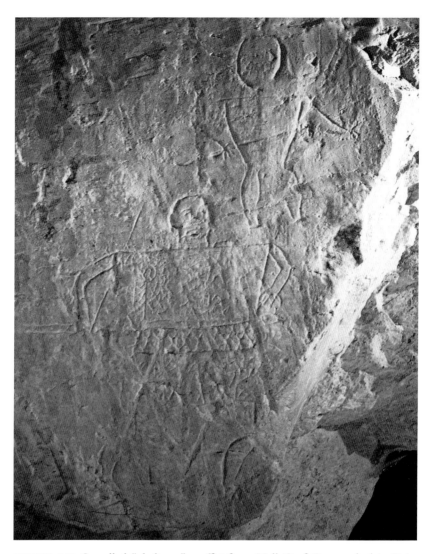

FIGURE 2.18. So-called "gladiator" graffiti from Hall C of Catacomb 4 in Beit Shearim; March 2011. Photo by Ezra Gabbay.

and nose are carved deeply and his hair stands on end. He wears a tunic decorated with cross-hatching, while his fingers extend toward the ground. Two other drawings echo this one; the divers are carved more simply with extended arms and also dive downward. Several quadrupeds, perhaps representing lions, are etched nearby. Their renderings lack excessive detail, though some animals appear to be smiling. Two human busts or statues

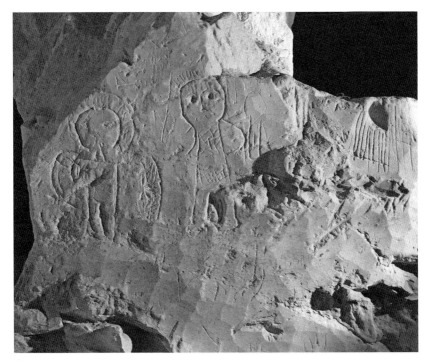

FIGURE 2.19. Combatant graffiti from Hall C of Catacomb 4 in Beit Shearim, Israel; March 2011. Photo by Ezra Gabbay.

are also sketched on the upper left.[53] Their positions, vis-à-vis the other markings, suggest their participation in a common scene. Farther back in the same cave, additional faces appear. They are carved with lines, which may indicate that they are weeping.

Catacomb 6. Across the valley, several additional catacombs are hewn, whose entrances face eastward. Most remain sparsely or entirely unpublished. Some have sustained degrees of collapse or modification, including Catacomb 6, which survives in partial form. Two sections of Catacomb 6 are accessed through a central courtyard, whose floor is adorned with a simple white mosaic.[54] Its interior includes arcosolia, bisected with spaces to accommodate single and multiple burials. The only identifiably ancient set of graffiti appears on a wall of the cave's southwestern section, beside the stairs from the entryway.

The internal corner of the stairway was carved, smoothed, and flattened in antiquity. The preponderance of graffiti on the surrounding walls, however, is recent: local teenagers and visitors scarred the surfaces when they discovered the space anew for themselves. But beneath layers of creeping root

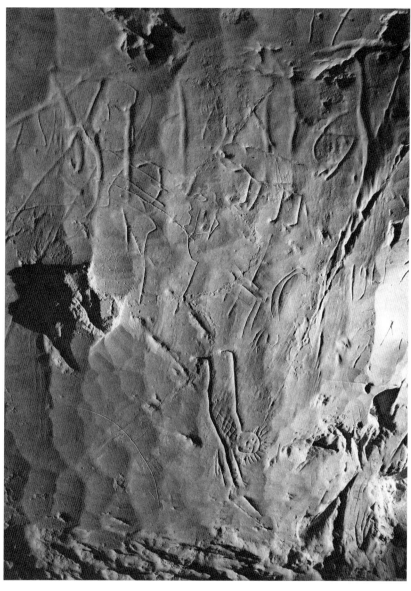

FIGURE 2.20. Scene of diving or falling man with quadrupeds in Hall C of Catacomb 4, Beit Shearim; March 2011. Photo by Ezra Gabbay.

and modern markings hides a cluster of ancient graffiti, positioned along the flattened corner, whose edges are smoothed with time (figure 2.21). About one meter above the current floor level, directly upon the corner, appears a human figure, carved facing directly forward.[55] His outstretched arms point downward and extend onto the neighboring walls; five stick-like fingers extend evenly from the end of each arm and five stick-like toes from each foot. Facial features remain obscure, but the figure's hair stands on end. Basic cross-hatching divides his tunic into six parts. And flanking each hand, roughly 3 cm away from the figure, on separate but adjacent walls of this cave, appear vertical pillars, each of which terminates in a pyramidal shape, much like those visible at the entrance to Catacomb 20 and elsewhere. Each of the latter shapes is decorated with cross-hatching and measures roughly 20 cm high.[56]

LOCAL AND REGIONAL PATTERNS IN THE BEIT SHEARIM GRAFFITI

What can we say about these graffiti in Beit Shearim—whether textual or pictorial, carved or painted, positioned inside cave entrances, passageways, or directly around tombs? Are their contents and locations as arbitrary and incidental as Mazar initially supposed? Closer attention to distribution patterns of graffiti throughout the site suggests not, but rather, bolsters an opposite conclusion: that visitors carved them systematically and with care. Comparisons between graffiti found in Beit Shearim and those from burial caves in nearby regions of Palestine, Syria, and Egypt, moreover, reveals something equally significant: that associated activities of graffiti writing were widespread. In fact, local and regional readings of graffiti advances a more compelling case for regarding their applications (whether in Beit Shearim or elsewhere), as vestiges of regionally conventional, if variable, mortuary activities.

Modes of Meeting and Greeting the Dead

Consideration of texts and pictures clustered around catacomb entrances, from the outset, reveals fundamental connections between their semantic contents and locations. Certain types of written messages, for instance, were not applied at random, but reflect their writers' deep desires to convey their messages—specifically to those entering the caves. But the exact vocabulary of these texts tells us even more about the precise audiences writers antic-ipated. The phrase facing the northern entrance to Catacomb 20 ("Be of good courage, pious parents, no one is immortal!"), for example, exhorts readers to be courageous, just as do Greek epitaphs from Beit Shearim, as well as those from cemeteries in Tyre, Abila, and elsewhere, where the

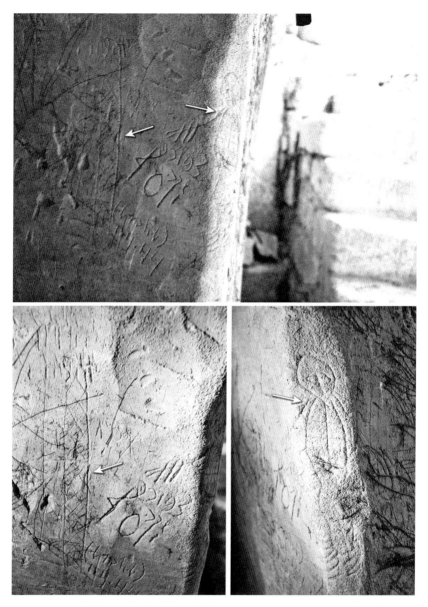

FIGURE 2.21. Skeleton flanked by obelisks on entryway corner in a burial hall in Catacomb 6 of Beit Shearim, as depicted *in situ* (top), with detail of obelisk on the western side (bottom left), and detail of the extended skeletal figure (bottom right); May 2014. Photos by Ezra Gabbay.

same term (*tharsi*) is used to offer comfort to many of the deceased.[57] The reminder that "no one is immortal!" also reflects upon the inevitability of death. And the direction of the same message to the "holy/pious" ones also, likely, counts its audience among the deceased: *hosios* is a term more commonly used in inscriptions to praise the dead, rather than to describe the living.[58] A second message ("Good luck in your resurrection!") similarly and explicitly engages the recently deceased, whose bodies were brought into the caves beyond: it wishes them well during their anticipated rebirths. Regardless of how visible the texts were to catacomb visitors, then, their writers carved them for the additional viewing of a particular incoming audience: the dead carried across the thresholds below.

What makes these sentiments so distinctive when expressed as graffiti, in these places, if so many regional epitaphs include identical terms and phrases? Their locations, anonymity, visibility, and size. Epitaphs carved directly around tombs primarily serve to label, memorialize, exhort, and eulogize the deceased individual. By contrast, graffiti such as these are splayed before and around a catacomb entrance, at eye level, several meters away from the closest sarcophagus or burial niche. The latter markings, then, appear to fulfill entirely different functions than do epitaphs, even if they deploy comparable expressions and address similar audiences. They exhibit more general and altruistic efforts to address the collective dead by wishing them well and assuring them of their consideration by the living.[59]

While acts of carving graffiti to greet and comfort the dead might seem strange to modern audiences, they may have resonated as conventional to contemporaneous ones. We know this because multiple messages, of comparable sorts, similarly appear inside tomb vestibules and entrances to burial caves throughout the region.[60] Most examples of ancient writings around cave entrances are particularly poorly preserved—an unfortunate fact, which impedes confident interpretations in several cases. Still, sufficient analogues recur around entrances to tombs in the Judean Shefelah (lowlands) and Jerusalem, and farther east in burial complexes in Abila (modern Jordan), to suggest that carving messages to the dead, particularly around cave openings and vestibules, was a relatively common endeavour in mortuary settings (for locations, see Map 1b).

Evidence for such practices extends from earlier periods of antiquity.[61] In the Judean Shefelah, farther to the south, excavated burial caves from the Iron Age through Byzantine periods incorporate distinctive architectural features, such as common rooms or vestibules, from which burial rooms, or tombs, extend.[62] Visitors similarly carved textual and pictorial graffiti around the entrances and vestibules to these types of caves. Inside the vestibule of an Iron Age period burial cave found in Horvat Beit Loya (also called Horvat Beit Lei), for example, texts and pictures abound. Among these is a textual graffito in Hebrew, which Joseph Naveh restored to read: "May YHWH

deliver [me]." Read in light of examples from Catacomb 20 in Beit Shearim, however, one could modify that particular restoration of the text to render: "May YHWH deliver [you (the deceased)]."[63] These and other texts from the cave vestibule, as a recent study suggests, may also serve as imprecations, perhaps on behalf of the dead.[64] By soliciting blessings and deliverance, these graffiti, like those in Catacomb 20, address and consider the incoming dead, as well as, perhaps, the living, who mourned and visited them.

Similar types of graffiti are also found in Jerusalem, where several free-standing burial monuments were built for local elites in the late Hellenistic and Roman periods.[65] Locations of writings found in some structures follow patterns evident in Beit Shearim and in Beit Loya; they, too, recur around cave entrances. In the vestibule of one burial complex of the Hellenistic and early Roman period, commonly called "Jason's Tomb" and situated in the modern Jerusalem neighborhood of Rehavia, for instance, many textual and pictorial graffiti and dipinti appear. The modern identification of the cave, indeed, draws from the name "Jason" in an Aramaic graffito, which, along with another example, may have also originally offered comfort, as well as lament, to and for the dead.[66] Adjacent textual graffiti are not positioned directly around the tombs of the dead and cannot be confused with epitaphs. Their expressions and locations, rather, exemplify distinct behaviors: common practices of writing messages around entrances, vestibules, and walls of burial caves to promise strength, comfort, and even deliverance to the dead, as well as to the living visitors, who traversed the thresholds of their mortuary complexes.

But visitors to Beit Shearim and other regional burial caves might have drawn pictures to perform comparable functions. We know this because visitors carved images, as well as texts, around entrances to regional burial caves. And while such pictures might initially appear to be too abstract or random to interpret, closer examinations reveal consistencies in their graphic features, which equally respond to their mortuary settings. At Beit Shearim, these types include carvings of archways or arcades (figures 2.5), crosshatched pillars terminating in triangles or pyramids (figures 2.6; 2.21), concentric circles, and domed shapes (figure 2.6).[67] Human figures also appear beside and between several of these forms (figure 2.5). Comparing these two-dimensional shapes to profiles of constructed mortuary monu-ments, and to similar drawings found in other mortuary and non-mortuary spaces, advances our reading of these drawings as vestiges of complementary activities, once undertaken inside entrances to mortuary spaces.

Outlines of figures from the entrance to Catacomb 20, for example, mimic shapes commonly found in the architecture of Beit Shearim and burial complexes elsewhere. The drawings of archways from the cave entryway (figure 2.5), in fact, closely resemble the external façades of two catacombs from the site—that of the surrounding catacomb, as well as of Catacomb 14, nearby.[68] The pillars with pyramidal tops, usually with cross-hatching, also

possess architectural analogues (figure 21). More elongated examples strongly resemble obelisks constructed for mortuary commemoration throughout Egypt.[69] Drawn pillars of slightly squatter dimensions more closely resemble the profiles of funerary towers, which were built throughout the Levant and Arabia, in places such as Amrit, Palmyra, and Dura-Europos in the north, and Petra and Hegra farther south.[70] In regional studies, the latter are commonly called *nefašot*, so-called because they are monuments for the souls (from the Hebrew *nefašot*, singular: *nefeš*) of the deceased; they are thought to have represented the souls of the dead or marked places where the dead were deposited.[71] Such forms are additionally echoed in the profiles of monumental tombs once constructed throughout Judea in the Hellenistic (Jason's Tomb) and early Roman periods (Zechariah's Tomb; Tomb of the Kings; Tomb of Absolom), which equally respond to architectural antecedents in the Hellenistic East, including the famed Tomb of Mausolos in Halicarnassus.[72]

Graffiti throughout the region, including those in Beit Shearim, thus appear to replicate these mortuary architectural forms in two dimensions. Mazar, in fact, once suggested that the arcade-like carving from Catacomb 1 replicated a motif common on Jewish ossuaries constructed in earlier periods in Jerusalem and Jericho.[73] But attention to the greater ranges of subjects in pictorial graffiti from Catacomb 20 and considerations of three- and two-dimensional comparisons from local and wider geographic and cultural contexts, such as those above, allows us to push Mazar's initial observations a bit further. Graffiti artists at Beit Shearim might have evoked ancient ossuary patterns in their carvings. Alternatively, however, the original carvings on ossuaries, including arcade or *nefeš* shapes, might reflect an underlying logic, which equally draws from regional architectural precedent in mortuary contexts. Indeed, that logic might have informed artists' decisions to carve their graffiti as they did, as well as ancient architects' decisions to design the façades of Catacombs 14 and 20 as they did. Perhaps, regional populations associated specific architectural forms, such as arcades, with mortuary processes and customs.

Similar possibilities might inform the popularity of comparable architectural drawings in mortuary contexts, which mimic obelisk or *nefeš* shapes. Many such obelisk graffiti appear around entrances to caves in Beit Shearim, but also elsewhere in the region. A graffito of an obelisk or *nefeš* shape, for instance, was carved into the wall of a Jewish burial complex of the Second Temple Period in Jericho (commonly called Goliath's Tomb).[74] But similar renderings also surrounded entrances to burial caves in the Shefelah, which possessed no Jewish association. Obelisk/*nefeš* shapes were carved in multiples around the doorjambs of a burial cave explored in Horvat Egoz and into vestibules of burial caves in Horvat Lavnin, Tel ʿEitun, and elsewhere (figure 2.22).[75] A similar form appears in the Helle-

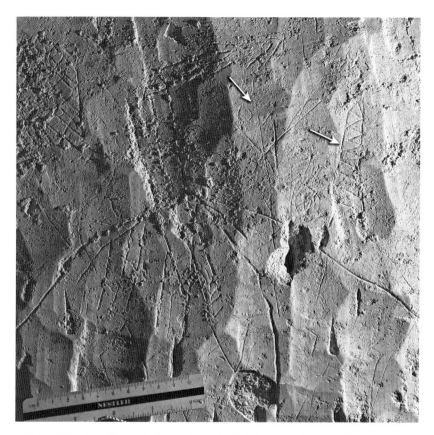

FIGURE 2.22. Graffiti including grid and obelisk on vestibule wall from the Horvat Lavnin burial cave in Israel; October 2013. Photo courtesy of Boaz Zissu.

nistic tombs of Maresha.[76] Still other forms, which may echo those of the "domed" figures in Catacomb 20, are recorded in a burial cave of Jewish association in Horvat ʿEitun.[77] In all cases, much like the Beit Shearim examples, the latter shapes are carved around burial cave entrances and vestibules. Etchings of obelisk/*nefeš* shapes inside the vestibule of Catacomb 20 (and Catacomb 6, for that matter), appear, like other regional examples, to serve specific purposes: to graphically reflect, demarcate, or, at the very least, to link the surrounding spaces with the mortuary architecture and environments of the dead.

Pairings of human and architectural images, such as those seen in Catacomb 6 at Beit Shearim, also recur in regional graffiti from multiple settings, including devotional as well as mortuary ones. Graffiti and dipinti

from temples and iwans of Syrian Dura-Europos and Hatra, for instance, frequently depict human figures, or cult statues, occupying spaces beneath and within drawings of temples or rounded cultic niches.[78] These clusters of graffiti, as I argue elsewhere, constitute scenes by graphically representing the architectural spaces, appurtenances, persons, and activities associated with cultic environments.[79]

Groupings of architectural and human figures, however, similarly recur in mortuary environments farther south in Jerusalem, the Shefelah (Horvat 'Eitun), and, in a deconstructed way, in tombs of Hellenistic and Roman Alexandria.[80] Human figures, as components of these scenes, are drawn in ways which today might seem child-like, with splayed hands and feet. As discussed additionally below, moreover, their wrapped attire remains diagnostic and somewhat unusual.[81] Renderings of the human figures, so comported and attired, might not accidentally appear beside graffiti that replicate architectural images. Such portrayals of human figures, drawn beside those of mortuary monuments, rather, may function much like cult-scene graffiti from Syria. Their forms constitute mortuary scenes, even if their individual components could have been added by different artists through time. These scenes, in which architectural figures frame representations of human ones, might have designated and reflected the realms, spaces, activities, and personalities of the deceased.

Interacting with Tombs

Distinct types of texts and images also cluster farther inside the catacombs— directly upon, around, and even inside of graves. These include written curses, abecedaries, renderings of ships, differently attired human figures, and abstract markings such as short vertical lines, Xs, Vs, and grid- or net-shapes (figure 2.23). Closer attention to the relationship between the types and locations of these markings reveals broader consistencies in their deployment at Beit Shearim and in burial caves nearby; at minimum, they attest to the conventionality of activities of writing and drawing directly around and inside of graves in Beit Shearim.

In a limited number of catacombs (Catacomb 12 and 13), for example, visitors applied curses directly around or inside of graves. Their scripts are painted with particular clarity, in red ochre, in Greek or Aramaic, and their contents are anonymous—with one exception, they omit mention of the specific names of the deceased (or of their writers).[82] An Aramaic dipinto painted above an arcosolium in Catacomb 12, for instance, threatens a person who violates ". . . this burial upon *whomever* is inside it [my emphasis]" (figure 2.13c). A Greek curse, which describes "the lady" buried beneath it (Catacomb 13), uses equally generic language and excludes the personal name of the dead (figure 2.14).

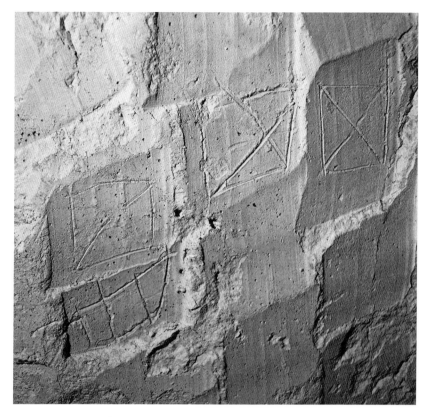

FIGURE 2.23. Graffiti of X figures inside box shapes from the northern side of Catacomb 25 in Beit Shearim; July 2016. Photo by Ezra Gabbay.

Consistent features of these anonymous curses may offer initial clues for their interpretation. First, and most obviously, the recurrence of curses and the potent threats they describe demonstrate how important it was for inscribers to try to protect the tombs. The reduplication of curses in two languages against tomb violators around an identical tomb demonstrates this most powerfully in Catacomb 12.[83] The consistently careful renderings of associated texts may also be significant. The curses, in many respects, are unlike many epitaphs in the necropolis, whose scrawled cursive renderings are stylistically indistinguishable from elements of graffiti nearby. Indeed, the remarkable clarity of the scripts of these curses suggests that specialists painted them graveside. This possibility, in turn, may relate to particular concerns about the legibility of their messages, particularly to ill-intentioned robbers or malefactors, or to the important role of writing, by practitioners, to assure the efficacy

of their messages. Decisions to paint the inscriptions in red ochre, too, likely remain significant. This choice of medium might have been in response to concerns about the visibility of the texts inside the dark cave; perhaps brightly painted letters would be more visible to robbers by torchlight than letters scratched lightly into the rough surface. The medium, alternatively (or in complement), could have retained additional apotropaic or protective properties; some suggest that red ochre was used in this way.[84] The extremity and visibility of these curses and their proximity to the bodies of the dead, nonetheless, suggest that their application, in multiple respects, endeavored to protect the bodies of the deceased.[85]

Such curses are regionally common. Comparably worded deterrents against tomb robbers (often exacted in comparable media) appear frequently and diachronically in regional mortuary contexts. An abbreviated and poorly preserved curse, in a graffito from the Judahite complex in Beit Loya, is limited to the single word "curse."[86] Mortuary curses from earlier periods also include the so-called Tomb of the Royal Steward inscription, discovered in Silwan in Jerusalem just meters from the inscription in the Kidron Valley. It announces: "This is [the Sepulchre of . . .]yahu who is over the house. There is no silver and no gold here | but [his bones] and the bones of his *amah* [concubine or wife] with him. Cursed be the man | who will open this!"[87] Such prohibitions invoke divine power to protect the bones of the deceased.[88] In slightly later periods, curses appear on Jewish ossuaries, with messages directed against those intending to reuse bone boxes for someone else's remains.[89]

Curses also appear in mortuary dipinti and graffiti from elsewhere, outside of Judahite or Judean contexts. Iron Age mortuary graffiti in Phoenician scripts foretell disaster for tomb violators in Byblos, Tyre, and Cyprus.[90] Greek curses, which declare, "Let no one open!" are scratched and painted around individual loculi in the Hellenistic tombs in Maresha, close to Beit Loya.[91] And a painted couplet, possibly containing curses against tomb violators, was also found inside a passageway in Tomb V in the Anfushi catacombs in Alexandria.[92] Inclusions of curses and threats against tomb violation are also particularly noted in epitaphs for Jews, farther north in Asia Minor and farther away in Syracuse.[93] Warnings against tomb robbers were thus common both diachronically and across several regions of the Mediterranean.

Although inscribers' priorities are clear in all cases—to apply curses to protect the tombs and bodies of the dead from appropriators, violators, or robbers—closer examination reveals that associated acts of writing at Beit Shearim should be viewed as somewhat distinctive within a broader regional tradition. First, curses at Beit Shearim are consistently (and somewhat unusually) anonymous. Inscribers might have wished to protect tombs through

painting these warnings, even if they did not know the identities of the deceased, who might have passed away decades, if not centuries, before their application. Rather than fulfilling a family obligation to name or eulogize the dead in a complex and protective epitaph, then, applications of such anonymous curses at Beit Shearim would have constituted different types of activities entirely—as altruistic acts to defend tombs of the anonymous dead.

Graphic elements, which commonly appear directly around and upon burial beds, might have served complementary functions. Ships are among the most prominent of these. Interpreting nautical graffiti remains particularly challenging in any spatial context, partly because ships are among the most popular motifs in graffiti from all periods in all cultural contexts throughout the Mediterranean.[94] Variations in representations of ships, even within identical catacombs at Beit Shearim, further muddy the picture; one graffito from Catacomb 1, for example, renders a ship outfitted with a mast and sails (Hall N), while another depicts the profile of a vessel with a similar hull, but without sails or oars (Hall P).[95] These differ significantly from renderings found nearby in Mugharet el-Jehennem and within Catacomb 25 (figures 2.7 and 2.16). Regardless of this variability, consistent patterns in the precise locations of ship graffiti inside Beit Shearim, as well as in tombs around the region, suggest correlations between their placements and function.[96]

Why did ancient visitors draw ships inside tombs? Abundant regional comparisons offer initial suggestions. Two outlines of boats, for example, are scratched into the vestibule walls of the Judahite burial complex in Horvat Beit Loya. Excavators originally posited, based on these drawings, that some of the individuals interred in the cave beyond once served as shipbuilders. Such hypotheses, however, remain largely untenable without corroborating evidence, particularly in an inland region, where such images are common in similar places.[97] A prow of a ship graffito was also preserved on the doorjamb of the entrance to Tomb 1 in Maresha, nearby, and several more tombs from the Shefelah also include ship drawings inside vestibules.[98] In a tomb in Quirbet Za'aquqa, probably associated with Idumaean populations, a drawing, which may resemble a horn, but more likely a ribbed sea vessel, appeared on the wall of the tomb vestibule alongside other pictorial graffiti of human busts and faces.[99] Another tomb dating to the Roman period, found in Tel 'Eitun, also includes a drawing of a ship; one discovered in Qhirbet Rafi may have originally adorned a local burial cave.[100] Three additional depictions of boats, drawn in carbon with varying degrees of detail, are still faintly visible on the west wall of the vestibule in Jason's Tomb in Jerusalem (c. second through first centuries BCE); at least one of these carries human passengers—some argue that these represent pirates (figure 2.24).[101]

Associations between ships and death, however, are not limited to archaeological examples from Hellenistic and Roman Judaea and

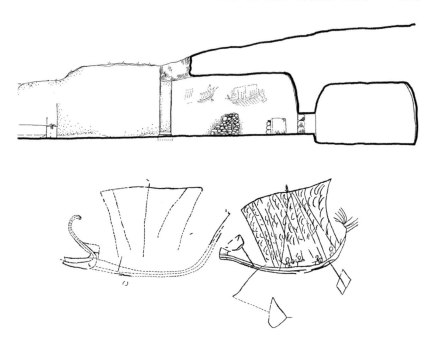

FIGURE 2.24. Carbon drawings of ships in situ and in detail from the vestibule wall of Jason's Tomb, Jerusalem, Israel; date of sketches unknown. Scanned from Rachmani, "Jason's Tomb," 67, 70; reproduced courtesy of Israel Exploration Society.

Palestine—they appear equally popular in wider geographic contexts.[102] In the Moustafa Pacha catacombs in Alexandria, for example, large ship graffiti appear beside others above a doorway in Room 4 of Tomb 1 (figure 2.25). Like those from Jason's Tomb, this example depicts people atop the ship with multiple extended oars, and an anchor extending below; traces of a second ship appear to its right. Additional ship graffiti recur in doorways and corridors of the Anfushi catacombs nearby.[103] Similar carvings are also found in Jewish mortuary contexts elsewhere in the Mediterranean—as far afield as Rome and Malta. In Rome, in the Villa Torlonia catacombs, an image of a ship, with one oar and an upright mast, was swept into the drying plaster that sealed a loculus embedded in the wall (figure 2.26). And in ancient Melita (modern Rabat on the mainland in Malta), the prow of a ship was painted in red beside a tomb otherwise associated with a Jewish elder.[104] Despite these consistencies, the precise explanation for the connection between ships and the dead, whether in Palestine or elsewhere in the Roman Empire, remains somewhat elusive.

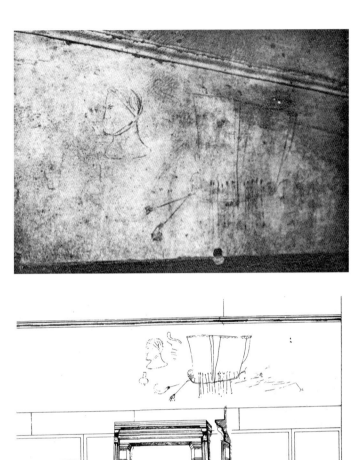

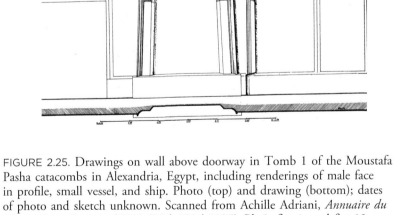

FIGURE 2.25. Drawings on wall above doorway in Tomb 1 of the Moustafa Pasha catacombs in Alexandria, Egypt, including renderings of male face in profile, small vessel, and ship. Photo (top) and drawing (bottom); dates of photo and sketch unknown. Scanned from Achille Adriani, *Annuaire du Musée Greco-Romain (1933-1934–1934-1935)*, Pl. 9, fig. 1; and fig. 13.

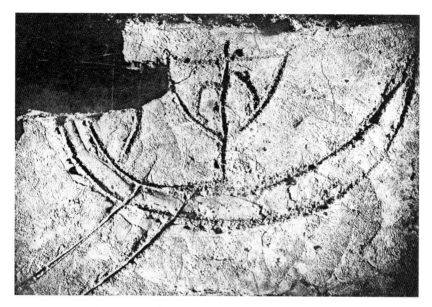

FIGURE 2.26. Ship graffito from Torlonia Catacombs in Rome, Italy; date of photo unknown. Image scanned from photo in Beyer and Leitzmann, *Torlonia*, Pl. 18.

When considering the potential relationship between ships and death, literary discussions appear to offer promising insights. The satirist Lucian, whose Syrian origins may bolster his relevance in investigating Levantine mortuary behaviors and beliefs, for example, mocks the multitudes for believing that the dead required transportation by boat to the underworld. To the uninformed masses, Lucian implies, the deceased are understood as helpless and abandoned without Charon's ferry, which must carry them to Hades across the dark lake Acheron, which "is too deep to be waded, too broad for the swimmer, and even defies the flight of birds deceased."[105] Such connections between ships and death are evident in Italy throughout the late Republic and early Empire, when nautical images pervaded regional funerary art.[106] In Petronius' *Satyricon*, for example, when the boastful Trimalchio describes the mortuary monument he anticipates for his own commemoration, he describes its inclusion of a sculptural ship at sail. By the time of Petronius' writing, however, ships had become so pervasive on mortuary monuments that their images had already become passé. This was most certainly the author's point in implicating Trimalchio's gaudy and outdated tastes.[107]

But longstanding associations between ships and death appear to have been held dear—not only by the "masses" of the Roman East and West,

but also by Egyptians of multiple periods and classes. For thousands of years, Egyptians understood boats to be critical implements in transporting the dead to the afterlife. Wall paintings and full-scale, three-dimensional models of ships were buried inside elite Egyptian tombs. Corresponding understandings echo throughout various texts retroactively grouped and labeled as the Egyptian "Book of the Dead."[108] Egyptian associations between ships and the afterlife might have synthesized with broader and cognate understandings in Hellenistic and Roman mortuary contexts to inform Levantine conceptions of death and its processes.

Might a connection between ships and death reflect a particularly "Jewish" understanding? Review of distinctly Jewish texts, of the Hellenistic and Roman periods, might offer supplementary insights. The earliest Jewish association between ships and death, after all, appears in the second-century text of 1 Maccabees, which recalls the grand monument Simon constructed for his deceased family members above their preexisting tomb.[109] The Greek text emphasizes the grandeur of Simon's construction by drawing attention to certain of its features, including its display of sculpted ships:

> . . . Simon built a monument over the tomb of his father and his brothers; he made it high so that it might be seen . . . for his father and mother and four brothers. For the pyramids he devised an elaborate setting, erecting about them great columns, and on the columns he put suits of armor for a permanent memorial, and beside the suits of armor he carved ships, so that they could be seen by all who sail the sea . . . (1 Macc 13:27–30).[110]

This anecdote emphasizes the impressive scale of Simon's monument, which, as Josephus reports, was still visible in his own day (*A.J.* 13.210–212).[111] Its projection of ship images, however, does not necessarily reflect any particularly "Jewish" mortuary association. The sheer scale and elaboration of the structure, rather, exemplifies Simon's emulation of monumental architectural paradigms, popular among regional kings in the Hellenistic period, which drew independently from Egyptian analogues.[112]

Nautical metaphors only ambiguously inform discussions of death in later rabbinic treatises.[113] Only one text, redacted in later periods, might reflect some connection between ships and death. A portion of the text reads:

> "[A good name is better than fragrant oil,] and the day of death than the day of birth [Eccl 7:1]." The day on which a man dies is more important than the day on which he was born. Why? For on the day of one's birth one does not know what his deeds will be; but at the time of his death, his deeds are made known to all. Thus

"better is the day of death than the day of birth." Rabbi Levi said: 'This is analogous to two seafaring ships, one leaving the harbor and the other entering the harbor. All were rejoicing for the ship that was departing, but not for the one entering.' A clever man, who was there, said: 'Things are the opposite of what they should be! For that ship leaving the harbor all should not rejoice, for they do not know whether she is ready, what tides or currents she may chance upon, and what winds she will encounter. But all should rejoice for the ship that is entering into the harbor, for they know that she enters in peace and came out of the sea unharmed. . . .' And about such a man, Solomon said: 'better is the day of death than the day of birth.' (*Exod. Rab.* 48:1)[114]

This text, of later if unknown date, offers additional and useful ways to imagine how nautical graffiti in Beit Shearim might also reflect metaphors useful to explain and comprehend life processes, including death. Perhaps rabbinic notions that ships represent an end of life's journey might inspire complementary readings of nautical images at Beit Shearim as symbols of life's end.

How, then, might archaeological and textual comparisons collectively illuminate the practice of carving ships so close to the bodies of the dead at Beit Shearim? Hellenistic, Roman, and Egyptian writings, whose literary and philosophical tropes (so paradoxically!) inform the literature of 1-2 Maccabees, and perhaps, even more indirectly, those in rabbinic treatises, may offer complementary insights into the deployment of nautical images at Beit Shearim, as well as in mortuary contexts farther to the west. Visitors might have carved them for purely decorative purposes, or because nautical motifs seemed conventional or appropriate for mortuary spaces. Alternatively, they might have drawn them with specific objectives in mind, by responding to notions about the afterlife, which echoed those current in nearby Egypt or elsewhere in the Hellenistic East or the Roman West. By contrast, they might have carved them to represent life at its end—safer at its conclusion than at its inception. Different artists may have retained correspondingly distinct motivations for drawing their ships around tombs.

What remains clearer (and perhaps more important), however, is the significance of the locations of ship graffiti at Beit Shearim. Ships carved in the necropolis follow distribution patterns that differ from those in other regional cemeteries and burial caves. Unlike burial caves in Jerusalem or the Shefelah, where ships are painted and carved into vestibules and around entrances, those at Beit Shearim are positioned directly around graves. This spatial distribution, perhaps surprisingly, most resembles that found around burials in Jewish contexts in Rome and Malta, and might possibly reflect an otherwise undocumented and specifically pan-Mediterranean Jewish practice

and understanding, rather than an entirely local one. Affinity with other local and trans-Mediterranean practices and beliefs does not detract from the specific, if elusive, "meaning" of nautical graffiti at Beit Shearim, but awareness of the regional conventionality of the markings, as well as their unconventional aspects, invites additional insights into the broader cultural horizons of commemorators' activities inside the cemetery.

Other pictures, however, similarly appear directly inside and around graves at Beit Shearim. These include human figures with specific iconographic traits. Examples drawn directly inside and around arcosolia in Catacomb 1 and Catacomb 3, for instance, are rendered as bald, with similar arm positions (left hand raised, right arm lowered, facing), splayed fingers, and defined eyebrows, eyes, and mouths. One such figure appears in the back of an arcosolium (Catacomb 1), while two others, stacked vertically, are scratched and painted in red ochre onto the interior archways of an arcosolium (Catacomb 4, Hall A). These are carved as if they are hovering just above the bodies of the inhumed dead (figures 2.15 and 2.17).

What might account for the comparable renderings of these figures and their placements directly inside burial beds? We have few clues. Their hairlessness may be significant, and so too their postures. Positionings of their hands at unequal heights distinguish their presentations from those classified, in later periods, as *orans* figures (whereby supplicants' hands extend to equal heights).[115] Some comparisons nonetheless exist for these graveside images. For instance, archaeologists discovered a large abstract human figure carved in relief in a burial complex in Abila, which is also drawn without hair; its hands, too, extend outward and upward asymmetrically.[116] Such figural drawings may thus serve as a particular regional "type," whose attributes and gestures directly relate to their mortuary context.

The garments of these figures, however, also retain useful information for their interpretation. Human figures drawn around the entrances to Catacombs 20 and 6 are rendered as clothed in wrappings of some sort. Multiple rabbinic and Christian texts suggest that wrapping the dead in linen shrouds was an important component of funerals and entombment in Roman Palestine.[117] Some later aggadic texts, in fact, suggest that forgetting to bind shrouds around a corpse might have negative implications for the living, by releasing ghosts of the deceased to wander unfettered above the earth and to cause mischief (*b. Ber.* 18b). Rare depictions of the dead on amulets and similar objects, however, also represent them as wrapped, possibly also in linen.[118] This particular "wrapping" feature may be significant and might associate related figures with the dead themselves. Their skeletal and hairless appearances, combined with a conventional placement of the images just inside arcosolium arches, might reinforce this representational sense.

Comparisons of the attire of these human figures with those found nearby in the catacombs highlight their distinctiveness. In Catacomb 4, Hall C, for example, the human images proximate to the epitaph for "Germanos, son of Isak the Palmyrene," are rendered quite differently from the previous category of figures: these wear armor and brandish weapons.[119] Dominant interpretations of their functions posit that they represent either the soldiers once buried nearby, or, alternatively, the gladiatorial activities that ultimately led to their demises.[120] Such analyses partly respond to the proximity of the images to one another and to their incisions beside epitaphs that include names (like Germanos) conventionally associated more with Roman than Jewish cultural contexts (a man named Germanos, some imply, might act in more "Roman" ways than did his father, whose parents had conferred to him an equivalent of the biblical name of Isaac).[121]

At first glance, assessments that these mortuary graffiti depict soldiers and gladiators might make sense. Images of soldiers and gladiators commonly appear in graffiti throughout the Roman world, from well-preserved cities like Pompeii in the Roman West to Dura-Europos and in Hatra in the east.[122] As I have argued elsewhere, however, spatiality and location should play a more significant role in the interpretation of mortuary graffiti such as these.[123] The facile equation of an image of soldier with the burial of a soldier, and the image of gladiator with the burial of a gladiator, remains entirely possible, but largely ignores the role of spatial context in the interpretations of associated images.

Comparisons of graffiti from Hall C with other regional examples suggest new ways to understand these figures, in ways which resist overdetermined interpretations of their contents. So-called gladiator graffiti on walls of contemporaneous burial caves in the Shefelah, for instance, demonstrate multiple similarities to those at Beit Shearim. In Tel 'Eitun, graffiti of weapon-clad figures also appear. Like examples from Beit Shearim, these render human figures with abstract facial features and upright hair. They, too, carry shields and chest armor and some wield weapons with spear points on one end and pitchforks on another (figure 2.27).[124] These figures are similarly carved directly upon and around arcosolia and point their weapons outward from the burial spaces in similar ways.[125] Scholars have interpreted these images, just as those at Beit Shearim, as representations of deceased soldiers or gladiators. Closer considerations of their distinct attributes and locations suggest, however, that they fulfill roles that might relate, in different ways, to the burial spaces nearby. As suggested tentatively below, these may reflect prophylactic or apotropaic functions.

Long neglected markings, discovered around many of the same graves, may retain supplementary information about visitors' efforts to use drawings to commemorate and protect the deceased. These include abstract designs, vertical score marks, and hatched shapes that resemble X and V figures,

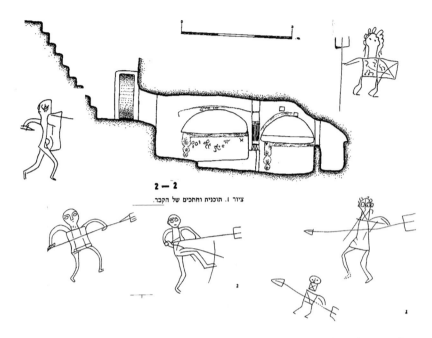

FIGURE 2.27. Drawings of combatant figures recorded in the burial cave of Tel ʿEitun in the Judean Shefelah, Israel; date of sketch unknown. Image synthesized from Tzaferis, "Roman Burial Cave," 23-4; reproduced with permission of Israel Exploration Society.

and grids or nets. While these types of markings have evaded scholarly interest, partly because of their nondescript and ambiguous nature, their presence around tombs is consistent.[126] Tens of examples of parallel lines and X- and V-shapes surround individual graves in Catacombs 3, 4, and 25. Grid or net-like shapes also appear directly around graves in Catacombs 20, 25, 4, and elsewhere (figure 2.28). Consistencies in their shapes and their densities of deposit, combined with their similarity to other local examples, demonstrate their systematic application.[127]

When one begins to pay attention, it becomes clear that such markings recur throughout the region—whether in pagan, Jewish, or Christian mortuary contexts. Crossed markings and V-shapes are particularly common inside burial caves associated with Idumaean populations from the Judean foothills. Multiple examples are present inside the vestibules of burial caves in Horvat Lavnin, Horvat el-Ein, and Horvat Beit Loya; only some of these are noted in excavation reports.[128] Six iterations are also carved into plaster beside the second- to fourth-century loculi discovered beneath the Church of the Annunciation in Nazareth, fewer than 20 km east of Beit Shearim.[129]

Grid-like or net-like designs are also common. Several are carved onto outer walls of first-century ossuaries discovered in Jerusalem.[130] Scratched images of grids or nets also commonly appear in porches of burial caves throughout the Shefelah; ten unpublished examples appear in cave vestibules in Horvat Lavnin, two in Tel ʿEitun, two in Horvat Beit Loya, and one in Horvat Zaʿaquqa (figure 2.22). Such markings also appear around graves in Nazareth, and another set appears in a burial cave in Bethphage (figure 2.28); the latter are accompanied by other abstract symbols, including one that resembles an infinity sign. The sheer ubiquity of such graffiti in mortuary contexts, however abstract they might appear, suggests their relationship to a distinct phenomenon of carving, particularly and directly around individual graves. While the meanings of these markings are elusive, their consistent presence also reflects systematic practices of application. Perhaps their proliferations around particular graves suggest that writers considered the deceased buried nearby to be more important than others, for whatever reason. This pattern might suggest something akin to the disproportionate adornment of martyrs' graves in Christian contexts (as opposed to other types of graves).[131] Perhaps, alternatively, they document historical practices of marking family tombs more generally or activities of drawing graffiti as boundary-markers? Additional and associated interpretations are considered below.

Marking Liminal Spaces

Additional ranges of texts and images that recur at Beit Shearim and elsewhere appear in distinct architectural spaces—particularly inside and around doorways or passageways. These include textual elements, such as replications of individual letters, portions of alphabets, or of isolated and repeated words (including *shalom*) in Greek, Aramaic, or Hebrew. Birds and animals particularly cluster in these places (Catacombs 12, 25), and so too do some human figures (Catacombs 12, 6, 4) and menorah symbols (Catacombs 1, 3, 12). What accounts for recurring clusters of letters, texts, and pictures around doorways and passageways? Explanations necessarily relate to their precise locations and relationships to their architectural contexts.

Interpretations of abecedaries, for example, largely remain context-dependent. Abecedaries (as alphabet lists are commonly called) record letters in their appropriate alphabetical order or in retrograde (figure 2.8). When archaeologists discover abecedaries painted or scratched onto ceramic ostraka inside civic or domestic spaces, they commonly link them to activities of scribal practice and training.[132] But when archaeologists discover identical configurations in different spatial contexts, such as burial caves, they rarely offer similar arguments; many conclude, rather, that such lists were applied for magical or apotropaic purposes.[133] These

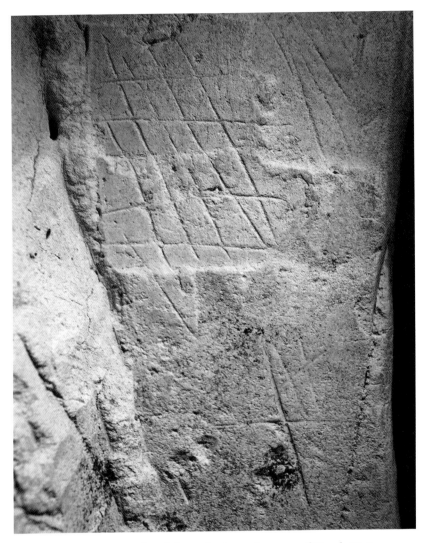

FIGURE 2.28. Drawing of grid from the inner doorway of Tomb 21 in Bethphage, Israel; October 2014. Photo by Ezra Gabbay.

assumptions are largely unprovable and therefore vulnerable for critique. Nonetheless, the relative abundance of alphabet lists, specifically around doorways at Beit Shearim and in other regional tombs, points to some sort of linked significance.[134]

At Beit Shearim, for example, abecedaries appear in both Hebrew and in Greek scripts. Some are carved into doorways and passageways, such as

the Greek alphabet scratched in Hall N of Catacomb 1; others are carved directly into the left sides of arcosolia, particularly in catacombs without distinct hallways (figure 2.13).[135] The locations and contents of these texts suggest some sort of deliberate deployment.

Comparisons with regional examples remain even more illustrative in this regard. In a family tomb in Jericho, for instance, excavators discovered an alphabetic graffito in a curious position. Rachel Hachlili, who excavated the cave, described how, in antiquity, someone had lifted a lid from an ossuary in the tomb, inscribed it with an alphabetical sequence, and propped it "purposefully" to face the entrance to the burial cave.[136] The physical position and display of the abecedary was thus deliberate and, perhaps, considered instrumental to its efficacy. Comparable presentations of alphabet lists, albeit on cave walls, include an example from Horvat ʿEitun (third to fourth centuries CE), where a complete Hebrew alphabet (letters *aleph* through *tav*) was carefully engraved on a wall between two burial chambers.[137] An unpublished retrograde abecedary from a vestibule in Horvat Lavnin appears close to the doorway to the burial cave beyond.[138] Such alphabets are consistently directed toward visitors in common spaces, around doorways and passageways, rather than placed in obscure corners of caves.

Different types of word and letter combinations also recur in interstitial spaces of tombs. Repeated inscriptions of the word *shalom* in Catacomb 1, for instance, appear in passageways, but not far from graves. Indecipherable texts also appear in similar places. Examples include an encircled and obscure graffito, rendered in writing that resembles a sort of Semitic script, in the vestibule of Catacomb 14.[139] Excavators also identified several repetitive and indecipherable texts around passageways and doorways inside burial caves from the Shefelah. In Horvat Egoz, images of *nefašot* framed extensive, and to this point, indecipherable Greek graffiti, which were engraved in multiples on the doorjambs around the entrance to the complex.[140] At Horvat Lavnin, a backward spelling of the Greek word *theos*, on the southern vestibule wall beside the entrance to interior loculi, may signify similar ritual applications (figure 2.22).[141] All such textual renderings—including alphabet inscriptions, repeated and retrograde words, and so-called "nonsense" inscriptions, might point to related phenomena. As some have noted, uses of verbal repetition, combined with the deployment of esoteric or obscure writing, remain hallmarks of ritual practice in the Levant and elsewhere.[142] Just like the carving of alphabetic texts above, inscribers might have carved words backwards or in esoteric scripts to harness their agency to protect associated spaces—acts which, as noted in the previous chapter, might have been more potent when applied around liminal spaces, such as doorways.[143]

Complementary functions might have impelled applications of menorah symbols in passageways and on doorjambs from Beit Shearim and else-

where. Menorahs are particularly common in certain burial caves at Beit Shearim, where they are often rendered in sculpted relief (Catacombs 20, 3) and carefully in paint (Catacomb 10).[144] In other instances, however, menorahs are scratched directly into walls and into passageways, particularly throughout Catacombs 1, 3, 12, and 20. Some examples of large menorah graffiti appear in multiple hallways in Catacomb 1 (e.g., Halls G and N), Catacomb 3 (Halls B and C), and to the south side of the easternmost doorway in Catacomb 20. A particularly unusual density of their renderings appears in Catacomb 12, where one deeply incised menorah graffito appears on the outward corner of the doorway facing the catacomb entryway (figure 2.10) and on the opposite doorjamb, where several copycat versions also appear.[145]

Comparisons of the spatiality of menorah drawings in Beit Shearim with those discovered in regional burial complexes, however, demonstrate a certain distinctiveness. The placement of many menorah graffiti in Beit Shearim, for instance, resembles analogues from Jason's Tomb in Jerusalem, where multiple examples of menorahs were carved into common areas, such as the tomb vestibule. But their placement differs from those in contemporaneous Byzantine burial sites farther north (Sumaqa and Tefen) and south (Beit Guvrin), where menorah graffiti are more commonly carved directly beside individual tombs. Additional features of the latter sites (Sumaqa, Tefen, and Beit Guvrin), moreover, offer clues to interpret these differences.[146] Several menorah-marked graves in Beit Guvrin and Sumaqa were positioned close to other tombs adorned with christograms and crosses. These sites retained "mixed" (Jewish and Christian) burial populations. Acts of scratching menorah graffiti in those specific locations, therefore, might have fulfilled distinct functions from those at Beit Shearim; by appearing on and around tombs, menorahs from these sites might have served to differentiate individual Jewish graves from neighboring ones explicitly marked as those of Christians. The incisions of menorah symbols into common areas of caves at Beit Shearim may serve to manifest the cultural identities of their inscribers or of the deceased in comparable ways. More likely, however, the distinct placements of menorah graffiti in Beit Shearim (or in Jason's Tomb)—mostly inside archways and common walls of burial halls—, suggest a different, if complementary, purpose.[147] As Margaret Williams has argued, they may serve some sort of ritual or apotropaic function, if not something else entirely.[148]

What about carvings of animals, which occasionally appear around doorways and on doorjambs, such as those on the northwest and southeast jambs of Catacomb 12 and even in a composite scene in the back of Catacomb 4? Their common locations (on doorjambs and around doorways) remain equally telling. Regional traditions of emplacing statues and pictures of humans and animals at the entrances to burial rooms, after

all, are longstanding. In the Hellenistic tombs of Maresha in the Judean foothills, a detailed image of Kerberus—described in Greek literature as the multi-headed guard dog of the underworld—was painted vividly on the right doorjamb of the entrance to Tomb I.[149] In earlier periods on Egyptian tombs, paintings, reliefs, and statues of sentinels were often positioned similarly beside and around entrances to catacombs, presumably to protect them from raiders and robbers. In later periods, however, in Alexandrian catacombs like Moustafa Pascha, statues of composite creatures, such as sphinxes, flanked individual loculi; in the nearby catacombs of Kom al-Shuqafa, paintings of snakes were similarly positioned.[150] Zoomorphic carvings in Beit Shearim might reflect the stylistic or decorative whims of their artists. Their consistent presence around doorways and doorjambs, however, suggests some degree of patterning and architectural significance. Visitors at Beit Shearim might have drawn animals, in these specific places, to designate the presence of guardians of some kind; these drawings, in such a way, might have functioned much like sculptures and paintings of animals and creatures around doorways of regional catacombs in Hellenistic Maresha and Alexandria. The abundance of regional analogues for these types of drawings is a significant feature, but explanations for associated practices remain speculative.

RABBINICAL MARKINGS AND ARCHAEOLOGICAL GRAFFITI

The argument above suggests that a spatial and comparative reading of graffiti from Beit Shearim offers new and substantive information about activities Jews and their neighbors conducted in burial caves throughout the Levant and northern Egypt. Many questions, of course, remain unanswered and many graffiti resist facile interpretation. Patterns in many graffiti deposits, nonetheless, largely and significantly demonstrate inscribers' participation in regionally common systems of mortuary writing and marking. Graffiti, unlike other features of burial spaces, document how visitors to burial caves (at Beit Shearim and elsewhere) moved through, manipulated, and engaged with their mortuary environments; these documented actions resemble those of their Jewish and non-Jewish predecessors and contemporaries in regions nearby. Visitors used paint, carbon, or sharp objects to apply ranges of sentiments and pictures around entrances, tombs, and doorways of the Beit Shearim necropolis, just as did others in smaller burial caves in regions along the eastern and southern Mediterranean littoral.

But if one were to adopt a functionalist perspective, one might ask what, ultimately, was the point of such behaviors? How did inscribers understand their activities? Did they believe that acts of writing and drawing graffiti could "do something" for them, for their audiences, or for the dead them-

selves? Ancient beliefs about associated behaviors are as elusive as they are varied. They also necessarily diverged according to individual proclivity, period, region, and cultural context. Visitors who applied identical types of graffiti to similar places in a burial cave, for example, might have explained their actions and efficacy in entirely different ways. Still, patterns in the contents and distribution of writings and pictures, in a limited number of cases, suggest some broader and consistent functions.

Inscribers, from the outset, appear to have carved and painted some graffiti to communicate with the dead directly and to comfort them. Several of the examples discussed above bespeak such efforts. The graffiti at the mouth of Catacomb 20 demonstrate this most clearly. Acts of carving wishes for the dead to "Be of good courage!" and experience "Good luck!" on their resurrection suggest that, to some degree, inscribers wished to convey messages to the deceased to temper the harsh realities of the cold tombs beyond. But did inscribers believe that their writings could communicate directly with the deceased? Perhaps, as messages about resurrection suggest, inscribers believed that the dead would be sentient for some length of time after their decease, in order for such messages to impact their target audiences (the dead).

In several additional cases, inscribers might have applied graffiti to protect the dead. Paintings of curses, directly around and inside of graves, explicitly demonstrate the intensity of visitors' desires to use acts of writing to protect tombs and the bones within them. Acts of writing that threatened potential tomb robbers with divine wrath surely exemplify this commitment. And applications of pictorial elements might reflect similar rationales. Visitors to tombs in Beit Shearim and the Shefelah, for instance, might have scratched armed human figures around graves, *not* to represent the occupations of the dead (as some have argued in the past), but rather, to serve prophylactic functions: to represent sentinels who might defend, in some sense, tombs and their contents from human or demonic intruders.[151] Drawing other types of images in specific places may betray artists' efforts to protect tombs in complementary ways: emplacements of skeletal figures inside of graves, or of animals around doorways, could exemplify related desires. Their artists might have believed that such figures offered greater protection to the dead than verbal curses might—even illiterate demons or tomb robbers could understand the threats implied by their presence.

Carvings of ships, positioned so close to the bodies of the dead, might be read with similar factors in mind. Perhaps individuals scratched various types of seafaring vessels around particular graves to suggest a means to transport the dead to the underworld (according to Egyptian or Greco-Roman notions), or to signify, as rabbinic texts suggest, that those entombed nearby had recently completed their final voyage of life. Regardless of the

precise interpretation of these images, their consistent presence upon graves throughout Beit Shearim demonstrates their normativity and significance in memorializing the lives and spaces of the deceased.

In these and additional instances, acts of writing graffiti reflect inscribers' demonstrations of agency, as well as their potential engagements with acts of ritual power. Some Jews and their contemporaries, for instance, also deposited inscribed lamellae and other objects into graves and beneath thresholds in Roman Palestine, Egypt, and Mesopotamia (among other places), because they believed that the gods their imprecations conjured resided in such places and could be more directly manipulated there.[152] Such practices might explain some of the most abstract markings of abecedaries, X and V markings, and grid shapes, which commonly appear beside tombs and in passageways in Beit Shearim, Bethphage, and the Shefelah. Grid shapes, in particular, resemble images painted onto the bases of Babylonian incantation bowls, on which net shapes commonly appear in isolation and often serve to visually "trap" demons.[153] Despite the risk of essentializing such images, it remains possible that drawing nets graveside might have fulfilled similar functions for their creators, whether to protect the dead from possible intruders, or, simultaneously (in trapping demons, ghosts, et al.), to represent a means to keep the spirits of the dead inside their tombs and away from the living. In complement, the consistent presence of small abecedaries, so-called nonsense and retrograde inscriptions, repetitions of *shalom*, and even menorahs, specifically around doorways and passageways, remains equally suggestive of engagement with acts of ritual power and manipulation. Perhaps acts of writing these particular words, letter combinations, and images, and depositing them in these specific and liminal locations, betray inscribers' comparable efforts to exert their agency to protect and manipulate the spaces of the dead. Attention to the spatiality of such markings reveals different ways in which acts of carving could have served simultaneously as enactments of ritual agency and power.

Other features of the archaeological and literary record suggest that visitors might have wished to commemorate their visits to tombs by permanently altering them. Carvings of lines, and X and V symbols, appear more abstract to scholars than symbols of definitive cultural association, such as menorahs or crosses. Perhaps, in some instances, these served as non-verbal markers of individuals' visits. Incising an X or a V, in such cases, could have functioned much like lighting candles beside graves, or placing rocks on a headstone when visiting modern cemeteries; these activities could serve, even in basic ways, to document an individual's visit for other commemorators or the dead to witness. Alternatively, or in complement, they might have served as signals of magical praxis, or as a means of beautification, as discussed above.

In other cases, inscribers might have applied graffiti to benefit the living, as well as the dead. Pictorial graffiti around cave entrances, whether in Beit Shearim or elsewhere, might have served such a function. Visitors might have drawn individual images, such as obelisks, *nefašot* and steles, or compound scenes that included architectural and skeletal images, to create spatial boundaries by labeling surrounding spaces as belonging to the deceased. Visitors with broad or basic ranges of literacy might have understood the mortuary sentiments written around tomb entrances, but graphic markers might have been even more effective for others less skilled at recognizing letters or words, who might have unwittingly traversed the surrounding spaces.

Why would such boundary-marking activities be necessary? Rabbinic texts occasionally speak of activities, such as prayer, or the wearing of particular prayer garments, which are forbidden in mortuary environments (*b. Ber.* 18a). Much like images of skulls and crossbones on a poison bottle, then, these texts and pictures around entrances might have served as warnings to passersby—either to prevent them from entering the cave, or, alternatively, to warn them to take care, because certain behaviors were considered inappropriate (or selectively appropriate!) to conduct around and among the dead beyond (cf. *b. Ber.* 18b; *b. Ta'an.* 16a).[154] In this way, the emplacement of such graffiti could have served much like boundary stones in Hellenistic and Roman contexts—to help differentiate the spaces and activities suitable for conduct within from those better suited for conduct without.[155]

These observations, in turn, might better illuminate some rabbinic texts, whose contents are otherwise overlooked in broader discussions of Jewish mortuary customs in the Levant and elsewhere. For example, several passages of the Babylonian Talmud prescribe or describe acts of marking (using the verb *lĕṣyyēn*) around the spaces of the dead (e.g., *b. Mo'ed Qaṭ* 5a).[156] Certain of these are aggadic texts, such as one from *Baba Meṣi'a*, which describes how Resh Laqish used to mark off (burial) caves of the rabbis (*b. B. Meṣ.* 85b). Another passage, from *Baba Batra*, states that R. Bana'ah also adorned the tombs of the righteous dead (*b. B. Bat.* 58a). Such texts are obscure and somewhat opaque, embedded in broader discussions of the strange and mystical visions that concern the spirits of the dead. Consideration of the archaeological record, in the form of graffiti, however, might inspire different readings of these passages. Perhaps, by marking tombs, Resh Laqish and R. Bana'ah were performing otherwise unrecognized activities, which many of their peers would have found to be entirely conventional—at least in Roman Palestine, Syria, Arabia, Egypt, Italy, or Malta (and perhaps even in Mesopotamia, where these particular texts were redacted). These two, like their Jewish and non-Jewish neighbors, might have marked and decorated burial caves with graffiti as a means to communicate with, care for, venerate, and commemorate, let alone delimit the spaces of the deceased.

Ultimately, we can use this information, collectively, to push our hypotheses about graffiti a bit further—to speculate about their authors' ranges of beliefs about death, the dead, their spaces, and the afterlife. Writings from Catacombs 12 and 20 offer significant information to conjecture about inscribers' beliefs in the afterlife and their notions about the state of the recently deceased. By ascribing to the Divine the epithet "He who promises to resurrect the dead" (Catacomb 12), or by wishing someone luck during resurrection (Catacomb 20), inscribers express their credence in some form of life after death. What is neither clear nor explicit in such texts, however, is exactly what such an afterlife or resurrection might entail. Were all of the dead expected to be resurrected, or only a select few, such as the *hosioi* (holy ones) heralded by another graffito nearby? Would people be reborn after death, or would they rise, or be reconstituted from the grave (cf. Isa 26:19; Dan 12; *b. Ber.* 58b)? And what would one's afterlife look like? Rabbinic texts variously describe the qualities of those eligible to enter "the world to come" following their demises (whether all the dead were eligible, only the pious, or any combination of the two).[157] While graffiti cannot be understood to reflect consistent positions on these subjects, some examples attest to writers' general beliefs in the process of resurrection and, perhaps, in an associated afterlife.

These patterns suggest a related point—a sense that the dead might have benefited directly from the actions (acts of carving and painting) of the living. Select rabbinic texts imply that acts conducted by the living (including reciting blessings, such as the *qaddish* prayer, in later periods), could benefit the deceased in substantive ways.[158] Offers of good wishes in textual graffiti, inscriptions of curses or drawings to scare away tomb robbers, carving ships, or emplacing menorahs around catacomb passageways might have been viewed, in some capacity, as a means to exact writers' agency to assist the dead in related ways.

Contribution of Graffiti at Beit Shearim and Beyond

Attention to graffiti evidence from burial caves suggests that some ancient Jews and their neighbors commonly and diachronically visited and elaborated the interiors of cemeteries after they had completed activities of burial and interment. At minimum, closer evaluation reveals that graffiti from Beit Shearim were not haphazard, as Mazar once claimed: incising and painting mortuary graffiti offered a proper and systematic means for the living to engage with the spaces associated with the deceased. Renewed considerations of the contents and placements of these markings and comparisons with regional analogues demonstrate distinct ways that commemorators might have used graffiti to offer comfort and emotional support to the dead, to physically protect and provide for them, to demarcate their spaces, and

to register their own visits to the deceased. Consideration of graffiti as a pervasive practice draws attention to the predictability of the markings and the complex cultural dynamics that informed their applications.

Graffiti, most importantly, offer rare and tangible evidence, seemingly absent from the literary record, for specific activities that individuals performed when they *visited* and *participated* in the houses of the dead after they had completed those related to burial and interment. However static the homes of the dead were, their surfaces offered endless opportunities for commemorators' personalization, redecoration, and spatial modification.

When regarded from this vantage, evidence from graffiti, perhaps surprisingly, contributes to broader debates about rabbinic culture and the demography of burial communities at Beit Shearim—one of the most significant cemeteries of the period. For decades, scholars have attempted to determine the nature of rabbinic populations who buried their dead in the complex, speculating about the relationships between the rabbis' local epitaphs and those whose arguments remain embedded in the treatises of the Mishnah and Talmuds. Attention to graffiti evidence, however, offers additional data for associated considerations, particularly in relation to attitudes toward burial spaces, espoused in some rabbinic texts.

Despite many inconsistencies in the details of presentation, for example, rabbinic texts generally discourage unnecessary interactions with the dead or their homes. Several explanations might account for this.[159] First, rabbis elaborate on biblical texts, which describe physical contact with graves and corpses as sources of unwanted *tum'ah*: this is why their texts imply that those of priestly lineage (*Kohanim*) and Nazirites, in particular, were to avoid them (*m. 'Ohal* 1.1–2:4; *b. 'Erub.* 26b).[160] Some rabbis and their contemporaries, moreover, understood cemeteries to be places where the dead might linger, in ghost-like form; such ghosts could be powerful and cause mischief among the living (*b. Ber.* 18b).[161] Cemeteries, in rabbinic sources, are at best described as places of neutral association; and at worst, they are places inhabited by ghosts or demons, and which might confer degrees of contagion to some of their visitors (*m. 'Ohal.* 1:7).

But those who commemorated the dead at Beit Shearim and elsewhere surely did spend time with the dead, certainly beyond the timeframe associated with most funerals. We know this best from graffiti; visitors took time to complete many of their carvings. The care taken to carve more extensive texts and images, such as elaborate birds (figure 2.9), ships (figures 2.7; 2.15), and human figures (figure 2.10), suggests that despite rabbinic discouragements against spending excessive time in places that might facilitate corpse contact, some Jews, like their neighbors, spent protracted periods in the caves to create their works of writing and picture-making.[162] Other graffiti, carved directly inside graves, such as those found in Catacombs 1, 4, and 25, reinforce this point—their

applications would have required standing inside or upon graves to do so (even if the graves were not yet in use). Graffiti thus reflect extensive practices, otherwise obscure in textual sources, whereby Jews used acts of writing and drawing to engage spatially and corporeally with the houses and remains of the deceased. Some rabbis, who engaged in Talmudic cultures, might have participated in such activities (*b. B. Meṣ.* 85b; *b. B. Bat.* 58a; *b. Moʿed Qaṭ.* 5a), while others, who denigrated spaces associated with the dead, might have avoided them. In any case, some Jews, just like their neighbors, engaged in such practices, whether or not they were directly associated with Talmudic rabbinic traditions. While excavators and historians commonly use rabbinic texts as frameworks to interpret the contemporaneous archaeological record, the treatment above thus advocates an opposite approach—the independent and contextual evaluation of multiple features of the archaeological record, which, in turn, facilitates a rereading and reinterpretation of ancient rabbinic discussions of Jewish mortuary beliefs and practices.

Juxtaposed analyses of additional evidence for burial and commemorative practices at the cemetery, moreover, can more productively illuminate features of the catacombs' demography—another well-discussed feature of the necropolis. To this point, for example, inscriptional evidence from epitaphs has justified scholars' speculations about the role of Beit Shearim as a cross-regional or international cemetery, which attracted individuals from urban centers like Beirut, Syrian Antioch, and Palmyra. Closer resemblances between Beit Shearim graffiti and analogues found in caves of Jewish and non-Jewish association farther south in Jerusalem, the Shefelah, and Hellenistic and Roman Alexandria, however, as demonstrated above, suggest greater cultural and perhaps demographic continuities with more southern regions of the Mediterranean littoral. While graffiti cannot directly resolve debates about the coalescence and erratic ascendancy of rabbinic populations in late ancient Palestine, or about the historical origins of the Beit Shearim dead, patterns in the content, iconography, and placement of graffiti emphatically suggest that the vast majority of those who used graffiti to commemorate their dead at Beit Shearim did so in regionally conventional ways.[163] Attention to old information traditionally overlooked in scholarly debates, like ancient graffiti, thus offers a new means to discuss the cultural habits of the populations throughout the eastern Mediterranean.

Levantine populations of Jews and non-Jews repurposed household objects, such as nails and pots of ochre, or natural objects, such as sticks, stones, or charred wood, to scratch or paint whatever words or images were considered attractive, appropriate, or essential to improve the conditions of the dead and the living inside and around mortuary spaces. Attention to these mundane acts in Beit Shearim highlights how ubiquitous compa-

rable practices in mortuary contexts were elsewhere in Judaea, Palestine, Egypt, Syria, and regions farther west. Deeper consideration of the ranges of these activities thereby contributes to ongoing studies of daily life and activities practiced in Roman and Byzantine Palestine and elsewhere in the late ancient Mediterranean.

If we travel, once again, to Marie Laveau's tomb, forward in time and eleven thousand kilometers distant, we arrive in a different place than where we began our story. In St. Louis Cemetery No. 1 in New Orleans, visitors to Laveau's tomb continue to perform ongoing acts of bodily manipulation, gift giving, and verbal utterances, which activate the words and pictures they draw around her grave. But we now realize how critical is the information gleaned from oral accounts, anthropological studies, and newspaper articles, to vivify associated activities of drawing and writing, let alone explain their relationships to neighboring deposits of lipstick vials, pieces of rotting fruit, and Mardi Gras beads. At Beit Shearim and elsewhere, we are missing these types of information, which might otherwise contextualize graffiti writing, as it originally related to a host of additional behaviors, for which little evidence remains. Marie Laveau's tomb, therefore, remains as useful to "think with" as does the Church of the Holy Sepulchre in the previous chapter. Awareness and observation of associated traditions help us imagine the types of bodily and verbal activities, as well as those of gift giving, which once might have accompanied, explained, and perhaps activated the messages and drawings visitors applied to cemetery walls—whether in New Orleans, Beit Shearim, the Shefelah, Alexandria, or Abila. This analysis thus draws attention to pieces of a lost story—of which only traces remain—a tale of how Levantine Jews and their neighbors, much like their modern Louisianan counterparts, consistently and deliberately used acts of writing and drawing to adorn, protect, venerate, gain advantage from, and delimit the spaces of their departed and beloved dead.

CHAPTER THREE

Making One's Mark in a Pagan and Christian World

Most Jews were demographic minorities in late antiquity—whether they inhabited Roman and Byzantine Palestine, Egypt and North Africa, Asia Minor, Syria, Greece, Malta, or Italy.[1] But while Jews' pagan and Christian neighbors sometimes ate different foods, worshipped other gods, and practiced distinct rites of passage, they often spoke and wrote in the same languages, named their children similarly, lived in identically designed houses, shopped in the same markets, bathed in the same bathhouses, and shared common political aspirations and senses of aesthetics.[2] Why, then, do historians continuously struggle to understand how Jews in the diaspora operated within, rather than outside, their surrounding societies?[3] First, because authors and editors of ancient rabbinic, pagan, and Christian literary sources, on whose writings historians rely, possess vested interests in magnifying and reifying divisions between Jews and their peers and in portraying contemporaneous Jewish populations as those who stand (or should stand) apart.[4] Archaeological evidence, by default, ossifies similar biases toward Jewish cultural separation. Scholars can associate inscriptions, objects, and buildings with ancient Jews only if they are regionally unusual in some way, if they bear diagnostic symbols (such as a menorah) or vocabulary (including biblical names or honorific titles), or are found in distinct groupings or spatial contexts (such as synagogues or cemeteries). Examinations of selective data, as well as residual scholarly expectations about Jewish difference, ensure that regionally typical evidence resists identification with potentially Jewish owners and commissioners.

Graffiti from public spaces, however, preserve rare evidence for investigating how Jewish populations engaged directly with their pagan and Christian neighbors. Unlike graffiti deposited in more secluded spaces, such as those reviewed in previous chapters, most examples discussed below were carved boldly into civic buildings in Asia Minor and along the Syrian littoral. Hundreds and thousands of people once visited surrounding structures (theatres, public assembly halls, and hippodromes) for multiple reasons, including civic engagement, entertainment, and commerce. When Jews and their neighbors inscribed graffiti in these places, I suggest, they activated their participation in public spectacles and public life.[5] While scholars used to debate whether Jews attended entertainments in the Greco-Roman world, including the theatre, dramatic and gladiatorial competitions, or horse races, graffiti in this chapter (among other types of data) incontrovertibly demonstrate that they did so.[6] More than this, however, these markings reveal that during periods of burgeoning anti-Jewish legislation and religious polemic, Jews reserved seats for themselves as spectators of public entertainments and drew menorahs where they sold their wares in public markets. They even attest to the presence of Jewish women in commercial settings. Graffiti that boast selective markers of Jewish difference thus demonstrate how interconnected were the spatial and cultural dimensions of Jewish life in Hellenistic, Roman, and Byzantine urban landscapes.[7]

Theories about everyday practice highlight the multiple ways in which graffiti serve as indices of urban engagement. Michel de Certeau's arguments about the "'enunciative' function[s]" of pedestrian and speech-acts, for example, help to highlight different ways in which acts of carving graffiti in public settings constituted strident acts of civic appropriation.[8] By writing diagnostic terms and symbols on theatres and hippodromes (including words such as *Ioudaioi* and, in later periods, *Hebraioi*, as well as images of menorahs), Jews asserted their presence in civic contexts and thereby staked claims to small pieces of public property. Their acts of non-monumental writing and decoration are spatially determined, moreover, and thus document their writers' agency and modes of "activation": by carving names and symbols into theatre seats, Jews adopted active roles as agents—as both participants in public entertainments and shapers of public architecture.[9] Such participatory acts of marking, in turn, reflected, reinforced, and created additional relationships between writers and their surroundings (including civic architecture and decoration, neighboring spectators and graffiti writers, and the spectacles they beheld). Theories about daily life, practice, and image-production, while grounded in early twentieth-century models of activity, display, and performativity, thus inspire new and relevant insights for understanding Jews' modes of social engagement in the public sphere.

Additional emphasis on the public nature of these graffiti, at first glance, might appear unnecessarily polarizing, because it presumes the existence of antithetical categories of markings and spaces (such as "private" ones). In previous chapters, moreover, such oppositional categories of "public" versus "private" were of little analytical use: while individuals carved graffiti into structures, such as synagogues, sanctuaries, or cemeteries for others to see (thus making them seemingly, but not exactly, public), their audiences were often selective (thus making the surrounding spaces, seemingly, but not exactly, private). Yet the category of "public" is a useful heuristic in this chapter, because the graffiti reviewed here are somewhat different in one particular respect: most adorned civic spaces and structures, built by municipalities, using common and donated monies. Thousands of people from all spectra of society—from the most renowned of local elites to the lowest of slaves—traversed thresholds of associated structures.[10] Here, therefore, the term "public" has a technical and context-specific sense: it designates graffiti carved into features of broadly accessible and well-populated features of civic and urban landscapes.

Designation of the context of certain markings as "public," of course, cannot completely illuminate their audiences' understandings of them. For instance, displayed writings and symbols, however explicit their contents might appear to modern eyes, often retain esoteric or encoded meanings, which are discernible only to particular viewers, but which the majority of contemporaneous observers might miss or interpret differently. The term (public), nonetheless, helps to isolate distinct spatial, architectural, and cultural contexts in which some Jewish inscribers and their peers used markings to identify themselves boldly among their neighbors. Enhanced attention to the open locations of these graffiti and to the diversity of their expressions and audiences, then, offers new insights into how Jewish populations throughout the Roman East used acts of writing and decoration to enunciate their presence in urban landscapes—among Jews and non-Jews alike.

Asia Minor, broadly described, offers an optimal canvas for this examination, as it retains some of the richest archaeological and literary evidence associated with ancient Jews. Many associated data are monumental and include the architectural remains of synagogues and donor inscriptions. Vestiges of certain synagogues have yielded particularly productive studies: considerations of the urban context, and architectural and decorative elements of the Sardis synagogue, for example, influence most scholarly treatments of ancient synagogues and their development, let alone specific considerations of Jews across regions of Asia Minor.[11] Attention to naming patterns, titles, and language use in donor inscriptions for Jews and "Godfearers" (*theosebeis*) in Sardis, Aphrodisias, and elsewhere, also informs ongoing arguments about regional Jews, their cultural cohesion, their social and legal status, and the potential attractiveness of their cus-

toms to their pagan and Christian counterparts.[12] Recently edited collections of epitaphs and donor inscriptions, which include extensive records for women's involvement with Jewish communities, furthermore, inspire important studies of gender and organizational practices in early Judaism, particularly in the east.[13] In multiple ways, the richness of archaeological and epigraphic records from Asia Minor (in terms of volume, quality, and distribution) thus demonstrates what is most lacking in evidence for Jews from many other parts of the ancient world.

A rich and diachronic literary record that documents regional Jews, in certain respects, matches the abundance of available archaeological remains. No works of regional Jewish writers are preserved. But Christian texts that chronicle Paul's missions and interactions with Jews throughout Asia Minor, and Melito's ardent accusations against Jews, are followed, centuries later, by promulgations of aggressive and prolific legal restrictions against Jews in the codes of Theodosian and Justinian.[14] Such sources collectively document the diachronic presence and potential influence of Jews throughout the region.[15] As some scholars have argued, the sheer volume and vehemence of these polemical writings may indeed suggest a Jewish demographic prominence in Asia Minor and its environs to degrees unrivalled by Jews elsewhere in the Mediterranean.[16] Nonetheless, most available pagan or Christian texts pose significant challenges for historians: as many scholars have detailed painstakingly, their fiery portrayals of regional Jewish populations and the stiffness of their legal regulations, which represent Jews as ubiquitous and their activities as pernicious, necessarily complicate evaluations of more neutral historical "facts" about them.[17] The ensuing trove of archaeological and literary evidence, nonetheless, justifiably encourages a particular concentration of scholarship about Jewish populations in Asia Minor, which focuses on the relationships between local Jews and their pagan and Christian neighbors.

Partly due to the attention garnered by all Jewish materials from Asia Minor and the ongoing excavations of specific archaeological sites, such as Miletos, Sardis, and Aphrodisias, many examples of the graffiti examined here have been selectively discussed in other contexts by several scholars, which include, among others, P. W. van der Horst and Tessa Rajak (Miletos and Sardis); Angelos Chaniotis, Charlotte Rouché, Joyce Reynolds, Robert Tannenbaum, and Margaret Williams (Aphrodisias); John Crawford, Keir Hammer, and Michele Murray (Sardis); Walter Ameling, David Noy, and Hanswulf Bloedhorn (cross-regional treatments of inscriptions); as well as Phil Harland and Paul Trebilco.[18] One might wonder, then, about the wisdom or necessity of incorporating these materials here. Concentrated analyses of public graffiti from Asia Minor and integration of comparable examples from the Syrian littoral, I suggest, offer important and distinct complements to preexisting scholarship—both to considerations of Jewish populations throughout Asia Minor and to broader and preceding discussions

of graffiti associated with Jews from elsewhere in the Mediterranean. By drawing attention to the diverse contexts and contents of regional graffiti, this chapter vivifies public aspects of Jewish life, including Jews' collective and individual engagements with local modes of entertainment, civility (in a technical sense), and commerce, in ways that other types of studies of identical materials cannot.

Regional demographic patterns and cultures, of course, varied significantly throughout Asia Minor (Aphrodisias, Miletos, and Sardis) and the Syrian littoral (Tyre), in cities that, during periods of Hellenistic, Roman, and early Byzantine hegemony, sustained distinct and proud local traditions, erratic patterns of conquest, different writing and language customs, and variable cultural and political dynamics. Evidence likewise suggests that relationships shifted significantly between Jews and their neighbors through-out these regions and periods; so too did local gender practices. These differences, often elusive, cannot and should not be overlooked. Rather than eliding social, religious, and political variegation within and between these towns and cities, then, attention to the spaces and manners of Jews' public graffiti writing offers a significant and rare means to chronicle, both diachronically and cross-regionally, the diversity of Jewish participation in the urban landscapes of the Mediterranean East.[19]

THE THEATRE

The earliest datable examples of graffiti associated with Jews in civic spaces in Asia Minor were discovered inside the theatre in Miletos in western Anatolia. Founded as a Greek city on the Meander River in Ionia, Miletos had sustained a history of prominence and conquest well before Alexander the Great and his successors overtook the region. Rome's seizure of the city in 133 BCE precipitated the renewal of its urban landscape, including a restructuring of its harbor, construction of a theatre, and the establishment of a *Via Sacra*, leading from Miletos to Didyma and its famed Apollo temple. Miletos sustained syntheses of local, Hellenistic, and Roman customs, and likely retained the official designation of *metropolis* well into the late ancient period.[20]

Jewish presence in the city may date from earlier centuries, but appears well established by periods of Roman hegemony. Josephus ascribes to P. Servilius Galba the declaration that Jews in Miletos should be assured protection to observe their ancestral customs (*A. J.* 14:244–246).[21] The precise impetus for the decree, sometime in the middle of the first century BCE, remains unknown, but may relate to preliminary attacks or encroach-ments by Milesians on local Jewish populations.[22] Paul's meeting in Miletos with members of the Ephesian Church during his third missionary journey,

moreover, suggests an increasingly complex religious landscape by the first and second centuries CE (Acts 20:16–38), which may have included followers of the Jesus Movement as well as Jews. The city appears to have particularly flourished until the third century, while local persecution of Christians in the fourth century accompanied its decline, which was well assured by the Byzantine period.

Of the archaeological remains from the city, only the theatre bears clear evidence of a Jewish presence. Archaeologists date most activities in the Milesian theatre, including those performed by Jews, to the second and third centuries CE, during periods of heightened urban activity. Clusters of textual graffiti that served as seat labels, which spectators etched deeply into the tops of the theatre seats, conventionally follow this dating. The first example, discovered in the fourth row from the bottom of the theatre, reads in Greek script: "*topos Eioudeōn tōn kai Theo⌜s⌝ ebion.*" The text is clear, even if the syntax is ambiguous: it is variously translated as "the (seating) place of Jews, who (are also known as) the ones who fear God," or as "the (seating) place both of the Jews and of the Godfearer(s)" (figure 3.1).[23] While this graffito has garnered the most attention, others, potentially related to the first, include a word incised in the same section and one row behind the previous text, which reads, "*The[os?]ebion*" ("Godfearers").[24] Still another graffito, carved farther from this cluster in between rows five and six, is conventionally restored to announce: "[the seats] of the Jews of/for the Blues" (*"Benetōn EIO.EŌN"*).[25]

Other corporations or guilds also inscribed seats nearby to reserve spaces for themselves. The "emperor-loving goldsmiths," for example, claimed a cluster of theatre seats close to those of the Jews, while the "friends of the Augusti" carved their titles upon special benches positioned in the front of the theatre.[26] While the "goldsmiths" may have participated in a type of professional association or *collegium*, the friends of the Augusti, similarly boastful of their imperial affections, might have occupied some sort of civic or elected office.[27]

Closer examination reveals why these seat reservations were more likely non-monumental than commissioned by the municipality. Contemporaneous dedicatory inscriptions displayed elsewhere in the theatre are placed differently; their contents and paleography remain distinctive. Members of the nominated groups, or scribes they had specifically commissioned for the purpose, most likely took matters into their own hands to stake claim to pieces of public property: they labeled their seats directly and for their own purposes and uses.

In several respects, then, the seat labels of Jews (*Eioudeōn*) from Miletos resemble the writings of neighboring groups, who also carved reservations for their constituents nearby. These similarities, in turn, support several conclusions about Milesian Jews and their places in the theatre. Foremost,

FIGURE 3.1. Seat inscription of Jews and Godfearers
from the theatre of Miletos, Turkey; date of photo
unknown. Photo courtesy of Phil Harland.

it appears that Jews in Miletos, just as did their peers, visited the theatre
with sufficient regularity to merit their reservation of multiple and adjacent
seating sections for their convocation. Regular theatre attendance, at a basic
level, thus exemplifies a tangible way in which Jews engaged directly with
their Milesian neighbors. But this point has broader cultural implications: it
suggests that Jews, just as their neighbors, could, to some degree, appreciate
the theatrical displays they witnessed below, including staged pantomimes,
oratory, and dramatic competitions, which often depicted the tribulations
of pagan gods and heroes. Occasions for these theatrical events included
religious festivals, acts to honor Roman emperors, as well as individuals'
impulses to display their largesse to the public (through patronage of indi-
vidual events).[28] However common were associated modes of diversion in
the urban world of the Roman East, their appreciation required audiences
(and local Jews among them!) to fundamentally understand and engage
in their cultural forms. Only direct acquaintance with local and regional
legends, customs of worship, theological beliefs and traditions, and subtle
and culturally embedded dynamics of pathos and humor could facilitate
this.[29] Consistent findings of evidence for Jewish presence in the theatre,
then, attest to degrees of Jewish social engagement in the civic activities
of Miletos, Jews' involvement in broader features of pagan society, and, by
extension, their occasional tolerance of and participation in cultic aspects
of popular entertainments—all publically exhibited.

The locations of the Jews' seat-graffiti, furthermore, suggest additional
and important information about the status of Jews as spectators in the
theatre and in Milesian society more broadly. As Charlotte Rouché has

described, theatres in Asia Minor, by the third century, also served as types of "showplace[s]"—locations for spectators to display modes of social, political, or professional solidarity.[30] Nomination of Jewish groups in seat labels suggests that Jews sat together when they visited the theatre, as did others who pursued common professions and incorporated themselves into *collegia* (associations), such as the local goldsmiths.[31] The precise reasons for adhering to specific social groupings at the theatre ultimately remain elusive. Jews could have sat together for protection, but local analogy suggests that they may have done so for other reasons, including fellowship, social solidarity, or as one form of collective civic participation.

The precise location of these graffiti, moreover, retains additional significance. With the assumption that more esteemed spectators sat closest to the stage, some have argued that the proximity of the Jews' seat inscriptions to the front of the theatre (fourth, fifth, and sixth rows) implies that Jews enjoyed degrees of elevated status and prestige among their Milesian neighbors. Otherwise, they would have been shunted farther back in the stands.[32] Indeed, the prominent position of the graffiti in relation to the stage, paired with the similarity of the content, appearance, and location of Jews' seat inscriptions to those of other local corporations, suggests that the Jews of Miletos were sufficiently comfortable, if not established in their surroundings, to conspicuously assert their collective presence in the theatre, both among other Jews and other inhabitants of Miletos.

By inscribing seat inscriptions and by sitting as collectives, both Jews and their neighbors were not passive observers in the life of the theatre. While they necessarily beheld entertainments, they also engaged in them. After all, both performers and spectators competed when they participated in public entertainments. When organizations (*factiones*) named after colors (including the Blues, Greens, Reds, and Whites), sponsored events in theatres, hippodromes, and public buildings in Miletos and elsewhere in the late Roman and Byzantine East, spectators cheered on performers (chariot racers, actors, orators) to whom they pledged factional allegiance. By advocating for the Blue faction in some of their graffiti, therefore, Milesian Jews took sides in rivalries between the Blue and Green entertainment factions in the theatre, just as their neighbors did.[33] I discuss this point in more depth below. Second, their acts of carving names, let alone factional preferences, into the stone seats of the theatre served enunciative functions: organizations and corporations, including those of local Jews, used non-monumental writing, in the form of seat reservations, as a means of collective expression, which permanently appropriated public property for their selective use.

The presence of Jewish graffiti in the theatre of Miletos cannot single-handedly imply that all Jewish populations throughout Asia Minor regularly enjoyed theatrical entertainments. While some graffiti discovered in the theatre in nearby Aphrodisias reserved seats for corporations, for example,

none of its markings explicitly suggest a corresponding Jewish presence.[34] Seat labels from the theatre of Miletos, nonetheless, can suggest that in one major urban center, if not in more, some Jews attended civic theatrical performances as a corporation, consistently engaged in the agonistic aspects of local entertainment culture, and used writing to document their presence and participation inside civic spaces.[35]

BOULETERION AND ODEON

Aphrodisias, one of the most magnificent cities of ancient Caria, retains the largest number of regional examples of public graffiti associated with Jewish populations. Situated on the Morsynos River, Aphrodisias initially gained renown for its temple to the Greek goddess Aphrodite, whose cult had absorbed the attributes of an older Anatolian goddess of war and fertility.[36] Ongoing excavations at Aphrodisias reveal the complexity of its urban plan, at the center of which were grand public buildings, including multiple marketplaces, a theatre, an Odeon or Bouleterion, a Sebasteion, a stadium, and the eponymous Temple of Aphrodite with its sacred precinct, later converted into a basilica (Map 4).[37] Local traditions of benefaction sustained the construction and renovation of civic structures by the provincial governor and local elites through late antiquity.[38] While Aphrodisias became the capital of Caria by the third century CE and Christian presence is well-attested by the fourth and fifth centuries, the city retained most of its pagan cultural forms through the sixth or seventh centuries CE, when it was renamed Stavropolis, or "City of the Cross."[39]

To this date, no synagogue has been discovered in Aphrodisias. Two monumental steles inscribed with the names of Jews and Godfearers who donated gifts for a local soup kitchen, however, offer some of the most salient, if controversial, information about the elevated economic, social, and legal positions of some Aphrodisian Jews.[40] These dedicatory plaques are well studied and their chronology remains disputed: late ancient dates for their inscriptions remain most likely.[41] In all cases, these significant texts are clearly monumental and meant to be displayed—either in a public/civic context or within a synagogue or analogous structure in Aphrodisias. Analyses of these monumental inscriptions, along with examples of local graffiti, have largely shaped studies of the Jews in Aphrodisias and surrounding regions of Caria.[42]

Graffiti found in civic spaces, nevertheless, comprise the most abundant evidence for Jewish presence in Aphrodisias. Most graffiti from the city, of course, bear little relationship to local Jewish populations. Throughout Aphrodisias, graffiti of diverse genres total in the hundreds and outnumber examples found in most other cities of the Roman East.[43] Their contents

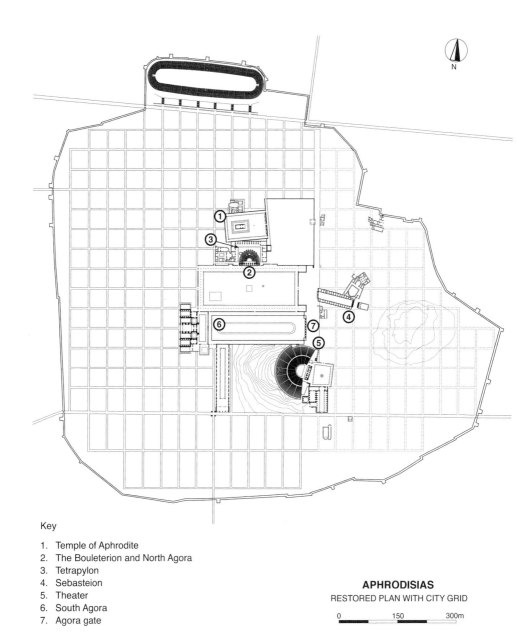

Key

1. Temple of Aphrodite
2. The Bouleterion and North Agora
3. Tetrapylon
4. Sebasteion
5. Theater
6. South Agora
7. Agora gate

APHRODISIAS
RESTORED PLAN WITH CITY GRID

0 150 300m

Map 4. Restored plan of the City of Aphrodisias with the city grid. Reproduced courtesy of N
York University Excavations at Aphrodisias (H. Mark).

range from lewd images and texts to love poems and devotional and symbolic writings. They appear everywhere: in the stadium and markets, around the town hall, inside the Aphrodite temple and theatre.[44] But a percentage of these graffiti, chronicled principally by Reynolds and Tannenbaum, Roueché, and Chaniotis, include words and symbols of Jewish identification.

Several examples of graffiti associated with Jews were discovered inside a covered building jointly identified as the Odeon and a Bouleterion (henceforth, for brevity, the Odeon), a structure which resembles a small theatre, situated on the northern boundary of the civic agora (Map 4).[45] Marble seats were placed throughout the building, which had an open interior plan that was covered in antiquity. The multipurpose public space probably served a number of overlapping functions during its varied three- to five-hundred-year history. In earlier periods, it may have housed public council meetings of the *boulē*, but also competitions of oratory and drama.[46] Changes to the architecture of the space in the middle of the fifth century, combined with a contemporaneous dedicatory inscription that calls the building a *palaestra*, suggest that the building assumed two additional uses in subsequent periods, as both a space for "competitions" (competitive entertainments) and as a "place of training" (in a pedagogical sense).[47] The local *boulē* thus may have continued to convene in the space, but the additional appearance of statuary inside it in the fifth century suggests its supplementary uses as an intellectual gathering place for combined expositions of philosophy, poetry, and rhetoric.[48]

Graffiti discovered throughout the building mostly date to this last phase of use in the fifth through seventh centuries CE, when competitive entertainments and intellectual performances took place inside. Textual and figural markings were discovered throughout different areas of the structure: around the stage, in the portico *post scaenam*, in the *paradoi*, and still others in and around the *cavea,* where additional markers, including letters and abbreviations, were also carved at intervals throughout.[49] The texts that nominate Jews fall exclusively into a category of non-monumental inscriptions,[50] discovered in the area where spectators sat and marked seats, in and around the semicircular seating area, which extends from the "corridor around the rim of the orchestra to an upper corridor."[51] Their inelegant paleography and carving prompted Reynolds to declare them as "poorly cut"; most are carved in different hands, and some appear to be partially reused through reinscription.[52] Just like the analogous inscriptions from Miletos, however, seating labels from the Odeon document ancient seating patterns, because they were discovered in places of their original deposit.[53]

Several graffiti explicitly command the reservation of seats for Jewish spectators (*Hebraioi*) in the Odeon, alongside those who affiliated themselves with them; Reynolds and Chaniotis independently date these texts

to the fifth or sixth centuries. A first cluster of texts appears in Block B of the lower *cavea*. One reads, "*topos Hebreōn* (place of the Jews)" in Row 8,[54] while another, which runs across two seats in Row 5, reads: "*topos neoterō<n>*" (place of the younger men).[55] The latter inscription likely relates to the first, and this connection is treated below. Slightly east of this cluster, in Block D, appear other roughly carved texts, also associated with Jewish populations, which may have been applied in different stages. In Row 6, on a seat, which had been punctured for subsequent plastering, a two-line inscription reads: "Place of the Blues|Of the Jews, the Elders (*paleiōn*)."[56] Irregular paleography and letter spacing suggest that the latter inscription may have been re-carved to accommodate a secondary Jewish constituency (figure 3.2).[57]

Useful comparisons for the Jewish seat inscriptions are lacking, because no other seat reservations from the structure nominate individual groups or corporations. Several others do, however, label seats designated for general supporters of the Blues, who sat together to root for their faction during competitive entertainments. In parallel rows in Block E, one mostly effaced inscription in Row 7 reads the "Place of the Blues" ("*topos Benetōn*") while, in the same row, an additional text similarly designated the "Place of the Blues."[58] Closer to the stage, in Row 5, the inscription, "[.]*benetou*; ([Place] of the Blue [faction])," may be restored to "Of the Blues."[59] Only a final graffito nearby, in Row 9 of the same seating block, includes the symbol of a cross. No textual markings accompany this graffito, but it may mark a place for Christians, who both beheld the spectacles below and, perhaps, supported the Blue faction; most graffiti from this section, including that of the Jews, bear some spatial relationship with the seating reserved by Blue supporters.

Extant graffiti from the structure probably represent a fraction of their original distribution. Blue supporters are disproportionately attested in graffiti, but admirers of competing factions probably once beheld and documented their distinct affiliations on stone seats nearby, even if their markings did not survive. In earlier periods, the Blue and Green factions, alongside the Reds and the Whites, had financed circus contests throughout the Roman East. But by the fifth century, the factions had begun to consolidate and expand their operations to fund other sorts of competitions as well, including theatrical and entertainment contests.[60] Graffiti written by Red supporters were discovered elsewhere in Aphrodisias, while acclamations for and by Green supporters similarly appear in Aphrodisian markets and, in particular, inside the Tetrapylon.[61] One imagines that many graffiti or dipinti from the Odeon were either effaced in antiquity or disappeared through accident, exposure, deliberate removal, or general reuse. The disproportionate documentation of Blue supporters (scarce evidence documents the presence of Green or Red supporters) in the Odeon thus remains difficult to interpret.

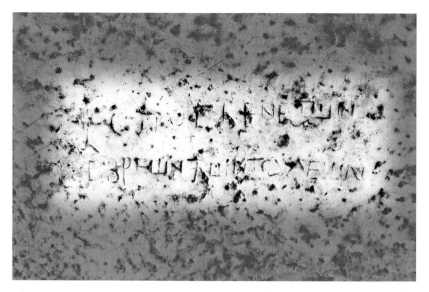

FIGURE 3.2. Seat inscription for the place of the elder Jews from the Bouleterion/Odeon of Aphrodisias, Turkey; August 1999. Photo courtesy of Angelos Chaniotis.

Based on the known seat inscriptions, however, one can hypothesize, to a limited degree, about certain features of spectator culture in the Aphrodisian Odeon. Despite the absence of graffiti from the *cavea* attributed to professional corporations (such as those found in Miletos, or in the local theatre), it appears that several groups, with common unifying traits, chose to sit together to witness local entertainments. Jews were among these groups. Seating clusters, moreover, may have followed more refined social contours; Jews, for example, may have seated themselves according to common age sets; the seat inscription for the *palaioi* (elders) suggests this. And while some have argued that the seat label for the *neoteroi* in Row 5 may simply designate a corporation of youths at Aphrodisias, equivalent to the *neoi* in other Hellenistic and Roman cities, who distinguished themselves as a collective in public contexts. But Roueché argues for a different interpretation: that these "younger men" (*neoteroi*) were counterparts to the elder Jews who identified themselves in markings in Block D. Their graffito would thus signify that younger Jews sat in corresponding places, just three rows behind another explicit *topos* marker for Jews of more advanced ages.[62] The proximity of these seat labels in the *cavea*, the relatively unusual use of the comparative (as opposed to the positive) form of the adjective to describe the younger men, the paucity of other seat designations for other groups, and an analogous inscription from a town nearby, all support Roueché's

reading.[63] Jews, as well as others, might have enjoyed their entertainments surrounded by peers of the same age set.

Contents and placements of the *Hebraioi* inscriptions also suggest that some Jews who visited the Odeon particularly favored the Blue faction. One of the seat labels makes these affections explicit ("*topos Benetōn | Hebraiōn. . . .*"). The remainder of the reservations that nominate Jews, moreover, mark seats in the same sections as those designated for other Blue supporters; these also indirectly indicate Jewish support of the Blue faction. Some scholars have marshaled this evidence from the Odeon, alongside that from the Milesian theatre and the Tyrian hippodrome (as discussed additionally below), to support assertions that ancient Jews throughout the east consistently supported the Blues. Indeed, ancient authors, such as John Malalas, echo these positions—he explicitly describes the Jews as supporters of the Blue faction.[64] While epigraphic evidence from the Odeon remains too partial to support definitive conclusions about the Jews' broader factional allegiances, patterns in inscriptions remain significant in Aphrodisias, where some Jews—of various ages—engaged in the agonistic aspects of local entertainment culture by advocating for the Blue faction.

Most graffiti that Blue supporters carved into the Odeon are likely associated with the presence of pagan and, occasionally, Christian spectators, as well as Jews. This cultural and religious diversity among supporters for a single faction, then, suggests something significant: that while particular populations inside Aphrodisias, such as the Jews, may have collectively thrown their support behind specific factions (such as the Blues), constituencies of factional support could be culturally heterogeneous; pagans, Jews, and, perhaps, Christians, supported identical factions.[65] This mode of factional solidarity is curious, particularly in periods when regional pagan and Christian authors increasingly attest to (and perhaps exacerbated) acrimony between such groups.[66] Still, Jews (both older and younger) felt sufficiently comfortable in public contexts in Aphrodisias, let alone within local entertainment culture, to advertise their participation and presence by scratching their markers into public seats.[67] This demographic diversity may have been absent from the Odeon in earlier periods, but by the fifth through seventh centuries CE, it seems somewhat axiomatic.

Certain features of the Odeon graffiti, then, correspond with those evident in Miletos. Foremost, they demonstrate that local Jews did not try to disappear into crowds of spectators. Aphrodisian Jews, rather, felt sufficiently comfortable to sit exclusively and visibly with each other inside the space—so much so that they sat in groupings according to age, as well as factional preference. Jewish presence, moreover, was presumably sufficiently acceptable to neighboring populations that Jews made their presence known and permanent: they boldly carved their identifications into public property for all to see. Finally, Jewish presence in the Odeon

was likely sufficiently frequent to merit Jews' carvings of permanent *topos* inscriptions into its seats. This reality, in turn, suggests additional correlary hypotheses: first, that Jews' presence in the building might have extended to meetings of the town council which also took place inside it; and that local Jews enjoyed degrees of cultural literacy, which enabled them to appreciate the dynamics of the rhetorical, dramatic, pedagogical, or even athletic contests witnessed below. Jews, then, were both sufficiently comfortable and integrated into their surrounding culture, its politics, its mores, and its dramas, to publically identify themselves, through carved writing, as participants and spectators inside the civic space.

MARKETPLACE AND AGORA

While Jews inscribed textual graffiti in regional entertainment complexes, the majority of markings associated with Jews in public spaces in the Roman East appear in commercial contexts; examples recur in the reused Sebasteion and the so-called South Agora in Aphrodisias (Map 4). The largest concentration of commercial graffiti associated with Jewish populations appears in the Sebasteion—a double colonnaded structure, east of the town center, which was originally built in the first century CE for the veneration of Roman emperors alongside that of the goddess Aphrodite.[68] The original building included two stories, which were lined with marble sculptures in relief that rendered imperial symbols, figures of Roman conquest and conquered peoples, and representations of emperors and gods.[69] Several graffiti in this building are also associated with Jews.

Both Reynolds and Tannenbaum and Chaniotis argue that all graffiti associated with Jewish populations inside the Sebasteion were drawn *after* the transformation of the building in the fourth century CE, when the structure was repurposed as a market and overtaken by traders, who set up shops (*tabernae*) in spaces between its interior columns.[70] The Sebasteion was in commercial use through the seventh century, which allows a roughly 150- to two-hundred-year range of graffiti deposit for Jews and neighboring populations, dated to this second phase of use. Of the eleven graffiti discovered inside the structure, which Chaniotis published and identified with Jewish inscribers, at least nine examples appear to be definitively so, and additional examples have been revealed in subsequent excavations.[71] Most such graffiti render images of menorahs. Several appear in clusters with other types of distinctive iconography.

Carefully carved menorah symbols appear in prominent positions throughout the Sebasteion, on its exterior and interior columns, as well as on its pavement. They assume various sizes (heights and widths of c. 3–22 cm), but most are carved boldly into places easily viewed by passersby.

Menorahs on columns, for example, are often positioned at chest- through eye-heights, facing the center of the structure (c. 1–1.4 m above ground level).[72] Reynolds first identified some of these on the north and south porticos of the building in the 1980s. One menorah appeared on a column of the north portico, while additional images, perhaps including a representation of a shofar, bordered a menorah on a column surrounding a shop in the south portico.[73] Several other examples, published subsequently by Chaniotis, are carved on or around the supporting columns that bounded traders' stalls. Counting from the east colonnade on the east side, a worn incision of a menorah appears on the ninth column of its north portico, while two small "partly erased" menorahs appear on the twelfth column of the north portico. One, 3 cm high, appears at chest-height (60 cm above the ground), close to another menorah of similar size, which was scratched approximately 67 cm above ground level.[74] A menorah adorns the first of the north portico between columns 13 and 14, while still another was scratched closer to eye-height on the west side of the north portico. A human figure accompanies a larger menorah, of 10 cm, placed on the twenty-third column of the west side of the Sebasteion, at around chest- or face-height (1.20 m off the ground), while a similar example, 9 cm high, was carved at the same height above ground on the east side of the twenty-fourth column.[75] Reynolds and Tannenbaum noted the presence of a large menorah, 22 cm high and 1.10 m off the ground on the forty-fifth column of the north portico in an effaced graffiti cluster, containing symbols of 10.5 cm average height. The latter grouping includes a menorah, lulab, and shofar, carved within a flute of the fifteenth column on the east side of the south portico, 1.40 m above the ground (figure 3.3).[76] A final block engraved with several Jewish symbols might have been reused in the Sebastaion, though it is unclear whether the stone was engraved in its primary or secondary stages of use.[77] Chaniotis has concluded that merchants, who sold their wares inside neighboring spaces, drew these graffiti.[78]

Surfaces of the South Agora also bear Jewish symbols, carved in prominent positions. Sometime in the sixth century, a Christian benefactor named Albinus had donated funds to restore the Agora; his donations and deeds are commemorated throughout the structure.[79] Multiple acclamations praised Albinus' works on the interior sides of the upper portions of columns and above their fluting; archaeologists have identified and published related inscriptions from nineteen of the original twenty columns in the Agora.[80] But surrounding two of these texts in a corner of the west portico of the Agora, Chaniotis has also identified two examples of large menorah graffiti, each 17 and 20 cm high, drawn 1.5 meters above the ground.[81] Albinus' pervasive acclamations were placed prominently for the viewing of Agora visitors, and, presumably, artists drew menorah graffiti in the same places as his proclamations for comparable reasons: these were places where their

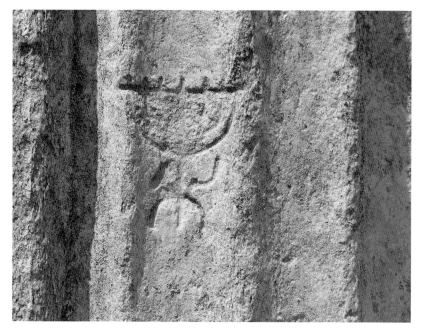

FIGURE 3.3. Menorah carving from the South Portico (Sebasteion) in
Aphrodisias, Turkey; August 1999. Photo courtesy of Angelos Chaniotis.

work would be easily seen by merchants and shoppers inside.[82] Regardless
of whether artists drew menorahs to appropriate the prominent real estate
previously claimed by Albinus' boasts, they applied their markings to be
seen easily by visitors to the structure.

Graffiti associated with Jewish populations, of course, represent only a
fraction of drawings and texts deposited throughout Aphrodisian market
spaces. In the Sebasteion, graffiti of menorahs comprise an unusually high
proportion of the markings still visible inside the building, which also
include love-graffiti and board games. Traces of other dipinti, now lost,
may have adorned many of the plastered surfaces of the inner walls of
the structure.[83] None of the many graffiti in the North Agora, however,
include Jewish symbols. In the South Agora, menorah graffiti appear, but
comprise a dramatic minority of the identified total (<3%) (figure 3.4).[84]
In the latter contexts, by contrast, Christian symbols are most popular.
Several graffiti carved onto columns of the North and South Agora, which
designated the stalls of particular sellers, are also decorated with Latin
crosses. Many of these include so-called *topos* inscriptions on the unfluted
lower or upper portions of columns, which recorded the personal names of

FIGURE 3.4. Menorah carving from the South Agora in Aphrodisias;
August 1999. Photo courtesy of Angelos Chaniotis.

sellers, occasionally their occupations, and sometimes Latin crosses.[85] For example, a graffito on a column base on the "thirteenth column from the west" indicates the place of Callinicus, followed by a cross, while a cross 1.35 cm above a column base precedes an advertisement for the *topos* of Theoctistus.[86] Religious symbols, then, were relatively common in marketplace graffiti from the North and South Agora, but mostly include symbols of Christian identification.

Comparisons of menorah graffiti in commercial environments in Aphrodisias with other regional analogues thus yield several distinct observations. First, unlike graffiti bordered by crosses, none of the menorah graffiti from commercial contexts in Aphrodisias are clearly associated with specific texts or names, whether in the Sebasteion or the South Agora; they all appear in isolation, or alongside other symbols. This pattern contrasts particularly with the majority of graffiti from the South Agora, where crosses frequently accompany *topos* inscriptions. Second, images, such as the menorah, are drawn in visible locations for public viewing. Menorahs and other Jewish symbols were not carved into interior surfaces of *tabernae*, but rather on and around the columns that bounded them. Furthermore, in the Sebasteion and the South Agora, menorah graffiti, like those of crosses, appear between chest- and chin-height; this placement assured their visibility, at eye-level, to building visitors. The physical dimensions of menorah graffiti (their sizes, placement, and prominence) collectively underscore their public nature: their artists drew them large enough that diverse audiences of shoppers and sellers could see them in their prominent locations.

Chaniotis evaluates such patterns to suggest that Jewish vendors carved menorahs in Aphrodisias for the same reasons that their Christian counterparts carved Latin crosses into similar structures; they did so to distinguish their associated spaces for work and trade. Still, it remains curious that, unlike their Christian counterparts, menorah graffiti do not accompany names or *topos* inscriptions, which specifically nominate the vendors in adjacent *tabernae*.[87] One might wonder, then, if the menorahs designated the stalls of unnamed and associated vendors, or whether shoppers, as well as vendors, applied them at will to surrounding public spaces. Additional data from forthcoming excavations might offer more definitive information to clarify these points.[88] Placements and sizes of these graffiti in Aphrodisian marketplaces, in all cases, collectively demonstrate that inscribers of menorahs desired that other shoppers and merchants view their handiwork.

Differences between commercial graffiti in Aphrodisias and those found in the nearby Lydian city of Sardis, however, highlight their local distinctiveness. For example, we know that both Jews and Christians populated Sardis, just as they did in Aphrodisias. Sardis, like Aphrodisias, flourished through late antiquity, and the grandeur and geographic position of its

synagogue, recently redated to the fifth century, has grounded many theories about the social and economic prominence of Jews in local society.[89] But graffiti associated with Jews from Sardis, also located in commercial spaces (as well as inside its synagogue), contrast significantly with analogous examples found in Aphrodisias.[90] The first distinct feature is their relative scarcity: negligible numbers of local graffiti found outside of the synagogue are explicitly connected to Jewish populations.[91] Moreover, commercial graffiti, which contain menorahs, appear farther from the public eye. While Christians in late ancient Sardis displayed crosses prominently outside and inside market stalls to be seen by patrons and passersby alike (particularly along the back route of the synagogue), Jewish merchants did not display their symbols in comparable ways. Menorah graffiti from Sardis, for example, do not appear on the outside of shops, but rather on interior surfaces, which could be viewed when people visited or exited shops, but only after they had already entered them.[92] The interiority of these markings suggests that, for whatever reason, Jews of Sardis were less inclined to publically display their symbols than were some of their Christian peers.

Reasons for this distinct spatial pattern of menorah graffiti remain unclear. Perhaps relationships between Jews and their pagan and Christian neighbors in Sardis were more strained than in other regional centers—a possibility that would directly contradict arguments, developed from studies of the local synagogue—which often assert that local Jews possessed a prominent position in Sardis.[93] Alternatively, perhaps menorah graffiti from Sardis might date to periods of later antiquity, after Justinian's legislation against Jewish populations gained greater efficacy. In the latter case, Jewish vendors might have been more fearful than in earlier periods to publicly identify their shops with diagnostic markings. Such graffiti might have been commercial liabilities, even if locals already knew that Jews owned and operated associated businesses. Perhaps these patterns indicate that fewer Jews worked as merchants inside the Byzantine shops of Sardis than worked in the shops of Aphrodisias, or perhaps there was a less vigorous graffiti culture in Sardis to encourage individuals, including Jews, to carve into its public surfaces. Explanations for these differences remain inconclusive, but illustrative—Aphrodisian menorah graffiti, unlike the few from Sardis, largely distinguish themselves by their boldness and their public prominence.

Menorah graffiti, regardless of their context, often remain difficult to interpret. While their symbolism seems explicit, their images are abstract, stylized, and therefore largely inscrutable.[94] Local and regional comparisons, however, can partially illuminate patterns in commercial graffiti in Aphrodisias, where merchants and shoppers must have felt sufficiently secure in their relationships to their surroundings that they would dis-

play Jewish symbols so publicly. As Chaniotis claims, the ubiquitous and visible menorahs, placed throughout the public spaces of the city, seem to exhibit "a great deal of self-confidence" among inscribers.[95] Comprehensive review of graffiti from Aphrodisias has demonstrated why this point remains sound.

Such findings possess implications for discussions of local Jews and of their ranging social and economic status. For example, scholars have heretofore relied on the monumental steles in Aphrodisias to speculate about Jews' elevated legal and social status inside the city. Their studies have largely focused on the names and civic titles of wealthier individuals, documented in these inscriptions, who could afford to contribute significantly to the public weal.[96] But emphases on these texts remain distorting, because their inscriptions testify to the euergetism of only the wealthiest members of local Jewish populations. Attention to graffiti from the Bouleterion/Odeon and commercial spaces thus offers complementary information about Aphrodisian Jews, by highlighting how embedded they were in the social and economic, entertainment, and commercial cultures of Aphrodisias and the daily activities of their peers—whether rich or poor, young or old.

A HIPPODROME MARKETPLACE

One last dipinto that includes Jewish symbols, found in a hippodrome in Tyre, complements examples discovered farther northwest in Asia Minor, because it also appears in a hybrid public context which sustained overlapping activities of entertainment and commerce. This set of markings remains exceptional for an additional reason—it explicitly links a Jewish woman to a civic space. Attention to the region and period of the application of the dipinto, as well as to the significance of the gender of its subject, enhances discussions of public graffiti application by Jews in the late Roman and Byzantine East.

Tyre, like neighboring cities farther to its north in Asia Minor, sustained an erratic political history in the centuries that followed its sequential conquest by Hellenistic, Roman, and Byzantine powers. While Semitic-speaking and -writing Phoenician populations, who worshipped indigenous Canaanite gods and retained local artistic and professional forms, had dominated the Levantine coastline for millennia, foreign conquests of Tyre had fully integrated cultic, pedagogical, and cultural features of the Greek world by late antiquity. Theological, historical, and philosophical works of Philo of Byblos and Porphyry of Tyre reflect the importation and transformation of Greek literature, civic customs, and letters, while Paul's travels anticipated the regional adoption of Christianity (Acts 21:3). As did its neighbors to

its north (Asia Minor), east (Syria), and south (Palestine), moreover, Tyre adopted many of the civic and cultural forms endemic to the Roman East, manifested in building projects that included its theatre, monumental necropolis, and hippodrome. Construction of the hippodrome was probably initiated during the reign of Septimius Severus, but was completed only in the Byzantine period.[97]

The architectural plan of the Tyrian hippodrome followed that of analogous structures throughout the region, except for its disproportionate size.[98] Archaeologists believe that it accommodated between thirty and forty thousand spectators in its heyday.[99] Well-documented rivalries between the Green and Blue factions dominated competitions within the structure, which included horse racing. Maurice Chéhab and Jean-Paul Rey-Coquais identified multiple inscribed circular floor mosaics, which expressed support for both Green and Blue factions. Graffiti and dipinti, applied by local spectators throughout the hippodrome, similarly record writers' factional preferences. More striking insights into local athletic rivalries were reflected in the discovery of two distinct bath complexes around the hippodrome, built on opposite sides of the structure during the Byzantine period; each side was designated for use by supporters of the Blues or the Greens.[100]

But rivalries also informed commercial as well as athletic and architectural features of the structure. The hippodrome served as a center of commerce as well as of athletic contest, as merchants sought to capitalize upon the popularity of the venue to sell goods to racing enthusiasts.[101] A system of vaults supporting the hippodrome stands created spaces where merchants might hawk their wares. Accordingly, visitors applied *topos* graffiti throughout the structure in two ways: to designate seating for spectators and to mark the locations where sellers plied their wares.[102] Certain vendors, who set up shops in the hippodrome, did so with deliberation: some chose locations for their shops that reflected their factional preferences.

One dipinto that falls into the latter category includes a *topos* inscription that identifies a female Jewish merchant named Matrona, who, like her neighbors, established a shop in a broad gallery beside the stands on the east side of the hippodrome—a section designated for supporters of the Blues.[103] This Matrona, or someone she commissioned, had carefully painted a sign in large red letters (7–11 cm high) onto a stone in the hippodrome arcade to proclaim that the surrounding space, measuring 64 cm × 192 cm, was the place of Matrona the *konchuleōs*—the purple-seller or purple-fisher (figure 3.5).[104]

Matrona's non-monumental dipinto rarely attracts attention from scholarly audiences, not only because it disappeared soon after its documentation, but also because it promises few insights into the life of Matrona herself, into the general workings of the hippodrome, or into the intertwined entertainment and economic cultures of the late Roman East. Closer

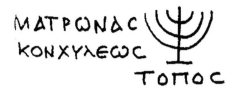

FIGURE 3.5. Painted place-holder (*topos*) inscription of Matrona from shops within the Tyrian Hippodrome; date of sketch unknown. Scan of drawing from J.-P. Rey-Coquais, "Inscriptions de l'hippodrome de Tyr," no. 14.

evaluation, however, reveals certain significant features. First, the personal name in the text unusually declares that the merchant was, indeed, a woman.[105] Matrona, a female *konchuleōs*, either produced purple dye from murex or conch shell, manufactured purple-dyed cloth, or represented a family affiliated with this work.[106] Related occupations were common in Tyre, even if fewer inscriptions directly link women with these trades.[107] The location of the text on the hippodrome's east side strongly suggests that Matrona, along with neighboring merchants, allied herself with the Blue faction.[108] But a final feature of the dipinto—its appearance beside a large red menorah with seven branches—tells us something even more exceptional about its subject. The rendering of the menorah in the same medium and thickness as the letters in the inscription, the symmetrical placement of the symbol, and the correspondence between its height and that of the two left lines of the text, collectively suggest that Matrona and a neighboring vendor (whose sign disappeared long ago) deliberately painted their names beside it to designate their market stalls (figure 3.5).[109] Matrona thus declared her place in a civic and commercial sphere through affiliation with this quintessentially Jewish symbol.[110]

Matrona's sign, in several ways, remains locally unexceptional in its broader epigraphic and functional context. For example, thirteen comparable, non-monumental inscriptions, similarly dated to the fifth or sixth centuries CE, were also found scratched and painted throughout the hippodrome. Most of these record spectators' general advocacies for the Blue competitors in the stadium, while others include seat reservations for particular groups, such as the "[place] of the Samaritans."[111] Others added Chi-Rho symbols and Latin crosses to their writings.[112] Only a few remaining *topos* dipinti, such as Matrona's, specifically designate spaces for individual vendors.[113] Matrona's painting of a sign for the commercial space, her inclusion of an explicit symbol, and her allegiance with a particular faction, are all conventional for non-monumental inscriptions in the hippodrome. Her public display of a menorah beside her inscription, most of all, demonstrates that the religious heterogeneity of spectators

inside the entertainment complex (including Christians and Samaritans) extended to vendors as well.

In specific respects, however, Matrona's dipinto remains more unusual. Hers is the only hippodrome inscription to retain a woman's name and a Jewish marker, and hers is the only vendor sign to incorporate a symbol with religious connotations. The size of the menorah next to the dipinto, moreover, is much larger than that of the crosses drawn on seat inscriptions nearby. These observations are significant for three principle reasons. First, the presence of the menorah constitutes the most direct available evidence for the existence of Jewish populations in Tyre. While scholars have identified epitaphs of Jews in the local reused cemetery, their conclusions about a Jewish presence rely largely on interpretations of questionably diagnostic names upon epitaphs.[114] More solid epigraphic attestations of Tyrian Jewish populations appear only in burial contexts in distant regions, including cemeteries farther south in Roman and Byzantine Palestine, where some funerary and dedicatory epitaphs from Beit Shearim and Tiberias commemorate Jews of Tyrian origins or lineage.[115] The presence of the menorah on Matrona's inscription thus constitutes rare and explicit evidence, *in situ*, for Jewish presence in late ancient Tyre.

Second, as some scholars have noted, archaeological evidence for the engagement of Jewish women in the public sphere remains surprisingly rare throughout this portion of the Mediterranean. Synagogue donor inscriptions and epitaphs might document the works and titles of some wealthier Jewish women and their prominence within Jewish communities, but cannot assist inquiries into the presence of Jewish women outside of spaces associated with Jewish populations and within their surrounding societies. Unlike the robust archaeological and epigraphic evidence for the public activities and occupations of lower-class pagan or Christian women in Italy, furthermore, objectively fewer ancient inscriptions from areas of modern Lebanon, Israel, Jordan, and Syria document the work of Jewish or non-Jewish women of the working classes, inside or outside of their homes.[116] Most inscriptions from Tyre that record information about professions derive from cemeteries; only few of these document women or their occupations at all.[117] While roughly half of the published epitaphs from the Roman necropolis in Tyre include the professions of the male deceased, women's professions are most conventionally omitted from tombstones.[118] Only three epitaphs for women, out of hundreds of inscriptions discovered in the great necropolis, document modes of female employment.[119] The scarcity of information about local women's occupations, compared to those of men, remains striking, and is echoed in Jewish burial contexts farther to the south and north; no epitaphs from surrounding regions clearly name the occupations of the Jewish female deceased.[120]

Regional rabbinic texts, by contrast, selectively allude to the employment of Jewish women as vendors in public spaces (*b. B. Qam.* 119a).[121] One passage from the Tosefta, for example, offers men permission to position their wives in storefronts to sell olives in their stead, if they are too embarrassed to do so themselves (*t. B. Qam.* 11:4). Some texts describe women as shopkeepers (*m. Ketub.* 9:4; *b. Ketub.* 86b) or wage earners in unspecified work environments. Pejorative considerations of the behaviors of women who "spin in the shuk," moreover, suggest that some Jewish women both sold fabrics in regional markets and created them in plain view.[122] Associations between women and textile manufacture and sale are echoed in Christian texts, which describe women from the eastern Mediterranean as purple-sellers and tentmakers (Acts 16:14; 18:3). As Cynthia Baker has recently argued, in many cases, fluidity between public and private spaces most afforded women these types of opportunities to practice trades inside public spaces, throughout the Levant.[123] Still, in light of widespread limitations in the regional epigraphic record, allusions in rabbinic texts to women who worked and sold wares in public spaces in the Roman East highlight the importance of Matrona's dipinto in offering documentary insights into activities Jewish women conducted in the public sphere.[124] The discovery of Matrona's dipinto thus constitutes an important precedent: its mere presence in a civic and commercial context supports hypotheses (otherwise tentative and reliant on cross-readings of textual evidence) that some Jewish women, indeed, worked in public contexts in late antiquity.

A third contribution of this dipinto, much like others found in late ancient Aphrodisias, is its direct contradiction of common assumptions about Jewish life and Jewish and Christian relationships in the Byzantine East. Most scholars draw from writings of contemporaneous jurists and theologians to conclude that by the sixth century, relations between local Jews, Christians, and Samaritans were sufficiently inimical to prohibit freer types of religious expression among local Jewish populations. Regional writers of slightly earlier periods, such as John Chrysostom, simultaneously attested to continuities between regional Jewish and Christian populations and to ongoing animosities between them. During periods that followed, however, Constantinople promulgated increasing numbers of laws to curtail the activities, lives, and status of Jews in the Roman East.[125] Despite the ambiguous picture of Jewish and Christian relations in the fifth and sixth centuries in Tyre, therefore, neither polemicists nor jurists cast it as an irenic one.[126] The dimensions and visibility of Matrona's dipinto inside the hippodrome thus remain particularly significant in relation to these discussions. The visual prominence and explicitness of Matrona's sign suggest that relations between some local Jewish, Samaritan, and Christian populations in the fifth and sixth centuries were sufficiently functional that

the placement of a large Jewish symbol would not create a commercial liability for an associated vendor.

To be certain, a hippodrome might have constituted an unusual workplace for some Jewish and non-Jewish women alike. But for one woman, this workplace was expedient. The stands along the hippodrome constitituted a lucrative public commercial environment—albeit a raucous one—a bustling space replete with ill-behaved spectators, who needed to make purchases of various sorts, including purple dye or purple-dyed products. By painting her name along the stalls in the market complex of the hippodrome, Matrona held her own to compete commercially with her peers. While her dipinto reads as a functional sign, it advances previous considerations of the roles of Jewish women in civic and commercial contexts in Tyre and elsewhere in the Roman East.[127]

Attention to the statistical distribution and contents of local inscriptions might initially cast Matrona's Tyrian dipinto as an outlier, barely representative of common practice. Alternative readings of the text and its associated symbols, however, highlight the dipinto as rare evidence for an elusive phenomenon—the presence of Jewish women in the public sphere—particularly in the marketplaces and athletic arenas in the eastern Mediterranean. When examined alongside regional literary and epigraphic data, Matrona's dipinto, however humble, offers rare documentation of the functional coexistence of some Jews and their neighbors in sixth-century Tyre.[128] It thus advances our understandings of the social dynamics of the city, in which both working and more leisured classes carved and painted markers of religious identification into their civic and public spaces.

ASSESSMENT

If a woman selling purple cloth believed that displaying a menorah would harm her business, she probably would not have painted the symbol on her shop sign. If spectators anticipated that inscribing "[The] Jews for the Blues!" onto theatre seats would be answered by violence, they might have thought twice about their actions. But the presence and improbable preservation of these and analogous markings exemplify something otherwise unexpected: that some Jews (women as well as men!), in several cities of Asia Minor and Syria in earlier and later antiquity, considered public acts of writing to be sufficiently acceptable, safe, and desirable modes of self and group expression.

More than this, messages and symbols that Jews drew on surfaces of theatres, assembly halls, markets, and hippodromes served as a means of cultural activation. Public graffiti document Jews' individual and collective engagements with civic and economic structures and their willingness to

reshape their urban environments to assert their collective presence in a public milieu. The resulting markings, in turn, reflect how writers and artists chose to represent themselves, symbolically and spatially, in the public sphere. By boldly displaying their religious and cultural affiliations and by documenting their presence inside civic structures, Jews applied graffiti as demonstrative and performative acts inside these public spaces.

Some scholars have recently used features of the archaeological record to challenge the historicity of Christian literary portrayals of Jewish populations in Asia Minor and the agonistic relationships they often project between Jews and their pagan and Christian neighbors.[129] Graffiti and dipinti found in public settings offer an additional means to read against the grain of pagan and Christian literary discourse concerning Jewish populations and their shrinking places in public life in late Roman Asia Minor and Tyre.

Closer readings of graffiti as public artifacts offer tangible evidence for the neutrality, or even amicability, of relationships between some Jews and their neighbors in parts of the eastern Mediterranean. Presumably, if Jews uniformly inhabited environments as consistently hostile as Christian authors describe, applications of menorah graffiti to public spaces throughout Asia Minor and northern Syria would be incredibly risky. But without overt signs of defacement or erasure on most examples of menorah graffiti, it appears that the public presence of Jews and their markings was at least marginally tolerable to some of their peers. Efforts to circumscribe the actual social-historical relationships between graffiti inscribers and their neighbors remain ongoing. To this end, interpretations of these graffiti, which emphasize their contents and modes of display, offer more definitive information about the perspectives of inscribers of graffiti and their viewers in the Roman East.

Some graffiti, however, can offer more tangible information about the social histories of local Jewish populations. First, appearances of diagnostic writings and symbols in theatres, town halls, and hippodromes document Jewish engagement in public life in Asia Minor, in ways unattested in literary sources. Second, and without any literary corroboration, they demonstrate the variability of the social statuses of Jews and their levels of comfort in their immediate surroundings. Theatre graffiti in Miletos and Odeon and marketplace graffiti in Aphrodisias suggest levels of prominence and confidence among local Jewish populations that may have differed, for example, from those enjoyed by Jews in late ancient Sardis. Examinations of graffiti, then, highlight, rather than elide, regional differences among Jewish populations and Jewish-Christian relations. Finally, Matrona's Tyrian dipinto preserves rare evidence for interfaces between gender and public life among Jewish populations and their peers. It attests to an otherwise elusive phenomenon only indirectly reported in literary sources—the presence of Jewish women in public marketplaces and athletic arenas in the eastern

Mediterranean. Graffiti thus nuance the picture of Levantine Jewish life in the eastern Mediterranean in ways that literary texts and monumental archaeology cannot.

Graffiti from public buildings offer proof that Jews engaged fully in multiple aspects of civic life in late antiquity in the Roman East. Their placements and sizes are bold and visible. While, in the writings of Christian emperors, jurists, and authors, Jews of the late Roman and Byzantine worlds were persecuted, prosecuted, marginalized, and ostracized, the placements and contents of graffiti demonstrate something else: the extent to which Jews boldly identified themselves as active participants in Eastern societies.[130] Graffiti exemplify how Jews of late ancient Asia Minor and Syria did not hide in the shadows, but rather, made their marks in the public sphere, in theatres, sporting events, assembly halls, and marketplaces and amidst their societies at large.

CHAPTER FOUR

Rethinking Modern Graffiti through Ancient

One morning during my daily walk across town toward the Albright Institute of Archaeological Research, I realized that new street art had sprung up overnight along the periphery of Paris Square in Jerusalem. Its location and visibility were astounding. With an ample size of roughly 2 by 3 meters and in neon colors, it blanketed a wall beside the vitrine of "SEAM," an upscale women's boutique for modest fashions opposite the Prima Kings Hotel, just steps away from the well-guarded precinct of the Israeli prime minister (figure 4.1). In shades of acid blue, orange, and pink, it seemed to depict the Jerusalem Temple, positioned atop fiery clouds with an eye floating within the central frame of the building. Thirteen winding steps led upward to its doorway, whose edge bore a *mezuzah*. Hebrew letters for *yah* (a hypocoristic name for the Jewish God) appeared beside the left frame of the door (facing). The precise meaning of the scene remained ambiguous, but an additional text bore a clue: the presence of the phrase, "one day," in English, on the lower left corner of the montage, suggested that this painting represented the messianic Temple of the future, rather than of the past—the Temple of the world to come. The artist proudly wrote his name and the Hebrew date on the lower right side of the panel—a seemingly bold move for the appropriation of public and private property.

My immediate response to viewing the wall was one of sheer panic, because I wanted to document the façade before it disappeared. Surely, I supposed, the municipality or the building owners would overpaint or

FIGURE 4.1. Street art depicting the "Third Temple" in Paris Square in Jerusalem; June 2013. Photo by Ezra Gabbay.

sandblast the wall as quickly as possible, in efforts to restore its surface to a nondescript and placid state. The surrounding interchange of Paris Square is a prominent one in Jerusalem: it is a popular locus for convocation and political protest, so close to the residences of high-profile politicians and national and municipal institutions. Given the strangeness of the image and the significance of its location I concluded that the painting's days were surely numbered.

But I was wrong. To my great surprise, my fear concerning the painting's removal was entirely unfounded. For months, I remained puzzled at the sustained presence of the gaudy scene. I imagined that the managers of the neighboring fashion boutique or of the Prima Kings Hotel across the street cringed whenever they viewed its garish colors and blatantly messianic message, which confronted their wealthy guests on a daily basis. It seemed like an equally unseemly element in an urban landscape that extended through the Israeli prime minister's residence, let alone the wealthy neighborhoods nearby. Were not these features sufficiently agitating to prompt its removal? Ultimately (and, indeed, I reflected upon it regularly), I settled upon a simple and pragmatic explanation for the improbable survival of the panel: the municipality did not have the wherewithal to address the problem.

Three years after I had intially and frantically photographed the wall, however, the panel persisted without substantial modification. And only after I had left Jerusalem to return to the United States did I finally imagine another possible explanation for its surprising durability—one informed by my ongoing considerations of ancient analogues, which equally constituted interfaces between writing and art, commerce, and concourse. Just like graffiti in Dura-Europos, for instance, which appeared inside sacred places and thus enhanced and assumed attributes of the spaces they adorned, perhaps it was the very sanctity of the "Third Temple" scene beside the Jerusalem boutique which most defended it from erasure.[1] Even if the esoteric meanings of the "throw-up" were best understood by the artist's target audience, most passersby, acquainted with Jewish texts and traditions, could decipher several of its features. Its imagery (which depicts a scene of maximal holiness) and its lucid inscription (containing the shortened divine name of the Jewish God) collectively served as the best protections from efforts to restore the building's surface. The creation of this panel and its maintenance allowed its artist and viewers rare, if desirable, opportunities to conjure, access, and even engage with the holy or the sacred in a place of public concourse.

On a most basic level, one of the most obvious and traditional ways to understand images and texts, such as those spray-painted in Paris Square, let alone those written on buildings somewhere in the Bronx or carved along cliffs in Egyptian El-Kanaïs, is as written forms of expression or communication. Such interpretations are logical, because both in modernity and antiquity, authors and artists consistently apply graffiti, in performative ways, to convey discrete messages to their viewers. In ancient sanctuaries and synagogues, graffiti writers solicited divine and human audiences, while in ancient burial caves, artists wrote graffiti to convey messages to the living and the deceased. Those who carved their designs inside hippodromes or theatres anticipated different viewers of their works, which included Jewish and non-Jewish spectators and peers. Graffiti, in all cases and throughout diverse spatial and chronological contexts, thus corporealize their creators' efforts to carve and project texts and pictures to communicate discrete messages to their peers.

But as previous chapters demonstrate, graffiti do many other things beyond conveying selective ideas or messages. The approaches of Lefebvre and others have particularly underscored how multiple aspects of human activity, including writing and drawing, transform and socialize preexisting spaces. Taking up a nail or a paintbrush to decorate a built or natural surface ossifies a profound interaction between a person and her surroundings, as well as between a writer and subsequent audiences of her work—an engagement that transforms the person performing the action and the meaning of the surrounding space—as understood by the author

and subsequent viewers. Graffiti writers thus perform acts of writing and drawing to communicate with audiences, but also to exert their agencies over their physical, as well as practical and cultural landscapes. Artists of the neon Jerusalem Temple in Paris Square and of pictures carved around the Dura-Europos synagogue, in these respects, might reflect comparable dynamics of devotion, agency, and socialization, which entail an artist's mastery over surfaces of her broader domain.

This mastery, moreover, is neither abstract nor symbolic. Many ancient people believed that their drawings or writings directly impacted the world in a broader way—they affected the posthumous fates or affects of the dead, the safety of the living (protecting them from wandering spirits), controlled the seating patterns in the chaotic civic spaces of a theatre or an Odeon, or competed to attract customers to their shops within marketplaces. In the eyes of its artist, likewise, drawing an image of the Third Temple on a wall in Jerusalem could be equally effective: it might, somehow, effect a speedier arrival of a messianic age. Graffiti serve as their writers' social, devotional, economic, and civic agents, which perpetuate their desires long after they pass on, by directly impacting and reshaping the world that surrounds them.

Perspectives such as these correct potential misconceptions that graffiti are/were somehow a "childish," "spontaneous," or "informal" type of writing.[2] In the preceding chapters, lexical and spatial analyses have revealed how patterned placements of graffiti reflect their creators' deliberation and care.[3] Engraving a message along the entrance to a large burial cave might have required significant preparation: the inscriber might have practiced her writing and spelling in advance; she might have carried appropriate tools over long distances to carve the letters.[4] Patterns in the contents and locations of graffiti, in all sorts of practical and spatial contexts, consistently betray the seriousness if not formality in their applications. And ultimately, whether in places of worship, burial, or civic convocation, such purposeful modes of writing and decoration serve as graphic footprints, which better illuminate the uses of ancient spaces and inspire hypotheses about the activities historically conducted inside and around them. These contributions are significant when addressing features of Jewish history.

Historians have long mourned the lack of documentation of the lives of many ancient Jews. So few of them possessed the means, the skills, the inclinations, and the posthumous luck of writers like Philo, Josephus, or the redactors of rabbinic texts, to produce durable and eloquent literary records of their daily activities and world outlooks, interpretations of Jewish traditions, and their experiences as Jews surrounded by pagan and Christian neighbors. While graffiti cannot assist the writing of ancient biographies or continuous tales about Jewish life throughout the Roman provinces in the same ways, they preserve selective information about how certain Jews operated within their surrounding environments. They

remind us that Jewish life in antiquity should appear somewhat strange to us: that it may resemble its modern incarnations far less (and in other cases, far more!) than we might assume. Writings on walls can apprise us of an ancient world in which Jews acted, and felt, in ways that were both similar to and different from their neighbors—graffiti are rare media that can attest to this.

The introductory chapter asserted that the subject of this book responds to a persistent lacuna in modern scholarship on ancient Jewish life through the medieval period, which largely relies on information supplied by Jewish and non-Jewish elites. As subsequent chapters have demonstrated, ancient graffiti address this gap, because they ultimately facilitate something quite unusual: a means to inspire new interpretations of the Jewish and Christian literatures, and archaeological and epigraphical data, that traditionally shape Jewish historiography. Reading graffiti as vestiges of ancient behaviors, bound by their own conventions of genre, space, and chronology, thus offers a novel means to imagine the daily lives of ancient Jews outside of the confines of traditional literary sources, written and dedicated nearly exclusively by Jewish elites.

The case studies above have revealed, foremost, how the examination of unprivileged archaeological data from a minority population can facilitate renewed understandings of the diversity of cultural practices among Jews and their contemporaries throughout the Hellenistic, Roman, and Byzantine Mediterranean. Attention to graffiti from Dura-Europos, for example, suggests that ancient synagogues might have been more sensual spaces than we commonly imagine: spaces of visitation, but also of transformation, inspiration, modification, personalization, and of varied and tactile expressions and experiences of devotion to the divine. They also document ways that Jews prayed alongside their non-Jewish neighbors, whether in synagogues, such as in Dura, in shrines, or in the open wilderness—places where such practices would otherwise continue undetected and unrecognized in the historical record. Consideration of graffiti from burial caves reveals the extent to which the homes of the dead were interactive and plastic zones for the living, where visitors and mourners used nails and paint to transform, personalize, and protect the surfaces of ceilings, doorways, and tombs with textual and pictorial works. Graffiti and dipinti from civic spaces, including hippodromes, theatres, and market stands, illustrate how boldly and repeatedly Jews asserted their presence in public buildings by marking seats, pillars, and spectator stands with menorahs and other symbols. While many of the graffiti examined here have, can, and should continue to be considered in other contexts, their comprehensive consideration, from this particular vantage, forges more continuous narratives about the day-to-day lives of ancient Jews throughout multiple geographic regions and periods of antiquity.

The associated contributions of this analysis are manifold. For example, general studies of ancient Jewish prayer have burgeoned in recent years. Scholars, in tandem, have plumbed literary accounts and archaeological remains to investigate multiple activities associated with synagogues, including those of assembly, prayer, charity giving or donation, vow-making, social consolidation and organizational hierarchies, gender stratification, liturgical and textual recitation, commensality and hospitality, and visual and narrative methods of interpreting biblical texts. Recent advances in literary theory and archaeological discoveries inform increasingly refined interpretations of these spaces, their uses, and the social and devotional practices they encompassed. But, in several ways, analyses of graffiti address missing links in discussions of the lived experiences of Jewish devotees—whether inside synagogues or around and inside pagan sanctuaries. While modern observers would consider graffiti in sites of worship as works of defilement or defacement, ancient evidence suggests a contrary view: they served, instead, as vestiges of devotional activities, which, in turn, reflect diverse modes of *participation* in religious life among neighboring Jews, pagans, Christians, and early Muslims.

Disparate site and excavation reports have erratically documented graffiti that adorn ancient burial spaces throughout the Levant and Egypt, but without addressing them systematically or synthetically. Recurring examples of carved texts and pictures inside regional mortuary spaces, applied from the Iron Age through late antiquity, highlight the consistent conduct of heretofore unrecognized practices—those of visitors' adornment, elaboration, inscription of, and dialogues with burial spaces (and their ensuing dialogues with the dead during funerals or visits to burial caves over time). Comprehensive considerations of these graffiti thus reveal significant and otherwise elusive facts—that, in multiple respects, Jews were writing and drawing inside their mortuary spaces in much the same ways as many of their immediate and regional neighbors. This is so, regardless of rabbinical prescription or preference.

By using graffiti to garner insights into the presence of Jews in theatre, hippodrome, and market settings, moreover, one can offer new hypotheses about how Jews operated within their societies at large. Public graffiti from Asia Minor and Tyre thus apprise us of additional, if otherwise undocumented, information about how Jews of the third through sixth centuries self-identified in civic spaces. Resemblances between the writing behaviors of Jews and their neighbors, indeed, resulted from Jews' emergence from *within* their surrounding societies (as opposed to imagined dynamics of their somehow living outside of them and learning about them through more superficial social "interactions"). While rabbinic discussions underscore divisions between Jewish and Christian populations, and while ancient Christian writers and jurists conventionally hearken to antipathic relations between Jews and Christians, these graffiti

demonstrate the boldness of Jewish presence inside public spaces populated by their neighbors—whether pagans, Christians, or Samaritans. While few examples of graffiti of Jewish association are found in high concentrations in many Mediterranean cities, these markings, when read within their particular find contexts, demonstrate the presence of Jews—women and men—in the civic events that framed participation in regional life.

Have graffiti resolved all problems inherent to the historiography of ancient Jewish populations? Of course not. For example, as indicated above, often we know little about their authors—many of whom remain nameless, anonymous. Graffiti do not speak to political or intellectual history, more broadly understood. From the very beginning, this book contended that ancient graffiti merit serious consideration, but for distinct reasons and objectives—to garner insights into the daily lives of their forgotten creators. As indicated above, scrutiny of graffiti, when read in these particular ways, offers novel and primary insights into activities Jews once conducted inside public and semi-private spaces, including synagogues, cemeteries, markets, theatres, and hippodromes. These markings, moreover, embed otherwise unattested information about their creators' behaviors, beliefs, and relationships to the cultures that encompassed them. And as they document individuals of all ranges of status—including non-elites, rich, and poor—they retain rare information concerning the experiences of those whose lives are otherwise infrequently documented and remain long forgotten in the historical record.

One might, of course, wish for a fuller corpus of materials to complement and extend this investigation. For example, if access is ultimately granted to the Torlonia Catacombs in Rome, where many graffiti are reported (but from which painfully few are formally documented), ensuing findings might highlight cross-regional variabilities in graffiti writing among Jews in mortuary contexts.[5] When excavations are extended around sites where menorah graffiti were found in Split, Croatia, scholars might also gain greater insights into the status and activities of Jews, including Jewish slaves, elsewhere in Europe. These projects are those of the future, whose findings will inevitably transform many of the conclusions presented above. But this study, even in its current form, intends to serve as a beginning, by offering an example of different ways to read old materials associated with diverse aspects of Jewish life.

Scholars continually strive to improve perspectives on the daily lives of ancient populations. Examinations of graffiti prove to be invaluable tools in this ongoing process. This examination of graffiti thus offers a distinct perspective—a new way to imagine the everyday lives of Jews in antiquity—outside of the rabbinic orbit and outside of our expectations, but fully and substantively inextricable from the complex and varied cultural worlds of their pagan, Christian, and early Muslim neighbors.

NOTES

PREFACE

1. I use as shorthand in the following analysis the term "pagan" to describe ancient people who did not regard themselves as Jews or Christians. I prefer this problematic (and oppositional) term, because of its capaciousness and brevity. Of course, not all pagans were polytheists (which is why I do not use the term as a replacement); neither were all Jews and Christians "monotheists" or "henotheists," in opposition. For the purposes of this analysis, I use "pagan" to distinguish individualized, civic, or state-sponsored theologies and cultic practices from those associated with Christians and Jews, even though, in reality, lines often blurred between these groups. Comparable methodological considerations are offered in *Christopher Jones, Between Pagan and Christian* (Cambridge: Harvard University Press, 2014), n. 11. In past decades, complementary discussions of Jewish and Christian populations, their complexity, and occasional porosity have proliferated, including, among several others, Adam Becker and Annette Yoshiko Reed, ed., *The Ways That Never Parted: Jews and Christians in Late Antiquity and the Early Middle Ages* (Minneapolis: Fortress Press, 2007).
2. This is a point duly noted in the work of Seth Schwartz, *The Ancient Jews from Alexander to Muhammad* (Cambridge: Cambridge University Press, 2014), 8, 152.

INTRODUCTION: GRAFFITI, ANCIENT AND MODERN

1. Bibliography on the subject abounds. Among many others examples are: Gregory J. Snyder, *Graffiti Lives: Beyond the Tag in New York's Urban Underground* (New York: New York University Press, 2009); Mia Gröndahl, *Revolution Graffiti: Street Art of the New Egypt* (London: Thames & Hudson, 2013). The most famous earlier studies include Mervyn Kurlansky,

Jon Naar, and Norman Mailer, *The Faith of Graffiti* (New York: Praeger, 1974); and its editing and reprint in Norman Mailer and Jon Naar, *The Faith of Graffiti*, 2nd ed. (New York: Harper Collins, 2009), esp. discussion, 1–9.

2. Ingrid K. Williams, "36 Hours in Rome," *The New York Times*, 2015, accessed August 3, 2016, www.nytimes.com/2015/03/08/travel/what-to-do-in-36-hours-in-rome.html. See also the acclaim for a recent installation of artist Jenny Holzer, whose graffiti-like art techniques adorn caves and grottoes in Ibiza: Hilary Moss, "Jenny Holzer's Unexpected New Canvas: The Boulders of Ibiza," *The New York Times*, June 20, 2016, accessed August 3, 2016, www.nytimes.com/2016/06/21/t-magazine/art/jenny-holzer-ibiza.html.

3. Banksy's work commonly draws mainstream attention, as attested in Max Ehrenfreund, "Banksy Opens New York 'Show'" *The Washington Post*, October 3, 2013, accessed August 3, 2016, www.highbeam.com/doc/1P2-35202673.html?refid=easy_hf; Charles Legge, "Uncovering Banksy; Graffiti or Great Art? Banksy's Work Is Often Humourous," *Daily Mail (London)*, February 26, 2008, accessed August 3, 2016, www.highbeam.com/doc/1G1-175407892.html?refid=easy_hf. Banksy's 'Walled Off Hotel,' in Bethlehem, along the border wall between Israel and the West Bank, also serves as a type of political performance piece; the website announces that the hotel is to remain open from 2017 to 2018 or longer; "The Walled Off Hotel," accessed November 15, 2017, www.bing.com/cr?IG=6B6E2380828241BDAA4E1A2BC093EC35&CID=233804F C7DB96DB50A630FC07CBF6C33&rd=1&h=iAeoYzisDPBr6 n0hu2-R2AjKPp64pt3QYEnba3CGOGQ&v=1&r=http%3a%2f%2fwww .walledoffhotel.com%2f&p=DevEx,5066.1. Considerations of graffiti as political protest can be found in Gröndahl, *Revolution Graffiti*, 34.

4. The current wave follows several previous moments of appreciation for the works of street artists. The most famous treatments of earlier phases include *The Faith of Graffiti* and its second edition.

5. Discussions of the complex functions of graffiti abound. Useful examples include Greg Snyder, *Graffiti Lives*, 9; Nicholas Ganz and Tristan Manco, *Graffiti World: Street Art from Five Continents* (London: Thames & Hudson, 2009).

6. The Adam Yauch playground in Brooklyn, dedicated in memory of Adam Yauch of the Beastie Boys, made national news in the United States when swastikas were found spray-painted onto its signs shortly after the American presidential election in the fall of 2016. CBS News, "Swastikas, 'Go Trump' found on Adam Yauch playground in Brooklyn," CBS News, November 18, 2016, accessed August 22, 2017, www.cbsnews.com/news/swastikas-go-trump-graffiti-at-adam-yauch-playground-in-brooklyn/.

7. Discussion of the utility of anachronistic categories considered in Karen B. Stern, "Celebrating the Mundane: Figural Graffiti and Daily Life among Jews in the Levant," in *Jewish Art in Its Late Antique Context*, ed. Uzi Leibner and Catherine Hezser (Tübingen: Mohr Seibeck, 2016), 238. Among many other treatments of these topics and on the discussion of

constructions of race, see Benjamin H. Isaac, *The Invention of Racism in Classical Antiquity* (Princeton, NJ: Princeton University Press, 2004); on religion, see Jonathan Z. Smith, *Imagining Religion: From Babylon to Jonestown* (Chicago: University of Chicago Press, 1982); consideration of sexualities include Judith P. Hallett and Marilyn B. Skinner, *Roman Sexualities* (Princeton: Princeton University Press, 1997). On the use of anachronistic terms, such as these, in the study of antiquity, see discussion in Schwartz, *The Ancient Jews*, 8.

8. Ammianus implies that such a project would be both futile and interminable, as he continues: "If someone wished to do that, he might as well try to count the tiny bodies coursing through space, the atoms, as we call them." (*Roman History*, 26.1.1); transl. Robert C. Knapp, *Invisible Romans* (Cambridge, MA: Harvard University Press, 2011), 2.

9. Scholarship in ancient studies increasingly considers artifacts and cultures of the day-to-day. Recent excellent examples include Roger S. Bagnall, *Everyday Writing in the Graeco-Roman East* (Berkeley: University of California Press, 2011); J. D. Baird and C. Taylor, ed., *Ancient Graffiti in Context* (London and New York: Routledge, 2011); John R. Clarke, *Art in the Lives of Ordinary Romans: Visual Representation and Non-elite Viewers in Italy, 100 B.C.–A.D. 315* (Berkeley: University of California Press, 2003); Knapp, *Invisible Romans*. Recent works have begun to reexamine the daily lives of Jewish populations, specifically in Israel and the Levant, including Jodi Magness, *Stone and Dung, Oil and Spit: Jewish Daily Life in the Time of Jesus* (Grand Rapids, MI: William B. Eerdmans, 2011); and Catherine Hezser, ed., *The Oxford Handbook of Jewish Daily Life in Roman Palestine* (New York: Oxford University Press, 2010). Broader discussions of daily life have emerged from those of Michel de Certeau, *The Practice of Everyday Life*, trans. Steven Rendell (Berkeley: University of California Press, 2011), 97. German historians advocated the study of everyday history (*Alltagsgeschichte*) in the 1980s in the form of microhistory; summary of related points in Alf Lüdtke, ed., *The History of Everyday Life* (Princeton: Princeton University Press, 1995).

10. Among countless additional instances, see examples in *b. Ber.* 30a; *b. B. Qam.* 52a; on widows, see *b. Ketub.* 93a.

11. Hayim Lapin discusses these and related points in *Rabbis as Romans: The Rabbinic Movement in Palestine 100–400 CE* (New York: Oxford University Press, 2012), 3–7.

12. Important treatments of this subject are well considered in Tessa Rajak, *The Jewish Dialogue with Greece and Rome: Studies in Cultural and Social Interaction* (Leiden: Brill, 2001), 488; Seth Schwartz, *Imperialism and Jewish Society, 200 B.C.E. to 640 C.E.* (Princeton: Princeton University Press, 2001), 103; Shaye J. D. Cohen, "Epigraphical Rabbis," *JQR* 72 (1981–1982): 1–17; Hayim Lapin, *Rabbis as Romans*, 43–6.

13. Consideration of these features of rabbinic literature can be found in Lapin, *Rabbis as Romans*, 23, 38–63. Lapin describes the advantage of "treating [rabbinic texts] as historical artifacts" (63).

14. The legacy of the ancient rabbis indelibly shapes modern perspectives on ancient Judaism. For an excellent synopsis of dominant hermeneutical categories in the discussion of Jewish history, see Schwartz, *Imperialism*, 7–8.

15. See discussion of related points in Steven Fine, *Art and Judaism in the Greco-Roman World* (Cambridge: Cambridge University Press), 125–35.

16. Occasionally, inscribed mosaics and fresco, as well as papyri from later periods, even attest to liturgical practices associated with synagogue worship. Discussions of related liturgical practices in Ophir Münz-Manor, "A Prolegomenon to the Study of Hekhalot Traditions in European Piyyut," in *Hekhalot Literature in Context: Between Byzantium and Babylonia*, ed. Ra'anan S. Boustan et al. (Tübingen: Mohr Siebeck, 2013), 231–242; also Ophir Münz-Manor, "Narrating Salvation: Verbal Sacrifices in Late Antique Liturgical Poetry," in *Jews, Christians, and the Roman Empire: The Poetics of Power in Late Antiquity*, ed. A. Y. Reed, N. Dohrmann (Philadelphia: University of Pennsylvania Press, 2013), 154–66, 315–19.

17. Archaeological evidence from earlier periods more clearly derives from the Jewish domestic sphere. See discussions of Andrea Berlin, "Household Judaism," in *Galilee in the Late Second Temple and Mishnaic Periods 100 BCE – 200 CE, Vol. 1: Life, Culture, and Society*, ed. D. Fiensy and J. Strange (Minneapolis, MN: Fortress Press, 2014), 208–15; and Andrea Berlin, "Jewish Life Before the Revolt: The Archaeological Evidence," *JSJ* 36.4 (2005): 417–70.

18. Indeed, only elites could likely afford to purchase most of the non-ephemeral materials more likely to survive for modern discovery and analysis.

19. New excavation methods have begun to change this pattern and so too have improved methods of recording finds. Examples, among many others, include those associated with the ongoing excavations at Huqoq, Israel, directed by Jodi Magness. Preliminary publications, which consider variability in local lore through mosaic iconography, include that of Matthew Grey, "'The Reedeemer to Arise from the House of Dan': Samson, Apocalypicism, and Messianic Hopes in Late Antique Galilee," *JSJ* 4 (2013): 553–89.

20. An exception includes the mosaic floor from the Sepphoris synagogue, whose design and registers may map out the activities conducted in certain parts of its assembly hall. See Ze'ev Weiss and Ehud Netzer, *The Sepphoris Synagogue: Deciphering an Ancient Message through Its Archaeological and Socio-historical Contexts* (Jerusalem: Israel Exploration Society, 2005), 34-9.

21. Several epitaphs from Asia Minor explicitly prescribe particular commemorative practices to be conducted at a tomb, e.g., IJO II nos. 171, 196. Such epitaphs describe how the deceased *desired* to be commemorated, even if we have no way of knowing whether their families and heirs ultimately honored their wishes.

22. Some caution against using raw archaeological data to reconstruct any features at all of the lives of ancient Jews; Martin Goodman considers related points in "Jews and Judaism in the Mediterranean Diaspora in the Late-Roman Period: The Limitations of Evidence," *Judaism in the Roman World* 4.2 (1994): 208–24. Associated methods also presented in Jaś Elsner,

"Archaeologies and Agendas: Reflections on Late Ancient Jewish Art and Early Christian Art," *JRA* 93 (2003): 114–28.

23. Review of related problems in Seth Schwartz, *Were Jews a Mediterranean Society? Reciprocity and Solidarity in Ancient Judaism* (Princeton: Princeton University Press, 2010), 3–6.

24. Discussions of the everyday, and the aesthetics of the everyday, in David Morgan, *Visual Piety: A History and Theory of Popular Religious Images* (Berkeley: University of California Press, 1996), 12–17.

25. These efforts are what Robert Knapp calls "seeing the invisible," in *Invisible Romans*, 1–3.

26. Graffiti has recently become an important focus of study in fields of ancient history and classics. Recent treatments include Baird and Taylor, *Ancient Graffiti*; Bagnall, *Everyday Writing*; Peter Keegan, *Graffiti in Antiquity* (New York: Routledge, 2015); Kristina Milnor, *Graffiti and the Literary Landscape in Roman Pompeii* (Oxford: Oxford University Press, 2014); Alix Barbet and Michel Fuchs, *Les Murs Murmurent: Graffitis Gallo-romains: Catalogue de L'exposition Crée au Musée Romain de Lausanne-Vidy, 2008* (Gollion (Suisse): Infolio, 2008). On Pompeiian graffiti, see also the prolific work of Rebecca Benefiel. Examples include "The Culture of Writing Graffiti within Domestic Spaces at Pompeii," in *Inscriptions in the Private Sphere in the Greco-Roman World*, ed. Rebecca Benefiel and Peter Keegan (Leiden: Brill, 2016), 80–110; Rebecca R. Benefiel, "Dialogues of Ancient Graffiti in the House of Maius Castricius in Pompeii," *AJA* 114, no. 1 (2010): 59–101. For discussions of graffiti in Arabia and other contexts, see multiple works of M. C. A. MacDonald, including: "Reflections on the Linguistic Map of Pre-Islamic Arabia," *Arabian Archaeology and Epigraphy* 11, no. 1 (2000): 28–79; Frédéric Imbert, "Le Coran dans les graffiti des deux premiers siècles de l'Hégire," *Arabica*, t. XLVII (2000): 384–90. Bibliography on Egyptian graffiti is more extensive and includes Elizabeth Frood, "Egyptian Temple Graffiti and the Gods: Appropriation and Ritualization in Karnak and Luxor," in *Heaven on Earth: Temples, Ritual and Cosmic Symbolism in the Ancient World*, ed. Deena Ragavan (Chicago: University of Chicago Press, 2013). Excellent treatment of later periods in Juliet Fleming, *Graffiti and the Writing Arts of Early Modern England* (Philadelphia: University of Pennsylvania Press, 2001).

27. Juliet Fleming discusses the role of Pompeii in scholarly approaches to graffiti in *Graffiti and the Writing Arts*, 39–40. Discussion of the history of graffiti-related terms can be found in Baird and Taylor, *Ancient Graffiti*, 1–3.

28. Fleming critiques the "handwriting" approach in *Graffiti and the Writing Arts*, 40.

29. Context figures prominently in the discussions of distinctions between these media in subsequent chapters. On discussions of the significances of media for interpretation and function, see discussions in Rebecca Benefiel, "Dialogues," 59–101.

30. Michael T. Taussig, *Defacement: Public Secrecy and the Labor of the Negative* (Stanford, CA: Stanford University Press, 1999). I thank Katherine Ulrich

for this reference. Alexei V. Zadorojni considers uses of graffiti for political purposes in Zadorojni, "Transcriptions of Dissent? Political Graffiti and Elite Ideology Under the Principate," in *Ancient Graffiti*, ed. Baird and Taylor, 110–33.

31. I thank Katherine Ulrich for reminding me of this feature of graffiti writing.

32. Sarah Scott and Jane Webster bring attention to this point in *Roman Imperialism and Provincial Art* (New York: Cambridge University Press, 2003).

33. See the related discussion in Molly Swetnam-Burland, "Encountering Ovid's *Phaedra* in House V.2.10–11, Pompeii," *AJA* 119, no. 2 (2015): 219; Milnor, *Graffiti and the Literary*, 1–6. Early excavations in Pompeii and Herculaneum revealed a limited number of dipinti and graffiti potentially associated with Jews (JIWE I nos. 38–9; 41). Some of these are better known, including a message drawn in carbon on a fresco in a domestic triclinium, which reads, "Sodom, Gomorrah!" (RegIX Ins.I no. 26; JIWE I no. 38, 57). Scholars have interpreted this phrase as associated with Jews (Pompeii's demise antedates the presence of Christians in the region who might equally evoke biblical terms and contexts). The expression may reflect the writer's anticipation of the eruption of Vesuvius and her witnessing smoke and fire from a distance. Others have offered alternative interpretations of the inscription, as an act by the writer to cast aspersions on the social and perhaps sexual behavior of native Pompeiians (JIWE I 57–8).

34. As Angelos Chaniotis cautions, "[u]nder certain conditions, a text of any content could be a graffito." Angelos Chaniotis, "Graffiti in Aphrodisias Images—Texts—Contexts," in *Ancient Graffiti*, ed. Baird and Taylor, 191–207; 193.

35. See the collection of such inscriptions in Baruch Lifshitz, *Donateurs et Fondateurs dans les Synagogues Juives, Répertoire des Dédicaces Grecques Relatives à la Construction et à la Réfection des Synagogues* (Paris: J. Gabalda, 1967).

36. While abundant examples of domestic graffiti from Pompeii demonstrate practices of writing graffiti inside of homes, appearances of graffiti in communal and civic spaces bespeak writers' *uses of*, but not *ownership of*, surrounding spaces. Multiple examples of this point in Milnor, *Graffiti and the Literary*; cf. Rebecca Benefiel, "The Culture of Writing Graffiti within Domestic Spaces at Pompeii," in *Inscriptions in the Private Sphere in the Greco-Roman World*, ed. Rebecca Benefiel and Peter Keegan (Leiden: Brill, 2016), 80–110.

37. Examples of these are published in H. Ingholdt, "Five Dated Tombs From Palmyra," *Berytus* 2 (1935): 58–120.

38. Not all graffiti, however, are necessarily carved directly by their authors. One recurring phrase in graffiti from regional tombs pronounces: "Remember the writer, and the reader, and me!" The sentiment may suggest that the writer and the subject of the anonymous graffito ("me") might not have been one and the same. Examples of this phrase appear in Abila in Jordan and in the Judean Shefelah; W. Harold Mare, C. J. Lenzen, Michael Fuller, Myra Mare, and Abraham Terian, "The Decapolis Survey Project: Abila, 1980, Background and Analytical Description of Abila of the Decapolis

and the Methodology Used in the 1980 Survey," *Annual of the Department of Antiquities, Jordan* 26 (1982): 60; Amos Kloner, "New Judean/Jewish Inscriptions from the 'Darom'," *Qadmoniyot* 18 (1985): 96–100 [Hebrew].

39. Angelos Chaniotis, "Graffiti in Aphrodisias," 194.
40. Ari Rabinovich, "Under Cover of Night, Graffiti Transforms Jerusalem Market into Colorful Canvas - Life," Haaretz.com, February 28, 2016, accessed August 03, 2016, www.haaretz.com/israel-news/culture/1.705893.
41. Summary in Chaniotis, "Graffiti in Aphrodisias," 193–94; cf. Martin Langner's "jede Ritzzeichnung an einem scheinbar beliebigen, dafür primär nicht vorgesehenen Ort"; Martin Langner, *Antike Graffitizeichnungen: Motive, Gestaltung und Bedeutung* (Wiesbaden: Ludwig Reichert, 2001), 12.
42. See the consideration of Chaniotis, "Graffiti in Aphrodisias," 194; J. N. Adams, *The Latin Sexual Vocabulary* (Johns Hopkins University Press: Baltimore, 1982), 124; Jeremy Hultin, *The Ethics of Obscene Speech in Early Christianity and Its Environment* (Leiden: Brill, 2008), 24; examples in Chaniotis, "Graffiti in Aphrodisias," 114.
43. Some graffiti from Dura demonstrate an exception to this pattern as they were drawn in between renovations of surrounding surfaces. See discussion of these points in Karen B. Stern, "Celebrating," 243.
44. Swetnam-Burland, "Encountering Ovid's *Phaedra*," 219.
45. See the emphasis on the dialogical nature of graffiti in Benefiel, "Dialogues," 59–101.
46. On material culture and communication, see Klaus Roth, "Material Culture and Intercultural Communication," *International Journal of Intercultural Relations* 25 (2001): 563–80.
47. This pattern embeds chauvinisms critiqued by Derrida in *On Grammatology*, whereby writing, in the traditional sense, is understood as a "sensible, finite" act, which, more than picture-making, falls "on the side of culture, technique and artifice"; Jacques Derrida, *Of Grammatology* (Baltimore: Johns Hopkins University Press, 1980), 15.
48. Roland Barthes, *The Rustle of Language*, trans. Richard Howard (Berkeley: University of California Press, 1989), 34; see also the discussion in Peter Burke, *Eyewitnessing: The Uses of Images as Historical Evidence* (Ithaca, NY: Cornell University Press, 2001), 169, 177.
49. Burke, *Eyewitnessing*, 13. On questions of literacy, see note 55 below.
50. Morgan, *Visual Piety*, 9.
51. One such poem, which commented on the Church as a "fisher of men," was shaped like a net. See discussion in Fleming, *Graffiti and the Writing Arts*, 20, fig. 5. On the discussion of comparable forms produced by Simmias of Rhodes (c. 300 BCE), see Fleming, *Graffiti and the Writing Arts*, 19.
52. Fleming, *Graffiti and the Writing Arts*, 18, 19–27; CIL 4,4755. Medieval Jewish micrography exhibits the same patterns. Dalia-Ruth Halperim, *Illuminating in Micrography: The Catalan Micrography Mahzor—MS Heb 8°6527 in the National Library of Israel* (Leiden and Boston: Brill, 2013), 263.
53. Swetnam-Burland, "Encountering Ovid's *Phaedra*," 219-21.

54. This also shatters Roland Barthes' critique that "text is parasitical" on the art; see the discussion in Roland Barthes, *S/Z* (Paris: Éditions Du Seuil, 1970), 4, 10.

55. Basic literacies and writing skills were complex and varied throughout the ancient world. Recent studies of ranges of ancient literacies now abound. Examples include Rosalind Thomas, *Literacy and Orality in Ancient Greece* (Cambridge: Cambridge University Press, 1992); Mary Beard, "Ancient Literacy and the Function of the Written Word in Roman Religion," in *Literacy in the Roman World, JRA Suppl. 3*, ed. J. H. Humphrey (Ann Arbor: JRA 1991), 35–58; James Collins and Richard K. Blot, *Literacy and Literacies: Texts, Power, and Identity* (New York: Cambridge University Press, 2003); Holt N. Parker and William A. Johnson, *Ancient Literacies: The Culture of Reading in Greece and Rome* (New York: Oxford University Press, 2011). Catherine Hezser, *Jewish Literacy in Roman Palestine* (Tübingen: Mohr Siebeck, 2001) considers questions about literacy in Jewish contexts, with an emphasis on discussions in rabbinic texts as well as epigraphic remains, while Michael Owen Wise in *Language and Literacy in Roman Judaea* (New Haven/London: Yale University Press, 2015) offers a nuanced consideration of regional literacy patterns, primarily through the consideration of papyri from the Judaean desert.

56. See the discussion in Patricia Cox Miller, "In Praise of Nonsense," in *World Spirituality, Vol. 15: Classical Mediterranean Spirituality*, ed. A. Hilary Armstrong (New York: Crossroads/Continuum Press, 1986), 481–505. Discussions abound online concerning the general and selective legibility of gang tags, because the topic is of real import to many who inhabit the neighborhoods overtaken by gang life; see note 60 below. Slightly different concerns about the legibility and the artfulness of graffiti relate to the projections of certain scripts in elaborate form. On the latter, see Malik Anas Al-Rajab, "Contemporary Arabic Calligraphy," in *Arabic Graffiti*, ed. Pascal Zoghbi and Don Karl aka Stone (Berlin: From Here to Fame Publishing, 2010), 24.

57. David Frankfurter, "The Magic of Writing and the Writing of Magic: The Power of the Word in Egyptian and Greek Traditions," *Helios* 21 (1994): 189–221.

58. A clear discussion of the advantages of replacing the category of "art" with the generalized taxon of "images" can be found in Morgan, *Visual Piety*, 26. Elimination of categories such as art deters polarizing "high" (or elite) and "low" forms of visual expression, which may detract from their improved interpretation for historiographical (rather than aesthetic) purposes (26–7).

59. These types of methods are exemplified in Goodenough's approach to Jewish symbols in his corpus, whereby pictures, such as boats, are presumed to have an essential meaning in Jewish contexts. E. R. Goodenough, *Jewish Symbols in the Greco-Roman Period*, Vol. 12 (New York: Pantheon Books, 1965), 151-2. See also the collections of Langner, *Antike Graffitizeichnungen*, e.g., Pl. 1–10. For a specific critique of Goodenough's approach, see Morton Smith, "Goodenough's Jewish Symbols in Retrospect," *JBL* 86 (1967), 53–68.

60. Gang tagging is often quite legible to readers, when writers *want* general audiences to know exactly who claims control of a building or neighborhood. See the discussion of this and similar points about strategic legibility and illegibility in José Martinez, "Know Your Graffiti: Disses, Threats and the Mexican Mafia," March 7, 2012, retrieved July 17, 2017, from www.oncentral .org/news/2012/03/07/know-your-graffiti-disses-threats-and-mexican -mafi/.

61. Inscriptions on homes and tombs throughout the Mediterranean and Arabia pronounce legal ownership of spaces and buildings, but the practical parameters of these legal realities often remain unknown. Modern legalities of ownership of land and land use may differ from those in antiquity. I thank Katherine Ulrich for emphasizing the latter point. Broader consideration of ancient legal realities (particularly in relation to property), in Éva Jacab, "Property Rights in Ancient Rome," in *Ownership and Exploitation of Land and Natural Resources in the Roman World*, ed. Paul Erdkamp, Koenraad Verboven, and Arjan Zuiderhoek, (Oxford: Oxford University Press, 2015), 107–35; specific discussion of property rights, 123-27.

62. S. J. Tambiah, "The Magical Power of Words," *Man* 3, no. 2 (1968): 175–208.

63. Snyder, *Graffiti Lives*, 15. See the discussion of this point in Karen B. Stern, "Tagging Sacred Space in the Dura-Europos Synagogue," *JRA* 25 (2012): 169. Also consider the excellent treatment of this point in Baird and Taylor, *Ancient Graffiti*, 4; Morgan, *Visual Piety*, 9.

64. Alfred Gell, *Art and Agency: An Anthropological Theory* (Oxford: Clarendon Press, 1998), 6–10. Gell advocated replacing emphasis on art-objects as *products* of human action (evaluated according to principles of aesthetics), with viewing art as a "system of *action*," because, he argued: "in theoretical respects, art objects are the equivalent of persons, or more precisely, social agents" (6). Gell exemplifies these points through his conclusion about an anthropological approach to the decoration of a shield. He declares: "I doubt, for example, that a warrior on a battlefield is 'aesthetically' interested in the design on an opposing warrior's shield; yet it was so as to be seen by this warrior (and to frighten him) that the design was placed there . . . its aesthetic properties (for us) are totally irrelevant to its anthropological implications. Anthropologically, it is not a 'beautiful' shield, but a fear-inducing shield" (6).

65. Gell, *Art and Agency*, 8.

66. See also Gell, *Art and Agency*, 7. I also appreciate Katherine Ulrich's reminder of this additional point, particularly in relation to the power accorded to statues and renderings of Buddha in South Asia.

67. Henri Lefebvre, *Production of Space*, trans. D. Smith (Oxford: Blackwell, 2012), 8; Lefebvre's Marxist approach frames his interpretation of space and society.

68. Lefebvre, *Production of Space*, 26.

69. Lefebvre, *Production of Space*, 33.

70. Lefebvre, *Production of Space*, 117–118.

71. While Marxist theories undergird Lefebvre's useful approach, they need not explain the social and economic realities of ancient graffiti writers.

72. Pierre Bourdieu, *Outline of a Theory of Practice*, trans. Richard Nice (Cambridge: Cambridge University Press, 1977), 1–10; 164. Also informing this approach to social theory is Theodore Schatzki, *Social Practices: A Wittgenstinian Approach to Human Activity and the Social* (Cambridge: Cambridge University Press, 1996).

73. Morgan, *Visual Piety*, 7.

74. Morgan, *Visual Piety*, 7.

75. In recent decades, sociologists and anthropologists have criticized the determinism implicit in the concept of *habitus* and the limits it presupposes on individuals' agency and behavior. One useful critique, particularly in the discussion of *habitus* and history, includes that of Mariano Croce, "The *Habitus* and the Critique of the Present: A Wittgensteinian Reading of Bourdieu's Social Theory," *Sociological Theory* 33 (2016): 327–346. Some graffiti writers might have done as they wished, but overwhelming commonalities and patterning in graffiti (with respect to their semantic contents and locations) indicate that many graffiti inscribers were following common, if unarticulated, codes of writing conduct.

76. On this and similar points, see the introduction and excellent essays edited by Jörg Rupke and Wolfgang Spickermann in *Reflections on Religious Individuality* (Berlin: DeGruter, 2012), 1–10. I thank Jörg Rupke for his reminder of related arguments.

77. In this study, the term "local" arbitrarily designates continuous and contiguous zones of limited geographic scope (roughly throughout an expanse of 20–30 km, such as the distance between Beit Shearim and Nazareth); "regional" describes areas which are culturally and geographically continuous, with more extensive geographic range (such as Arabia or Sinai); while "cross-regional" designates independent geographic zones with little topographical continuity (such as Syria and Italy, or the Black Sea and North Africa).

78. Recent studies in landscape theory, conducted by Christopher Tilley and others, draw attention to the spatial, geographic, and experiential "fields" of rock art and graffiti. Consideration of the precise placements of individual graffiti, their geometric relationships to neighboring markings, and surrounding architectural and natural features reflects some of Tilley's questions about writing and landscape, which illuminate writers and viewers' perceptions of them. On these and similar points see Christopher Tilley and Wayne Bennett, *Body and Image: Explorations in Landscape Phenomenology 2* (Walnut Creek, CA: Left Coast Press, 2008), 6. See also Colin Renfrew, Chris Gosden, and Elizabeth DeMarrais, *Substance, Memory, Display: Archaeology and Art* (Cambridge: McDonald Institute for Archaeological Research, University of Cambridge, 2004).

79. Human action, to Tilley, reflects and impacts the ways that "people experience and understand the world." Christopher Tilley, *Phenomenology of Landscape I* (Oxford: Berg, 1993), 11.

80. Tilley, *Phenomenology I*, 23, 25, where he states: "Landscapes are experienced in practice, in life activities."

81. David Morgan, *The Sacred Gaze: Religious Visual Culture in Theory and Practice* (Berkeley: University of California Press, 2005), 25. Ongoing research of the senses (as well as the emotions) has enhanced the study of the ancient world. One example of this is Mark Bradley, ed., *Smell and the Ancient Senses: The Senses in Antiquity* (London: Routledge, 2015); see also Deborah Green, "Sweet Spices in the Tomb: An Initial Study of the Uses of Perfume in Jewish Burials," in *Commemorating the Dead: Texts and Artifacts in Context: Studies of Roman, Jewish and Christian Burials*, ed. Laurie Brink and Deborah Green (Berlin: DeGruyter, 2008), 145–76.

82. Carl Kraeling, *The Christian Building. The Excavations at Dura-Europos: Final Report VIII, Part 2* (New Haven, CT: Dura-Europos Publications, 1967), 89–100. On this perspective concerning the visual and the devotional gaze, see David Morgan, *The Sacred Gaze*, 25.

83. On distinctions between the experiences of creators and audiences, see the discussions in Jaś Elsner, *Roman Eyes: Visuality and Subjectivity in Art and Text* (Princeton: Princeton University Press, 2007), 132–176; John Clarke, *Art in the Lives*, 9.

84. As Rachel Neis soundly cautions, the quest to "recover" or "replicate" any ancient sensory experiences (let alone those experienced by graffiti inscribers and audiences) remains futile; Rachel Neis, *The Sense of Sight in Rabbinic Culture* (Oxford: Oxford University Press, 2013), 18.

85. Rachel Neis, *Sense of Sight*, 18.

86. This loosely conforms to what David Morgan would describe as a type of "third way" for the study of history (through images), which navigates between positivist structuralist and post-structuralist vantages on human activity and its interpretation. Morgan, *Visual Piety*, 7–12.

87. Cf. Elsner, "Archaeologies and Agendas," 114–115.

88. Approach considered in Margaret Williams, "Jewish Festal Names in Antiquity – A Neglected Area of Onomastic Research," *JSJ* 36, no. 1 (2005): 21–40; also Williams, "The Use of Alternative Names by Diaspora Jews in Late Antiquity," *JSJ* 38 (2007): 307–27. On names diagnostic of Jewish populations in Judaea/Palestina and the Mediterranean diaspora, see the careful ongoing studies of Tal Ilan, *Lexicon of Jewish Names in Late Antiquity 330 BCE – 650 CE: The Western Diaspora* (Tübingen: Mohr Siebeck, 2008); Tal Ilan, *Lexicon of Jewish Names in Late Antiquity 330 BCE – 650 CE. Part IV: Eastern Diaspora* (Tübingen: Mohr Siebeck, 2011); Tal Ilan, *Lexicon of Jewish Names in Late Antiquity. Part II: Palestine 200–650* (Tübingen: Mohr Siebeck, 2012); Tal Ilan, *Lexicon of Jewish Names in Late Antiquity. Part I: Palestine 330 BCE–200 CE* (Tübingen: Mohr Siebeck, 2002).

89. On criteria for establishing connections between Jews and inscriptions, see David Noy, *Jewish Inscriptions of Western Europe, Volume I: Italy (excluding the City of Rome), Spain and Gaul* (Cambridge: Cambridge University Press, 1993), ix–x. For a recent discussion of broader and related points, see Cyn-

thia Baker, *Jew, Key Words in Jewish Studies* (New Brunswick, NJ: Rutgers, 2016); also see Cohen, *Beginnings of Jewishness*, 69–106; Ross Kraemer, "On the Meaning of the Term 'Jew' in Greco-Roman Inscriptions," *HTR* 82 (1989), 35–53; see also Lawrence Kant, "Jewish Inscriptions in Greek and Latin," *ANRW II* 20.2 (1987): 671–713.

90. It remains notoriously difficult, in many cases, to differentiate between Jewish, Christian, and pagan iconography and names—particularly in periods of late antiquity. See discussions in Karen B. Stern, "Limitations of 'Jewish' as a Label in Roman North Africa," *JSJ* 39 (2008), 307–36; Ross Kraemer, "Jewish Tuna and Christian Fish: Identifying Religious Affiliation in Epigraphic Sources," *HTR* 84 (1991): 141–62; and Elsner, "Archaeologies and Agendas," 115.

91. On this and similar points see David Frankfurter, "Iconoclasm and Christianization in Late Ancient Egypt: Christian Treatments of Space and Image," in *From Temple to Church: Destruction and Renewal of Local Cultic Topography in Late Antiquity*, ed. Johannes Hahn, Stephen Emmel, and Ulrich Gotter (Leiden: Brill, 2008), 152.

92. Nicola Denzey Lewis discusses the lack of reliability of using the presence of Jewish graves to determine the "Jewishness" of the surrounding cemetery in *The Early Modern Invention of Late Ancient Rome* (Cambridge: Cambridge University Press, forthcoming 2018).

93. Examinations of these objects cannot determine, for example, *what kind of Jew* would have scratched an acclamation outside of a pagan sanctuary, or, for that matter, *what kind of Jew* would have scratched the image of his face into the wall of a synagogue; such questions draw from a host of negative assumptions about what behavior was considered normative among ancient Jews.

94. Jewish cultures throughout the Greco-Roman world necessarily varied by region; see discussion of this point in Karen B. Stern, *Inscribing Devotion and Death: Archaeological Evidence for Jewish Populations of North Africa* (Leiden: Brill, 2008), 1–11.

95. The most recent and significant assessment of these questions, with extensive bibliography, offered in Baker, *Jew*, 1–33.

96. The problem of determining what symbols definitively designate whether or not burials are "Jewish" remains central to examinations of archaeological evidence for Jewish populations in antiquity. For a discussion of this point, see Goodman, "Jews and Judaism," esp. 210–12.

97. Scholars such as Ross Kraemer have noted that reliance on criteria like those above entails a significant selection bias, such that identity markers limit ranges of information available to discuss ancient Jews. But as Hayim Lapin notes, we can only analyze archaeological materials associated with Jews when people marked them as such. Kraemer, "Jewish Tuna," 142; Lapin, *Rabbis as Romans*, 5. An account of comparable difficulties in the identification of Jewish "magical" materials can be found in Gideon Bohak, *Ancient Jewish Magic: A History* (Cambridge: Cambridge University Press, 2008), 295–6.

98. Hypotheses abound for the precise chronology of Dura's destruction, let alone the process whereby the synagogue fell out of use (and reuse). See chapter 1, note 20 below.

99. See the questions raised in Schwartz, *Imperialism*, 154. This question of reuse beleaguers the assessment of a grafitto associated with Jews found on the Temple of Bel in Palmyra, which, according to Noy and Bloedhorn, "presumably post-dates the Christian use of the building and pre-dates the Islamic one" (Syr48; IJO III, 75–6).

100. Aramaic graffiti and dipinti are somewhat more difficult to date, as Aramaic may have been used continuously through later centuries; see the discussion of the latter point in Tal Ilan, *Lexicon*, 499–505.

101. Presumably, for example, any regional Greek graffiti are appropriately dated to Hellenistic through later Byzantine periods—the language was not used significantly in the Levant after these points outside of Eastern Orthodox contexts.

102. To those who could not read words easily (individuals who operated along various spectra of literacy), such applications of words could appear to be encoded, but to others (who could read words more easily), the inscriptions might be easily comprehensible. See the discussion of this point in Karen B. Stern, "Tagging Sacred Space," 169; also Baird and Taylor, *Ancient Graffiti*, 7. For bibliography concerning ranges of literacy, see also Introduction, note 57 above.

103. In many contexts, indeed, decisions to write with pictures, rather than words, might have been context-dependent, rather than ability-driven.

104. Elites commonly wrote graffiti throughout the Mediterranean; sometimes graffiti indicates the work of elites, while, at other times, it demonstrates lower status individuals' elite aspirations. For the former, see the remarks on this point in Zadoronjnyi, "Transcripts of Dissent," 110–33; for the latter, Molly Swetnam-Burland, "Encountering Ovid's *Phaedra*," 225–27. See also Keegan, *Graffiti in Antiquity*, 193.

105. Elites, in most geographic contexts, are disproportionately represented in the archaeological record, because only they could afford to purchase and commission diagnostic buildings, housewares, and adornments in non-ephemeral (more durable) materials that flaunted their status and better resisted decay. Elites' prolific donations to public works and life were also well measured in inscriptions detailing their precise activities. Many difficulties, however, beset efforts to triangulate more ambiguous positions of class and status in the ancient world, where such categories map inexactly onto ancient terminologies (whether in Greek, Latin, or Hebrew). These and additional points are raised in Clarke, *Art in the Lives*, 4. For a reproduction of diagrams on social order and comparisons of social groups with a "class model" in Rome, see Clark, *Art in the Lives*, 6 (figs. 1 and 2). Interpretive models for class and status in Roman society are presented in Brent Shaw, "Social Science and Ancient History: Keith Hopkins in Partibus Infidelium," *Helios* 9 (1982): 34–8; also Knapp, *Invisible Romans*, 5; Inge Mennen, *Power and Status in the Roman Empire, AD 193–284* (Leiden: Brill, 2011). Discussions

of local elites and their roles can be found in Judith Perkins, *Roman Imperial Identities in the Early Christian Era* (New York: Routledge, 2009), where Perkins uses "elite" "to designate the trans-empire group identity evolving in the early empire of persons bound together by ties of privilege, education, culture, and connections with the imperial center and by the shared self-identity these ties constituted" (5). See also the critiques of the latter point and associated methodologies in Daniëlle Slootjes, "Local Elites and Power in the Roman World: Modern Theories and Models," *Journal of Interdisciplinary History* 42, no. 2 (2011): 235–49; and the seminal work of Peter Garnsey, *Social Status and Legal Privilege in the Roman Empire* (Oxford: Oxford University Press, 1970).

106. For a slightly different perspective on the status of rabbis in the Roman world, see Schwartz, *The Ancient Jews,* 155.

107. Hayim Lapin notes that: "Rabbis as a group were urban, highly educated, and relatively wealthy participants in the Roman East—and, presumably citizens—after 212 C.E." Lapin, "The Law of Moses and the Jews: Rabbis, Ethnic Making, and Romanization," in *Christians and the Roman Empire: The Poetics of Power in Late Antiquity,* ed. Nathalie Dohrmann and Annette Yoshiko Reed (Philadelphia: University of Pennsylvania Press, 2013), 79–92; 91. A discussion of the priestly class in post-destruction Judea and Palestine can be found in Jodi Magness, "Third Century Jews and Judaism at Beit Shearim and Dura Europus," in *Religious Diversity in Late Antiquity,*" ed. David M. Gwynn and Susanne Bangert (Leiden: Brill, 2010), 164.

108. Avigad reports that the menorah, with tripod base, measures 20 cm high and 12 cm (restored) wide. These graffiti are significant, in any case, as they are the most geographically proximate renderings of Temple implements from a period when the Temple still stood. See Nahman Avigad, "Excavations in the Jewish Quarter of the Old City in Jerusalem, 1969–1970," *IEJ* 1/2 (1970): 4–5; Nahman Avigad, "Jerusalem: Herodian Period," in *NEAEHL* 2:731; also Nahman Avigad, *Discovery Jerusalem* (Jerusalem: T. Nelson, 1983), 148; Rachel Hachlili, *Ancient Jewish Art and Archaeology in the Land of Israel* (Leiden: Brill, 1988), 81.

109. See the related points in Aryeh Kasher, *The Jews in Hellenistic and Roman Egypt: The Struggle for Equal Rights* (Tübingen: Mohr Siebeck, 1985), 143.

110. Clarke, *Art and the Roman Viewer,* 8.

111. Examples of this pattern proliferate at Pompeii and in other parts of Italy and Egypt. For Pompeii, see discussions in Swetnam-Burland, "Encountering Ovid's *Phaedra*," 222.

112. A range of perspectives are considered in Joshua Ezra Burns, "The Archaeology of Rabbinic Literature and the Study of Jewish-Christian Relations," in *Religion, Ethnicity, and Identity in Ancient Galilee: A Region in Transition,* ed. Jürgen Zangenberg, Harold Attridge, and Dale B. Martin (Tübingen: Mohr Siebeck, 2017), 403–24.

113. See the discussion in Tilley, *Body and Image,* 6.

114. This is furnished via John Harman's website, which offers public access to these technologies. One presenter at the University of Oxford Symposium,

Scribbling through the Past, organized by Chloë Ragazzoli and Elizabeth Frood at Baliol College, Oxford, introduced participants to methods of digital analysis such as these. The graffiti database and associated documentation for graffiti associated with this project will be detailed additionally in subsequent publications, hopefully with the benefit of RTI documentation.

115. Such debates reflect scholars' ongoing assessments of divergent data for ancient Jewish populations and reactions to a scholarly legacy that overemphasized Jewish essentialism: such scholarship assumed that throughout the ancient Mediterranean (let alone throughout time), all Jews, somehow, were intrinsically the same; see Smith, "Goodenough's Jewish Symbols," 53–68, and the comprehensive summary in Schwartz, *Imperialism,* 155. Schwartz also discusses the "anti-essentialist" focus in the study of Judaism and its implications in *The Ancient Jews,* 13.

CHAPTER 1: CARVING GRAFFITI AS DEVOTION

1. Writing practices associated with Levantine pilgrimages are considered in Fleming, *Graffiti and the Writing Arts,* 30.
2. These graffiti have received lesser attention for many reasons, including their linguistic diversity. Considerations of early Georgian graffiti can be found in Yana Tchekhanovets, "Early Georgian Pilgrimage to the Holy Land," *Liber Annuus* 61 (2011): 457; and Syriac graffiti in Sebastian Brock, Haim Goldfus, and Aryeh Kofsky, "The Syriac Inscriptions at the Entrance to Holy Sepulchre, Jerusalem," *Aram* 18–19 (2006–2007): 415–38. Compare also discussions in Emmanuele Testa, *Nazaret Giudeo-Cristiana: Riti. Iscrizioni. Simboli* (Gerusalemme: Tipografia Dei Pp. Francescani, 1969), 57; Joan E. Taylor, *Christians and the Holy Places: The Myth of Jewish-Christian Origins* (Oxford: Clarendon Press, 1993), 221–67. See also Avraham Negev, *The Inscriptions of Wadi Haggag, Sinai* (Jerusalem: Institute of Archaeology, Hebrew University of Jerusalem, 1977); and Michael Edward Stone, *Rock Inscriptions and Graffiti Project Catalogue of Inscriptions* (Atlanta, GA: Scholars Press, 1992); Roman Christian graffiti are considered in Ann Marie Yasin, "Prayers on Site: The Materiality of Devotional Graffiti and the Production of Early Christian Sacred Space," in *Viewing Inscriptions in the Late Antique and Medieval World,* ed. A. Eastmond (Cambridge: Cambridge University Press, 2015), 36–60.
3. Assumptions continue to prevail that for ancient Jews, the physical surroundings of prayer mattered little. Many assume that after the Roman destruction of the Temple in 70 CE, the importance of the *locality* or "place-ness" of Jewish devotional practice transformed; Jonathan Z. Smith, *To Take Place: Toward Theory in Ritual* (Chicago: University of Chicago Press, 1992).
4. On the role of the visual in rabbinic culture, see the introduction to the recent work of Neis, *Sense of Sight,* 5–10.

5. A useful summary of these features presented in Lee I. Levine, "The Synagogue," in *The Oxford Handbook of Jewish Daily Life in Roman Palestine*, ed. Catherine Hezser (New York: Oxford University Press, 2010), 531–2.
6. So emphasized in Patricia Baquedano-López, who describes how "Prayer, in this way, is an intrinsic human meaning-making activity that relates the known and the unknown. Prayer grounds humans to earth, yet orients them to a higher spiritual point," in Baquedano-López, "Prayer," *Journal of Linguistic Anthropology* 9, no. 1–2 (1999): 197.
7. Uri Ehrlich, *The Nonverbal Language of Prayer: A New Approach to Jewish Liturgy* (Tübingen: Mohr Siebeck, 2004); Neis, *Sense of Sight*, 1–5; 20–31; see also Reuven Kimelman, "The Rabbinic Theology of the Physical: Blessings, Body and Soul, Resurrection, and Covenant and Election," in *The Cambridge History of Judaism, Vol. 4: The Late Roman–Rabbinic Period*, ed. Steven T. Katz (Cambridge: Cambridge University Press, 2006), 946–76.
8. In many ways, these understandings mirror approaches to "magical" texts and practices in antiquity. See the remarks of Gideon Bohak, *Ancient Jewish Magic*, 112, 303.
9. Examples include 1 Kgs 8:3–11; 2 Chr 6–9; Ezek 10.
10. See the nuanced discussion of "liturgical looking" in Neis, *Sense of Sight*, 186–99. Note the incorporation of "visual blessings" in the rethinking of activities associated with prayer (191); (*m. Ber.* 9:2; *t. Ber.* 6:2–6). As Neis argues, the Temple continued to be as much a focal point of visual orientation and reflection as of argumentation long after its destruction; see also Münz-Manor, "Narrating Salvation," 154–66.
11. See the contextual analysis of graffiti from Dura-Europos in Jennifer Baird, *The Inner Lives of Ancient Houses: An Archaeology of Dura Europos* (Oxford: Oxford University Press, 2014), 173, 175–76; also Yasin, "Prayers on Site," 36–60; David Frankfurter, ed., *Pilgrimage and Holy Space in Late Antique Egypt* (Leiden: Brill, 1998); and Jaś Elsner and Ian Rutherford, *Pilgrimage in Graeco-Roman and Early Christian Antiquity: Seeing the Gods* (Oxford: Oxford University Press, 2005).
12. A consideration of the properties of sanctity can be found in Yasin, *Saints and Church Spaces in the Late Ancient Mediterranean* (Cambridge: Cambridge University Press, 2012), 288; Juliette Day et al., *Spaces in Late Antiquity: Cultural, Theological and Archaeological Perspectives* (New York: Routledge, 2016).
13. See discussion in Annabel Wharton, "Erasure: Eliminating the Space of Late Ancient Judaism," in *From Dura to Sepphoris. Studies in Jewish Art and Society in Late Antiquity. Journal of Roman Archaeology*, suppl. 40, ed. Lee I. Levine and Ze'ev Weiss (Portsmouth, RI: *Journal of Roman Archaeology*, 2000), 195–214.
14. These graffiti are published in disparate compendia; those found in Saudi Arabia are sometimes published in Saudi publications in Arabic, which renders them inaccessible to some interested scholars.
15. Graffiti of menorahs are preserved in later synagogues, such as those in Stobi and Sardis. A map of the Stobi synagogue, which indicates the locations of

its menorah graffiti, is included in IJO I, 58–69. Also J. Wiseman and D. Mano-Zissi, "Stobi: A City of Ancient Macedonia," *JFA* 3 (1976), 295–6, fig. 31. For discussion of dipinti from the synagogue, most of which include monumental paintings and inscriptions, see James Wiseman, "Jews at Stobi," in *Miscellanea Emilio Marin Sexagenario Dicata*, ed. Hrvatin G. Jurišić (Split: Zbornik Kačić, 2011), 325–50; Alexander Panayotov, "Jews and Jewish Communities in the Balkans and the Aegean until the Twelfth Century," in *The Jewish-Greek Tradition in Antiquity and the Byzantine Empire*, ed. James K. Aitken and James Carleton Paget (New York: Cambridge University Press, 2014), 60. Examples at Sardis are mentioned in the textual assessment of John H. Kroll, "The Greek Inscriptions of the Sardis Synagogue," *HTR* 94.1 (2001): 5–55.

16. Keegan, *Graffiti in Antiquity*, 2.
17. The demography of Dura is considered in C. Welles, "The Population of Roman Dura," in *Studies in Roman Economic and Social History in Honor of Allan Chester Johnson*, ed. P. R. Coleman-Norton (Princeton, NJ: Princeton University Press, 1951), 251–74; Bernard Goldman, "Foreigners at Dura-Europos," *Le Muséon* 103, no. 1 (1990): 5–25; Jaś Elsner, *Roman Eyes*, 258–81; Susan B. Downey, *Mesopotamian Religious Architecture: Alexander through the Parthians* (Princeton, NJ: Princeton University Press, 1988), 79–101; Ted Kaizer, "Religion and Language in Dura-Europos," in *From Hellenism to Islam: Cultural and Linguistic Change in the Roman Near East*, ed. Hannah Cotton et al. (Cambridge: Cambridge University Press, 2009), 235–54.
18. The Palmyrene cult is addressed in Lucinda Dirven, *The Palmyrenes of Dura-Europos: A Study of Religious Interaction in Roman Syria* (Boston: Brill, 1999). The Christian building is discussed in Carl H. Kraeling and C. Bradford Welles, *The Christian Building* (New Haven: Dura-Europos Publications, 1967); and L. Michael White, *Building God's House in the Roman World: Architectural Adaptation among Pagans, Jews, and Christians* (Baltimore, MD: Johns Hopkins University Press, 1990).
19. There is a fascinating treatment of Dura's demise in the recent work of Simon James, "Stratagems, Combat, and 'Chemical Warfare' in the Siege Mines of Dura-Europos," *AJA* 115, no. 1 (2011): 69; and Baird, *The Inner Lives*, 1–38.
20. Dates for these events remain disputed, as reviewed in James, "Stratagems, Combat": 69.
21. The date of this renovation is explicitly announced in one of the dipinti on the ceiling tiles; see the discussion in Karen B. Stern, "Mapping Devotion in Roman Dura-Europos: A Reconsideration of the Synagogue Ceiling," *AJA* 114, no. 3 (2010): 473–504. The phasing of the synagogue is outlined in White, *Building God's House*, 123–31; Rachel Hachlili, *Ancient Jewish Art and Archaeology in the Diaspora* (Leiden: Brill, 1998); Annabel Jane Wharton, *Refiguring the Post-Classical City: Dura Europos, Jerash, Jerusalem, and Ravenna* (Cambridge: Cambridge University Press, 1995); and Ben Zion Rosenfeld and Rivka Potchebutzky, "The Civilian-Military Community in the Two Phases of the Synagogue at Dura Europos: A New Approach," *Levant* 41, no. 2 (2009): 195–201.

22. Inscriptions and iconography of murals explicitly associated the space with Jewish populations; Lea Roth-Gerson, *The Jews of Syria as Reflected in the Greek Inscriptions* (Jerusalem: Merkaz Zalman Shazar Le-toldot Yiśraʾel, 2001); Carl H. Kraeling, *The Synagogue* (New York: Ktav Publishing House, 1979).

23. Steven Fine, *Art and Judaism in the Greco-Roman World: Toward a New Jewish Archaeology* (Cambridge: Cambridge University Press, 2005), 174–85.

24. Scholarship on the synagogue abounds, but seminal treatments include that of Michael Ivanovitch Rostovtzeff et al., *The Excavations at Dura-Europos; Preliminary Report of the 6th Season of Work October 1932–March 1933: Conducted by Yale University and the French Academy of Inscriptions and Letters* (New Haven, CT: Yale University Press, 1936); Michael Ivanovitch Rostovtzeff, C. Bradford Welles, and Frank Edward Brown, *Preliminary Report of the 7th and 8th Seasons of Work, 1933–34 and 1934–35* (New Haven, CT: Humphrey Milford, 1939); Eliezar Lipa Sukenik, *The Synagogue of Dura Europos and Its Frescoes* (Jerusalem: Mossad Bialik, 1948); Ann Louise Perkins, *The Art of Dura-Europos* (Oxford: Clarendon Press, 1973); Kraeling, *The Synagogue*; Joseph Gutmann, *The Dura-Europos Synagogue; a Re-evaluation (1932–1972)* (Chambersburg, PA: American Academy of Religion, 1973); White, *Building God's House*; Wharton, *Refiguring the Post-Classical City*; Rachel Hachlili, *Ancient Jewish Art and Archaeology in the Diaspora* (Leiden: Brill, 1998); Robin Jensen, "The Dura Europos Synagogue, Early Christian Art, and Religious Life in Dura Europos," in *Jews, Christians, and Polytheists in the Ancient Synagogue: Cultural Interaction during the Greco-Roman Period*, ed. Steven Fine (London: Routledge, 1999), 154–68; Lee I. Levine, *Ancient Synagogue: The First Thousand Years* (New Haven, CT: Yale University Press, 2008); Margaret Olin, "'Early Christian Synagogues' and 'Jewish Art Historians': The Discovery of the Synagogue of Dura-Europos," *Marburger Jahrbuch Für Kunstwissenschaft* 27 (2000): 7–28; Fine, *Art and Judaism*, 174–185; Elsner, *Roman Eyes*, 271–80.

25. Figural graffiti from the synagogue are considered in Karen B. Stern, "Celebrating," 240–8.

26. Fewer than one third of the graffiti identified in the synagogue are pictorial. This count is based on collections of inscriptions and images published in *IJO* III and Kraeling, *The Synagogue*; also clarified in Stern, "Tagging Sacred Space," 181.

27. See the related discussions in Bernard Goldman, "Pictorial Graffiti of Dura Europos," *Parthica* 1 (1999): 19–106; Baird and Taylor, *Ancient Graffiti*, 4; Kraeling, *The Synagogue*, 261–320.

28. Most signatures are in Aramaic; see Sukenik, *Dura Europos Synagogue*, 45. One Persian graffito discovered on a doorjamb may contain a Persian name (Syr126), while a Greek graffito scratched onto the so-called Dado below panel WD7(S) may also replicate this pattern of incised names (Syr107). Due to the precise location of the letters on the border of a painted image and to its significantly larger size (roughly 4–9.7cm), it may, as Roth-Gerson suggests, serve as the name of a workman or a painter; *Jews of Syria*, 101.

29. Syr94; a distinct reading and translation of this text, from autopsy, is in Compte du Mesnil du Buisson, *Les Peintures du Doura-Europos* (Rome: Pontifical Biblical Institute, 1939), 162, no. 21. Please note that all transcriptions and translations of graffiti from the Dura synagogue follow those of IJO III, unless otherwise noted. The prefix of "Syr" indicates the IJO cataloguing system.

30. This text was discovered on a plaster fragment in the debris from the synagogue forecourt. I divide this inscription into three (Syr93a-c), because of paleographic and spatial distinctions; IJO III and Torrey in Kraeling, *The Synagogue*, assign it a single number.

31. Karen B. Stern, "Inscription as Religious Competition in Third-Century Syria," in *Religious Competition in the Third Century C.E.: Jews, Christians, and the Greco-Roman World*, ed. Jordan D. Rosenblum, Lily Vuong, and Nathaniel P. DesRosiers (Gottingen: Vandenhoeck and Ruprecht, 2014), 141–52. The personal name does not recur in epigraphic contexts with great frequency. Another example from Jaffa is considered in CIIP III no. 2198.

32. This probably derives from Room 7 of the earlier building. Another Aramaic graffito, discovered on a piece of stone trim from the later synagogue, comparably declares: "I am Phineas, son of Jeremiah, son of . . ." (Syr95).

33. See the discussion of Noy and Bloedhorn, IJO III, 138. While these two graffiti include similar syntax, they are written in different hands; there is little indication that these three texts on the same lintel were written at the same time.

34. E.g., Syr90; on the Greek formula for remembrance, see Albertus Rehm, "MNĒSTHĒ," *Philologus* 39 (1940): 1–39.

35. Syr82; fig.9.

36. Syr91; this restoration, transcription, and translation in IJO III follow those of Naveh, "Graffiti and Dedications," *BASOR* 235 (1979): 27–29.

37. These types of dedicatory inscriptions, which explicitly describe donors' activities, do appear in the synagogue ceiling (Syr85–88) and on the architectural niche (Syr89). These texts commemorate donations to the building; cf. Syr87; 83; 91; 92.

38. Synagogues from Nāwa (southern Syria) to Susiya (southern Palaestina) commonly employ similar formulae of remembrance in Greek and Aramaic dedicatory texts. Roth-Gerson, *The Jews of Syria*, 69; see also examples throughout Joseph Naveh, *On Stone and Mosaic: The Aramaic and Hebrew Inscriptions from Ancient Synagogues* (Tel Aviv: Pel'i, 1978).

39. Commemoration of dedications of specific portions of a synagogue is attested in Apamea, where donors conventionally announced the number of feet of mosaic they had commissioned; e.g., Syr59–69; see the discussion in David Noy and Susan Sorek, "'Peace and Mercy upon All Your Blessed People': Jews and Christians at Apamea in Late Antiquity," *Jewish Culture and History* 6, no. 2 (2003): 14–17.

40. Examples of these types of inscriptions abound. See John Healey, "'May He Be Remembered for the Good': An Aramaic Formula," in *Targumic*

and Cognate Studies: Essays in Honour of Martin McNamara, ed. Kevin
J. Cathcart, Michael Maher, and Martin McNamara (Sheffield, UK: Shef-
field Academic Press, 1996), 177–86; and examples in Naveh, "Graffiti and
Dedications," 28; A. H. Al-Jadir, "A New Inscription from Hatra," *Journal
of Semitic Studies* 51, no. 2 (2006): 307–8; Jacob Hoftijzer et al., *Dictionary
of the North-West Semitic Inscriptions* (Leiden: Brill, 1995), 248–49; 321–30;
Rehm, "MNĒSTHĒ"; and *Lexicon*, 542.

41. For discussion of acclamations in Asia Minor see Charlotte Roueché, "Accla-
mations in the Later Roman Empire: New Evidence from Aphrodisias,"
JRS 74 (1984): 181–83; Baird, "The Graffiti of Dura-Europus," in *Graffiti
in Context*, 52.

42. Baird, "The Graffiti of Dura-Europos," in *Ancient Graffiti in Context*,
ed. J. Baird and C. Taylor (New York: Routledge, 2011), 52.

43. Excavators of Dura have noted in passing that verbal, rather than pictorial
graffiti, are discovered more frequently in areas of cultic significance through-
out the city; see Michael Rostovtzeff et al., *The Excavations at Dura-Europos;
Preliminary Report of the 5th Season of Work October 1931–March 1932:
Conducted by Yale University and the French Academy of Inscriptions and Letters*
(New Haven: Yale University Press, 1934), 15; also Kaizer, "Religion and
Language," 235–54; Roberto Bertolino, *Corpus Des Inscriptions Semitiques
De Doura-Europos* (Napoli: Istituto Orientale Di Napoli, 2004); Roberto
Bertolino, *Manuel D'épigraphie Hatréenne* (Paris: Geuthner, 2007).

44. These percentages follow my tabulations and methods presented in Stern,
"Tagging," 184. For locations and transcriptions, see Rostovtzeff et al.,
Preliminary Report of the 5th Season, no. 439, 125. Some of these graffiti
include drawings of male heads or torsos alongside inscriptions, e.g., P. V.
C. Baur et al., *The Excavations at Dura-Europos: Conducted by Yale University
and the French Academy of Inscriptions and Letters. Preliminary Report of the
4th Season of Work* (New Haven, CT: Yale University Press, 1933), 160,
165. These consistently precede one or more personal names and occasion-
ally accompany incised figural images. Rostovtzeff et al., *Preliminary Report
of the 5th Season*, 121; 458; no. 463–6; 131–200; also 21, no. 387; and
16; no. 373. Examples of this appear in Durene fortifications—part of the
precinct of the so-called Temple of Azzanthkona (ibid., 14–16; ibid., nos.
423, 424, 426, 427, 430).

45. Several acclamations were found scratched onto the background of one
cultic niche in the room labeled as D6 and surrounding the altar of room
W7; the area behind the cult statue was painted and covered with graffiti
abbreviated to *mu* to signify *mnēsthē;* Hopkins in Rostovteff et al., *Preliminary
Report of the 5th Season*, 121, 132, 139. See Table 3: row K/column C, of
Stern, "Tagging Sacred Space," 185. It is worth noting that many of the
graffiti discovered were not reported at all in the preliminary publications
of excavations in Dura; few, if any, were drawn or photographed.

46. Graffiti inside domestic spaces can also be associated with cultic contexts;
domestic shrines and altars were common in Dura and elsewhere in the
Mediterranean (e.g., Rostovtzeff et al., *Preliminary Report of the 5th Season*,

15; Baur et al., *Preliminary Report of the 4th Season*, no. 401); discussion of comparable points in Baird, *The Inner Lives*, 274. Clusters of written graffiti around spaces associated with sacrifice and devotional practices suggest the importance of the written word. This pattern also persists in Hatra (e.g., Delbert Roy Hillers and Eleonora Cussini, *Palmyrene Aramaic Texts* [Baltimore: Johns Hopkins University Press, 1996], [*PAT*] nos. 101, 53, 23:4f).

47. Naveh, "Graffiti and Dedications," 27–8.

48. Antecedent traditions in West Asia regard invoking names to serve as rites of remembrance, e.g., 2 Sam 18:18. I thank Saul Olyan for this point and associated references.

49. Al-Jadir's translation of the seven-line text reads:
 1. Remembered before Māran and Mārtan and Barmārēn be
 2. everyone who has entered inside the wall of the city . . .
 3. The curse of [Māran] against anyone who reads this inscription
 4. [and does not say, 'Remembered] for good and excellence before Māran be . . .'
 5. this *NŠRYHB*
 6. before.. . . . '*QBŠM*' for good . . .
 7. wrote [this].

 Al-Jadir, "A New Inscription," 306. This inscription, which follows the *dkr qdm* + deity formula, appears in Iwan 20 of the Hatra temple complex. In this complete version of the formula, the inscriber places an injunction on a passerby to repeat his (the inscriber's) name out loud: should the viewer not vocalize the name, he would (according to the writer's prescription) suffer consequences.

50. Echoes of these emphases on the visual and visual recognition recur in the accounts of later Christian pilgrims, such as Egeria, who emphasize the point of "seeing" a sacred space. I thank Gil Klein for this point. John Wilkinson, *Egeria's Travels*. 3rd ed. (Liverpool: Liverpool University Press, 1999).

51. Recent research on the "dialogical" aspects of Pompeiian graffiti, whereby writers anticipated a secondary response, is presented in Rebecca Benefiel, "Dialogues," 59–101.

52. As Saul Olyan has argued, friends, allies, and relatives who support a petitioner by embracing mourning rights do so to attract the deity's attention to the plight of the petitions more effectively; Saul Olyan, *Biblical Mourning: Ritual and Social Dimensions* (Oxford: Oxford University Press, 2004).

53. Other types of graffiti and dipinti, however, do not necessarily follow these distribution patterns.

54. A Greek graffito from the burial cave in the southern Shefelah in Israel emphasizes the importance of the reader's role. See discussion of texts in Kloner, "New Judean/Jewish Inscriptions," 99.

55. Both the use of *voces magicae* and the importance of speech and magic are discussed in Bohak, *Ancient Jewish Magic*, 203, 243. See the remarks on activation, in church contexts, in Yasin, *Saints and Church Spaces*, 148, n.106.

56. I thank Gil Klein for reminding me of this point. The importance of the locations of the deposits of spells are considered in David Frankfurter,

"Scorpion/Demon: On the Origin of the Mesopotamian Apotropaic Bowl," *JNES* 74, no. 1 (2015): 9–18.

57. See Stern, "Tagging Sacred Space," Tables I–IV.

58. For discussions of the spatial variability of sanctity, see Joan Branham, "Vicarious Sacrality: Temple Space in Ancient Synagogues," in *Ancient Synagogues: Historical Analysis and Archaeological Discovery*, Vol. 2, ed. Dan Urman and Paul Flesher (Leiden: Brill, 2005), 319–45; also Yasin, *Saints and Church Spaces*, 147.

59. Locations of Christian graffiti are recorded by Welles in Kraeling, *The Christian Building*, 92, nos. 8, 6, 7, 15.

60. Other discoveries from the Dura synagogue, including unexpected sealed deposits of two finger bones beneath metal plates within the bases of door sockets that once bordered the synagogue assembly hall, suggest the important apotropaic role of doorways in the synagogue; cf. Rostovtzeff et al. *Preliminary Report of the 6th Season*, Pl. XXIX; Stern, "Tagging Sacred Space," 189.

61. Cf. Exod 21. Placements of menorah graffiti around doorways in mortuary contexts, such as those from Beit Shearim and Jish (unpublished) may reflect similar beliefs about space; see the discussion below. I thank Eldad Keynan for touring me through the Jish site.

62. Deut 6.4–9; 28:5; cf. Exod 21. Decoration of one stone doorframe discovered nearby in Palmyra, for example, quite literally exemplifies this commandment (Deut 6.4–9), as its lintel and frames were continuously inscribed with the *shema* (Syr44) and other biblical passages (Syr45–47); each of these quotes passages from Deuteronomy. It remains difficult, however, to establish dates for these inscriptions. See also discussion in Joseph Naveh and Shaul Shaked, *Magic Spells and Formulae: Aramaic Incantations of Late Antiquity* (Jerusalem: Magnes Press: Hebrew University, 1993), 30; Roth-Gerson, *Jews of Syria*, 277–80. Josephus had praised the custom of affixing writing on doors, years earlier. He described the practice as akin to placing phylacteries on the body; both customs advertise God's great works and confer blessings upon those who perform these actions (A.J. 4.213). Bohak suggests that *mezuzahs* included both liturgical texts and, in some instances, names of angels (*Ancient Jewish Magic*, 64).

63. Stern, "Harnessing the Sacred," 233; discussions of regional Syrian and Mesopotamian analogues for the privileging of doorways and associated deposits in Karen B. Stern, "Opening Doors to Jewish Life in Syro-Mesopotamian Dura-Europos," *JAJ* (2018, forthcoming).

64. In some administrative centers, names and remembrance inscriptions were also found in Greek, i.e., the House of Nebucheleus with the formula of "remember the writer" (*"mnēsthē ho graphas"*); Baur et al., *Preliminary Report of the 4th Season*, 81–5; 189, 191, 192, and 193). Welles writes of the presence of the graffiti: "Either the owner [of the building] would have made no effort to restrain the tendency, ubiquitous at Dura, for children, servants and citizens alike to write their names to indulge their artistic fancy on every available surface, or, in view of the comparative cheapness

of plaster . . . he would presently have had the walls resurfaced . . ."; ibid., 136. Such perspectives, of course, are rooted in modern prejudices about graffiti writing, such as those described in the introduction above. Compare also the discussion of the realities of graffiti writing in Barbet, *Les Murs,* 15-21.

65. See discussion of these panels in IJO III, 180–4. Clusters of writing appear on panels depicting scenes from the life of Elijah (WC1; SC4; SC2–SC3); the triumph of Mordechai (WC2); and Ezekiel and the Valley of Dry Bones (NC1). See the discussion of this point in Wharton, *Refiguring,* 49; see also IJO, 180–181. Some dipinti appear to tattoo the limbs of Haman, Mordechai, and Mordechai's horse (Syr115; Syr116; Syr117); while others mimic the directionality of folds of fabric (Syr111).

66. Syr112; this also indicates that the scribes were at least marginally aware of the subjects in the paintings (Syr119; Syr122).

67. Here I modify the IJO III translation by changing the reading of "God" and "Gods" to "god" and "gods"; Syr113; one scribe, Hormezd, responded to the details of panel WC1 by painting on Elijah's foot: ". . . 'Living | is the child (who had been) dead'" (Syr119).

68. Scribes wrote most of these and reported that they enjoyed their visits there; Syr111; 114–18; 120; 123.

69. These include Syr125 and Syr124, respectively.

70. Some have argued that these were Persian Jews, but their references to plural divinities ("the gods") and their typical Zoroastrian names suggest Zoroastrian rather than Jewish affiliation. Discussion in Steven Fine, "Jewish Identity at the *Limus*: The Earliest Reception of the Dura Europos Synagogue Paintings," in *Cultural Identity in the Ancient Mediterranean: Issues and Debates,* ed. Erich Gruen (Los Angeles: Getty Research Institute, 2011), 289–306.

71. Most of the Persian writings cluster around particular panels, which depict a portion of the Purim story (WC2), Ezekiel's visions (NC1) and the works of the prophet Elijah (SC 2-3). The intensified clustering on these panels, in different ways, suggests that their subject matter particularly resonated with Persian visitors; they seem to have identified with the Persian setting of the Purim story, and additionally, Ezekiel's visions may have resonated with Zoroastrian theology and thought. Still other Persian texts seem to engage in invocatory or devotional writing that seems to evoke Zoroastrian perspectives (including IJO III no. 121). For recent interpretations of Persian dipinti, which are painted and follow distinct formats, see Fine, "Jewish Identity," 289–306. Graffiti are distinguished from other types of texts in the synagogue in Stern, "Tagging Sacred Space," 173.

72. Jensen, "The Dura Europos Synagogue," 105.

73. On related points, see the discussions in Stern, *Inscribing Devotion and Death,* 1–33; and considerations of Michael Satlow, "Beyond Influence: Toward a New Historiographical Paradigm," in *Jewish Literatures and Cultures: Context and Intertext,* ed. Anita Norich and Yaron Z. Eliav (Providence, RI: Brown Judaic Studies, 2008), 91–108.

74. Rostovtzeff et al., *Preliminary Report of the 6th Season*, 15. One graffito emphasizes the "humbleness" of supplicants in the Christian building in Dura, while similar vocabulary recurs in other Christian contexts in the passive voice; see Kraeling, *The Christian Building*, no. 16, 17. In the Mithraeum, in particular, the word "*Nama*" may solicit acclaim or blessings for named inscribers, or for Mithras; see Rostovteff et al. *Preliminary Report of the 5th Season*, 135. On Mithraic graffiti in Dura, see E. D. Francis, "Mithraic Graffiti from Dura Europos," in *Mithraic Studies, vol. II: Proceedings of the First International Congress of Mithraic Studies*, ed. John Hinnells (Manchester, UK: Manchester University Press, 1975), 424–45.

75. Stern, "Tagging Sacred Space," 172.

76. Fine, "Jewish Identity," 303–20.

77. Lindsay Jones particularly advocates viewing sacred spaces through an experiential and hermeneutic lens in *The Hermeneutics of Sacred Architecture* (Cambridge, MA: Harvard University Press, 2000), 122–5. I thank Gil Klein for this reference.

78. On cognate topics, see, among many others: Chad Spigel, *Ancient Synagogue Seating Capacities* (Tübingen: Mohr Siebeck, 2012); Michael Satlow, "Giving for a Return: Jewish Votive Offerings in Late Antiquity," in *Religion and the Self*, ed. David Brakke, Michael Satlow, and Steven Weizman (Indiana: Indiana University Press, 2005), 91–108; Bernadette J. Brooten, *Women Leaders in the Ancient Synagogue: Inscriptional Evidence and Background Issues* (Chico, CA: Scholars Press, 1982); Fine, *Sacred Realm*; Münz-Manor, "Narrating Sacrifice," 154; Fine, "Jewish Identity," 310; Jordan Rosenblum, *Food and Identity in Early Rabbinic Judaism* (Cambridge: Cambridge University Press, 2010), 179; Rajak, *Jewish Dialogue with Greece and Rome*, 463–78; Lee Levine, *The Synagogue*; Louis Isaac Rabinowitz, "The Synagogue," *Encyclopedia Judaica*, 2nd ed. (2007), 19: 352–5.

79. Steven Fine, *Sacred Realm: The Emergence of the Synagogue in the Ancient World* (New York: Oxford University Press, 1996); Fine, "Earliest Reception," 310; Fine, *Towards a New Archaeology*, 1–10.

80. This counters many assumptions, such as those recorded by Louis Isaac Rabinowitz, that the "institution of the synagogue. . . . has remained remarkably consistent throughout the 2,500 years of its history." Louis Isaac Rabinowitz, "The Synagogue," 355.

81. Yasin, *Saints and Church Spaces*, 143–6.

82. Anne Katrine De Gudme, *Before the God in this Place for Good Remembrance: A Comparative Analysis of the Aramaic Votive Inscriptions from Mount Gerizim* (Berlin/Boston: de Gruyter, 2013), 52–89.

83. I thank Gil Klein for emphasizing this point in our conversation.

84. Rachel Mairs, "Egyptian 'Inscriptions' and Greek 'Graffiti' at El Kanais in the Egyptian Eastern Desert," in *Ancient Graffiti in Context*, ed. J. A. Baird and Claire Taylor (New York: Routledge, 2011), 159; C. E. P. Adams, "Travel and the Perception of Space in the Eastern Desert of Egypt," in *Wahrnehmung und Erfassung geographischer Räume in der Antike*, ed. Michael Rathmann (Mainz am Rhein: Philipp von Zabern, 2007), 212–14; see

André Bernand, *Le Paneion D'El-Kanaïs: Les Inscriptions Grecques* (Leiden: Brill, 1972), 30–67; and also André Bernand, *Pan du Désert* (Leiden: Brill, 1977), 1–5; and 241–3, no. 83.

85. Traveler graffiti also appear along wadis, trade routes, and in other Pan temples, e.g., Bernand, *Pan*, 7–31; 118–40; 141–60.

86. Bernand documented ninety-two Greek graffiti during a brief visit to the Paneion in El-Kanaïs; other Greek and Arabic examples remain unpublished. Mairs, "Egyptian 'Inscriptions,'" 152.

87. Adams argues that trade routes shifted considerably in the Roman period and reduced travel through El-Kanaïs in "Travel and the Perception of Space," 214.

88. During this period the term could equally, variously, and concurrently be read as Judean (as a toponymic designation) or as a cultic one (a person who worships the God who dwells in the central Temple in Jerusalem). The meaning of the word is particularly difficult to ascertain during this particular place and time. For such reasons, in the associated discussion, I more cautiously preserve the adjective as *Ioudaios*. See ongoing discussions in Cynthia Baker, *Jew*, 1–12; Cohen, *Beginnings of Jewishness*, 69–106; Adele Reinhartz, "The Vanishing Jews of Antiquity"; and Steve Mason, "Jews, Judeans, Judaizing, Judaism: Problems of Categorization in Ancient History," *Journal for the Study of Judaism* 38 (2007): 457–512, among others.

89. JIGRE no. 121 reads: "*theou eulogia · |Theu{o}dotos Dōriōnos | Ioudaios sōtheis ek pe|l<ag>ous*"; cf. Bernand, *Paneion*, no. 42 (=CIJ II 1537). According to Bernand's measurements, the base of the outline containing the inscription is 1.23 m above the rock ledge, and the inscribed rectangle extends 32 cm high and 40 cm wide (Bernand, *Paneion*, 105–6); consideration of the text and the identity of its subject in Alan Kerkeslager, "Jewish Pilgrimage and Jewish Identity in Hellenistic and Early Roman Egypt," in *Pilgrimage and Holy Space*, ed. David Frankfurter, 220. For challenges associated with translating the term *Ioudaios* into English see note 88 above.

90. JIGRE no. 122=CIJ II 1538=Bernand no. 34; letter heights of 12–15 mm; transcription follows Bernand, no. 34: "*eulogei ton theon. | Ptolemaios | Dionysiou | Ioudaios.*"

91. Translation follows JIGRE no. 123: "*Lazar[os]| e[leluth]ạ | tṛi[ton]*". A fourth graffito merits greater skepticism in its classification as being associated with Jews due to its poor preservation. The text, from the hypostyle room on the first column to the left of the Paneion entrance, is heavily restored by Bernand to read: ". . . and Lazarus came here for the third time . . ." ([- - - kai | La]zar[o]s (?) | elẹlụthan ẹ[vtau | th]a tritoṇ YN [..|..] Y [.]; Bernand no. 24). The inscription is listed in JIGRE (no. 124), but its name is so heavily restored that Horbury and Noy are skeptical about its association with a Jewish writer/commissioner with a diagnostic name.

92. Bernand, *Paneion*, 106; see nos. 26, 47. Horbury and Noy note that the reading of the text is clear, but its syntax is not: Ptolemaios might be the subject of the verb, or the verb might be in the imperative (JIGRE, 210; cf. Bernand no. 34).

93. The Greek reads "*ton theon.*" The lapidary script on the stone cannot indicate any connotations of divine exclusiveness or lack thereof (by differently designating the God, as opposed to a god).

94. The resulting acclamation in the *Ioudaioi* graffiti ("bless 'the God'" in place of "bless Pan") stands out as unusual. Bernand argues that the article before the word for god (*ton*) should be translated as a possessive; "Ioue *notre* Dieu, c'est-à-dire le Dieu des Juifs," *Paneion*, 96. Note that the text is engraved 1.63 m above the rock ledge. Several other graffiti from El-Kanaïs directly address Pan with multiple epithets, such as *Euodos* (giver-of-good-roads), *Sōtēr* (savior), *Epēkoos* (he who listens to prayer), and *Euagros* (of the good-hunt). Translated epithets are given in Adams, "Travel and the Perception of Space," 216; Mairs, "Egyptian 'Inscriptions,'" 159. None of these texts, however, addresses the god as an abstraction (*theon*).

95. Bernand, *Paneion*, 96.

96. Bernand no. 73=JIGRE no. 124. During the Ptolemaic period, the name Lazarus is common, particularly among Egyptian and Cyrenaican Jewish populations, whose bilingual inscriptions translate it from the Hebrew name "Eleazar"; it appears in definitive Jewish contexts in Antinoopolis in or before the second century CE (JIGRE no. 119) and in an Egyptian epitaph discovered in Jaffa from the second through fourth centuries CE (*JIGRE* no. 149). Cf. U. Jantzen, R. Felsch, and H. Keinast, "Samos 1972: Die Wasserleitung des Eupalinos," *Archäologischer Anzeiger, Beiblatt zum Jahrbuch des (Kaiserlichen) Deutschen Archäologischen Instituts* 88 (1973): 401–14.

97. Schwartz, *Imperialism*, 72–4.

98. Mairs, "Egyptian 'Inscriptions,'" 155; Bernand, *Paneion*, 33.

99. The word's gender remains ambiguous, partly because it does not appear in the nominative form in JIGRE nos. 121–2. Horbury and Noy, for example, note that two *Ioudaios* graffiti exclude the "dedication to Pan Euodos which occurs in most of the site's inscriptions." JIGRE, 208. This statement is technically true, but only a slight majority of graffiti found in and around the Paneion explicitly invokes or thanks Pan; see Bernand nos. 2, 39.

100. Multiple visits are attested in Bernand nos. 89, 24, 73, 87, 90; signature graffiti also abound (e.g., Bernand no. 17). Mairs argues that at least 33 percent of the graffiti Bernand records of the Ptolemaic period include only names. "Egyptian 'Inscriptions,'" 155.

101. The other text records a dedication of Didymarchos, son of Eumelios, which invokes Pan as savior (Bernand, *Paneion*, no. 39).

102. See, e.g., Bernand, *Paneion*, no. 39; Pl. 37, 1; nos. 72, 75; Pl. 47, 2.

103. I thank Saul Olyan for this important observation.

104. Graffiti application is considered in Mairs, "Egyptian 'Inscriptions,'" 162. If *Ioudaioi* were capable of scratching words in Greek, they might recognize letters in neighboring graffiti that acclaimed Pan.

105. See the discussion of this point in later Jewish contexts in Stern, "Tagging Sacred Space," 192–4.

106. Non-spontaneous and state-sponsored counterparts of graffiti—the inscriptions on boundary stones—also reflect this approach to landscape. As Gil Klein has usefully reminded me, these stones have a cultic dimension, particularly when they refer to Roman emperors.

107. Discussion in Bernand, *Paneion*, 107; Mairs, "Egyptian Inscriptions," 164 n.2.

108. Some Theban examples exhibit such overwriting, e.g., Jules Baillet, *Inscriptions Grecques et Latines des Tombeaux des Rois ou Syringes à Thèbes* (Le Caire: Institut Français d'Archéologie Orientale du Caire, 1920), Pl. 13b; 17c; 18. Dialogical features of graffiti placement are reflected in graffiti position and context, e.g., Bernand nos. 71, 4; cf. Mairs, "Egyptian 'Inscriptions,'" 162; cf. Rebecca Benefiel, "Dialogues of Ancient Graffiti," 59–101.

109. Mairs, "Egyptian 'Inscriptions,'" 160; Adams calls such graffiti writing, "a ritual of transition," in "Travel and the Perception of Space," 220.

110. Adams, "Travel and the Perception of Space," 220.

111. The editors of IJO I draw a connection between the genres of graffiti associated with Jews in the Paneion and a type of graffito-prayer found carved into the rocks along Grammata Bay in Syros (IJO I Ach72; photo 243). While the vocabulary of the prayer shares much with early Christian imprecations, the text from Syros is enclosed by a tabula ansata and accompanied by a prominent menorah, lulab, and small container inside its upper right boundary (facing). The beginning of the Greek transcription reads: *"K(yri)e Boēthē to dou-|lo sou Eunomio . . ."* ("Lord help your servant Eunomius and all of his crew, Naxians.") IJO I Ach73 follows a similar pattern; it too is accompanied by a menorah and includes a formula that mimics the traveler graffiti found in the Paneion. Editors translate this to: "In the name of the living God, Heortylis the Jew(?), having returned safely, for a good voyage(?)" (IJO I, 245).

112. While the Greek texts and drawings on the cave walls are ancient, ongoing use of the modern shrine continues to curtail excavations that might otherwise illuminate the earliest phases of its use; *Lexicon*, 499.

113. For detailed history of scholarship on the site, see *Lexicon*, 501–3. Presently, the cave and the adjacent platform are open to tourists and to modern pilgrims; the Israeli Ministry of Tourism regulates the site, which is divided into sections for men and women by a movable partition.

114. Largely neglected by scholars until quite recently, Asher Ovadiah's brief initial report on the inscriptions from the cave was published in 1969; in 2011 and 2012, Ovadiah offered supplementary treatments including Asher Ovadiah and Rosario Pierri, "Elijah's Cave on Mount Carmel and Its Inscriptions. Part III," *Liber Annuus* 62 (2012): 203–82; and Asher Ovadiah and Rosario Pierri, *Elijah's Cave on Mount Carmel and Its Inscriptions* (Oxford: Archeopress, 2015); additionally, Ilan published, nearly simultaneously, the appendix about Elijah's Cave in *Lexicon*, 499–584.

115. "From there it is three parasangs to Haifa, which is Hahepher on the seaboard, and on the other side is Mount Carmel, at the foot of which there are many Jewish graves. On the mountain is the cave of Elijah, where the Christians have erected a structure called St. Elias . . ." Excerpt from

the twelfth-century account of Benjamin of Tudela (with note numbers removed); Marcus Nathan Adler, trans., *The Itinerary of Benjamin of Tudela: Critical Text, Translation and Commentary* (New York: Phillip Feldheim, Inc., 1907), digitized version available from depts.washington.edu/silkroad/texts/tudela.html#N_66_, last accessed September 13, 2017.

116. Ilan and Pinkpank thoroughly document literary evidence for associations between Mt. Carmel and the cave and Elijah or Elisha, in *Lexicon*, 503–20.

117. *Lexicon* no. 17; see also no. 27. Cf. Ovadiah and Pierri, *Elijah's Cave* no. 18. Elios is the *subject* of the inscription, an individual who additionally possesses the title of Decurion (of Akko/Ptolemais) and has a son named Cyrillus. The remainder of the text is incomplete, but its presence reinforces the importance of the specific place (*topos*) it adorns. Please note that subsequent translations of texts in the cave follow those of *Lexicon*, unless otherwise noted.

118. *Lexicon* no. 17.

119. One text, for example, declares: "Caius (declared a) vow (*votum*) | Hest (Hestia?) | . . . gentleness to all" (*Lexicon* no. 20a).

120. Ovadiah and Pierri publish more than 150 Greek inscriptions and 43 Hebrew ones, from the east wall of the cave, in an appendix of *Elijah's Cave*, 45. Ilan and Pinkpank have recently published nearly fifty inscriptions but agree that the total number of texts (including those that are impossibly effaced) number in the hundreds. Many of the inscriptions are presently visible, but fabric wall hangings, propped ladders, framed decorations, and bookshelves, which currently decorate the cave, obscure countless others. Ilan and Pinkpank establish the chronology of the graffiti deposits based on the appearance and position of these texts, relative to others in the cave. They also suggest that two monumental inscriptions related to the cave's original use were deliberately effaced by Greek-speaking and Greek-writing Jews who used the cave in later periods in *Lexicon*, 553 and nos. 18,19. No image or icon of a god survives, but such a text, in addition to the presence of an effaced figural relief nearby, implies some sort of pagan cultic use of the site.

121. I have not been able to identify the text during my visits to the cave, but Ovadiah originally read it in 1967. He transcribes a text found in the "aedicula" as follows: "The image (*ikasia=eikasia*) of the god | . . . Theodoros to me | dedicated." Presence of such a text, combined with the presence of an effaced figural relief nearby, collectively suggest a pagan cultic use of the site. Ovadiah and Pierri, "Elijah's Cave, Part III," no. 24, figs. 5, 7; Ovadiah and Pierri, *Elijah's Cave*, no. 24; figs. 52, 53.

122. As I argue elsewhere, niche forms frequently designate cultic spaces throughout the region. Three-dimensional analogues also abound outside comparable cave shrines, such as Banyas, and in temples, such as the Durene Temple of the Aphlad; see also a photo in Ovadiah and Pierri, *Elijah's Cave*, fig. 164. There is further discussion of this point in Stern, "Celebrating," 244–5.

123. Ilan argues against Christian use of the site (*Lexicon*, 509). She also suggests that Christians more rarely employed the *mnēsthē* formula in the form demonstrated here (505, 524). Multiple examples of Christian uses of the

same formula (in the active voice), however, recur in Sinai, as in *Haggag* nos. 25, 31, 47, 90, 245, 248.

124. *Lexicon* no. 17.

125. As *euchē* appears at the beginning of the line, it could intend "prayer," or "vow" like in other regional monumental inscriptions, or could complete the name of a synagogue official (*proseuchē*). Ilan's restoration of the female name following that of Ioudas follows a pattern common in the cave, of including both husbands' and wives' names in inscriptions and dedications of vows (*Lexicon* no. 23).

126. My modification of the translation in *Lexicon* no. 8, which changes the names into Hebrew forms. Ilan and Pinkpank argue in their commentary (to no. 8) that while *Iōannēs* became a popular name among Christians, the spelling of *Ioananos*, which more closely preserves the syllables in its Semitic pronunciation (of *Ioḥanan*), did not.

127. Cf. *Lexicon*, 344, 475.

128. *Lexicon* no. 30; they also include texts of ambiguous cultural association, such as, "Remember Alexander!" (*Lexicon* no. 18).

129. Ovadiah and Pierri, *Elijah's Cave*, fig. 126.

130. *Lexicon* no. 1a. While it remains difficult to establish a date for the Arabic inscription, its incision certainly follows the period of the Arab conquest and probably precedes the Crusader conquest of the region. Ilan argues that this overwriting was deliberate and that the text, an incipit for each Sura of the Qur'ān, served to appropriate the space from Jewish predecessors, whose presence was signified by carvings of menorahs, among other inscriptions; *Lexicon* 509; 525.

131. Ilan offers this argument about the dating of the menorah symbol; *Lexicon*, 509.

132. For example, the chronology of the four or five Hebrew and Aramaic inscriptions found in the cave remains particularly ambiguous; their contents differ markedly from their Greek counterparts, and evidence for Jewish use of the space in the Middle Ages and earliest modernity cautions against arguing that these inscriptions are necessarily ancient, rather than medieval or early modern; see treatments in *Lexicon* nos. 10, 11, 37.

133. *Lexicon* no. 23. Jews and Christians in late antiquity often assigned common names: this fact complicates the identification of Jewish inscribers based on names in their signature and remembrance graffiti. Discussion of comparable points in the introduction, above.

134. While Philip (244–249 CE) undertook efforts to consolidate the northern portion of Arabia as Provincia Arabia (southern Syria, the Negev, Jordan, and northwest Saudi Arabia) and to distinguish it from lands farther to the south and southeast, subsequently known as Arabia Felix, it appears that his imperial policies effected few substantive changes. Roman Arabia was never truly or fundamentally romanized, to the degree that one could generalize about cultural change in such a way. On similar topics, see G. W. Bowersock, *Roman Arabia* (Cambridge, MA: Harvard University Press, 1983); Fergus Millar, *The Roman Near East, 31 B.C. – A.D. 337*

(Cambridge, MA: Harvard University Press, 1993), 92–7; Gordon Newby, *The History of the Jews of Arabia from Ancient Times to Their Eclipse under Islam* (Columbia: University of South Carolina Press, 1988), 8. Please note that the following discussion uses "Arabia" as shorthand to describe the region that corresponds with Roman Provincia Arabia and not farther south (Arabia Felix).

135. Nigel Groom, in *Frankincense and Myrrh: A Study of the Arabian Incense Trade* (London and New York: Longman; Beirut: Librairie du liban, 1981), 214–28, argues that the lands of Arabia were less arid in antiquity; cf. Newby, *History of the Jews*, 12.

136. Newby, *History of the Jews*, 10.

137. These types of exchanges are amply detailed in the Periplus of Hanno.

138. Regional historiography is challenging and relies disproportionately on the epigraphic record, as Arabia did not sustain an extensive literary (let alone historiographical) culture in earliest antiquity. Newby, *History of the Jews*, 13.

139. Notable exceptions to this pattern are considered in Newby, *History of the Jews*, 13; see also Robert Hoyland, "The Jews of the Hijaz in the Qurʾān and in their inscriptions," in *New Perspectives on the Qurʾān: The Qurʾān in its Historical Context 2*, ed. Gabriel Said Reynolds (New York: Routledge, 2011), 92; discussion of Jews in southern Arabia in Christian Robin, "Himyar et Israël," *Comptes-rendus des Séances de l'année . . .– Académie Des Inscriptions et Belles-lettres CRAI* 148, no. 2 (2004): 831–40; also Christian Robin, "Le judaïsme de Himyar," *Arabia* I (2003): 97–172.

140. Only one late rabbinic text specifically refers to a rabbi's trip to Hegra, the southern and secondary capital of the Nabataean kingdom; this may reflect a reality or a basic awareness, on the rabbis' part, that some Jews lived or traveled there (e.g., *Exod. Rab.* 42:4). For a broader question of identification, see Haggai Mazuz, "North Arabia and its Jewry in Early Rabbinic Sources: More than Meets the Eye," *Antiguo Oriente* 13 (2015): 149–68.

141. On this point, see Hoyland, "The Jews of the Hijaz," 91–6.

142. Hoyland, "Jews of the Hijaz," translates the text: "This is the tomb which Shubaytu son of Aliu, the Jew (*yhwdy*ʾ), made for himself and his children and for ʿAmirat, his wife. They may be buried in it by hereditary title . . ." (Hoyland no. 1; *CIS* 2.219; JS Nab4). Please note that this and subsequent translations (and transliterations) of Arabian inscriptions follow those of Hoyland, unless otherwise noted. The monumentality of the tomb associated with the inscription above, its resemblance to neighboring examples, and the tomb inscription's explicit declaration, indicates that Shubaytu intended for it to house the remains of multiple generations of his family. This, in turn, suggests that Shubaytu (the son of a Jew) and his family maintained permanent residence around Hegra (modern Madāʾin Ṣāliḥ, Saudi Arabia). Cf. also Hoyland no. 3= JS Nab 386; Jean Cantineau, *Le Nabatéen* (Paris: Leroux, 1930), 2.41; and John F. Healey, "May He Be Remembered for Good: An Aramaic Formula," in *Targumic and Cognate Studies: Essays in Honour of Martin McNamara*, ed. Kevin J. Cathcart, Michael Maher, and

Martin McNamara (Sheffield, UK: Sheffield Academic Press, 1996), H4; Noja, I. Compare the foundation inscription in Robin, "Le Judaïsme," 107, 115.

143. M. C. A. MacDonald, "Ancient Arabia and the Written Word," in *The Development of Arabic as a Written Language*, ed. M. C. A. MacDonald (Oxford: Archaeopress, 2010), 5–28; 15.

144. Robin, "Himyar et Israël," 842; Newby, *History of the Jews*, 10. See discussion of Françoise Demange, "The Frankincense Caravans," in *Roads of Arabia: Archaeology and History of the Kingdom of Saudi Arabia* (Paris: Louvre, 2010), 132–5; on this topic see also the musings of Pliny the Elder, *Nat.* 12, 30–2; Herodotus, *Hist.* 3, 107.

145. Hoyland, "The Jews of the Hijaz," 93.

146. For full apparatus, see Hoyland no. 13; see also Noja XXII.

147. Also one Nabataean Aramaic text is written by a certain "Abīyu son of Salmu" in ʾal-Ulā (first through third century, CE); Hoyland no. 8; Noja VIII; JS Nab387.

148. See also the name and patronymic in a graffito that reads: "ʿAzaryah son of Asyah," in Lihyanite (Dedanitic); names, such as Yehuda and Joseph, may argue for a relationship between the subjects; Hoyland no. 10, cf. no. 5. See also *Haggag*, nos. 14–22; nos. 207–8, 211, 220, 233.

149. Benno Rothenberg, "An Archaeological Survey of South Sinai: First Season 1967–1968. Preliminary Report," *PEQ* 102 (1970): 20.

150. Unedited, Hoyland no. 4.

151. See also "May ʿEzer be remembered well," Hoyland no. 9 (drawing 108); Laïla Nehmé, "A Glimpse of the Development of the Nabatean Script into Arabic Based on Old and New Epigraphic Material," in *The Development of Arabic as a Written Language (Supplement to the Proceedings of the Seminar for Arabian Studies 40)*, ed. M.C.A. MacDonald (Oxford: Archaeopress, 2010), 83. The form *yhwdh* (from the name *yhwsp br yhwdh*) appears in a signature on the Starcky Papyrus, line 39; see Ada Yardeni, "The Decipherment and Restoration of Legal Texts from the Judean Desert: A Reexamination of the Papyrus Starcky (P. Yadin 36)," *SCI* 20 (2001): 127–9, 133.

152. Laïla Nehmé includes these in her treatment of "transitional" Nabataean/ Arabic scripts, in "A Glimpse of the Development," 70, 75, 83. Two additional Nabataean Aramaic graffiti, found in proximity in Umm Judhayidh, may request remembrance for members of the same lineage. One reads, "May Ghanam son of Yehūdā be remembered," (*dkyr ghnmw br yhwdʾ*) and another records, "May Joseph the son of Ghanam be remembered well. Peace"; (*dkyr ywsf br ghnmw b-ṭb w-šlm*) Hoyland nos. 14, 15.

153. Hoyland no. 20. One graffito read in the 1970s on a rock face in the eastern Sinai in Ein Hudeira, dated more definitively to the third through fourth centuries CE, beseeches in Hebrew: "May Samuel son of Hillel be blessed and protected" (Hoyland no. 21), while another graffito in Ein Hudeira includes a Hebrew text bordered by a large menorah. Surrounding graffiti,

most of which date through late antiquity, probably predate the medieval demise of the associated trade route.

154. Rothenberg, "An Archaeological Survey," 20; Pl. VIIIB.

155. An inscription identified in Wadi Haggag, in Sinai reads "+Bless of Lord, your servant Theodore, and Kassia, and Auxos, and Auxos, and Nonna, and Stephan, and John"; *Haggag*, no. 101. Other Greek graffiti include expressions, such as "O Lord Save! (*sōson*)," *Haggag*, no. 102; cf. no. 131; or, "O Lord protect (*phylaxon*) Severus!" no. 112.

156. Rothenberg, "An Archaeological Survey," Pl. VIIIB; IX, XB.

157. For full apparatus see Hoyland no. 23; "Gjobbeh 3–4," 6; Noja XX–XXI.

158. Hoyland no. 24; JS Heb 1; Noja XXVIII; full apparatus in Hoyland. The name Na'īm is culturally ambiguous, but the precise spelling of Isaac and the use of Hebrew writing for the messages jointly index Jewish practice.

159. Hoyland no. 29.

160. M. C. A. MacDonald, "Literacy in an Oral Environment," in *Literacy and Identity in Pre-Islamic Arabia*, ed. M. C. A. MacDonald (Burlington and Farnham: Variorum Collected Studies, 2009), 81; 49–118.

161. Compare discussion in Baird and Taylor, *Ancient Graffiti*, 4.

162. For example, a remembrance request directly addresses the goddess Allat (Alat; JS Nab212; cf. JS Nab213). On regional variations in the *qdm* formula, see assessment in Healey, "'May he be remembered,'" 186.

163. Naveh, "Graffiti and Dedications," *BASOR* (1979): 27–30; 27, n. 3. For complete versions of the formula, see CIS II nos. 401, 403, 572, 698, 912, 1479, 3048, 3072; and also Joseph Naveh, "Sinaitic Remarks," *Sefer Shmuel Yeivin*, ed. S. Abramski et al. (Jerusalem: Kiryat Sepher, 1970), 373–4.

164. The Sinai graffiti were particularly found in areas of Christian pilgrimage, where crosses and Christian imagery also appear in abundance. It remains to be seen whether the proliferation of menorahs and crosses suggest a type of religious contest, visually represented, or merely document a pattern whereby Jews, just like Christians, considered the space of equal importance for a common route of pilgrimage. Negev discusses the importance of the associated pilgrimage route in *Haggag*, 76.

165. Graffiti writing is not only used as prayer in Mediterranean traditions. Ulrich has described to me that she has witnessed, inside Hindu temples in Tamilnadu, students writing their student ID numbers on the walls of secondary shrines as a form of prayer to ask the deity for help in exams. I thank her for these insights.

166. *b. Meg.* 22b; *b. Yoma* 53b; for raised hands, also see Josephus, *C. Ap.* 1.22.209–10.

167. Neis, *Sense of Sight*, 41–79.

168. Ehrlich, *Non-Verbal Language*, 254.

169. Satlow, "Giving for a Return," 102.

170. Cf. Marla Carlson, *Performing Bodies in Pain: Medieval and Post-Modern Martyrs, Mystics and Artists* (New York, Palgrave, 2010).

CHAPTER 2: MORTUARY GRAFFITI IN THE ROMAN EAST

1. Richard A. Webster, NOLA.com | The Times-Picayune. "Tomb of Marie Laveau, Voodoo Queen of New Orleans, Refurbished in Time for Halloween," NOLA.com. 2014. October 29, 2014; updated March 14, 2016, accessed August 11, 2016, www.nola.com/crime/index.ssf/2014/10/tomb_of_marie_laveau_voodoo_qu.html.
2. Robert Florence and J. Mason Florence, *New Orleans Cemeteries: Life in the City of the Dead* (New Orleans, LA: Batture Press, Inc.), 51–61, discuss these points, particularly concerning the use of the Cemetery of St. Louis No. 1.
3. BS I, 136; cf. L. Y. Rahmani and Ayala Sussmann, *A Catalogue of Jewish Ossuaries: In the Collections of the State of Israel* (Jerusalem: Israel Antiquities Authority, 1994), 20.
4. See recent discussion of Lee I. Levine, *Visual Judaism in Late Antiquity: Historical Contexts of Jewish Art* (New Haven, CT: Yale University Press, 2013), 119–40.
5. Rabbinic debates about mourning procedures, for example, detail men's obligations to commission professional female musicians and mourners to play dirges at their wives' funerals (*m. Ketub.* 4:4).
6. Hayim Lapin, *Rabbis as Romans: The Rabbinic Movement in Palestine, 100–400 CE* (New York: Oxford University Press, 2012), 22.
7. Lapin, *Rabbis as Romans*, 64–102; Tessa Rajak, "The Rabbinic Dead and the Diaspora Dead at Beth Shearim," in *The Jewish Dialogue with Greece and Rome: Studies in Cultural and Social Interaction*, ed. Tessa Rajak (Leiden: Brill, 2001), 479–502.
8. Ze'ev Weiss, "Burial Practices in Beth She'arim and the Question of Dating the Patriarchal Necropolis," in *Follow the Wise*, ed. Ze'ev Weiss, Oded Irshai, Jodi Magness, and Seth Schwartz (Winona Lake: Eisenbrauns, 2010), 207–31. It is worth noting, moreover, that the majority of inscriptions from the complex are in Greek, rather than in Hebrew or Aramaic. See the discussion of the latter point in Seth Schwartz, "Language, Power, and Identity in Roman Palestine," *Past and Present*, no. 148 (1995): 3–47.
9. Tilley and Bennett, *Body and Image*, 8–16.
10. On Mazar's personal interests in the site, see Steven Fine, "Death, Burial, and Afterlife," in *The Oxford Handbook of Jewish Daily Life in Palestine* (New York: Oxford, 2010), 453.
11. Three volumes summarizing the Beit Shearim excavations were first published in Hebrew in the 1950s and in English in the 1970s, which recorded discoveries from Catacombs 1–4 and 12–22 and inscriptions from Catacombs 1–8, 11–21, and 25–26. These works summarized the results of excavations from the 1936–1942 and 1954–1958/9 field seasons (BS I–BS III). With the exception of subsequent and isolated explorations of individual catacombs, these publications have directed most data available for scholarly enquiry—particularly since most of the field notes from the excavations have been lost. Few publications, with the exception of *SWP*, have addressed the contents of the surveyed but unexcavated caves; *SWP* I, 343-51.

12. The epitaph, discovered in the mausoleum beside Catacomb 11, is presently on display in the Israel Museum in Jerusalem. Its Greek text translates to "I, the son of Leontios, lie dead, Justus, the son of Sappho | Who, having plucked the fruit of all wisdom | left the light, my poor parents in endless mourning | And my brothers, too, alas in my *Besara* (in BS II translation: "Beth She'arim") | And having gone to Hades, I, Justus, lie here| With many of my own kindred, since mighty Fate so willed | Be of good courage, Justus, no one is immortal!" Transcription and translation from BS II, 97, no. 127. Please note that these and subsequent translations of inscriptions from Beit Shearim follow or modify those published in BS I–III, unless otherwise indicated.

13. Additional discussion of these points in Rajak, "The Rabbinic Dead," 483; and Lapin, "Epigraphical–Reconsidered," 316; *b. Sanh.* 32b.

14. The town does not appear to have occupied a major role in regional trade or commerce, but may have grown in local importance with the presence of the Sanhedrin and the prosperity of neighboring Sepphoris. Avigad estimates that the stonecutters, sculptors, and builders required for the functioning of the necropolis would have been based in the town above the necropolis (BS III, 2–3). Common names discovered in inscriptions from the hilltop synagogue and the subterranean caves suggest significant links between them. Yigal Tepper and Yoram Tepper, *Beth She'arim: The Village and Nearby Burials* (Tel Aviv: Ha-Kibbutz Ha-Meuchad, 2004) [Hebrew]. Many traditionally argued, on the basis of literary and numismatic evidence, that the Beit Shearim catacombs fell out of use by the time of the Gallus Revolt in the late Roman period (c. 352 CE), but a recent article by Ze'ev Weiss convincingly documents the cemetery's extended use from the second century through the Byzantine period; Weiss, "Burial Practices," 231; and also Fanny Vitto, "Byzantine Mosaics at Beth She'arim: New Evidence for the History of the Site," 'Atiqot 28(1996): 136-41. One of the most comprehensive studies of the period and region remains Michael Avi-Yonah, *The Jews under Roman and Byzantine Rule: A Political History of Palestine from the Bar Kokhba War to the Arab Conquest* (New York: Schocken Books, 1984). Scholars, however, have recently challenged certain features of Avi-Yonah's account, such as the regional impact of the Gallus Revolt (esp. 176–81). Renewed excavations of the town, directed by Adi Erlich, remain ongoing and promise additional insights into the history of the settlement.

15. The only exception to this remains an oil lamp, discovered in the first seasons of excavations, which may have borne a Chi-Rho symbol on its discus (BS III, 224, n. 195). Avigad's notes on the object remain apologetic and the image of this lamp remains unpublished. Consultation with drawings of the lamp held in the Mandatory Archive of the Israel Antiquities Authority (in March of 2011), however, revealed that such a reading of the artifact is tenuous at best. The lamp sustained damage on its discus and around the pouring hole before the piece was drawn, which prevents a clear understanding of the original decoration. Additional exploration of

the unexcavated catacombs, however, would surely shed more light on the cultural diversity (or lack thereof) of those buried at Beit Shearim.

16. One portion of a lead sarcophagus was found in Catacomb 20, and five intact examples were found in independent graves nearby (BS III, 173–82). See the comprehensive discussion of lead sarcophagi in L. Y. Rahmani, *A Catalogue of Roman and Byzantine Lead Coffins from Israel* (Jerusalem: Israel Antiquities Authority, 1999).

17. Many postulate that the southeastern portion of the necropolis was in use in earlier periods than most of the northern excavated area (BS III, 259). Several catacombs, moreover, such as 1, 3, 4, 6, 7, and 10, are elaborately painted or carved with consistent decorative programs; it is difficult to establish dates for these. Many of these remain unpublished, aside from brief summaries and drawings in *SWP*. On burial typology and chronology, see the important assessment of Weiss, "Burial Practices," 295. For epigraphic considerations, see the upcoming treatment of inscriptions in CIIP (Galilee volume, forthcoming). For a general treatment of burial practices, art, and architecture among Jews in the Levant and elsewhere, see Rachel Hachlili, *Jewish Funerary Customs, Practices and Rites* (Leiden: Brill, 2005).

18. Lapin, "Epigraphical–Reconsidered," 326.

19. See discussion in BS I, 5. Many debates about the catacombs are social-historical. Inclusions of titles of *rb, rib, rabi,* and *berabbi* on epitaphs, for example, have inspired arguments about the rabbinic populations in Roman Palestine; see the remarks in Hayim Lapin, "Epigraphical Rabbis: A Reconsideration," *JQR* 101 (2011): 317; Lee I. Levine, "Bet She'arim in its Patriarchal Context," 197–225; Shaye J. D. Cohen, "Epigraphical Rabbis," *JQR* 72 (1981–1982): 1–17; Rajak, "The Rabbinic Dead," 481.

20. See Lapin, "Epigraphical–Reconsidered," 313, 316; Rajak, "Rabbinic Dead," 490; also Catherine Heszer in *The Oxford Handbook of Jewish Daily Life in Roman Palestine*, ed. Catherine Heszer (New York: Oxford University Press, 2010), 23; Fergus Millar, "Inscriptions, Synagogues, and Rabbis in Late Antique Palestine," *JSJ* 42 (2011): 253–77; Ben Zion Rosenfeld, "The Title 'Rabbi' in Third- to Seventh-Century Inscriptions in Palestine Revisited," *Journal of Jewish Studies* 61, no. 2 (2010): 234–56; Stuart S. Miller, "The Rabbis and the Non-Existent Monolithic Synagogue," in *Jews, Christians, and Polytheists in the Ancient Synagogue*, ed. S. Fine (New York: Routledge, 1999), 57–70. There is a brief summary of the dynamics between rabbinic and non-rabbinic Jewish populations in Palestine in Schwartz, *Imperialism*, 164–6; Levine, *Visual Judaism*, 402–55.

21. This count is discussed in Rajak, "Rabbinic Dead," 489. Also see Michael Peppard, "Personal Names and Ethnic Hybridity in Late Ancient Galilee: The Data from Beit Shearim," in *Religion, Ethnicity and Identity in Ancient Galilee: A Region in Transition*, ed. Jürgen Zangenberg, Harold Attridge, and Dale Martin (Tübingen: Mohr Siebeck, 2007), 99–114.

22. In particular, the epitaph of "noble Karteria" in BS II, 157, no. 183; see also Nahman Avigad and Benjamin Mazar, "Beth Shearim," *The New*

Encyclopedia of Archeological Excavations in the Holy Land, ed. E. Stern (New York, Carta, 1993), 238.

23. Historians in the earliest days of modern Israeli statehood particularly emphasized this feature of the necropolis. Fine, "Death, Burial," 410. See also Rajak, "Rabbinic Dead," 481. Arguments respond to texts including those of *y. Kil.* 9:3, 41b-42a; and *y. Mo'ed Qaṭ.* 3:5, 14b.

24. Lapin, *Rabbis as Romans*, 233; Lee I. Levine, "Bet She'arim," 197–225; Lapin, "Epigraphical Rabbis," 311; Schwartz, *Imperialism*, 155; and Rajak, "Rabbinic Dead," 479–82; cf. the approach of Isaiah Gafni, *Land, Center and Diaspora: Jewish Constructs in Late Antiquity* (Sheffield, UK: Sheffield, 1997), who notes: "The inscriptions in Greek probably serve as the main testimony to those who were brought to Bet Shearim from abroad, although some of the Greek inscriptions, and certainly the Hebrew and Aramaic ones, may also designate graves of deceased persons from the land of Israel" (*Land, Center*, 89, n. 29). Greek remained a dominant epigraphic language in Judaea and Palestine from the Hellenistic through Byzantine periods; see also Jon Davies, *Death, Burial and Rebirth in the Religions of Antiquity* (London and New York: Routledge, 1999), 108. Seminal discussions of this point can be found in Saul Lieberman, *Greek in Jewish Palestine* (New York: Jewish Theological Seminary of New York, 1942); and Schwartz, "Language, Power, and Identity," 3–10.

25. All but one sarcophagus from Catacomb 20 suffered aggressive damage from robbing; loculus and arcosolium graves had all been looted before archaeologists could study them. Due to the pervasive pillage of the site, as described above, few artifacts from the cemetery were discovered *in situ*; BS III, 93.

26. A large proportion of figural graffiti and monumental decoration from Catacombs 3 and 4 were more recently targeted.

27. Parts of the façade were reconstructed to its present form, but the graffiti remain *in situ*.

28. I prefer and modify the translation in BS II ("Be of good courage, pious parents! No one is immortal.") to that in BS III ("May you be comforted holy fathers, no one is immortal") for the Greek: "*tharsite | pateres 'hosioi | oudis athanatos.*"; BS II no. 193, fig. 19 (cf. BS III, 95, fig. 41) =SEG 17.780. Letter heights of this inscription vary considerably and range from 5 to 13 cm. These and subsequent measurements are my own unless otherwise indicated.

29. The Greek reads: "*<ech> eutychōs tē hymōn <u>anastasi*"; BS II no. 194, fig. 20 (cf. BS III, 95, fig 42). BS III translates this as "Good luck in your resurrection" (BS III, 95, fig. 42), while BS II elaborates: "Good luck for the resurrection of your souls" (BS II no. 194)=SEG 17.781. The transcription in BS III, furthermore, does not make note of the initial epsilon and chi, which appear at the beginning of the phrase. The letters remain sufficiently clear to support these readings.

30. Most notably, the alphas are rendered in entirely different ways in each text.

31. Heights of these figures vary and average between 7–13 cm high and 2–5 cm wide.
32. BS II nos. 136, 137, 141, 147, 148.
33. BS II, 122, fig. 5. The graffito is 1.42 m above the current ground level. It clearly renders: "*AEKSO EPH.*" Average letter heights are 14 cm. Moshe Schwabe viewed this graffito and the menorah graffito around the corner as linked in a meaningful way, and a means to render a "semi-pictographic sentence"; BS III, 22. According to this understanding, the Greek expression, translated as "[May]I attain [happiness]" is completed through the signification of the menorah symbol around the corner (the menorah as aspirational); BS III, 23 (=BS II no. 133).
34. Both inscriptions in BS II, 121–2, no. 133.
35. Please note that I adopt the terminology employed in BS I–III to map the numbers of the catacombs, their constituent halls, and rooms.
36. BS II, 123, no. 134; BS III, 23.
37. Translation from BS III, 23, 233. Curses such as these recur in tombs associated with Jews from elsewhere. An example from Syracuse of the fourth or fifth century appears in JIWE I no. 152=CIJ I 652.
38. BS III, 24.
39. Its demography may be distinctive from that of Catacomb 12; inscriptions from Catacomb 13 are written in Greek and in Hebrew, rather than in Aramaic.
40. The translation here follows that in BS II. Consideration of Catacomb 13, Room II in BS II, 139; BS III, 36, Pl. XI. Schwabe and Lifshitz report that "the formula used in the present inscription has no parallel at Beth She'arim nor at other places in Palestine and constitutes explicit evidence of the current belief in resurrection of the dead" (BS II, 139, 223–4); cf. the treatment in J. Park, *Conceptions of Afterlife in Jewish Inscriptions* (Tübingen: Mohr Siebeck, 2000).
41. BS I, 61; for location see plan in BS I, 46, Plan 1.
42. BS II, no. 73; BS I, 122; ships in Pl. XX, 1,2.
43. Joseph Patrich, "Inscriptions araméennes juives dans les grottes d'El-'Aleiliyāt," *RB* 92 (1985): 270 n. 12.
44. BS I, 150–1.
45. See the discussion of this point in Schwartz, *Imperialism*, 156.
46. Catacomb 10, by far, has the grandest painted decoration of the explored catacombs in Beit Shearim. It is not open to visitors and is now partly cemented off. See drawings of cave in *SWP I*, 243.
47. These and other figural images were purposefully effaced in the early 1990s by vandals.
48. "Pagan" features of this personal name often inform interpretations of surrounding graffiti; on this point, see my discussion in "Graffiti as Gift: Mortuary and Devotional Graffiti in the Late Ancient Levant," in *The Gift in Antiquity*, ed. Michael Satlow (New York: Wiley-Blackwell, 2013), 144.
49. BS I, 182–4; fig. 15; pl. XXXVI, 2. The top of the combatant's head is approximately 170 cm above the current ground level. Excavators suggest

that the image is that of a soldier who represents the deceased Germanos; see note 120, below.

50. BS I, 183. Images reproduced in BS I, pl. XXXVI, 3; and Stern, "Graffiti as Gift," fig. 10.3.
51. Weiss, "Adopting a Novelty," 47–8. The middle of the graffito is approximately 105 centimeters above the current ground level in the cave.
52. Photo in BS I, Pl. XXXVI, 5; Stern, "Graffiti as Gift," fig. 10.4.
53. Mazar points to the ancient Near Eastern context of the last image (BS I, 187); see also M. Avi-Yonah, *Oriental Art in Roman Palestine* (Rome: University of Rome, 1961), 135. One of the closest analogues for the image, however, comes from Italy; Ross Holloway, "The Tomb of the Diver," *AJA* 110 (2006): 365–88.
54. Its construction and courtyard decoration thus mirror that of Catacomb 8 across the valley, an observation that betrays some effort for a more programatic approach to mortuary architecture on this side of the necropolis.
55. The figure is 18 cm high and appears 1.13 meters above the current floor level in the burial cave.
56. The obelisk on the left side (facing) is 20 cm high.
57. Comparable phrases are found in epitaphs from the late ancient cemeteries of Tyre and in those discovered in modern Jordan. On examples from the Hauran see Bert de Vries, " 'Be of Good Cheer! No One on Earth is Immortal': Religious Symbolism in Tomb Architecture and Epitaphs at the Umm el-Jimal and Tall Hisban Cemeteries," in *The Madaba Plains Project: Forty Years of Archaeological Research in Jordan's Past*, ed. Douglas R. Clark et al. (Abington: Routledge, 2014), 196-215. Epitaphs from Beit Shearim that include identical phrases and other anonymous messages that address the dead (BS II, nos. 59, 127, 136; BS III, 26, Pl. V, 4) ; cf. Littmann nos. 356, 357, 374, 420, 441, 517.
58. This is also the case in Rome; see discussion of this point in Leonard Victor Rutgers, *The Jews of Late Ancient Rome: Evidence of Cultural Interaction in the Roman Diaspora* (Leiden: Brill, 1995); JIWE II, nos. 556, 127, 173, 376, 552, 347, 236; cf. BS III, 36, 40. One exception includes the phrase (face B, line 34) "of the famed Jews and Godfearers" inscription from Aphrodisias ("*kai hosioi Theosebis . . .*"); Reynolds and Tannenbaum, Jews and Godfearers, 6, line 34. Apparatus in IJO II no. 14.
59. Examples of graffiti that include the same verb and also border epitaphs that nominate the dead abound in Catacomb 12 (BS III, 26, Pl. V, 4). Cf. Littmann nos. 374, 386. The possibility remains that the chosen expression, *tharsite*, like similar verbs in Hebrew and Greek biblical texts, may be proffered as a technical term to comfort the mourners and the dead. In the canonical Gospels and in Christian texts, this verb (*tharseō*) is used similarly in the imperative to offer comfort. Mark 10:49; 1 Thess 3:1–7, 5:9–11; 2 Thess 2:16–17; 2 Cor 13:1. Also see the translation in *LXX* Prov 31:11.
60. Examples in A. Tzaferis, "A Monumental Roman Tomb on Tel 'Eitun," *'Atiqot* 8 (1972): 62 [Hebr. Ser.]; Joseph Naveh, "Old Hebrew Inscrip-

tions from a Burial Cave," *IEJ* 2 (1963): 74–92 [Hebrew]; also compare Leah DiSegni, Gideon Foerster, and Y. Tsafrir, "The Basilica and Altar to Dionysos at Nysa-Scythopolis," in *The Roman and Byzantine Near East*, ed. J. H. Humphrey, vol. 2, *Some Recent Archaeological Research* (*JRA* Suppl. 31) (Portsmouth, RI: JRA, 1999), 59–75.

61. The Late Hellenistic Jason's tomb in Jerusalem remains another early example of the application of graffiti on its inner porch. See discussion of Andrea Berlin, "Power and Its Afterlife in Roman Palestine," *Near Eastern Archaeology* 62 (2002): 142; also see L. Y. Rahmani, "Jason's Tomb," *IEJ* 17 (1967): 69–73.

62. Regional mortuary architecture and practices in ancient Judah presented in Elizabeth Bloch-Smith, *Judahite Burial Practices and Beliefs about the Dead* (Sheffield, UK: Sheffield Academic Press, 1992).

63. Naveh differently restores the text at the entrance to read, "Yahweh deliver (us)"; "Old Hebrew Inscriptions," 86. Naveh, however, supplies the first-person object of the sentence. Based on the decipherable letters and context, the text could equally be restored as "Yahweh deliver (you)." This type of imprecation may be echoed in much later periods in Greece: a fourth-century dipinto beside a menorah in a tomb in Thessaloniki proclaims, "The Lord (is) with us!"; translation from IJO I Mac13.

64. See the treatment of Jeremy Smoak and Alice Mandell, "Reconsidering the Function of Tomb Inscriptions in Ancient Judah: Khirbet Beit Lei as a Test Case," *Journal of Near Eastern Religions* 16 (2016): 192–245. The associated cave has been dated to various periods in the first millennium from the eighth to the sixth centuries BCE. Additional discussion of its dating, ibid., no. 8.

65. Systematic studies of burial architecture in Judea and Jerusalem can be found in Berlin, "Power and Its Afterlife," and Orit Peleg-Barkat, "The Relative Chronology of Tomb Façades in Early Roman Jerusalem and Power Displays by the Élite," *JRA* 25 (2012): 403–18.

66. Rahmani, "Jason's Tomb," 4–27.

67. Concentric circles also appear on loculi in the catacombs of Villa Torlonia in Rome; JIWE II, no. 519.

68. Images of the façades are documented in BS III, Pl. XIV; XXX–XXXI. The carving from Catacomb 1 includes four columns (with bases and capitals), which support three arches within a rectangular frame (c. 24–40cm).

69. L. Habachi, *Obelisks: The Skyscrapers of the Past* (London: J. M. Dent and Sons, 1978). Obelisks were transported throughout the Roman Empire after Rome's conquest of Egypt, which might have broadened general acquaintance with its forms. For an excellent discussion of related points, see Molly Swetnam-Burland, *Egypt in Italy: Visions of Egypt in Roman Imperial Culture* (Cambridge: Cambridge University Press, 2015).

70. See the discussions of these traditions in Lidewijde de Jong, *The Archaeology of Death in Roman Syria: Burial, Commemoration, and Empire* (Cambridge: Cambridge University Press, 2017), 74, 201, 318.

71. Tombs, in general, are also called by these terms in several inscriptions, including those from Beit Shearim itself (BS I, 198, no. 12; Pl. 8, 4). In a

personal communication, M. C. A. MacDonald has expressed skepticism about the appropriateness of using this term to describe the architectural form, even if, at times, the word *nefeš* is used in epitaphs to describe the tomb itself. Concerning *nefašot* throughout the region, see Michel Mouton, "Les tours funéraires d'Arabie, Nefesh Monumentales," *Syria* 74 (1997): 83, fig.1; Pascale Clauss, "Les tours funéraires du Djebel Bagoûz dans l'histoire de la tour funéraire syrienne," *Syria* 79 (2002): 155–94.

72. Peleg-Barkat, "Relative Chronology," 403–7.

73. Examples in *CJO* 31–2; cf. 64, figs. 11, 13, 14, 15, 16; nos. 231, 473, 599, 601; photo of Beit Shearim engraving in BS I, Pl. VII.5

74. Rachel Hachlili, "The *nefeš*, the Jericho Column-Pyramid," *PEQ* 113 (1981): 33–8.

75. Rachel Hachlili, *Jewish Funerary Customs, Practices, and Rites during the Second Temple Period* (Leiden: Brill, 2005), 341–53; Mouton, "Les tours," 81–6. Measurements are recorded in Boaz Zissu, "A Burial Cave with a Greek Inscription and Graffiti at Khirbet el-ʿEin, Judean Shephelah," *ʿAtiqot* 50 (2005): 27–36, fig. 13; Amos Kloner, Dalit Regev, and Uriel Rappaport, "Burial Caves in the Judean Shefelah," *ʿAtiqot* 20 (1991): 31 [Hebr. Ser.]. This rendering, cross-hatched with a pyramidal top, appears beside several other pictorial and textual markings; see also Boaz Zissu, "Horbat Lavnin," *HA–ESI* 113 (2001): 104, 153; Boaz Zissu, "Horbat Egoz," *HA–ESI* 19 (1997): 85, fig. 173; 123–4; Boaz Zissu, "Horbat el-ʿEin," 109 *HA–ESI* (1999): 109. Another, more abstract version of the form is carved at Tel ʿEitun, near Hebron; see A. Tzaferis, "A Monumental Roman Tomb on Tel ʿEitun," *ʿAtiqot* 8 (1982): 24, fig. 4. On the *nefeš* in Jericho, see Hachlili, "The *nefeš*," 33–8. Note that a comparable form of graffito appears, detached from its original context, in Mordechai Aviam, *Jews, Pagans, and Christians from the Galilee* (Rochester, NY: University of Rochester Press, 2004), 120, figs 11.10, 22.11. I thank Andrea Berlin for this reference.

76. Peters and Thiersch, *Painted Tombs*, 60, fig. 20.

77. Amos Kloner, "New Judean/Jewish Inscriptions from the 'Darom'," *Qadmoniyot* 18 (1985): 96–100 [Hebrew].

78. Stern, "Celebrating," 241–2; the niche shapes surrounding cult statues were discussed in the previous chapter and in ibid. Architectural examples of these features of cult-statue placement can be seen in G. J. Wightman, *Sacred Spaces: Religious Architecture in the Ancient World* (Leuven: Peeters, 2007), 658–9.

79. Stern, "Celebrating," 245–6; comparable images appear elsewhere, such as in Asia Minor; cf. that in Charlotte Roueché and J. M. Reynolds, *Aphrodisias in Late Antiquity: the Late Roman and Byzantine Inscriptions Including Texts from the Excavations at Aphrodisias Conducted by Kenan T. Erim* (Oxford: The Society for the Promotion of Roman Studies, 1989), described in 187; 142, Pl. XXXIV.

80. Kloner, "New Judean/Jewish Inscriptions," 96–8; Marjorie Venit, *Monumental Tombs of Ancient Alexandria: The Theatre of the Dead* (Cambridge: Cambridge University Press, 2002), 74; 89.

81. See the discussions of similar points on the "childishness" of figures in Barbet, *Les Murs*, 56; Alix Barbet, "Graffitis à la romaine: un essai d'archéologie expérimentale," in *Inscriptions mineures: nouveautés et réflexions. Actes du premier colloque Ductus (19–20 juin 2008, Université de Lausanne)*, ed. M. Fuchs, R. Sylvestre, and C. Schmidt Heidenreich (Berne: Peter Lang, 2012), 243.

82. A lacquered preservative has been applied to some of these, which may enhance their vividness.

83. BS II, 223–4.

84. Margaret Williams, "The Menorah in a Sepulchral Context: a Protective, Apotropaic Symbol?" in *The Image and Its Prohibition in Jewish Antiquity*, ed. Sarah Pierce (Oxford: Journal of Jewish Studies, 2013), 77–88.

85. The pervasiveness of curses in epitaphs throughout the Hellenistic and Roman world suggest that such a concern was rather commonplace—particularly in the East. For an early yet comprehensive synthesis, see A. Parrot, *Malédictions et violations de tombes* (Paris: Geuthner, 1939); for a discussion in Jewish contexts see Hachlili, *Jewish Funerary Customs, Practices, and Rites during the Second Temple Period* (Leiden: Brill, 2005), 496; P. W. Van der Horst, *Ancient Jewish Epitaphs* (Leuven: Peeters, 1991), 54–60. Similar traditions were also common throughout the Levant in Phoenician and Nabataean contexts. For examples see Hachlili, *Jewish Funerary Customs*, 496–505; BS III, 23–8; and Joseph Naveh, *On Sherd and Papyrus: Aramaic and Hebrew Inscriptions from the Second Temple, Mishnaic and Talmudic Periods* (Jerusalem: Magnes Press, 1992), 198; Van der Horst, *Ancient Jewish Epitaphs*, 54–60.

86. Smoak and Mandell, "Reconsidering the Function," 220–32.

87. While paleography dates the inscription to the Iron Age, the precise dating of this text is disputed—different scholars ascribe it to either the first or second temple periods; the above translation and discussion in David Ussishkin, *The Village of Silwan: The Necropolis from the Period of the Judean Kingdom* (Jerusalem: Israel Exploration Society, 1993), 247–9; 329; BS III, 137–52. The Hebrew word *'mh*, as Avi Toiv has noted, might be equally translated as "maidservant." This curse follows longstanding prototypes of the region, which (1) name the deceased, (2) announce that the bones of the dead are present, but no valuables are buried with them, and (3) curse anyone who should open the tomb. A similar prohibition, from the first century, was painted prominently in Aramaic in red ochre over a loculus on the eastern slope of Wadi Sal'ah in the Kidron Valley to read: "This loculus was made for the bones of our fathers (=parents); (its) length (is) is two cubits—and not to open (=it should not be opened) on them!" (translation from CIIP no. 460).

88. Examples include CIIP I nos. 604; 287, 375, 385, 466, 507, 93, 451; a broader discussion of the topic and bibliography can be found in the commentary of CIIP I no. 385.

89. Graffiti of earlier periods appear three times identically on the exterior of a gabled ossuary from Jerusalem: "Closed. By the (daily) lamb (offering,

it is forbidden) to change/harm (this ossuary) and to bury another man with him (the deceased) in this ossuary. Closed. Closed" (translation from CIIP I no. 605). These inscribed warnings are more unusual among inscribed ossuaries, which commonly list only the names of the deceased.

90. Texts with similar formulae also appear inside of epitaphs and are common in Phoenician dialects inside tombs in Cyprus, and in southern Lebanon around Beirut, Sidon, and Tyre. The famous Ahiram inscription from Byblos, considered to be the oldest legible text in Phoenician, is likewise engraved with a text that curses the individual who might open up the sarcophagus; SSI 3, no. 4=KAI nr. 1. In addition to this sarcophagus inscription, however, a graffito was also discovered in the shaft grave into which the coffin had been placed. Gibson translates from the Phoenician: "Beware! Behold, there is disaster for you . . . !" (SSI 3, no. 5=KAI nr. 2). Examples from Cyprus include SSI 3, no. 12=KAI nr. 30. Gibson's translation of the Phoenician reads (SSI 3, 29): ". there is nothing of note. And as for the man who (and comes upon) this grave, if (he should open what is) over this man (and) his and should destroy the [inscription] (that) man. (be it) by the hand of Baal or by the hand of man or by (the hand). (the whole) company of the gods."

91. John Punnett Peters and Hermann Thiersch, *Painted Tombs in the Necropolis of Marissa* (London: Palestine Exploration Fund, 1905), 48, 50, nos. 16, 17, 22, 29; one graffito above the first loculus in Tomb One reads: "*Mētheis* (Nobody!)" (no. 16; fig. 13); above the fourth loculus in the same tomb, scratched into the images of the hippopotomus and the wild donkey are the words: "*e Mēthena kinein | thugatera*" ("let no one disturb daughter!") (no. 17, fig. 14). Above loculus 7 in the same tomb, "painted with brown clay mortar" were the words: "*Mēthena anoigein*" ("let no one open") no. 22, cf. nos. 17 and 29. The latter text, according to Peters and Thiersch, was painted on with "brown clay mortar" (51). Apotropaic sentiments like these are common in mortuary contexts in the Levant and elsewhere, but here they are applied independently of the epitaph itself. Detailed discussions of these types of texts appear in commentaries on ossuary inscriptions in the recent CIIP. For older treatments see Parrot, *Malédictions*; in Jewish contexts see Van der Horst, *Ancient Jewish Epitaphs*, 54; and, for curses in Jewish tomb inscriptions from Asia Minor, see Johan H. M. Strubbe, "Curses Against Violation of the Grave in Jewish Epitaphs from Asia Minor," in *Studies in Early Jewish Epigraphy*, ed. Jan Willem van Henten and Pieter Willem van der Horst (Leiden: Brill, 1994), 70–128; and Paul Trebilco, *Jewish Communities in Asia Minor* (Cambridge: Cambridge University Press, 1991), 60–78.

92. Achille Adriani, "Nécropoles de l'île de Pharos. B). Section d'Anfouchy," *Annuaire du Musée Greco-Romain, Alexandrie* 4 (1940–1950), (Alexandria: Société de Publications Égyptiennes, 1952), 55–128. This same curse might have taken the form of a couplet, according to Marjorie Venit, *Monumental Tombs*, 85.

93. Strubbe, "Curses Against Violation," 70–81; the example of the arcosolium with doubled curses in Catacomb 12 illustrates this most explicitly—a robber's trench mars the corner of the burial bed.

94. This point was noted repeatedly, particularly by Roger Bagnall, in the discussion of a symposium on graffiti, held at Oxford University in September 2013.

95. Additional examples include intensified degrees of detail with oars and sails of different shapes and sizes and, as Seth Schwartz asks rhetorically: "Do they, then, imply a conception of the grave as a passageway, without specific reference to Greek mythology?" (Schwartz, *Imperialism*, 156). The precise form of the ships remains important and may impact the broader interpretation of the drawings, but these stylistic differences may also bespeak distinct templates available to the artist. More extensive typologies of ancient ships are presented in Lionel Casson, *Ships and Seamanship in the Ancient World* (Baltimore: Johns Hopkins University Press, 1995); N. Kashtan, "The Ship as Reality and Symbol: How It Was Perceived in Hellenistic and Roman Palestine," in *6th International Symposium on Ship Construction in Antiquity* [*Tropis* VI], ed. H. E. Tzalas (Athens: Institut héllenique pour la preservation de la tradition nautique, 1991), 317–29. See also Lucien Basch, *Musée imaginaire de la marine antique* (Athens: Institut hellénique pour la préservation de la tradition nautique, 1987), 455–76, figs. 1036, 1052; Daniel Sperber, *Nautica Talmudica* (Bar Ilan: Ramat Gan, 1981), 48, 76; Arie Ben-Eli, *Ships and Parts of Ships on Ancient Coins* (Haifa: Maritime Museum Foundation, 1975), no. 66. Interpretations are subjective: for example, the on-deck "cabin" that Sperber describes in one graffito (*Nautica Talmudica*, 76) is differently classified as "a kind of hat" in Ben-Eli, *Ships and Parts of Ships*, 74. Also Amos Kloner and Boaz Zissu, *The Necropolis of Jerusalem in the Second Temple Period, Interdisciplinary Studies in Ancient Culture and Religion* 8 (Peeters: Leuven and Dudley, 2007).

96. For example, those in Catacomb 1, Hall O, Room V; Catacomb 1, Hall P, Room I.

97. This is discussed more extensively in Stern "Graffiti as Gift," 144.

98. Peters and Thiersch, *Painted Tombs*, 19, Pl. III; D.M. Jacobson, *Hellenistic Paintings of Marisa*. PEF Annual, vol. II (London: Maney, 2007), Pl. 7b.

99. Khirbet Za'aquqa is 6 km east of Maresha; Langner, *Graffiti*, no. 2247; Kloner et al., "A Hellenistic Burial Cave," 45.

100. Tzaferis, "A Monumental Roman Tomb on Tel 'Eitun," *'Atiqot* 8 (1972): 22 [Hebr. Ser.]; on Quirbet Rafi, see Amos Kloner and Shelley Wachsman, "A Ship Graffito from Khirbet Rafi (Israel), *The International Journal of Nautical Archaeology and Underwater Exploration 3* (1978): 227–44.

101. Rachmani, "Jason's Tomb," 69-71, figs. 5a, 5b. Also see Naveh, "Old Hebrew Inscriptions," fig. 7; also the treatment of the ship motif in E. R. Goodenough, *Jewish Symbols in the Greco-Roman Period*, Vol. 12 (New York: Pantheon Books), 1965; additional discussion can be found in Amos Kloner, "Burial Caves with Wall-Paintings from the First-Century CE in Jerusalem and Judea," in *Graves and Burial Practices in Israel in the*

Ancient Period, ed. I. Singer (Jerusalem: Israel Exploration Society, 1994), 165–72 [Hebrew]; E. D. Oren and Uriel Rapaport, "The Necropolis of Maresha-Beth Govrin," *IEJ* 34 (1984): 114–53. A ship graffito appears in still earlier periods (c. third century BCE) in Hellenistic Maresha; also see Elie Haddad and Michal Artzy, "Ship Graffiti in Burial Cave 557 at Maresha," *NEA* 74, no. 4 (2011): 236–40; cf. Shimon Gibson, "The Tell Sandahannah Ship Graffito Reconsidered," *PEQ* 124 (1992): 26–30; also Kashtan, "The Ship as Reality," 27, n.32.

102. For images of ships in funerary contexts from elsewhere that explicitly include sails or oars, see Langner, *Graffiti*, no. 1943 from Via Nomentana in Rome; also H. W. Beyer and H. Lietzmann, *Die jüdische Katacombe der Villa Torlonia* (Berlin: Walter de Gruyter, 1930), Pl. 18; *CIJ* I, 44), and a clearly rendered ship graffito from the Piraeus in Greece (Langner, no. 2000).

103. Venit, *Monumental Tombs*, 68–95; Adriani, *Annuaire* (1940–1950), 70–5.

104. Mario Buhagiar, *Late Roman and Byzantine Catacombs and Related Burial Places in the Maltese Islands* (Oxford: British Archaeological Reports, 1986), 125–30; Mario Buhagiar, "The Jewish Catacombs of Melite," *The Antiquaries Journal* 91 (2011): fig. 15.

105. Lucian comments, through an interlocutor, that the only way the soul can get to the afterlife is by being ferried via ship; *On Mourning* 15, 123, Loeb. transl. Harmon, 1960. Images of ships are consistently associated with commemorative iconography throughout the Roman Empire; Basch, *Musée Imaginaire*, 395–477.

106. Examples can be found in Casson, *Ships and Seamanship*, figs. 174, 176, 177–9, 181.

107. Trimalchio's plan for ships on his funerary monument with sailing ships reflects this pattern (Petr. *Satyr.* 71–2).

108. Egyptian books of the dead, still copied through the Hellenistic and Roman periods, maintained notions that processes of rebirth were facilitated by ship, just as the Sun god Re traveled daily on his barge through the sky. See M. Smith, *Traversing Eternity: Texts for the Afterlife from Ptolemaic and Roman Egypt* (Oxford: Oxford University Press, 2009).

109. Jodi Magness emphasizes this point in *Stone and Dung*, 158–9.

110. Translation *NRS*; Daniel Harrington, *First and Second Maccabees: A Commentary* (Minnesota: Liturgical Press, 2012), 72–3.

111. Christian writers including Eusebius (*Onomasticon* 132.16–17) and Jerome also likely encountered this monument; Boaz Zissu and L. Perry, "Identification of Ancient Modi'in and Byzantine Moditha: Towards a Solution of a Geographical-Historical Issue," *Cathedra* 125 (2007): 5–20.

112. On Hellenistic monumental building, see Berlin, "Power and Its Afterlife," 138–48; Peleg-Barkat, "Relative Chronology," 403–10.

113. Sperber notes one instance where a nautical metaphor is used to describe the difficult process of the soul leaving the body at death: "Said R. Ḥanina: The departure of the soul is as difficult as the *zippori* in the (lit:) mouth (or opening) of the gullet. R. Yoḥanan said: Like a *pituri* in the mouth of

the gullet" (*b. Moʻed Qaṭ.* 28b–29a); trans. Sperber, *Nautica Talmudica,* 12–13; 42–3, n. 4–5.

114. I thank Ezra Gabbay for his translation of the text; compare Eccl. Rab. 8:1.

115. Robin Jensen, *Living Water: Images, Symbols, and Settings of Early Christian Baptism* (Leiden: Brill, 2011), 52.

116. Mare et al., "The Decapolis Survey Project," 37–62.

117. Matt 27:59–61.

118. Christian amulets from the Byzantine period, displayed in the Israel museum and the Bible Lands Museum in Jerusalem, portray a rising Lazarus wrapped in linen strips. The rising Lazarus image was common on Christian amulets, including engraved semi-precious stones in the fifth century in Roman Palestine.

119. Catacomb 4, Hall C, Room I; see BS I, 182; Fig. 15. Ongoing debates about uses of figural art in Jewish contexts have made discussion of these graffiti particularly controversial. For a fuller account, see treatment in Weiss, "Adopting a Novelty," 48.

120. BS I, 183; Pl. XXXVI. Mazar asserts that the image of the dead "Germanos" is that of a Roman legionary, while the gladiator scene portrays the cause of death of another in the hall (BS I, 184). Also see Zeʼev Weiss, "Adopting a Novelty: Jews and the Roman Games in Palestine," in *The Roman and Byzantine Near East: Recent Archaeological Research, II. Journal of Roman Archaeology,* supp. 31, ed. J. H. Humphrey (Portsmouth, RI: Journal of Roman Archaeology, 1999), 23–49; and Tzaferis, "Monumental Roman Tomb," 22–5. Weiss describes that "A graffito depicting a gladiatorial battle between a *myrmillo* and a *retiarius* was found on the wall of Unit 4 in Beth Sheʼarim catacombs. . . . similar engravings were found in a Jewish burial cave at Tel ʻEitun in Judaea . . . indicating that death was a direct outcome of participation in a gladiatorial combat since a relative recorded his story on the wall of his tomb" (48; figs. 14, 16). Jews, rabbis, and gladiators are considered in Marc Brettler and Michael Poliakoff, "Rabbi Simeon ben Lachish at the Gladiator's Banquet: Rabbinic Observations on the Roman Arena," *HTR* 83 (1990): 93–8; and Zeʼev Weiss, *Public Spectacles in Late Antique Palestine* (Cambridge, MA: Harvard University Press, 2014), 200–1.

121. As several scholars have noted repeatedly in recent years, names individuals bore cannot predict actions and cultural practices they performed during their lifetimes. See the discussions of Jewish names and naming in Gerard Mussies, "Jewish Personal Names in Some Non-Literary Sources," in *Studies in Early Jewish Epigraphy,* ed. J. W. van Henten and P. W. Van der Horst (Leiden: Brill, 1994), 242. Also see Williams, "Jewish Festal Names," 21–40; and Williams, "Use of Alternative Names," 320–7.

122. Graffiti that may have been inscribed by or for gladiators are also treated in A. Cooley and M. G. L. Cooley, eds., *Pompeii: A Sourcebook* (London and New York: Routledge, 2004), 65.

123. For military graffiti, see E. D'Ambra and G. Métraux, *The Art of Citizens, Soldiers and Freedmen in the Roman World* (Oxford: Oxford University Press, 2006); see also Francesco Paolo Maulucci Vivolo, *Pompei I graffiti*

figurati (Foggia, Bastogi Editrice Italiana,1993), 32, 33, 28 (=CIL 4,1474), 30 (=CIL 4,5215), 34, 37a and 37b (=CIL 4,8055, 8056).

124. Tzaferis, "Monumental Roman Tomb," 24.

125. Naveh, "Old Hebrew Inscriptions," 78–80 fig. 6.D; Pl. 10; Naveh also includes a sketch of a graffito of an orant figure; Tsaferis, "A Monumental Roman Tomb," 24; Weiss, "Adopting a Novelty," 48.

126. Comparable points are considered in Alix Barbet, "Traces fortuites ou intentionelles sur les peintures murales antiques," *Syria* 77 (2010): 169–80.

127. During slightly earlier periods, X-, V-, and encircled cross shapes were engraved into gabled roofs and along upper sides of ossuaries found in Jerusalem and Jericho. Scholars commonly classify all such abstract designs as paired directional marks, which likely indicated the appropriate placements of lids on the terracotta and stone boxes, which housed the bones of the deceased. Several unpaired examples, however, which appear on ossuaries' sides (and whose top and bottom parts still fit neatly together and are composed of the same material), may defy such explanations. Examples include two Xs and an encircled cross on CIIP no. 266, figs. 266.3 (a) and 266.4 (b)= *CJO* no. 88; Kloner and Zissu 2003, 219, 334; also ossuaries from Talbiyeh in Jerusalem (*CJO* nos. 71, 72), Emmaus (*CJO* nos. 91, 92), the Kidron Valley (*CJO* no. 100), Qatamon (*CJO* no. 144), Sanhedriya-Mahanayim (*CJO* no. 151), Romema (*CJO* no. 173; 304), Ramat Rahel (*CJO* no. 190), Shmuel Hanavi St (*CJO* no. 206); Giv'at Hamivtar (*CJO* no. 222; 427); Mt. Scopus (*CJO* no. 3, 42–4, 313, 322, 379, 386, 418, 433, 448, 467, 468, 488, 504, 507–11, 572, 581, 583, 593, 642, 666, 691, 698, 745–8, 884, 887); Talpiot (*CJO* no. 725, 729, 731); and in other areas of Jerusalem (*CJO* no. 276, 287, 289, 343, 352, 357, 363, 423, 461, 568, 590, 678, 737–8, 740); and Jericho (*CJO* no. 792, 803; and of unknown provenance (*CJO* no. 823–4, 831, 845).

128. These shapes are not reported in the published survey of Horvat Lavnin, but were observed during two visits to the cave with Boaz Zissu in May 2011 and October 2013. Zissu, who published the previous survey, attested to their earlier presence in the caves. More detailed publication of images and texts from Lavnin in Zissu, Ecker, and Stern (forthcoming).

129. Photographs of images of these designs in Nazareth in the east wall of the "little grotto" were reproduced in Du R. P. Prosper Viaud, "Nazareth et ses deux églises de l'anonciation et de Saint-Joseph après les fouilles récents," *Revue des Études Byzantines* 13, no. 85 (1910): 364–5; Pl. D, no. 17; and drawn in Bellarmino Bagatti, *Excavations in Nazareth,* trans. E. Hoade (Jerusalem: Franciscan Printing Press, 1969), 205, no. 4.

130. Net-like designs are carved into ossuaries discovered in Giv'at Hamivtar and on Mt. Scopus in Jerusalem; Rahmani, *CJO*, nos. 361, 386.

131. In particular, graffiti clustered around martyrs' tombs in the Shefelah and in Rome might offer parallels for this; Lea DiSegni and Joseph Patrich, "The Greek Inscriptions in the Cave Chapel of Horvat Qaṣra," *'Atiqot* 10 (1990): 31–45 [Hebr. Ser.]; there is a brief overview of the Roman context for graffiti around martyr's tombs in Keegan, *Graffiti in Antiquity,* 110.

132. Treatment of the tenth-century Tel Zayit inscription reflects this context-sensitive interpretation. Discussions include David McLain Carr, "The Tel Zayit Abecedary in (Social) Context," in *Literature Culture and Tenth-Century Canaan: The Tel Zayit Abecedary in Context*, ed. Ron Tappy and Kyle McCarter (Winona Lake, IN: Eisenbrauns, 2008), 124; and Seth L. Sanders, *The Invention of Hebrew (Traditions)* (Urbana: University of Illinois Press, 2011), 131; Emile Puech, "Les Écoles dans l'Israël Préexilique: Donné Épigraphiques," in *Congress Volume 1986*, ed. J. Emerton (Leiden: Brill, 1988), 189–203; Alice Bij de Vaate, "Alphabet Inscriptions from Jewish Graves," in *Studies in Early Jewish Epigraphy*, ed. Jan Willem van Henten and Pieter Willem van der Horst (Leiden: Brill, 1994), 154.
133. For a discussion of alphabet inscriptions, see Bij de Vaate, "Alphabet Inscriptions," 160; BS II, 46. BS I, 163; scholars, such as Joseph Patrich, describe the presence of multiple Hebrew abecedaries in this and other caves, which remain unpublished; Patrich, "Inscriptions araméennes," 270 n. 12.
134. There is an excellent discussion of this point in Bij de Vaate, "Alphabet Inscriptions," 149–50.
135. BS I, 137.
136. Hachlili, "Goliath's Tomb," 40–2; also see the discussion in Rahmani, *CJO*, no. 787.
137. See Amos Kloner, "Inscriptions of the 'Darom,'" *Qadmoniyot* 71–2 (1982): 96–100; and Kloner, "ABCDerian inscriptions in Jewish Rock-Cut Tombs," in *Proceedings of the Ninth World Congress of Jewish Studies, Jerusalem, August 4–12, 1985* (Jerusalem, 1986), Division A, 125–32 [Hebrew]. In his brief treatment of the topic, Rahmani notes that: "the abecedaries at Bet Shearim may indicate a foreign influence" (*CJO*, 18). While it is unclear what this means exactly, the practice of inscribing alphabet lists for protective purposes circulates in multiple cultural contexts throughout the Mediterranean. See additional discussion in Bij de Vaate, "Alphabet Inscriptions," 150.
138. See discussion of this unpublished text in Zissu, Ecker, and Stern, forthcoming. Broader consideration of other inscriptions from the cave in Zissu, "Horvat Lavnin," 153–4.
139. This inscription is described as resembling Persian script, and, at the time of publication, indecipherable; BS III, 53.
140. Images in Zissu, "Horbat Egoz," fig. 173. Concerning so-called "nonsense" texts, see Patricia Cox Miller, "In Praise of Nonsense," 481–505; a different approach is taken in Adrienne Mayor, J. Colarusso, and D. Saunders, "Making Sense of Nonsense Inscriptions Associated with Amazons and Scythians on Athenian Vases," *Hesperia* 83, no. 3 (2014): 447–93.
141. Zissu, "Horvat Lavnin," 153.
142. See the discussion of magic and burial in Hachlili, *Jewish Funerary Customs*, 508–15; on the significance of "nonsense" inscriptions, see note 54 above; on retrograde inscriptions, see Joseph Naveh, "Lamp Inscriptions and Inverted Writing," *IEJ* 38 (1988): 36–43.

143. For related points, see Bernard Goldman, *The Sacred Portal: A Primary Symbol in Ancient Judaic Art* (Detroit: Wayne State University Press, 1966), 1–3; Jodi Magness, "Third Century Jews and Judaism at Beth Shearim and Dura Europus," in *Religious Diversity in Late Antiquity*, ed. David M. Gwynn and Susanne Bangert (Leiden: Brill, 2010), 135–66.

144. They are carved in relief into walls of Catacomb 20 (BS III, Pl. XXXVI, 1), and include a striking sculpted relief of a menorah balanced on a man's head in Catacomb 3. Catacomb 10, which remains entirely unpublished aside from a brief description in *SWP*, 349, includes multiple representations of large menorahs, painted beside the entryway in faded red or pink paint. Williams discusses representations of menorahs such as these in "The Menorah in a Sepulchral Context," 77–88.

145. I discuss dialogical and responsive carvings of graffiti in "Celebrating," 247.

146. Gideon Avni, Uzi Dahari, Amos Kloner, eds., *The Necropolis of Bet Guvrin-Eleutheropolis* (Jerusalem: Israel Antiquities Authority, 2008); see also the discussion of Jodi Magness and Gideon Avni, "Jews and Christians in a Late Roman Cemetery at Beth Guvrin," in *Religions and Ethnic Communities in Late Roman Palestine*, ed. Hayim Lapin (Bethesda: University Press of Maryland, 1998), 87–115. Shimon Dar, *Sumaqa: A Roman and Byzantine Jewish Village on Mount Carmel, Israel. BAR International Series 815.* (Oxford: Archaeopress, 1999), 108–17; Pl. 158; Z. Lederman and M. Aviam, "A Tomb in the Tefen Region of Galilee and its Incised Menoroth," *Qadmoniyot* 20 (1987): 124–5 [Hebrew].

147. A red dipinto of a menorah beneath an arcosolium in Catacomb 3, Hall E (arcosolium 1) and a deliberately punctured shape of a menorah beneath an arcosolium in Catacomb 13 appear to be part of the formal decorative program of those burials. Multiple examples of large menorahs painted in bright orange and pink colors remain in the unexcavated Catacomb 10.

148. Recent work on the menorah include Rachel Hachlili, *The Menorah: The Ancient Seven-Armed Candelabrum: Origin, Form, and Significance* (Leiden: Brill, 2001); Steven Fine, "When Is a Menorah 'Jewish'? On the Complexities of a Symbol under Byzantium and Islam," in *Age of Transition: Byzantine Culture in the Islamic World*, ed. H. Evans (New York: Metropolitan Museum of Art, 2013), 38–53; Steven Fine, *The Menorah: A Biography* (Cambridge, MA: Harvard University Press, 2016). As Williams has proposed, menorahs, when carved in this way (and in common spaces), may have possessed apotropaic properties for those who incised them; Williams, "The Menorah," 81–8. A menorah, thus, would not have an intrinsic meaning in a burial context, but a relational one, entirely dependent on the broader spatial and practical context (let alone the medium!) in which it was deployed.

149. Peters and Thiersch, *Painted Tombs*, Pl. 4.

150. Achille Adriani, *Annuaire du Musée Gréco-Roman (1933-34–1934-5): La necropole de Moustafa Pacha Alexandria Egypt* (Alexandria: Société de Publications Égyptiennes, 1936), 109; Pl. XXVII, XXVIII. Small renderings of animals and composite creatures are stationed at entryways to rooms within some burial halls.

151. Scholars have often noted similarities between the architecture of Levantine burial caves and those of Alexandrian and Egyptian antecedents; perhaps the continuities in mortuary practice extend to the decoration as well as the construction of the catacombs. J. Y. Empereur, *A Short Guide to the Catacombs of Kom El Shoqafa, Alexandria* (Alexandria: Serapis, 1995); A. Corbelli, *The Art of Death in Graeco-Roman Egypt* (Buckingham: Shire, 2006); Judith McKenzie, *The Architecture of Petra* (Oxford: Oxbow, 1995).

152. One example of this practice in Christopher Faraone and Joseph L. Rife, "A Greek Curse against a Thief from the Koutsongila Cemetery at Roman Kenchrai," *ZPE* 160 (2007): 141–57; an example from a Jewish context includes that mentioned in Magness and Avni, "Jews and Christians," 104; also Gideon Avni, Uzi Dahari, and Amos Kloner, "Notes and News: Beth Guvrin: The Ahinoam Cave Cemetery," *IEJ* 36 (1986): 72–4.

153. Few treatments consider the decoration of Mesopotamian incantation bowls. Rare exceptions include the work of Naama Volozny, "The Art of the Aramaic Incantation Bowls," *Aramaic Bowl Spells: Jewish Babylonian Aramaic Bowls Volume One*, ed. Shaul Shaked, Siam Bhayro, James Nathan Ford (Leiden: Brill, 2012), 29–37.

154. In the Babylonian Talmud, for example, discussions consider the appropriate attire to wear inside cemeteries, in order to avoid "mocking" the dead by their inability to do the same. See also *b. Ketub 8b.* 16a in this context for discussions of wrappings of the dead.

155. Marietta Horster, "Religious Landscape and Sacred Ground: Relationships between Space and Cult in the Greek World," *Revue de l'Histoire des Religions* 4 (2010): 435–58.

156. Noteworthy are the discrepencies between the treatments in *b. Moʿed Qaṭ* 2a and 5a, in which discussion of marking graves is associated with the avoidance of impurity.

157. See discussions of the afterlife and the world to come in Park, *Conceptions of Afterlife*, 122–73; Kraemer, *Meanings of Death*, 46–50; Davies, *Death, Burial and Rebirth*, 110–24; Jordan Rosenblum, *Jewish Dietary Laws in the Ancient World* (Cambridge: Cambridge University Press, 2016), 135–40.

158. David Brodsky, "Mourner's Kaddish, The Prequel: The Sassanian Period Backstory that Gave Birth to the Medieval Prayer for the Dead," in *The Aggada of the Bavli in Its Cultural World*, ed. Jeffrey Rubenstein and Geoffrey Herman (BJS, forthcoming, 2018).

159. See the remarks on related points in D. Zlotnick, *The Tractate 'Mourning': (Semaḥot): (Regulations Pertaining to Death, Burial and Mourning)* (New Haven, CT: Yale University Press, 1966) and compare *b. Taʿan.* 16a.

160. Broader discussions of the distinctiveness of biblical notions of corpse pollution in rabbinic texts are considered in Mira Balberg, *Purity, Body, and Self in Early Rabbinic Literature* (Berkeley: University of California Press, 2014), 32–3; Balberg notes that the question of contamination relates to the possibility of contact with small pieces of a corpse (*Purity, Body, and Self*, 88, 202 n.2). See also Magness, *Stone and Dung*, 159.

161. Placements of lamellae inside cemeteries, throughout the Mediterranean, attest to comparable understandings that the resident dead, and their spirits, were ripe for manipulation through acts of ritual power. See the discussion in Faraone and Rife, "A Greek Curse," 141–57.
162. Balberg, *Purity, Body, and Self,* 88.
163. This might enforce one of Rajak's hypotheses about the local assimilation of Jewish populations of diasporic origin; "The Rabbinic Dead," 490.

CHAPTER 3: MAKING ONE'S MARK IN A PAGAN AND CHRISTIAN WORLD

1. Estimations of population percentages of Jews in the eastern empire are given in Salo Baron, *A Social and Religious History of the Jews,* Vol. 1 (New York: Columbia University Press, reprint, Philadelphia: JPS, 1952), 167–71; Michael Grant, *The Jews in the Roman World* (New York: Simon and Schuster, 1973), xi; Avi-Yonah, *The Jews Under Roman and Byzantine Rule* (New York: Schocken, 1984), 19; Ramsay MacMullen, *Christianizing the Roman Empire, AD 100–400* (New Haven, CT: Yale University Press, 1984), 109–10; Robert Wilken, *The Christians as the Romans Saw Them* (New Haven, CT: Yale University Press, 1984), 113–14; Stephen Wilson, *Related Strangers: Jews and Christians 70–170 CE* (Minneapolis: Fortress, 1995), 21, 25; for later periods, see Nicolas de Lange, "Jews in the Age of Justinian," in *The Cambridge Companion to the Age of Justinian,* ed. Michael Maas (New York: Cambridge University Press, 2005), 401–26. On the peculiar demographic conditions of Roman and Byzantine Palestine, see Jack Lightstone, "Urbanization in the Roman East: The Inter-Religious Struggle for Success," in *Religious Rivalries and the Struggle for Success in Sardis and Smyrna,* ed. Richard S. Ascough (Ontario: Wilfred Laurier University Press, 2005), 238–41. Lightstone asserts that in the time of Julius Caesar, Jews represented 20 percent of the population of the eastern half of the Roman Empire and (with the exception of those in Palestine and southern Syria) mostly dwelled in its cities; "Urbanization," 237; 294, n. 11.
2. Compare Tertullian's apologetic assessment of the seamless integration of Christians in pagan society (*Apol.* 42): "[We Christians] live with you, enjoy the same food, have the same manner of life, and dress, the same requirements for life. . . . We cannot dwell together in the world without the marketplace, without butchers, without your baths, shops, factories, taverns, fairs, and other places of business. We sail in ships with you, serve in the army, toil the ground, engage in trade as you do; we provide skills and services to the public for your benefit"; translation of R. M. Grant, "The Social Setting of Early Christianity," in *Jewish and Christian Self-Definition, Vol. 1: The Shaping of Christianity in the Second and Third Centuries,* ed. E. P. Sanders (London: SCM, 1980), 16–29; and Lightstone, "Urbanization," 237. An example of this type of continuity also exists for Jews; consider, for example, an inscription from Acmonia that may describe

a Jew's prescription to practice rites of the Roman *rosalia*; Trebilco, *Jewish Communities*, 79–81, 178; 220= e.g., IJO II no. 171.

3. Excellent considerations of these patterns include those of Hayim Lapin, *Rabbis as Romans*; Seth Schwartz, *Were Jews a Mediterranean Society?*; and Cynthia M. Baker, *Rebuilding the House of Israel: Architectures of Gender in Jewish Antiquity* (Stanford, CA: Stanford University Press, 2003).

4. Literature on this point is extensive and includes, among many other examples, Judith Lieu, *Image and Reality: The Jews in the World of the Christians in the Second Century* (Edinburgh: T. & T. Clark, 1996); Paula Fredriksen and Oded Irshai, "Christian Anti-Judaism: Polemics and Policies," in *The Cambridge History of Judaism, Vol. IV*, ed. Steven T. Katz (Cambridge: Cambridge University Press, 2006), 997–1033; Becker and Reed, *The Ways that Never Parted*, 1–7.

5. In his treatment of evidence for Jews in Asia Minor, for example, P. W. van der Horst favors the study of more monumental evidence; "Jews and Christians in Aphrodisias, in the Light of Their Relations in Other Cities of Asia Minor," *Nederlands Theologisch Tijdschrift* 43 (1989): 106–21. See also the approach of Paul Trebilco, particularly on Sardis, in *Jewish Communities*, 37–55, 56–7, 167–86. On discussion of "activation" as the transformation of the passive position of the "spectator," see Claire Bishop, *Participation*, Cambridge, MA: Whitechapel, MIT Press, 2006), 10–17; and *Artificial Hells: Participatory Art and the Politics of Spectatorship* (London: Verso, 2012), 77.

6. Compare Jack Lightstone's assertion about early Christians of the eastern empire: ". . . Christians (like the Jews) rejected outright the city's deities and cult, tended (like the Jews) to abhor civic festivals and games . . ." in "Urbanization," 235. Some texts in the Cairo Geniza reflected agents' desires to manipulate the results of horse-races; Weiss, "Adopting a Novelty," 47.

7. Their contributions are generalized in Trebilco, *Jewish Communities*, 175, 177.

8. Bishop, "The Social Turn," 16–17, n. 14; Walter Benjamin, "The Author as Producer," in *Benjamin, Selected Writings, vol. 2, part 2, 1931–34* (Cambridge, MA: Harvard University Press, 2003), 777; on Jacques Derrida's "Countersignature," *Paragraph*, 27.2 (2004): 7–42; also Michel de Certeau, *The Practice of Everyday Life*, trans. Steven Rendell (Berkeley: University of California Press, 2011), 97.

9. Bishop, "The Social Turn," 16–17. As Michel de Certeau might describe it, they could constitute acts of "kinesthetic appropriation," *Practice of Everyday*, 97.

10. Civic spaces included roads, streets, and water supplies, but also municipal architecture built for common use, including marketplaces, structures for entertainment (hippodromes, stadiums, odeons, and theatres), and worship (temples and sanctuaries). See the discussion of this point, particularly in relation to the cities of the Roman East, in Jack Lightstone, "Urbanization," 211–44, esp. 223–4; cf. Henri Lefebvre, "The Right to the City," in *Writings on Cities*, ed. Eleonore Kofman and Elizabeth Lebas (Cambridge, MA: Wiley Blackwell), 158.

11. Jodi Magness, "The Date of the Sardis Synagogue According to the Numismatic Evidence," *AJA* 109 (2005): 443–75.

12. Margaret Williams, *Jews in a Greco-Roman Environment* (Tübingen: Mohr Siebeck, 2013), 377–81.

13. Tessa Rajak and David Noy, "*Archisynogogoi*: Office, Title, and Social Status in the Greco-Roman Synagogue," *JRS* 83 (1993): 87; Bernadette J. Brooten, *Women Leaders*, 32; Levine, *The Synagogue*, 501–8; Katherine Bain, *Women's Socioeconomic Status and Religious Leadership in Asia Minor in the First Two Centuries, C.E.* (Minneapolis: Fortress Press, 2014), 121; on women in Christian communities, see Carolyn Osiek and Margaret Y. MacDonald, *A Woman's Place: House Churches in Earliest Christianity* (Minneapolis: Augsburg Fortress Press, 2006).

14. Treatments of these laws abound and include those of Amnon Linder, *The Jews in Roman Imperial Legislation* (Detroit: Wayne State University Press, 1998); Amnon Linder, "The Legal Status of the Jews in the Roman Empire," in *Cambridge History of Judaism, Vol. 4: The Late Ancient-Rabbinic Period*, ed. Steven T. Katz (Cambridge: Cambridge University Press, 2006), 128–69; also Nicholas de Lange, "Jews in the Age of Justinian," 401–26; 410.

15. Jewish practices and synagogues might have indeed inspired the esteem and participation of some regional Christians, as John Chrysostom has alleged. Related points recur throughout Chrysostom's work, with examples in *Adv. Iud.* V.2; V.8.

16. Such arguments are proposed by Rick Strelan, *Paul, Artemis, and the Jews of Ephesus* (Berlin, New York: De Gruyter, 1996); Lloyd Gaston, "Jewish Communities in Sardis and Smyrna," in *Religious Rivalries and the Struggle for Success in Sardis and Smyrna*, ed. Richard S. Ascough (Ontario: Wilfred Laurier University Press, 2005), 17–25; Lightstone, "Urbanization," 211–44; Philip A. Harland, *Associations, Synagogues, and Congregations: Claiming a Place in Ancient Mediterranean Society.* (Minneapolis: Fortress, 2003).

17. On such topics, see the approaches in commentaries on legal texts from Constantinople in Amnon Linder, *Jews in Roman Imperial Legislation*, 190; 262–5.

18. Many examples of graffiti from these regions have been published and incorporated in compendia. Several examples addressed here were published in Joyce Reynolds and Robert Tannenbaum, *Jews and God-fearers at Aphrodisias: Greek Inscriptions with Commentary: Texts from the Excavations at Aphrodisias Conducted by Kenan T. Erim* (Cambridge: Cambridge Philological Society, 1987), 132–4; Charlotte Roueché and Nathalie De Chaisemartin, *Performers and Partisans at Aphrodisias in the Roman and Late Roman Periods: A Study Based on Inscriptions from the Current Excavations at Aphrodisias in Caria* (London: Society for the Promotion of Roman Studies, 1993); IJO II; Angelos Chaniotis, "The Jews of Aphrodisias: New Evidence and Old Problems," *SCI* 21 (2002): 209–42; Jean-Paul Rey-Coquais, "Inscriptions de l'hippodrome de Tyr," *JRA* 15 (2002): 325–35; IJO III. Trebilco (*Jewish*

Communities) and Harland (*Associations, Synagogues, and Congregations*) offer more generalized interpretations of some of these; see also Tessa Rajak, "The Jewish Community and Its Boundaries," in *The Jews among Pagans and Christians*, ed. Judith Lieu, J. North and Tessa Rajak (London: Routledge, 1992), 9–28; Gary Gilbert, "Jewish Involvement in Ancient Civic Life: The Case of *Aphrodisias*" *RB* 113 (2006): 18–36.

19. Trebilco discusses the position of women in Asia Minor and in synagogues elsewhere in *Jewish Communities*, 104–26.

20. On "metropolis" status for Miletos, see Charlotte Roueché, "Metropolis," in *Late Antiquity: A Guide to the Postclassical World*, ed. Glen Warren Bowersock, Peter Brown, and Oleg Grabar (Cambridge, MA: Harvard University Press), 577; for Sardis, see Barbara Burrell, *Neokoroi: Greek Cities and Roman Emperors* (Leiden: Brill, 2004), 114; for Aphrodisias, see ALA, 33, 52.

21. Thomas Kraabel, "The Diaspora Synagogue," in *Ancient Synagogues: Historical Analysis and Archaeological Discovery*, ed. Dan Urman and Paul Virgil McCracken Flesher (Leiden: Brill, 1995), 106.

22. See the discussion of Jews in the letters of Josephus in Lutz Doering, *Ancient Jewish Letters and the Beginnings of Christian Epistolography* (Tübingen: Mohr Siebeck, 2012), 309–10.

23. In Greek, "*topos Eioudeōn tōn kai Theo˹s˺ebion*"; (IJO II no. 37; CIJ II 748; SEG 4.441); Section I, 4, 5 of theatre; Kraabel describes it as an "inelegant inscription." As Ameling notes in his edition of Jewish inscriptions from Asia Minor, the absence of a genitive plural ending for "theo˹s˺ebion" presents a challenge to the translation of the seating inscription (IJO II, 167). Links between "Godfearers" and Jews remain controversial, and the precise reading of this text figures prominently in the debate. The letters of the text are quite large (avg. 4–5 cm) and relatively deeply carved.

24. *The[os?]ebion* incised in Section I, 4, 2, in the fifth row of seats from the bottom; IJO II no. 38, 171–2.

25. IJO II no. 39; cf. IJO II no. 38. The second word is commonly restored to *EIO[D]EŌN* or *EIOU[D]EŌN*. Multiple graffiti, then, announce the presence of Jews in the theatre. The status of *theosebeis* and related debates, however, pervade the literature on Jews in Asia Minor. While the link between Jews and "Godfearers" in the inscription remains obscure, however, the inclusion of the word "Jews" is not. See the extensive scholarship on "Godfearers," e.g., Reynolds and Tannenbaum, *Jews and Godfearers*, 86–7. See also discussion in Cameron, *Circus Factions: Blues and Greens at Rome and Byzantium* (Clarendon: Oxford, 1976), 315.

26. Harland, *Associations, Synagogues*, 109.

27. See discussion in Harland, *Associations, Synagogues*, 109–10.

28. Charlotte Roueché, "Inscriptions and the Later History of the Theatre," in *Aphrodisias Papers, 2*. K. T. Erim and R. R. R. Smith, eds., JRA Monograph 2 (Ann Arbor, MI: JRA, 1991), 103.

29. See "The Question of Laughter, Ancient and Modern," in Mary Beard, *Laughter in Ancient Rome: On Joking, Tickling, and Cracking* Up (Berkeley: University of California Press, 2014), 23–48.
30. Rouché, "Inscriptions and the Later History," 102.
31. A useful summary of discussions relating to associations and *collegia* throughout the ancient Mediterranean is given in John S. Kloppenborg, "*Collegia and Thiasoi*: Issues in Function, Taxonomy and Membership," in *Voluntary Associations in the Graeco-Roman World*, ed. John S. Kloppenborg and Stephen G. Wilson (London: Routledge, 1996), 16–30.
32. In his study of the Jews of Asia Minor, Paul Trebilco concludes, based on the location of the graffiti, that "some Jews regularly attended the theatre, which was a centre of the cultural life of the city. . . . In addition . . . the Jews enjoyed the privilege of reserved seats (and fine fifth row seats at that) [which] shows that they were prominent and respected members of the theatre audiences" (*Jews of Asia Minor*, 175).
33. Multiple points of comparison are available for the Jews' *topos* inscriptions. See G. Kleiner, *Das römische Milet* (Wiesbaden: F. Steiner, 1970), 132; MILET IV 1 Taf. 12f.; MILET VI 2, 940 III; MILET VI 2, 940 III g., Taf. 49, 297; MILET VI 2, Taf. 49, 298; also see D. F. McCabe and M. A. Plunkett, *Miletos Inscriptions* (Princeton: Institute for Advanced Study, 1984), 97, no. 436. The culture of competitive entertainments summarized in ALA, 218-9.
34. Seats for corporations are recorded, but their contexts are largely difficult to reconstruct (e.g., ala2004 no. 212, i–vii). Individuals, as well as groups, reserved seats for themselves in the theatre (e.g., *IAph*2007 8.53–8.81). A marble block carved with two menorahs and a written prayer was located in the theatre in Aphrodisias, but in a state of reuse; see also Chaniotis, "Jews of Aphrodisias," Appendix II no. 26 A.
35. Broader discussion of this point can be found in Rajak, *The Jewish Dialogue*, 347–52.
36. Angelos Chaniotis, "Graffiti in Aphrodisias," 191.
37. D. Parrish, "Introduction: The Urban Plan and Its Constituent Elements," in *Urbanism of Roman Asia Minor: The Current Status of Research*, ed. D. Parrish (Portsmouth, RI: JRA, 2001), 8–41; also C. Ratté, "New Research on the Urban Development of Aphrodisias in Late Antiquity," in *Urbanism of Roman Asia Minor*, 117–47; Chaniotis, "Graffiti in Aphrodisias," 191.
38. Chaniotis, "Graffiti in Aphrodisias," 191.
39. Examples of Christian inscriptions and graffiti appear in Angelos Chaniotis, "New Inscriptions from Late Antique Aphrodisias," *Tekmeria* 9 (2008): 219–32. For a discussion of the dynamics of the transition from pagan to Christian Aphrodisias, see Jones, *Between Pagan and Christian*, 133–4.
40. Studies of these inscriptions are multiple and include the original publications of Reynolds and Tannenbaum, *Jews and Godfearers*; Chaniotis, "Jews of Aphrodisias," 209–42; P. W. Van der Horst, "Jews and Christians in Aphrodisias, in the Light of Their Relations in Other Cities of Asia Minor," *Nederlands Theologisch Tijdschrift* 43 (1989): 106–21;

P. Van Minnen, "Drei Bemerkungen zur Geschichte des Judentums in der greischisch-römischen Welt," *ZPE* 100 (1994): 166–81; Trebilco, *Jewish Communities*, 152–5; Jerome Murphy-O'Connor, "Lots of God-Fearers? Theosebeis in the Aphrodisias Inscription," *RB* 99 (1992): 418–24; Rajak, "The Jewish Community," 20; Margaret Williams, "The Jews and Godfearers Inscriptions from Aphrodisias: A Case of Patriarchal Interference in Early Third Century Caria?" *Historia* 41 (1992): 297–310; M. P. Bonz, "The Jewish Donor Inscriptions from Aphrodisias: Are They Both Third Century and Who Are the Theosebeis?" *HSCP* 76 (1994): 281–99; Thomas Braun, "The Jews in the Late Roman Empire," *SCI* 17 (1998): 142–71; Lee I. Levine, "The Hellenistic-Roman Diaspora 70 CE/235 CE: The Archaeological Evidence," in *The Cambridge History of Judaism III: The Early Roman Period*, ed. W. Horbury, W. D. Davies, and J. Sturdy (Cambridge: Cambridge University Press, 1999), 1009; Margaret Williams, "The Contribution of the Study of Inscriptions to the Study of Judaism," in *The Cambridge History of Judaism III: The Early Roman Period*, ed. W. Horbury, W. D. Davies, and J. Sturdy (Cambridge: Cambridge University Press, 1999), 93; Martin Goodman, "Review of Reynolds and Tannenbaum 1987," *JRS* 78 (1988): 261–2; Margaret Williams, "Jews and Jewish Communities in the Roman Empire," in *Experiencing Rome: Culture, Identity and Power in the Roman Empire*, ed. J. Huskinson (London: Routledge, 2000), 305–33.

41. Chaniotis, "Jews of Aphrodisias," 219, 226. Chaniotis has convincingly argued, based on their onomastic and textual elements, that these inscriptions are best dated to the fourth century CE.

42. On Jewish communities elsewhere in Asia Minor, see E. Miranda, "La comunità giudaica di Hierapolis di Frigia," *Epigraphica Anatolica* 31(1999): 109–55 (Hierapolis); H. Botermann, "Die Synagoge von Sardes: Eine Synagoge aus dem 4 Jahrhundert?" *Zeitschrift für die Neutestamentliche Wissenschaft* 81 (1990): 103–21; Magness, "The Date of the Sardis Synagogue,": 443–55; Tessa Rajak, "The Gift of Gods at Sardis," in *Jews in a Graeco-Roman World*, ed. Martin Goodman (Oxford: Oxford University Press, 1998), 229–39; J. S. Crawford, "Jews, Christians and Polytheists in Late Ancient Sardis," in *Jews, Christians, and Polytheists in the Ancient Synagogue: Cultural Interaction in the Graeco-Roman Period*, ed. S. Fine (London: Routledge, 1999), 190–200; and Tessa Rajak, "Jews, Pagans and Christians in Late Antique Sardis: Models of Interaction," in *Jewish Dialogue*, 432–62.

43. Chaniotis, "Graffiti in Aphrodisias": 192.

44. Examples of figural graffiti include Langner, nos. 2424, 2470, 2498, 134, 165, 376, 428, 579–82, 585, 589, 632, 718, 912, 1291.

45. Lionel Bier, "Bouleterion," in *Aphrodisias Papers 4: New Research on the City and Its Monuments*, ed. Christopher Ratté and R. R. R. Smith, JRA Supplementary Series 70 (Portsmouth, RI: Journal of Roman Archaeology, 2008), 144–68. On the transformed role of the *boulē* in the east and the city assembly, see Lightstone, "Urbanization," 228.

46. Bier argues that, unlike analogues elsewhere, gladiatorial competitions could not have been held in such a space, because the "theatre-like building" was so small; Bier, "Bouleterion," 160–1.
47. In all cases, graffiti and seat inscriptions that assert the presence of the Blue faction suggest that some sort of "competitive display" took place in the space. On dating of the space, see Reynolds, "Inscriptions from the Bouleterion/Odeion," in Ratté and Smith, *Aphrodisias Papers 4*, 167. This would explain the factional graffiti carved in the seating; e.g., ala2004 no. 79; see also Bier, "Bouleterion," 164.
48. Bier, "Bouleterion," 163; on Jews' potential roles in the *boulē*, in its earliest phases, see Lightstone, "Urbanization," 231. While "competitive displays" may have taken place by the fifth century, explicit mention of the "Aphrodisians" in the space probably dates the structure's use to before the middle of the seventh century, when the city was renamed; see the discussion in Reynolds, "Inscriptions from the Bouleterion/Odeion," no. 8.
49. Roueché, *Performers*, 117f=Reynolds, "Inscriptions from the Bouleterion/Odeon," 179–82, no. 12, suggests that these perhaps indicated tribal or organizational distinctions.
50. Bier, "Bouleterion," 165.
51. Reynolds, "Inscriptions from the Bouleterion/Odeon," 172. Graffiti associated with Jewish populations were neither discovered in the back of the stage, which connected the building to the agora, nor were they found in inscriptions related to the construction of the building; see Roueché, *Performers and Partisans*, 118–19. Multiple types of labels existed for the seating; some included letters and numbers by the staircase entryways, which may have directed people to their seats (Reynolds, "Inscriptions from the Bouleterion/Odeon," A. 1, i–iv). Other clusters of letters—in groups of two, three, or four—appeared on the risers or seats and appear to postdate the third century. Examples of these read, "*NO*" (row 1), "*ZĒ, ARDĒ, ZĒ*" (row 4), "*ĒRA, ADE ADE ADR*" (row 7), etc. Reynolds notes that the meaning of these markings ultimately remains obscure; "Inscriptions from the Bouleterion/Odeon," 173.
52. Reynolds, "Inscriptions from the Bouleterion/Odeon," 172.
53. While the seats in the *cavea* were repaired after their excavation in the 1960s, records demonstrate they were not moved during the process; Bier, "Bouleterion," 165.
54. It reads: "*topos [Hebr]eōn.*" IJO II no. 15; SEG 37.847. Photo in Chaniotis, "Jews of Aphrodisias," fig. 3 (=Appendix II no. 18).
55. This one reads "*topos neoterō<n>.*" Photo in Reynolds, "Inscriptions from the Bouleterion/Odeon," Fig. 4 no. 4 C i=Chaniotis, "Jews of Aphrodisias," Appendix II no. 19. In their present state, the first three letters of *Hebraioi*—epsilon through *rho*—seem worn or deliberately effaced.
56. IJO II no. 16: "*topos Benetōn, Hebreōn tōn Paleōn.*" Full apparatus in IJO II no. 16; SEG 37.846. Photo and drawing in Chaniotis, "Jews of Aphrodisias," fig. 4 (=Appendix II no. 17). Slight discrepancies between the carving of the word for "Blues" and the remainder of the text prompt Reynolds to

say that it might have been carved at a later date; Reynolds, "Inscriptions from the Bouleterion/Odeon," 174.

57. Discrepancies between the formation of the *beta*s and broader differences in paleography may suggest that the *topos* portion of the inscription was originally carved for another group by another hand; Reynolds, "Inscriptions from the Bouleterion/Odeon," 174; No. 4 C ii. It is worthwhile to note, however, that a similar discrepancy appears in the former inscription for the "place of the younger men"—"*topos*" is carved in a more elegant hand, while "*neoterō<n>*" is carved more roughly where it appears a few rows below. Perhaps, in both cases, the entities reserving the seats were the second or third parties to do so.

58. "*[Topos] Benet(ōn)*." This reading was produced in 1986; no evidence for the latter text is presently legible; Reynolds, "Inscriptions from the Bouleterion/Odeion," 175; No. 4 C iii.

59. Finally, in Row 9 of the same block, another inscription includes a cross and the letters "*CPH*"; according to Reynolds, these pro-Blue graffiti probably derive from a period after which "circus factions undertook organizations of theatrical and other entertainments; "Inscriptions from the Bouleterion/Odeion," 174.

60. See the broader discussion in Cameron, *Circus Factions*, 79.

61. These include ala2004 nos. 184–5. Another such acclamation reads: "*NIKA/ĒTY/CHE/TŌN/ROU/SEŌN*"; "May the fortune of the Reds win!" "Aphrodisias report of the 2013 season," accessed February 6, 2018, www .nyu.edu/gsas/dept/fineart/pdfs/.../2013-Aphrodisias-REPORT.pdf. See also discussion in ala2004 X.8.

62. ALA, 222; existence of a marble inscription from a synagogue in Hypaipa in Lydia, dated by Ameling and others to the late second and early third centuries, records the presence of "*Iouda | [i]ōn ne | ōte | rōn*," or, "the younger Jews" (IJO II no. 47, 199; CIJ II no. 755).

63. Chaniotis, "Jews of Aphrodisias," 221; see note 57.

64. Consideration of this point can be found in Rey-Coquais, "Inscriptions de l'hippodrome," 331; and P. W. van der Horst, *Jews and Christians in their Graeco-Roman Context* (Tübingen: Mohr Siebeck, 2006), 56; concerning Malalas and his writings, see ALA, 222.

65. While Christian symbols appear more frequently in the markings behind the Odeon stage, only one graffito from higher up in the seats suggests a Christian presence among spectators in the space. Reynolds, "Inscriptions from the Bouleterion/Odeion," 170.

66. Archaeological evidence consistently aligns the Jews and the Blues, but in other cases, some Jews might have allied themselves with the Greens.

67. It is unclear whether these inscriptions come from earlier periods of late antiquity (fifth instead of seventh century) because of the relative lack of Christian support for the local entertainments. See the discussion of this point in Reynolds, "Inscriptions from the Bouleterion/Odeion," 170–89.

68. Chaniotis, "Jews of Aphrodisias," 221; Angelos Chaniotis, "The Conversion of the Temple of Aphrodite at Aphrodisias in Context," in *From Temple to Church: Destruction and Renewal of Local Cultic Topography in Late*

Antiquity, ed. Stephen Emmel, Ulrich Gotter, and Johannes Hahn (Leiden: Brill, 2008), 243–74.

69. The majority of research on the Sebasteion concerns its marbles; R. R. R. Smith, *The Marble Reliefs from the Julio-Claudian Sebasteion at Aphrodisias* (Darmstadt: Philipp von Zabern, 2013); R. R. R. Smith and A. Ertug, *Aphrodisias: City and Sculpture in Roman Asia* (Istanbul: Ertug and Kocabiyik, 2009).

70. Chaniotis, "Jews of Aphrodisias": 221; Reynolds and Tannenbaum, 134.

71. Certain of these were published in the appendix of Reynolds and Tannenbaum, *Jews and Godfearers*, but the remainder were identified and published for the first time in Chaniotis, "Jews of Aphrodisias." Those listed as Chaniotis, Appendix II, nos. 6 and 15, include the images of a rosette (no. 6) and a "chevron" (no. 15), which may be too ambiguous to associate them with Jews.

72. Measurements recorded in Chaniotis, "Jews of Aphrodisias": 221–2.

73. Chaniotis, "Jews of Aphrodisias": fig. 5; Appendix II no. 6.

74. Chaniotis, "Jews of Aphrodisias": Appendix II nos. 8 and 9.

75. For the above, see Chaniotis, "Jews of Aphrodisias": Appendix II nos. 10–13.

76. Reynolds and Tannenbaum, *Jews and Godfearers*, 134, 133f= Chaniotis, "Jews of Aphrodisias," nos. 13–14.

77. It contains four menorahs, shofar(s), a jug, and perhaps lulabs and ethrogs, on a 96 x 57 x 21 cm marble block found between columns 38 and 39 on the South Portico; Chaniotis, "Jews of Aphrodisias," Appendix II no. 16.

78. Chaniotis, "Jews of Aphrodisias," 230.

79. ALA, 129–36.

80. ALA, 129, no. 83.

81. Chaniotis, "Jews of Aphrodisias," 222; in a conversation on August 3, 2014, Chaniotis suggested that these were located in the corner of the structure.

82. While no other menorah graffiti were found in the space, a sherd of a clay lamp, embossed with a menorah mold, was found nearby. See Chaniotis, "Jews of Aphrodisias," 223; image in fig. 7; Appendix II no. 4.

83. Point emphasized in conversation with Chaniotis, August 3, 2014.

84. In conversation on August 3, 2014, Chaniotis estimated that approximately three of the one hundred total graffiti identified in the South Agora bore markings of Jewish identification.

85. ala2004 nos. 198–207; one inscription from the North Agora, for example, indicates the "[place of] Philip," whose name is carved below the column fluting (ala2004 no. 198). In the South Agora, several other *topos* inscriptions appear on lower portions of columns. One on the "twenty-fourth column from the west" includes the effaced *topos* inscription of *M[us]*, topped with a cross (ala2004 no. 199). A place inscription on a column in the South Agora marks the place (*topos*) for a "Zōtikos" and one for a "Eugraphios the Phylarch," which share a portion of a column, 1.25 meters above its base (ala2004 nos. 201 i and 201 ii; Pl. xlii).

86. See ala2004 no. 202. According to ALA, this text appears in the north portico of the South Agora, "nineteen columns from the east"; cf. ala2004 no. 204. Other texts also indicate the places of peddlers (e.g., ala2004 nos. 203–6), such as an inscription on the wall of the theatre in the

southeast corner of the complex, which labels the place of "Zotikos the peddler," alongside the names of adjacent sellers, surrounded by crosses (ala2004 no. 206).

87. Reynolds and Tannenbaum, *Jews and Godfearers*, 134.

88. The density of the graffiti is also both surprising and revealing. While graffiti with Jewish symbols represent a smaller proportion of the published markings from the South Agora (roughly 3 percent), they comprise a larger proportion of the markings in the Sebasteion. Perhaps the display of a menorah symbol, like a nearby Latin cross, would help buyers identify the religious proclivities of merchants, which might sway their decisions of where to shop. See the broader discussions of such points in Jordan Rosenblum, Lily C. Vuong, and Nathaniel DesRosiers, eds., *Religious Competition in the Third Century CE: Jews, Christians, and the Greco-Roman World* (Gottingen: Vandenhoeck and Ruprecht, 2014); Chaniotis, "Jews of Aphrodisias," 231.

89. The lavish decoration of the space has played a prominent role in the discussion of the associated structure; Kraabel, "The Diaspora Synagogue," 101–6.

90. Graffiti from the synagogue are also recorded in IJO II nos. 144–5.

91. Most other known examples are associated with Jews on the basis of ambiguous onomastic evidence; cf. Jones, *Pagan and Christian*, 133.

92. John Kroll describes how the menorahs appear in two out of the four total shops associated with Jews in Sardis. These identifications are based on onomastic information as well as the presence of menorahs; "Greek Inscriptions," 8, n. 9; also John Crawford, *The Byzantine Shops at Sardis. Archaeological Exploration of Sardis Monograph 9.* (Cambridge: Harvard University Press, 1990), 18, 61, 65, 79, 81, 84, 86–7, 89; see also figs. 311–2, 422, 428, 429, 462, 483.

93. Many of these arguments about the date of the Sardis synagogue rely on interpretations of its geographic position; see the discussion in Botermann, "Die Synagoge von Sardes," 453–5; Magness, "The Date of the Sardis Synagogue," 443–55; and Crawford, "Jews, Christians and Polytheists," 198–200.

94. See discussions of the subject in Fine, *The Menorah: A Biography* (Cambridge, MA: Harvard University Press, 2016), 10.

95. Chaniotis, "Jews of Aphrodisias": 226.

96. See examples in Reynolds and Tannenbaum, *Jews and Godfearers*, 78-131; cf. Chaniotis, "Jews of Aphrodisias," 211–15.

97. Maurice Chéhab, "Le Cirque du Tyr," *Archéologia* 55 (1973): 16–20.

98. The structure of the hippodrome and its environs have finally been published in Hany Kahwagi-Janho, *L'Hippodrome Romain de Tyr: Étude d'architecture et d'archeologie* (Bourdeux: Ausonius, 2012).

99. Chéhab, "Le Cirque du Tyr," 17.

100. Alan Cameron, *Circus Factions*, 212.

101. Chéhab, "Le Cirque du Tyr," 16–20.

102. IJO III, 17; position and map in Rey-Coquais, "Inscriptions," 333, 335.

103. In area N25, inv. no. 2186; IJO III, 17; Rey-Coquais, "Inscriptions," 333. Rey-Coquais dates these stalls and their corresponding inscriptions to the

fifth through sixth centuries CE; J.-P. Rey Coquais, "Fortune et rang social des gens de métiers de Tyr au Bas Empire," *Ktema* 4 (1979): 281.

104. Transcription follows that of the French and Greek transcription in Rey-Coquais, "Inscriptions," no. 14=Bulletin d'Archéologie et d'architecture Libanaise (Beyrouth) no. 142=Kahwagi-Janho, *L'Hippodrome*, no. X; IJO III, 17–18; Syr10. Similar *topos* inscriptions appear in Aphrodisias, e.g., SEG 37. 846–54.

105. On the name "Matrona" in Jewish contexts, see Tal Ilan, *Lexicon of Jewish Names in Late Antiquity, Part III: The Western Diaspora 330 BCE–650 CE* (Tübingen: Mohr Siebeck, 2008), 599.

106. Rey-Coquais argues ("Inscriptions," 333) that Matrona was related to a purple-fisher, but plied her own trade; cf. IJO III, 19.

107. Related professions (*konchuthleis* and *konchuleuzai*) constitute one fifth of those commemorated in Tyre's necropolis; Rey-Coquais, "Fortune et rang": 281–92. Women purple-fishers are documented in J.-P. Rey-Coquais, *Inscriptions grecques et latines découvertes dans les fouilles du Tyr* (Paris: Maisonneuve, 1977); nos. 68 and 24B.

108. On this point, see Rey-Coquais, "Inscriptions," 327, 329–30, 333–4, figs. 1–4, 6–8; Pieter Van der Horst, *Jews and Christians in Their Graeco-Roman Context* (Tübingen: Mohr Siebeck, 2006), 53–8; cf. Alan Cameron, *Porphyrius the Charioteer* (Oxford: Oxford University Press, 1973).

109. A second inscription probably appeared on the menorah's opposite side; IJO III, 17–18.

110. On the menorah as a marker, see Ilan, *Lexicon III*, 35; Cynthia Baker, *Rebuilding the House of Israel: Architectures of Gender in Jewish Antiquity* (Stanford: Stanford University Press, 2003), 77–8, 99. On women in circuses, see Ze'ev Weiss, *Public Spectacles*, 195.

111. Rey-Coquais, "Inscriptions," 332, no. 9= IJO III, Syr11.

112. Crosses precede four seat inscriptions, according to the transcription of Rey-Coquais.

113. Part of a similar vendor's text is preserved, as: "*topos | Tou. . . .*"; another reads: "*[t]opos Simōnos| -------|-------*"; Rey-Coquais, "Inscriptions," 333, nos. 11–12.

114. But especially in late antiquity, these criteria remain somewhat less reliable, because several of the names in question could be common to Jewish, Christian, and Samaritan populations. Cf. Lidewijde DeJong, "Performing Death in Roman Tyre: The Life and Afterlife of a Roman Cemetery in the Province of Syria," *AJA* 114 (2010): 597–630; Rey-Coquais, "Fortune et rang"; and see the discussion in IJO III, 17–18.

115. Epitaphs from Catacombs 19 and 21 at Beit Shearim identify the Tyrian origins of the deceased; see Hayim Lapin, "Palestinian Inscriptions and Jewish Ethnicity in Late Antiquity," in *Galilee through the Centuries: Confluence of Cultures*, ed. Eric Meyers (Winona Lake, Indiana: Eisenbrauns, 1999), 257, nn. 55; Steven Fine, "A Cosmopolitan 'Student of the Sages': Jacob of Kefar Nevoraia in Rabbinic Literature," in *Maven in Blue Jeans:*

A Festschrift in Honor of Zev Grabar, ed. Steven L. Jacobs (West Lafayette, IN: Purdue University Press, 2009), 37.

116. Compare with Claire Holleran, "Women in Retail in Roman Italy," in *Women and the Roman City in the Latin West*, ed. E. Hemelrijk and Gregg Woolf (Leiden: Brill, 2013), 313, 317.

117. Tal Ilan, *Jewish Women in Greco-Roman Palestine: An Inquiry into Image and Status* (TSAJ 44; Tübingen: Mohr Siebeck, 1995), 38.

118. Many stones, marked with Christian or Samaritan vocabulary or symbols, commemorate male carpenters and bakers, cheese-makers, garum sellers, grain dealers, murex fishers, and purple-dyers. Tabulations from Rey-Coquais, "Fortune et rang," 285; cf. DeJong, "Performing Death," 597–630.

119. Rey-Coquais, *Inscriptions grecques*, nos. 68 and 24B.

120. Connections between Tyre and Beit Shearim are reviewed in BS III, 178–82; 27, 42, 82, 118. While the professions of some men are commemorated on tombstones in Beit Shearim, for example, no epitaphs ascribe professions to women; cf. BS *III*, 36, 42; BS II, 215, nos. 61, 79, 81, 92, 188, 189, 202. Women's epitaphs and status are considered in Heszer, *Jewish Literacy*, 388, n. 262; BS II, no. 200. Compare the conclusions of Serena Zabin, "Iudaeae Benemerenti: Towards a Study of Jewish Women in the Western Roman Empire," *Phoenix* 50, no. 3/4 (1996): 278.

121. Several texts explicitly advocate excluding women from mixed work environments, streets, springs, and marketplaces (*m. 'Ketub.* 1:8–10; *t. Ketub.* 4:9), but other texts imply that women in those regions manufactured and sold cloth directly to customers around or outside of their homes (*m. B. Qam.* 10:9; *t. B. Qam.* 11:3).

122. *b. Ketub.* 72b; Baker, *Rebuilding*, 102, 107, 108–9, n.78; cf. Ze'ev Safrai, *The Economy of Roman Palestine* (New York: Routledge, 1994), 194. Employment of women, however, was neither limited to textile trades, nor to the marketplace, but could include working in homes as maidservants (Josephus *A.J.* 17.141); or, allegedly, as sorceresses or prostitutes (*m. 'Abot* 2:7; *b. 'Erub.* 64b; *m. Tem.* 6:2; *b. Sanh.* 67a; *b. 'Abod. Zar.* 18a-b; cf. Tal Ilan, *Jewish Women*, 207); see also Ross Kraemer, *Her Share of the Blessings: Women's Religions among Pagans, Jews, and Christians in the Greco-Roman World* (Oxford: Oxford University Press, 1992), 108–9; and Miriam Peskowitz, *Spinning Fantasies: Rabbis, Gender, and History* (Berkeley: University of California Press, 1997), 54, 132–3, 149.

123. Baker, *Rebuilding*, 108–19.

124. Literary elites of late antiquity demonstrated little concern for the lives and behaviors of women of lower status, who were more likely to pursue trades outside of the home. This point is considered in Miriam Groen-Vallinga, "Desperate Housewives? The Adaptive Family Economy and Female Participation in the Roman Urban Labour Market," in *Women and the Roman City in the Latin West*, ed. E. Hemelrijk and Gregg Woolf (Leiden: Brill, 2013), 295–312; 298. See also Kraemer, *Her Share*, 113.

125. See the overview in Amnon Linder, "The Legal Status," 128–69. For efforts to enforce unheeded laws, see discussion in Hagith Sivan, *Palestine in Late Antiquity* (Oxford: Oxford University Press), 131.
126. Legal and literary accounts remain sparse and incorporate evidence from contiguous regions; *Cod. Theod.* 13.15.18; 16.18.16; *Nov. Just.* No. 139; Malalas, *Chron.* 386 and 395; also Linder, "The Legal Status," 144–54.
127. Rabbinic and Christian authors associated circuses with impropriety; Weiss, *Public Spectacles*, 195–254.
128. Rey-Coquais' identifications of epitaphs from Tyre as "Jewish" remain tenuous—particularly in later periods; Rey-Coquais, *Inscriptions Grecques*, nos. 164; 167; on Tyrian Jews in Palaestina in CIJ I, no. 991.
129. See the discussion in Magness, "The Date of the Sardis Synagogue," 475.
130. Weiss, *Public Spectacles*, 195–254.

CHAPTER 4: RETHINKING MODERN GRAFFITI THROUGH THE ANCIENT

1. Considerations of comparable points can be found in Annabel Wharton, "Erasure," 195–214.
2. Benjamin Mazar, *Beth She'arim; Report on the Excavations during 1936–1940* (New Brunswick, NJ: Rutgers University Press on Behalf of the Israel Exploration Society and the Institute of Archaeology, Hebrew University, 1973), among many other examples.
3. Baird and Taylor, *Graffiti in Context*, 3; Chaniotis, "Graffiti in Aphrodisias," 193–4; Lucian, *Dialogues of the Courtesans*, 10.4.
4. Chaniotis, "Graffiti in Aphrodisias," 193–4.
5. The Villa Torlonia catacombs have been closed to the public, scholarly and otherwise, since the summer of 2012 and through the publication date of this book.

REFERENCES

Adams, C.E.P. "Travel and the Perception of Space In the Eastern Desert of Egypt." In *Wahrnehmung und Erfassung geographischer Räume in der Antike*, edited by Michael Rathmann, 211–20. Mainz am Rhein: Philipp von Zabern, 2007.

Adams, J. N. *The Latin Sexual Vocabulary*. Baltimore, MD: Johns Hopkins University Press, 1982.

Adler, Marcus Nathan, trans., *The Itinerary of Benjamin of Tudela: Critical Text, Translation and Commentary*. (New York: Phillip Feldheim, Inc., 1907); digitized version available from depts.washington.edu/silkroad/texts/tudela.html#N_66_. Last accessed September 13, 2017.

Adriani, Achille. *Annuaire du Musée Gréco-Romain* (1933-34–1934-5): *La nécropole de Moustafa Pacha Alexandria Egypt*. Alexandria: Société de Publications Égyptiennes, 1936.

———. *Annuaire du Musée Gréco-Romain* (1940–1950). Alexandria: Société de Publications Égyptiennes, 1952.

Al-Jadir, A. H. "A New Inscription from Hatra." *Journal of Semitic Studies* 51, no. 2 (2006): 305–11.

Al-Rajab, Malik Anas. "Contemporary Arabic Calligraphy." In *Arabic Graffiti*, edited by Pascal Zoghbi and Don Karl a.k.a. Stone, 24. Berlin: From Here to Fame Publishing, 2010.

Ameling, Walter. *Inscriptiones Judaicae Orientis. Vol. II: Asia Minor*. Tübingen: Mohr Siebeck, 2004.

Aviam, Mordechai. *Jews, Pagans, and Christians from the Galilee*. Rochester, NY: University of Rochester Press, 2004.

Avigad, Nahman. "Excavations in the Jewish Quarter of the Old City in Jerusalem, 1969–1970." *IEJ* 1/2 (1970): 1–8.

———. *Beth She'arim, Report on the Excavations during 1953–1958. Volume 3: Catacombs 12–23*. New Brunswick, NJ: Rutgers University Press, 1976.

———. *Discovery Jerusalem*. Jerusalem: T. Nelson, 1983.

———. "Jerusalem: Herodian Period." In *The New Encyclopedia of Archaeological Excavations in the Holy Land*, Vol. 2, edited by E. Stern, 730-1. New York: Carta, 1993.

Avigad, Nahman, and Benjamin Mazar. "Beth Shearim." In *The New Encyclopedia of Archeological Excavations in the Holy Land*, Vol. 1, edited by E. Stern, 236–48. New York: Carta, 1993.

Avi Yonah, Michael. *The Jews under Roman and Byzantine Rule: A Political History of Palestine from the Bar Kokhba War to the Arab Conquest*. New York: Schocken Books, 1984.

Avni, Gideon, Uzi Dahari, Amos Kloner. *The Necropolis of Bet Guvrin-Eleutheropolis*. Jerusalem: Israel Antiquities Authority, 2008.

Bagatti, Bellarmino. *Excavations in Nazareth*. Translated by E. Hoade. Jerusalem: Franciscan Printing Press, 1969.

Bagnall, Roger S. *Everyday Writing in the Graeco-Roman East*. Berkeley: University of California Press, 2011.

Baillet, Jules. *Inscriptions Grecques et Latines des Tombeaux des Rois ou Syringes à Thèbes*. Le Caire: Institut Français d'archéologie Orientale du Caire, 1920.

Bain, Katherine. *Women's Socioeconomic Status and Religious Leadership in Asia Minor in the First Two Centuries, C.E.* Minneapolis: Fortress Press, 2014.

Baird, Jennifer A. *The Inner Lives of Ancient Houses: An Archaeology of Dura-Europos*. Oxford: Oxford University Press, 2013.

———. "The Graffiti of Dura-Europos: A Contextual Approach." In *Ancient Graffiti in Context*, edited by J. Baird and C. Taylor, 49–68. New York: Routledge.

Baird, Jennifer A., and Claire Taylor, eds. *Ancient Graffiti in Context*. New York: Routledge, 2011.

Baker, Cynthia. *Rebuilding the House of Israel: Architectures of Gender in Jewish Antiquity* (Divinations). Stanford, CA: Stanford University Press, 2003.

———. *Jew (Key Terms in Jewish Studies)*. New Brunswick, NJ: Rutgers, 2016.

Balberg, Mira. *Purity, Body, and Self in Early Rabbinic Literature*. Berkeley: University of California Press, 2014.

Baquedano-Lopez, Patricia. "Prayer." *Journal of Linguistic Anthropology* 9, no. 1–2 (1999): 197–200.

Barbet, Alix. "Traces fortuites ou intentionelles sur les peintures murales antiques." *Syria* 77 (2010): 169–80.

————. "Graffitis à la romaine: un essai d'archéologie expérimentale." In *Inscriptions mineures: nouveautés et réflexions. Actes du premier colloque Ductus (19–20 juin 2008, Université de Lausanne)*, edited by M. Fuchs, R. Sylvestre, and C. Schmidt Heidenreich, 241–60. Berne: Peter Lang, 2012.

Barbet, Alix, and Michel Fuchs. *Les Murs Murmurent: Graffitis Gallo-romains: Catalogue de L'exposition Crée au Musée Romain de Lausanne-Vidy, 2008*. Gollion (Suisse), Infolio, 2008.

Baron, Salo. *A Social and Religious History of the Jews*. Vol. 1. New York: Columbia University Press. Reprint, Philadelphia: JPS, 1952.

Barthes, Roland. "Death of the Author" (1968). In *The Rustle of Language*, 49–55. Translated by Richard Howard. Berkeley: University of California Press, 1989.

————. "From Work to Text" (1971). In *The Rustle of Language*, 56–64. Translated by Richard Howard. Berkeley: University of California Press, 1989.

————. *S/Z*. Translated by Richard Miller. Hill and Wang: New York, 2000.

Basch, Lucien. *Musée imaginaire de la marine antique*. Athens: Institut hellénique pour la preservation de la tradition nautique, 1987.

Baur, P.V.C. M. I. Rostovtzeff, and A. R. Bellinger. *The Excavations at Dura-Europos: Conducted by Yale University and the French Academy of Inscriptions and Letters. Preliminary Report of the 4th Season of Work*. New Haven, CT: Yale University Press, 1933.

Beard, Mary. "Ancient Literacy and the Function of the Written Word in Roman Religion." In *Literacy in the Roman World*, edited by J. H. Humphrey, 35–58. JRA Suppl. 3. Portsmouth, RI: JRA, 1991.

————. *Laughter in Ancient Rome: On Joking, Tickling, and Cracking Up*. Berkeley: University of California Press, 2014.

Becker, Adam H., and Annette Yoshiko Reed, eds. *The Ways That Never Parted: Jews and Christians in Late Antiquity and the Early Middle Ages*. Minneapolis: Fortress Press, 2007.

Ben-Eli, Arie. *Ships and Parts of Ships on Ancient Coins*. Haifa: Maritime Museum Foundation, 1975.

Benefiel, Rebecca R. "Dialogues of Ancient Graffiti in the House of Maius Castricius in Pompeii." *AJA* 114, no. 1 (2010): 59–101.

Benefiel, Rebecca. "The Culture of Writing Graffiti within Domestic Spaces at Pompeii." In *Inscriptions in the Private Sphere in the Greco-Roman World*, edited by Rebecca Benefiel and Peter Keegan, 80–110. Leiden: Brill, 2016.

Benefiel, Rebecca, and Peter Keegan, eds. *Inscriptions in the Private Sphere in the Greco-Roman World*. Leiden: Brill, 2016.

Benjamin, Walter. "The Author as Producer." In *Walter Benjamin, Selected Writings, vol. 2, part 2: 1931–34*, edited by Howard Eiland and Michael William Jennings. Cambridge, MA: Harvard University Press, 2003.

Bennett, C. M. "The Jerusalem Ship." *International Journal of Nautical Archaeology and Underwater Excavation* (Notes and News) 3 (1974): 307–9.

Berlin, Andrea. "Power and Its Afterlife in Roman Palestine." *NEA* 62 (2002): 138–48.

———. "Jewish Life Before the Revolt: The Archaeological Evidence." *JSJ* 36, no. 4 (2005): 417–70.

———. "Household Judaism." In *Galilee in the Late Second Temple and Mishnaic Periods 100 BCE–200 CE, Vol. 1: Life, Culture, and Society*, edited by D. Fiensy and J. Strange, 208–15. Minneapolis, MN: Fortress Press, 2015.

Bernand, André. *Le Paneion d'El-Kanaïs: Les inscriptions grecques.* Leiden: Brill, 1972.

———. *Pan du Désert.* Leiden: Brill, 1977.

Bertolino, Roberto. *Corpus des Inscriptions Semitiques de Doura-Europos.* Napoli: Istituto Orientale Di Napoli, 2004.

———. *Manuel D'épigraphie Hatréenne.* Paris: Geuthner, 2007.

Beyer, Hermann W., and Hans Leitzmann. *Die jüdische Katacombe der Villa Torlonia in Rom.* Berlin and Leipzig: W. de Gruyter, 1930.

Bier, Lionel. "The Bouleterion." In *Aphrodisias Papers 4: New Research on the City and Its Monuments [JRA Supplementary Series 70]*, edited by Christopher Ratté and R. R. R. Smith, 144–68. Portsmouth, RI: Journal of Roman Archaeology, 2008.

Bishop, Claire. "The Social Turn: Collaboration and Its Discontents." *Artforum.com.* February 2006. artforum.com/inprint/id=10274. Accessed August 4, 2016.

———. *Artificial Hells: Participatory Art and the Politics of Spectatorship.* London: Verso Books, 2012.

Bloch-Smith, Elizabeth. *Judahite Burial Practices and Beliefs about the Dead.* Sheffield, UK: Sheffield Academic Press, 1992.

Bohak, Gideon. *Ancient Jewish Magic: A History.* Cambridge: Cambridge University Press, 2008.

Bonz, M. P. "The Jewish Donor Inscriptions from Aphrodisias: Are They Both Third Century and Who Are the Theosebeis?" *Harvard Studies in Classical Philology* 76 (1994): 281–99.

Botermann, H. "Die Synagoge von Sardes: Eine Synagoge aus dem 4 Jahrhundert?" *Zeitschrift für die Neutestamentliche Wissenschaft* 81 (1990): 103–21.

Bourdieu, Pierre. *Outline of a Theory of Practice.* Cambridge: Cambridge University Press, 1977.

Bowersock, G. W. *Roman Arabia*. Cambridge, MA: Harvard University Press, 1983.

Boyarin, Daniel. *Dying for God: Martyrdom and the Making of Christianity and Judaism*. Stanford, CA: Stanford University Press, 1999.

———. *Border Lines: The Partition of Judaeo-Christianity*. Philadelphia: University of Pennsylvania Press, 2004.

———. *Socrates and the Fat Rabbis*. Chicago: University of Chicago Press, 2009.

Bradley, Mark, ed. *Smell and the Ancient Senses (The Senses in Antiquity)*. London and New York: Routledge, 2015.

Branham, Joan. "Vicarious Sacrality: Temple Space in Ancient Synagogues." In *Ancient Synagogues: Historical Analysis and Archaeological Discovery, Vol. 2*, edited by Dan Urman and Paul Flesher, 319–45. Leiden: Brill, 1998.

Braun, Thomas. "The Jews in the Late Roman Empire." *SCI* 17 (1998): 142–71.

Brettler, Marc Zvi, and Michael Poliakoff. "Rabbi Simeon ben Lachish at the Gladiator's Banquet: Rabbinic Observations on the Roman Arena." *HTR* 83 (1990): 93–8.

Brodsky, David. "Mourner's Kaddish, The Prequel: The Sassanian Period Back-story that Gave Birth to the Medieval Prayer for the Dead." In *The Aggada of the Bavli in Its Cultural World*, edited by Jeffrey Rubenstein and Geoffrey Herman (Providence: BJS, forthcoming, 2018).

Brock, Sebastian, Haim Goldfus, and Aryeh Kofsky. "The Syriac Inscriptions at the Entrance to Holy Sepulchre, Jerusalem." *Aram* 18–19 (2006–2007): 415–38.

Brooten, Bernadette J. *Women Leaders in the Ancient Synagogue: Inscriptional Evidence and Background Issues*. Chico, CA: Scholars Press, 1982.

Buhagiar, Mario. *Late Roman and Byzantine Catacombs and Related Burial Places in the Maltese Islands* [BAR Int Ser S302]. Oxford: British Archaeological Reports, 1986.

———. "The Jewish Catacombs of Roman Melite." *The Antiquaries Journal* 91 (2011): 73–100.

Burke, Peter. *Eyewitnessing: The Uses of Images as Historical Evidence*. Ithaca, NY: Cornell University Press.

Burns, Joshua Ezra. "The Archaeology of Rabbinic Literature and the Study of Jewish-Christian Relations." In *Religion, Ethnicity, and Identity in Ancient Galilee: A Region in Transition*, edited by Jürgen Zangenberg, Harold Attridge, and Dale B. Martin, 403–24. Tübingen: Mohr Seibeck, 2007.

Burrell, Barbara. *Neokoroi: Greek Cities and Roman Emperors*. Leiden: Brill, 2004.

Cameron, Alan. *Porphyrius the Charioteer*. Oxford: Oxford University Press, 1973.

———. *Circus Factions: Blues and Greens at Rome and Byzantium*. Clarendon: Oxford, 1976.

Cameron, Averil, Hagit Amirav, and R. B. ter Haar Romeny. *From Rome to Constantinople: Studies in Honour of Averil Cameron*. Leuven: Peeters, 2007.

Cantineau, Jean. *Le Nabatéen*. Paris: Leroux, 1930.

Carlson, Marla. *Performing Bodies in Pain: Medieval and Post-Modern Martyrs, Mystics and Artists*. New York: Palgrave, 2010.

Carr, David McLain. "The Tel Zayit Abecedary in (Social) Context." In *Literature Culture and Tenth-Century Canaan: The Tel Zayit Abecedary in Context*, edited by Ron Tappy and Kyle McCarter, 124. Winona Lake, IN: Eisenbrauns, 2008.

Casson, Lionel. *Ships and Seamanship in the Ancient World*. Baltimore, MD: Johns Hopkins University Press, 1995.

CBS News. "Swastikas, 'Go Trump' found on Adam Yauch playground in Brooklyn." CBS News. November 18, 2016. www.cbsnews.com/news/swastikas -go-trump-graffiti-at-adam-yauch-playground-in-brooklyn/. Accessed August 22, 2017.

Chaniotis, Angelos. "The Jews of Aphrodisias: New Evidence and Old Problems." *SCI* 21 (2002), 209–42.

———. "New Inscriptions from Late Antique Aphrodisias." *Tekmeria* 9 (2008), 219–32.

———. "The Conversion of the Temple of Aphrodite at Aphrodisias in Context." In *From Temple to Church: Destruction and Renewal of Local Cultic Topography in Late Antiquity*, edited by Stephen Emmel, Ulrich Gotter, and Johannes Hahn, 243–74. Leiden: Brill, 2008.

———. "Graffiti in Aphrodisias: Images—Texts—Contexts." In *Ancient Graffiti in Context*, edited by J. A. Baird and Claire Taylor, 191–208. New York: Routledge, 2010.

———. *Sources and Methods for the Study of Emotions in the Greek World*. Stuttgart: Steiner, 2012.

Chéhab, Maurice. "Le Cirque du Tyr." *Archéologia* 55 (1973): 16–20.

Clarke, John R. *Art in the Lives of Ordinary Romans: Visual Representation and Non-elite Viewers in Italy, 100 B.C.–A.D. 315*. Berkeley: University of California Press, 2003.

Clauss, Pascale. "Les tours funéraires du Djebel Bagoûz dans l'histoire de la tour funéraire syrienne." *Syria* 79 (2002): 155–94.

Cohen, Shaye J. D. "Epigraphical Rabbis." *JQR* 72 (1981–1982): 1–17.

———. *The Beginnings of Jewishness: Boundaries, Varieties, Uncertainties*. Berkeley: University of California Press, 1999.

Coleman, Michael. *Tag*. London: Orchard, 1998.

Collins, James, and Richard K. Blot. *Literacy and Literacies: Texts, Power, and Identity*. New York: Cambridge University Press, 2003.

Cooley, A. and M.G.L. Cooley, eds. *Pompeii: A Sourcebook*. London and New York: Routledge, 2004.

Corbelli, A. *The Art of Death in Graeco-Roman Egypt*. Princes Risborough, UK: Shire, 2006.

Crawford, John. *The Byzantine Shops at Sardis. Archaeological Exploration of Sardis Monograph 9*. Cambridge: Harvard University Press, 1990.

Crawford, John S. "Jews, Christians and Polytheists in Late Ancient Sardis." In *Jews, Christians, and Polytheists in the Ancient Synagogue. Cultural Interaction in the Graeco-Roman Period*, edited by Steven Fine, 190–200. London and New York: Routledge, 1999.

Croce, Mariano. "The *Habitus* and the Critique of the Present: A Wittgensteninian Reading of Bourdieu's Social Theory." *Sociological Theory* 33 (2010): 327–46.

D'Ambra, Eve, and Guy P. R. Métraux. *The Art of Citizens, Soldiers and Freedmen in the Roman World*. Oxford: Archaeopress, 2006.

Dar, Shimon. *Sumaqa: A Roman and Byzantine Jewish Village on Mount Carmel, Israel. BAR International Series 815*. Oxford: Archaeopress, 1999.

Davies, Jon. *Death, Burial and Rebirth in the Religions of Antiquity*. London and New York: Routledge, 2013.

Day, Juliette, Raimo Hakola, Maijastina Kahlos, and Ulla Tervahauta. *Spaces in Late Antiquity: Cultural, Theological and Archaeological Perspectives*. New York: Routledge, 2016.

de Certeau, Michel. *The Practice of Everyday Life*. Translated by Steven Rendall. Berkeley: University of California Press, 2011.

De Jong, Lidewijde. "Performing Death in Roman Tyre: The Life and Afterlife of a Roman Cemetery in the Province of Syria." *AJA* 114 (2010): 597–630.

de Lange, Nicolas. "Jews in the Age of Justinian." In *The Cambridge Companion to the Age of Justinian*, edited by Michael Maas, 401–26. New York: Cambridge University Press, 2005.

Demange, Françoise. "The Frankincense Caravans." In *Roads of Arabia: Archaeology and History of the Kingdom of Saudi Arabia*, 132–5. Paris: Louvre, 2010.

Derrida, Jacques. *Of Grammatology*. Baltimore, MD: Johns Hopkins University Press, 1980.

———. "Countersignature." *Paragraph* 27, no. 2 (2004): 7–42.

de Vries, Bert. "'Be of Good Cheer! No One on Earth is Immortal': Religious Symbolism in Tomb Architecture and Epitaphs at the Umm el-Jimal and Tall Hisban Cemeteries." In *The Madaba Plains Project: Forty Years of Research in*

Jordan's Past, edited by Douglas R. Clark, Larry G. Herr, Øystein S. LaBianca, and Randall W. Younker. 196-215. Abingdon and New York: Routledge, 2014.

Dirven, Lucinda. *The Palmyrenes of Dura-Europos: A Study of Religious Interaction in Roman Syria*. Boston: Brill, 1999.

DiSegni, Lea, and Joseph Patrich. "The Greek Inscriptions in the Cave Chapel of Ḥorvat Qaṣra." *'Atiqot* 10 (1990): 31–45. [Hebr. Ser.].

DiSegni, Leah, Gideon Foerster, and Y. Tsafrir. "The Basilica and Altar to Dionysos at Nysa-Scythopolis." In *The Roman and Byzantine Near East. Vol. 2: Some Recent Archaeological Research [JRA Supplementary Series 31]*, edited by John Humphrey, 59–75. Ann Arbor, MI: JRA, 1999.

Doering, Lutz. *Ancient Jewish Letters and the Beginnings of Christian Epistolography*. Tübingen: Mohr Seibeck, 2012.

Downey, Susan B. *Mesopotamian Religious Architecture: Alexander through the Parthians*. Princeton, NJ: Princeton University Press, 1988.

Du Mesnil du Buisson, Compte. *Les Peintures de la Synagogue de Doura-Europos, 245–256 apres J.-C.* Rome: Pontificio Instituto Biblico, 1939.

———. "Sur quelques inscriptions juives de Doura-Europos," *Biblica* 18 (1937): 153-73; 458-9.

Du R. P. Prosper, Viaud. "Nazareth et ses deux églises de l'anonciation et de Saint-Joseph après les fouilles récents." *Revue des Études Byzantines* 13, no. 85 (1910): 364–5.

Ehrenfreund, Max. "Banksy Opens New York 'Show.'" *The Washington Post*, October 3, 2013. www.highbeam.com/doc/1P2–35202673.html?refid=easy_hf. Accessed 2016.

Ehrlich, Uri. *The Nonverbal Language of Prayer: A New Approach to Jewish Liturgy*. Tübingen: Mohr Siebeck, 2004.

Elsner, Jaś. "Archaeologies and Agendas: Reflections on Late Ancient Jewish Art and Early Christian Art." *JRS* 93 (2003): 114–28.

———. *Roman Eyes: Visuality and Subjectivity in Art & Text*. Princeton, NJ: Princeton University Press, 2007.

Elsner, Jaś, and Ian Rutherford, eds. *Pilgrimage in Graeco-Roman & Early Christian Antiquity: Seeing the Gods*. Oxford: Oxford University Press, 2005.

Empereur, Jean-Yves. *A Short Guide to the Catacombs of Kom El Shoqafa, Alexandria*. Alexandria: Serapis, 1995.

Faraone, Christopher, and Joseph L. Rife. "A Greek Curse against a Thief from the Koutsongila Cemetery at Roman Kenchrai." *ZPE* 160 (2007): 141–57.

Fasola, U. M. "Le Due catacombe ebraiche di villa Torlonia." *Revista de archaeologia cristiana* 52 (1976): 7–62.

Fine, Steven. *Sacred Realm: The Emergence of the Synagogue in the Ancient World*. New York: Oxford University Press, 1996.

————. *Art and Judaism in the Greco-Roman World: Toward a New Jewish Archaeology.* Cambridge: Cambridge University Press, 2005.

————. "A Cosmopolitan 'Student of the Sages': Jacob of Kvar Nevoraia in Rabbinic Literature." In *Maven in Blue Jeans: A Festschrift in Honor of Zev Grabar*, edited by Steven L. Jacobs, 35–43. West Lafayette, IN: Purdue University Press, 2009.

————. "Death, Burial, and Afterlife." In *The Oxford Handbook of Jewish Daily Life in Palestine*, edited by Catherine Heszer, 440–64. New York: Oxford, 2010.

————. "Jewish Identity at the *Limus:* The Earliest Reception of the Dura Europos Synagogue Paintings." In *Cultural Identity in the Ancient Mediterranean: Issues and Debates*, edited by Erich Gruen, 289–306. Los Angeles: Getty Research Institute, 2011.

————. "When is a Menorah 'Jewish'? On the Complexities of a Symbol under Byzantium and Islam." In *Age of Transition: Byzantine Culture in the Islamic World*, edited by Helen Evans, 38–53. New York: Metropolitan Museum of Art, 2013.

————. *The Menorah: A Biography.* Cambridge, MA: Harvard University Press, 2016.

Fleming, Juliet. *Graffiti and the Writing Arts of Early Modern England.* Philadelphia: University of Pennsylvania Press, 2001.

Florence, Robert, and J. Mason Florence. *New Orleans Cemeteries: Life in the City of the Dead.* New Orleans, LA: Batture Press, 1997.

Francis, E. D. "Mithraic Graffiti from Dura Europos." In *Mithraic Studies, vol. II: Proceedings of the First International Congress of Mithraic Studies*, edited by J. Hinnells. Manchester, UK: Manchester University Press: 1975, 424–45.

Frankfurter, David, ed. *Pilgrimage and Holy Space in Late Antique Egypt.* Leiden: Brill, 1998.

Frankfurter, David. Review of Christopher A. Faraone, "Ancient Greek Love Magic." *Phoenix* 54, no. 1/2 (2000): 165–8.

Frankfurter, David. "Iconoclasm and Christianization in Late Ancient Egypt: Christian Treatments of Space and Image." In *From Temple to Church: Destruction and Renewal of Local Cultic Topography in Late Antiquity*, edited by Johannes Hahn, Stephen Emmel, and Ulrich Gotter, 136–60. Leiden: Brill, 2008.

————. "Scorpion/Demon: On the Origin of the Mesopotamian Apotropaic Bowl." *JNES* 74, no. 1 (2015): 9–18.

————. "The Magic of Writing and the Writing of Magic: The Power of the Word in Egyptian and Greek Traditions," *Helios* 21 (1994): 189–221.

Fredriksen, Paula. *Augustine and the Jews: A Christian Defense of Jews and Judaism*. New Haven, CT: Yale University Press, 2014.

Fredriksen, Paula, and Oded Irshai. "Christian Anti-Judaism: Polemics and Policies." In *The Cambridge History of Judaism*, Vol. 4, edited by Steven T. Katz, 997–1033. Cambridge: Cambridge University Press, 2006.

Freedberg, David. *The Power of Images: Studies in the History and Theory of Response*. Chicago: University of Chicago Press, 1989.

Frey, Jean-B. *Corpus Inscriptionum Judaicarum*. Vol. 1. Rome: Pontificio Istituto di Archeologia Cristiana, 1970.

Frood, Elizabeth. "Egyptian Temple Graffiti and the Gods: Appropriation and Ritualization in Karnak and Luxor." In *Heaven on Earth: Temples, Ritual and Cosmic Symbolism in the Ancient World*, edited by Deena Ragavan, 285–318. Chicago: University of Chicago Press, 2013.

Funari, P.P.A. "Apotropaic Symbolism at Pompeii: A Reading of the Graffiti Evidence." *Revista de história* 132 (1995): 9–17.

Gafni, Isaiah. "Reinterment in the Land of Israel: Notes on the Origin and Development of the Practice." *Jerusalem Cathedra* 1 (1981): 96–104.

———. *Land, Center and Diaspora: Jewish Constructs in Late Antiquity*. Sheffield, UK: Sheffield, 1997.

Gager, John G., ed. *Curse Tablets and Binding Spells from the Ancient World*. New York: Oxford University Press, 1992.

Ganz, Nicholas, and Tristan Manco. *Graffiti World: Street Art from Five Continents*. London: Thames & Hudson, 2009.

Garnsey, Peter. *Social Status and Legal Privilege in the Roman Empire*. Oxford: Oxford University Press, 1970.

Gaston, Lloyd. "Jewish Communities in Sardis and Smyrna." In *Religious Rivalries and the Struggle for Success in Sardis and Smyrna*, edited by Richard S. Ascough, 17–25. Ontario: Wilfred Laurier University Press, 2005.

Gawlikowski, M. "La Notion du tombeau en Syrie romaine." *Berytus* 21 (1972): 5–15.

Gell, Alfred. *Art and Agency: An Anthropological Theory*. Oxford: Clarendon Press, 1998.

Gibson, Shimon. "The Tell Sandahannah Ship Graffito Reconsidered." *PEQ* 124 (1992): 26–30.

Gilbert, Gary. "Jewish Involvement in Ancient Civic Life: The Case of *Aphrodisias*." *RB* 113 (2006): 18–36.

Goldman, Bernard. *The Sacred Portal: A Primary Symbol in Ancient Judaic Art*. Detroit: Wayne State University Press, 1966.

———. "Foreigners at Dura-Europos." *Le Muséon* 103. 1 (1990): 5–25.

————. "Pictorial Graffiti of Dura Europos." *Parthica* 1 (1999): 19–106.

Goodenough, E. R. *Jewish Symbols in the Greco-Roman Period.* Vols. 1–12. New York: Pantheon Books, 1953–1967.

Goodman, Martin. "Review of Reynolds and Tannenbaum 1987." *JRS* 78 (1988): 261–2.

————. "Jews and Judaism in the Mediterranean Diaspora in the Late-Roman Period: The Limitations of Evidence." *Judaism in the Roman World* 4, no. 2 (1994): 208–24.

————. *State and Society in Roman Galilee: A.D. 132–212.* 2nd ed. London: Vallentine Mitchell, 2000.

Grant, Michael. *The Jews in the Roman World.* New York: Simon and Schuster, 1973.

Grant, R. M. "The Social Setting of Early Christianity." In *Jewish and Christian Self-Definition. Vol. 1, The Shaping of Christianity in the Second and Third Centuries,* edited by E. P. Sanders, 16–29. London: SCM, 1980.

Green, Deborah. "Sweet Spices in the Tomb: An Initial Study of the Uses of Perfume in Jewish Burials." In *Commemorating the Dead: Texts and Artifacts in Context: Studies of Roman, Jewish and Christian Burials,* edited by Laurie Brink and Deborah Green, 145–76. Berlin: De Gruyter, 2008.

Grey, Matthew. "'The Redeemer to Arise from the House of Dan': Samson, Apocalypticism, and Messianic Hopes in Late Antique Galilee." *JSJ* 4 (2013): 553–589.

Groen-Vallinga, Miriam. "Desperate Housewives? The Adaptive Family Economy and Female Participation in the Roman Urban Labour Market." In *Women and the Roman City in the Latin West,* edited by E. Hemelrijk and Gregg Woolf, 295–312. Leiden: Brill, 2013.

Gröndahl, Mia. *Revolution Graffiti: Street Art of the New Egypt.* London: Thames and Hudson, 2013.

Groom, Nigel. *Frankincense and Myrrh: A Study of the Arabian Incense Trade [Arab Background Series].* London and New York: Longman; Beirut: Librairie du liban, 1981.

Gruen, Erich S. *Diaspora: Jews amidst Greeks and Romans.* Cambridge, MA: Harvard University Press, 2002.

Gruen, Erich S., ed. *Cultural Identity in the Ancient Mediterranean: Issues and Debates.* Los Angeles: Getty Research Institute, 2011.

Gudme, Anne Katrine, de. *Before the God in this Place for Good Remembrance: A Comparative Analysis of the Aramaic Votive Inscriptions from Mount Gerizim.* Berlin/Boston: de Gruyter, 2013.

Gutmann, Joseph. *The Dura-Europos Synagogue; a Re-evaluation (1932–1972).* Chambersburg, PA: American Academy of Religion, 1973.

Hachlili, Rachel. "The Goliath Family in Jericho: Funerary Inscriptions from a First-Century AD Jewish Monumental Tomb." *BASOR* 235 (1979): 31–63.

———. "The *nefeš*, the Jericho Column-Pyramid." *PEQ* 113 (1981): 33–8.

———. *Art and Archaeology in the Land of Israel*. Leiden: Brill, 1988.

———. *Ancient Jewish Art and Archaeology in the Diaspora*. Leiden: Brill, 1998.

———. *The Menorah: The Ancient Seven-armed Candelabrum. Origin, Form, and Significance*. Leiden: Brill, 2001.

———. *Jewish Funerary Customs, Practices, and Rites during the Second Temple Period*. Leiden: Brill, 2005.

Hachlili, Rachel, and Ann Killebrew, *Jericho: The Jewish Cemetery of the Second Temple Period*. Jerusalem: Israel Antiquities Authority, 1999.

Haddad, Elie, and Michal Artzy. "Ship Graffiti in Burial Cave 557 at Maresha." *NEA* 74, no. 4 (2011): 236–40.

Hallett, Judith P., and Marilyn B. Skinner. *Roman Sexualities*. Princeton, NJ: Princeton University Press, 1997.

Halperim, Dalia-Ruth. *Illuminating in Micrography: The Catalan Micrography Mahzor—MS Heb 8°6527 in the National Library of Israel*. Leiden and Boston: Brill, 2013.

Harland, Philip. *Associations, Synagogues, and Congregations: Claiming a Place in Ancient Mediterranean Society*. Minneapolis: Fortress Press, 2003.

Harmon, A. M. transl. *Lucian*. Vol. 2. Loeb Series. Cambridge, MA: Harvard University Press, 1960.

Harrington, Daniel. *First and Second Maccabees: A Commentary*. Minnesota: Liturgical Press, 2012.

Healey, John F. "A Nabataean Sundial from Madā'in Ṣāliḥ." *Syria* 66 (1989): 331–6.

Healey, John. "'May He Be Remembered for the Good': An Aramaic Formula." In *Targumic and Cognate Studies: Essays in Honour of Martin McNamara*, edited by Kevin J. Cathcart, Michael Maher, and Martin McNamara, 177–86. Sheffield, UK: Sheffield Academic Press, 1996.

Hezser, Catherine. *Jewish Literacy in Roman Palestine*. Tübingen: Mohr Seibeck, 2001.

Hezser, Catherine, ed. *The Oxford Handbook of Jewish Daily Life in Roman Palestine*. New York: Oxford University Press, 2010.

Hillers, Delbert Roy, and Eleonora Cussini. *Palmyrene Aramaic Texts*. Baltimore, MD: Johns Hopkins University Press, 1996.

Hoftijzer, Jacob, Karel Jongeling, Bertold Spuler, and Hady R. Idris. *Dictionary of the North-West Semitic Inscriptions*. Leiden: Brill, 1995.

Holleran, Claire. "Women in Retail in Roman Italy." In *Women and the Roman City in the Latin West*, edited by E. Hemelrijk and Gregg Woolf, 313–30. Leiden: Brill, 2013.

Holloway, Ross. "The Tomb of the Diver." *AJA* 110 (2006): 365–88.

Horster, Marietta. "Religious Landscape and Sacred Ground: Relationships between Space and Cult in the Greek World." *Revue de l'Histoire des Religions* 4 (2010): 435–58.

Hoyland, Robert. "The Jews of the Hijaz in the Qurʾān and in their inscriptions." In *New Perspectives on the Qurʾān: The Qurʾān in its Historical Context 2*, edited by Gabriel Said Reynolds, 91–116. New York: Routledge, 2011.

Hultin, Jeremy. *The Ethics of Obscene Speech in Early Christianity and Its Environment*. Leiden: Brill, 2008.

Ilan, Tal. *Jewish Women in Greco-Roman Palestine: An Inquiry into Image and Status [TSAJ 44]*. Tübingen: Mohr Siebeck, 1995.

———. *Lexicon of Jewish Names in Late Antiquity 330 BCE–650 CE. Part III. The Western Diaspora*. Tübingen: Mohr Siebeck, 2008.

———. *Lexicon of Jewish Names in Late Antiquity 330 BCE–650 CE. Part IV. The Eastern Diaspora*. Tübingen: Mohr Siebeck, 2011.

———. *Lexicon of Jewish Names in Late Antiquity. Part II. Palestine 200–650*. Tübingen: Mohr Siebeck, 2012.

Imbert, Frédéric. "Le Coran dans les graffiti des deux premiers siècles de l'Hégire." *Arabica* 47 (2000): 384–90.

Ingholdt, H. "Five Dated Tombs from Palmyra." *Berytus* 2 (1935): 58–120.

Isaac, Benjamin H. *The Invention of Racism in Classical Antiquity*. Princeton, NJ: Princeton University Press, 2004.

Jacab, Éva. "Property Rights in Ancient Rome." In *Ownership and Exploitation of Land and Natural Resources in the Roman World*, edited by Paul Erdkamp, Koenraad Verboven, and Arjan Zuiderhoek, 107–35. Oxford: Oxford University Press, 2015.

Jacobson, D. M. *The Hellenistic Paintings of Marisa. PEF Annual, Vol. II*. London: Maney, 2007.

James, Simon. "Stratagems, Combat, and 'Chemical Warfare' in the Siege Mines of Dura-Europos." *AJA* 115, no. 1 (2011): 69–101.

Jantzen, U., R. Felsch, and H. Keinast. "Samos 1972: Die Wasserleitung des Eupalinos." *Archäologischer Anzeiger, Beiblatt zum Jahrbuch des (Kaiserlichen) Deutschen Archäologischen Instituts* 88 (1973): 401–14.

Jensen, Robin. "The Dura Europos Synagogue, Early Christian Art, and Religious Life in Dura Europos." In *Jews, Christians, and Polytheists in the Ancient*

Synagogue: Cultural Interaction during the Greco-Roman Period, edited by Steven Fine, 154–68. London: Routledge, 1999.

————. *Living Water: Images, Symbols, and Settings of Early Christian Baptism.* Leiden: Brill, 2011.

Jones, Christopher. *Between Pagan and Christian.* Cambridge, MA: Harvard University Press, 2014.

Jones, Lindsay. *The Hermeneutics of Sacred Architecture.* Cambridge, MA: Harvard University Press, 2000.

Kahwagi-Janho, Hany. *L'Hippodrome Romain de Tyr: Étude d'architecture et d'archeologie.* Bourdeux: Ausonius, 2012.

Kaizer, Ted. "Religion and Language in Dura-Europos." In *From Hellenism to Islam: Cultural and Linguistic Change in the Roman Near East*, edited by Hannah Cotton, Robert Hoyland, Jonathan Price, and David Wasserstein, 235–54. Cambridge: Cambridge University Press, 2009.

Kant, L. H. "Jewish Inscriptions in Greek and Latin." *ANRW II* 20.2 (1987): 671–713.

Kasher, Aryeh. *The Jews in Hellenistic and Roman Egypt: The Struggle for Equal Rights.* Tübingen: Mohr Siebeck, 1985.

Kashtan, N. "The Ship as Reality and Symbol: How It was Perceived in Hellenistic and Roman Palestine." In *6th International Symposium on Ship Construction in Antiquity* [*Tropis* VI], edited by H. E. Tzalas, 317–29. Athens: Institut héllenique pour la preservation de la tradition nautique, 1991.

Keegan, Peter. *Graffiti in Antiquity.* Oxon and New York: Routledge, 2015.

Kimelman, Reuven. "The Rabbinic Theology of the Physical: Blessings, Body and Soul, Resurrection, and Covenant and Election." In *The Cambridge History of Judaism. Vol. 4. The Late Roman-Rabbinic Period*, edited by Steven T. Katz, 946–76. Cambridge: Cambridge University Press, 2006.

Kleiner, G. *Das römische Milet.* Wiesbaden: F. Steiner, 1970.

Kloner, Amos. "New Judean/Jewish inscriptions from the 'Darom'." *Qadmoniyot* 71–2 (1982): 96–100 [Hebrew].

————. "ABCDerian Inscriptions in Jewish Rock-Cut Tombs." In *Proceedings of the Ninth World Congress of Jewish Studies, Jerusalem, August 4–12, 1985*, Division A, 125–32. Jerusalem: n.p., 1986 [Hebrew].

————. "Burial Caves with Wall-Paintings from the First-Century CE in Jerusalem and Judea." In *Graves and Burial Practices in Israel in the Ancient Period.* Edited by I. Singer. Jerusalem: Israel Exploration Society, 165–72 [Hebrew].

Kloner, Amos, and Boaz Zissu. *The Necropolis of Jerusalem in the Second Temple Period, Interdisciplinary Studies in Ancient Culture and Religion* 8. Peeters: Leuven and Dudley, 2007.

Kloner, Amos, Dalit Regev, and Uriel Rappaport. "Burial Caves in the Judean Shefelah." *'Atiqot* 20 (1991): 25–50 [Hebrew].

Kloner, Amos, Dan Regev, and Uriel Rappaport. "A Hellenistic Burial Cave in the Judean Shephelah." *'Atiqot* 21 (1992): 27–45.

Kloner, Amos, and Shelley Wachsmann. "A Ship Graffito from Khirbet Rafi (Israel)." *The International Journal of Nautical Archaeology and Underwater Exploration* 7 (1978): 227–44.

Kloppenborg, John S. "Collegia and *Thiasoi*: Issues in Function, Taxonomy and Membership." In *Voluntary Associations in the Graeco-Roman World*, edited by John S. Kloppenborg and Stephen G. Wilson, 16–30. London and New York: Routledge, 1996.

Knapp, Robert C. *Invisible Romans.* Cambridge, MA: Harvard University Press, 2011.

Kraabel, Thomas. "The Diaspora Synagogue: Archaeological and Epigraphic Evidence Since Sukenik." *ANRW* II.19 (1979): 477–510.

Kraeling, Carl H. *The Synagogue.* New York: Ktav Pub. House, 1979.

Kraeling, Carl H., and C. Bradford Welles. *The Christian Building.* New Haven, CT: Dura-Europos Publications, 1967.

Kraemer, Ross. "On the Meaning of the Term 'Jew' in Greco-Roman Inscriptions." *HTR* 82 (1989): 35–53.

Kraemer, Ross. "Jewish Tuna and Christian Fish: Identifying Religious Affiliation in Epigraphic Sources." *HTR* 84 (1991): 141–62.

———. *Her Share of the Blessings: Women's Religions among Pagans, Jews, and Christians in the Greco Roman World.* Oxford: Oxford University Press, 1992.

Kroll, John H. "The Greek Inscriptions of the Sardis Synagogue," HTR 94.1 (2001): 5–55.

Kurlansky, Mervyn, Jon Naar, and Norman Mailer. *The Faith of Graffiti.* New York: Praeger, 1974.

Langner, Martin. *Antike Graffitizeichnungen. Motive, Gestaltung und Bedeutung.* Wiesbaden: Verlag, 2001.

Lapin, Hayim. "Palestinian Inscriptions and Jewish Ethnicity in Late Antiquity." In *Galilee through the Centuries: Confluence of Cultures*, edited by Eric Meyers, 239–68. Winona Lake, IN: Eisenbrauns, 1999.

———. *Economy, Geography, and Provincial History in Later Roman Palestine.* Tübingen: Mohr Seibeck, 2001.

———. "Epigraphical Rabbis: A Reconsideration." *JQR* 101 (2011): 311–46.

———. "The Law of Moses and the Jews: Rabbis, Ethnic Making, and Romanization." In *Christians and the Roman Empire: The Poetics of Power in Late Antiquity*, edited by Nathalie Dohrmann and Annette Yoshiko Reed, 79–92. Philadelphia: University of Pennsylvania Press, 2013.

———. *Rabbis as Romans: The Rabbinic Movement in Palestine, 100–400 CE.* New York: Oxford University Press, 2012.

Lederman, Z., and Mordechai Aviam. "A Tomb in the Tefen Region of Galilee and Its Incised Menoroth." *Qadmoniyot* 20 (1987): 124–5 [Hebrew].

Lefebvre, Henri. *The Production of Space.* Oxford: Blackwell, 1991.

———. "The Right to the City." In *Writings on Cities*, by Henri Lefebvre, translated and edited by Eleonore Kofman and Elizabeth Lebas. Cambridge, MA: Wiley Blackwell, 2008.

Legge, Charles. "Uncovering Banksy; Graffiti or Great Art? Banksy's Work Is Often Humourous." *Daily Mail (London)*, February 26, 2008. www.highbeam .com/doc/1G1–175407892.html?refid=easy_hf. Accessed 2016.

Leibner, Uzi, and Catherine Hezser, eds. *Jewish Art in Its Late Antique Context.* Tübingen: Mohr Siebeck, 2016.

Levine, Lee I. "The Hellenistic-Roman Diaspora 70 CE/235 CE: The Archaeological Evidence." In *The Cambridge History of Judaism III: The Early Roman Period*, edited by William Horbury, W. D. Davies, and J. Sturdy, 991–1024. Cambridge: Cambridge University Press, 1999.

———. *Ancient Synagogue: The First Thousand Years.* New Haven, CT: Yale University Press, 2008.

———. "The Synagogue." In *The Oxford Handbook of Jewish Daily Life in Roman Palestine*, edited by Catherine Hezser. New York: Oxford University Press, 2010.

———. *Visual Judaism in Late Antiquity: Historical Contexts of Jewish Art.* New Haven, CT: Yale University Press, 2013.

Lewis, Nicola Denzey. *The Early Modern Creation of Late Ancient Rome.* Cambridge: Cambridge University Press, forthcoming.

Lieberman, Saul. *Greek in Jewish Palestine.* 2nd ed. New York: Jewish Theological Seminary of New York, 1965.

———. "Some Aspects of After Life in Early Rabbinic Literature." In *Texts and Studies*, edited by Saul Lieberman, 235–72. New York: Ktav, 1974.

Lieu, Judith. *Image and Reality. The Jews in the World of the Christians in the Second Century.* Edinburgh: T. & T. Clark, 1996.

Lifshitz, Baruch. *Donateurs et Fondateurs dans les Synagogues Juives, Répertoire des Dédicaces Grecques Relatives à la Construction et à la Réfection des Synagogues.* Paris: J. Gabalda, 1967.

Lightstone, Jack. "Urbanization in the Roman East and the Inter-Religious Struggle for Success." In *Religious Rivalries and the Struggle for Success in Sardis and Smyrna*, edited by Richard S. Ascough, 235. Ontario: Wilfrid Laurier University Press, 2005.

Linder, Amnon. *The Jews in Roman Imperial Legislation*. Detroit: Wayne State University Press, 1987.

Littmann, E. *Greek and Latin Inscriptions in Syria. Division III. Section A, Southern Syria, Part 3: Umm Idj-Djimal*. Leiden: Brill, 1913.

Lüdtke, Alf, ed. *The History of Everyday Life*. Princeton, NJ: Princeton University Press, 1995.

MacDonald, M.C.A. "Reflections on the Linguistic Map of Pre-Islamic Arabia." *Arabian Archaeology and Epigraphy* 11, no. 1 (2000): 28–79.

———. *Literacy and Identity in Pre-Islamic Arabia*. Variorum Collected Studies 906. Farnham: Ashgate, 2009.

———. "Literacy in an Oral Environment." In *Literacy and Identity in Pre-Islamic Arabia*, edited by M.C.A. MacDonald, 49–118. Variorum Collected Studies 906. Farnham: Ashgate, 2009.

———. "Ancient Arabia and the Written Word." In *The Development of Arabic as a Written Language. [Supplement to the Proceedings of the Seminar for Arabian Studies 40]*, edited by M.C.A. MacDonald, 5–28. Oxford: Archaeopress, 2010.

MacMullen, Ramsay. *Christianizing the Roman Empire, AD 100–400*. New Haven, CT: Yale University Press, 1984.

Mailer, Norman and Jon Naar, *The Faith of Graffiti*, 2nd ed. New York: Harper-Collins, 2009.

Magness, Jodi. "The Date of the Sardis Synagogue According to the Numismatic Evidence." *AJA* 109 (2005): 443–75.

———. "Third Century Jews and Judaism at Beth Shearim and Dura Europus." In *Religious Diversity in Late Antiquity*, edited by David M. Gwynn and Susanne Bangert. Leiden: Brill, 2010.

———. *Stone and Dung, Oil and Spit: Jewish Daily Life in the Time of Jesus*. Grand Rapids, MI: William B. Eerdmans, 2011.

Mairs, Rachel. "Egyptian 'Inscriptions' and Greek 'Graffiti' at El Kanais in the Egyptian Eastern Desert." In *Ancient Graffiti in Context*, edited by J. A. Baird and Claire Taylor, 153–165. New York: Routledge, 2011.

Mare, W. Harold, C. J. Lenzen, Michael Fuller, Myra Mare, and Abraham Terian. "The Decapolis Survey Project: Abila, 1980. Background and Analytical Description of Abila of the Decapolis and the Methodology Used in the 1980 Survey." *Annual of the Department of Antiquities, Jordan* 26 (1982): 37–62.

Martinez, J. "Know Your Graffiti: Disses, Threats and the Mexican Mafia." March 7, 2012. www.oncentral.org/news/2012/03/07/know-your-graffiti-disses-threats -and-mexican-mafi/. Accessed July 17, 2017.

Mason, Steve. "Jews, Judeans, Judaizing, Judaism: Problems of Categorization in Ancient History." *JSJ* 38 (2007): 457–512.

Mayor, Adrienne, J. Colarusso, and D. Saunders. "Making Sense of Nonsense Inscriptions Associated with Amazons and Scythians on Athenian Vases." *Hesperia* 83, no. 3 (2014): 447–93.

Mazar, Benjamin. *Beth She'arim; Report on the Excavations during 1936–1940*. New Brunswick, NJ: Rutgers University Press on Behalf of the Israel Exploration Society and the Institute of Archaeology, Hebrew University, 1973.

Mazuz, Haggai. "North Arabia and its Jewry in Early Rabbinic Sources: More than Meets the Eye," *Antiguo Oriente* 13 (2015): 149–68.

McCabe, D. F., and M. A. Plunkett, *Miletos Inscriptions*. Institute for Advanced Study: Princeton, 1984.

McKenzie, Judith. 1995. *The Architecture of Petra*. Oxford: Oxbow, 1995.

Mennen, Inge. *Power and Status in the Roman Empire, AD 193–284*. Leiden: Brill, 2011.

Meyers, Eric. *Jewish Ossuaries: Reburial and Rebirth; Secondary Burials in their Near Eastern Setting*. Rome: Biblical Institute Press, 1971.

Millar, Fergus. *The Roman Near East, 31 B.C.–A.D. 337*. Cambridge, MA: Harvard University Press, 1993.

———. "Inscriptions, Synagogues, and Rabbis in Late Antique Palestine." *JSJ* 42 (2011): 253–77.

Miller, Patricia Cox. "In Praise of Nonsense." *World Spirituality, Vol 15. Classical Mediterranean Spirituality*, edited by A. Hilary Armstrong, 481–505. New York: Crossroads/Continuum Press, 1986.

Miller, Stuart. *Sages and Commoners in Late Antique Erez Israel: Philological Inquiry into Local Traditions in Talmud Yerushalmi*. Tübingen: Mohr Siebeck, 2006.

Miller, Stuart S. "This Is the Beit Midrash of Rabbi Eliezer ha-Qappar" (Dabbura Inscription)—"Were Epigraphical Rabbis Real Sages, or Not More than Donors and Honored Deceased?" In *Talmuda de-Eretz Israel: Archaeology and the Rabbis in Late Antique Palestine*, edited by Steven Fine and Aaron Koller, 239–74. Boston and Berlin: deGruyter, 2014.

Milnor, Kristina. *Graffiti and the Literary Landscape in Roman Pompeii*. Oxford: Oxford University Press, 2014.

Miranda, E. "La comunità giudaica di Hierapolis di Frigia." *Epigraphica Anatolica* 31(1999): 109–55.

Morgan, David. *Visual Piety: A History and Theory of Popular Religious Images*. Berkeley: University of California Press, 1996.

———. *The Sacred Gaze: Religious Visual Culture in Theory and Practice*. Berkeley: University of California Press, 2005.

Moss, Hilary. "Jenny Holzer's Unexpected New Canvas: The Boulders of Ibiza." *The New York Times.* June 20, 2016. www.nytimes.com/2016/06/21/t-magazine /art/jenny-holzer-ibiza.html. Accessed August 03, 2016.

Mouton, Michel. "Les tours funéraires d'Arabie, Nefesh Monumentales." *Syria* 74 (1997): 81–9.

Münz-Manor, Ophir. "Narrating Salvation: Verbal Sacrifices in Late Antique Liturgical Poetry." In *Jews, Christians, and the Roman Empire: The Poetics of Power in Late Antiquity*, edited by Annette Yoshiko Reed and Nathalie Dohrmann, 154–66, 315–19. Philadelphia: University of Pennsylvania Press, 2013.

———. "A Prolegomenon to the Study of Hekhalot Traditions in European Piyyut." In *Hekhalot Literature in Context: Between Byzantium and Babylonia*, edited by Ra'anan Boustan, Martha S. Himmelfarb, and Peter Schäfer. Tübingen: Mohr Siebeck, 2013.

Murphy-O'Connor, Jerome. "Lots of God-Fearers? Theosebeis in the Aphrodisias Inscription." *RB* 99 (1992): 418–24.

Mussies, Gerard. "Jewish Personal Names in Some Non-Literary Sources." In *Studies in Early Jewish Epigraphy*, edited by J. W. van Henten and P. W. Van der Horst, 242–76. Leiden: Brill, 1994.

Naveh, Joseph. "Old Hebrew Inscriptions from a Burial Cave." *IEJ* 2 (1963): 74–92.

Naveh, J. "Sinaitic Remarks." In *Sefer Shmuel Yeivin*, edited by S. Abramski, 373–4. Jerusalem: Kiryat Sepher, 1970.

———. *On Stone and Mosaic: The Aramaic and Hebrew Inscriptions from Ancient Synagogues.* Jerusalem: Israel Antiquities Authority, 1978 [Hebrew].

———. "Graffiti and Dedications." *BASOR* 235 (1979): 27–9.

———. "Lamp Inscriptions and Inverted Writing." *IEJ* 38 (1988): 36–43.

———. *On Sherd and Papyrus: Aramaic and Hebrew Inscriptions from the Second Temple, Mishnaic and Talmudic Periods.* Jerusalem: Magnes Press, 1992.

Naveh, Joseph, and Shaul Shaked. *Magic Spells and Formulae: Aramaic Incantations of Late Antiquity.* Jerusalem: Magnes Press, Hebrew University, 1993.

Negev, Avraham. *The Inscriptions of Wadi Haggag, Sinai.* Jerusalem: Institute of Archaeology, Hebrew University of Jerusalem, 1977.

Nehmé, Laïla. "A Glimpse of the Development of the Nabatean Script into Arabic Based on Old and New Epigraphic Material." In *The Development of Arabic as a Written Language (Supplement to the Proceedings of the Seminar for Arabian Studies 40)*, edited by M. C. A. MacDonald, 47–88. Oxford: Archaeopress, 2010.

Neis, Rachel. *The Sense of Sight in Rabbinic Culture: Jewish Ways of Seeing in Late Antiquity.* New York: Cambridge University Press, 2013.

Newby, Gordon. *The History of the Jews of Arabia from Ancient Times to Their Eclipse under Islam*. Columbia: University of South Carolina Press, 1988.

Noja, S. "Testimonianze epigrafiche di Giudei nell'Arabia settentrionale." *Bibbia e Orientale* (Brescia) 21 (1979): 283–316.

Noy, David. *Jewish Inscriptions of Western Europe. Vol. II: The City of Rome*. Cambridge: Cambridge University Press, 1993.

———. *Jewish Inscriptions of Western Europe. Vol. I: Italy (Excluding the City of Rome), Spain and Gaul*. Cambridge: Cambridge University Press, 2005.

Noy, David, Alexander Panayotov, and Hanswulf Bloedhorn, eds. *Inscriptiones Judaicae Orientis. Vol. I: Eastern Europe*. Tübingen: Mohr Siebeck, 2004.

Noy, David, and Hanswulf Bloedhorn. *Inscriptiones Judaicae Orientis. Vol. III: Syria and Cyprus*. Tübingen: Mohr Seibeck, 2004.

Noy, David, and Susan Sorek. "'Peace and Mercy upon All Your Blessed People': Jews and Christians at Apamea in Late Antiquity." *Jewish Culture and History* 6, no. 2 (2003): 11–24.

Olin, Margaret. "'Early Christian Synagogues' and 'Jewish Art Historians': The Discovery of the Synagogue of Dura-Europos." *Marburger Jahrbuch Für Kunstwissenschaft* 27 (2000): 7–28.

Olyan, Saul. *Biblical Mourning: Ritual and Social Dimensions*. Oxford: Oxford University Press, 2004.

Oren, E. D., and U. Rapaport. "The Necropolis of Maresha-Beth Govrin." *IEJ* 34 (1984): 114–53.

Osiek, Carolyn, and Margaret Y. MacDonald. *A Woman's Place: House Churches in Earliest Christianity*. Minneapolis: Augsburg Fortress Press, 2006.

Ovadiah, Asher, and Rosario Pierri. "Elijah's Cave on Mount Carmel and Its Inscriptions. Part III." *Liber Annuus* 62 (2012): 203–82.

———. *Elijah's Cave on Mount Carmel and Its Inscriptions*. Oxford: Archeopress, 2015.

Panayotov, Alexander. "Jews and Jewish Communities in the Balkans and the Aegean until the Twelfth Century." In *The Jewish-Greek Tradition in Antiquity and the Byzantine Empire*, edited by James K. Aitken and James Carleton Paget, 54–76. New York: Cambridge University Press, 2014.

Park, J. *Conceptions of Afterlife in Jewish Inscriptions*. Tübingen: Mohr Siebeck, 2000.

Parker, Holt N., and William A. Johnson. *Ancient Literacies: The Culture of Reading in Greece and Rome*. Oxford: Oxford University Press, 2011.

Parker, S. T. "The Byzantine Period: An Emperor's New Holy Land." *NEA* 62 (1999): 134–81.

Parrish, D. "Introduction: The Urban Plan and Its Constituent Elements. In Urbanism of Roman Asia Minor: The Current Status of Research [JRA Suppl. 45], edited by D. Parrish, 8–41. Portsmouth, RI: JRA, 2001.

Parrot, A. *Malédictions et violations de tombes*. Paris: Geuthner, 1939.

Patrich, Joseph. "Inscriptions araméennes juives dans les grottes d'El-ʿAleiliyāt." *RB* 92 (1985): 265–73.

Peleg-Barkat, Orit. "The Relative Chronology of Tomb Façades in Early Roman Jerusalem and Power Displays by the Élite." *JRA* 25 (2012): 403–18.lx

Peppard, Michael. "Personal Names and Ethnic Hybridity in Late Ancient Galilee: The Data from Beit Shearim." In *Religion, Ethnicity and Identity in Ancient Galilee: A Region in Transition*, edited by Jürgen Zangenberg, Harold Attridge, and Dale Martin, 99–114. Tübingen: Mohr Siebeck, 2007.

Perkins, Ann Louise. *The Art of Dura-Europos*. Oxford: Clarendon Press, 1973.

Perkins, Judith. *Roman Imperial Identities in the Early Christian Era*. New York: Routledge, 2009.

Peskowitz, Miriam. *Spinning Fantasies: Rabbis, Gender, and History*. Berkeley: University of California Press, 1997.

Peters, John Punnett, and Hermann Thiersch. *Painted Tombs in the Necropolis of Marissa*. London: Palestine Exploration Fund, 1905.

Puech, Emile. "Les Écoles dans l'Israël Préexilique: Donné Épigraphiques." In *Congress Volume 1986*, edited by J. Emerton, 189–203. Leiden: Brill, 1988.

Rabinovich, Ari. "Under Cover of Night, Graffiti Transforms Jerusalem Market into Colorful Canvas – Life." Haaretz.com. February 28, 2016. www.haaretz .com/israel-news/culture/1.705893. Accessed August 3, 2016.

Rabinowitz, Louis Isaac. "The Synagogue." In *Encyclopedia Judaica*. Vol. 19, 2nd ed, edited by Michael Berenbaum and Fred Skolnik, 352–83. Detroit, MI: Keter, 2007.

Rachmani, L. Y., and Ayala Sussmann. *A Catalogue of Jewish Ossuaries: In the Collections of the State of Israel*. Jerusalem: Israel Antiquities Authority, 1994.

Rahmani, L. Y. "Jason's Tomb." *ʿAtiqot* Hebr. Ser. 4 (1964): 1–31 [Hebrew].

———. "Jason's Tomb." *IEJ* 17 (1967): 61–100.

———. *A Catalogue of Roman and Byzantine Lead Coffins from Israel*. Jerusalem: Israel Antiquities Authority, 1999.

Rajak, Tessa. "The Jewish Community and its Boundaries." In *The Jews among Pagans and Christians*, edited by Judith Lieu, J. North, and Tessa Rajak, 9–28. London and New York: Routledge, 1992.

———. "The Gift of Gods at Sardis." In *Jews in a Graeco-Roman World*, edited by Martin Goodman, 229–39. Oxford: Oxford University Press, 1998.

————. *The Jewish Dialogue with Greece and Rome: Studies in Cultural and Social Interaction.* Leiden: Brill, 2001.

————. "Jews, Pagans and Christians in Late Antique Sardis: Models of Interaction." In *The Jewish Dialogue with Greece and Rome: Studies in Cultural and Social Interaction,* edited by Tessa Rajak, 432–62. Leiden: Brill, 2001.

————. "The Rabbinic Dead and the Diaspora Dead at Beth Shearim." In *The Jewish Dialogue with Greece and Rome: Studies in Cultural and Social Interaction,* edited by Tessa Rajak, 479–502. Leiden: Brill, 2001.

Rajak, Tessa, and David Noy. "*Archisynogogoi*: Office, Title, and Social Status in the Greco-Roman Synagogue." *JRS* 83 (1993): 75–93.

Ratté, Christopher. "New Research on the Urban Development of Aphrodisias in Late Antiquity." In *Urbanism of Roman Asia Minor: The Current Status of Research* [JRA Suppl. 45], edited by D. Parrish, 117–47. Portsmouth, RI: JRA, 2001.

Rehm, Albertus. "MNĒSTHĒ." *Philologus* 69 (1940): 1–39.

Reinhartz, Adele. "The Vanishing Jews of Antiquity." *Marginalia: A Los Angeles Review of Books,* June 24, 2014. marginalia.lareviewofbooks.org/vanishing-jews-antiquity-adele-reinhartz/. Accessed August 10, 2016.

Renfrew, Colin, Chris Gosden, and Elizabeth DeMarrais. *Substance, Memory, Display: Archaeology and Art.* Cambridge: McDonald Institute for Archaeological Research, University of Cambridge, 2004.

Rey-Coquais, Jean-Paul. *Inscriptions grecques et latines découvertes dans les fouilles du Tyr.* Bulletin du Musée de Beyrouth 29. Paris: Maisonneuve, 1977.

————. "Fortune et rang social des gens de métiers de Tyr au Bas Empire." *Ktema* 4 (1979): 281–92.

Rey-Coquais, Jean-Paul. "Inscriptions de l'hippodrome de Tyr." *JRA* 15 (2002): 325–35.

Reynolds, Joyce M. "Inscriptions from the Bouleterion/Odeion." In *Aphrodisias Papers 4: New Research on the City and Its Monuments [JRA Supplementary Series 70],* edited by Christopher Ratté and R.R.R. Smith, 169–89. Portsmouth, RI: JRA, 2008.

Reynolds, Joyce, Charlotte Roueché, Gabriel Bodard, *Inscriptions of Aphrodisias* (2007). insaph.kcl.ac.uk/iaph2007. Last access date November 19, 2017.

Reynolds, Joyce Marie, and Robert Tannenbaum. *Jews and God-Fearers at Aphrodisias: Greek Inscriptions with Commentary: Texts from the Excavations at Aphrodisias Conducted by Kenan T. Erim.* Cambridge: Cambridge Philological Society, 1987.

Robin, Christian. "Himyar Et Israël." *Comptes-rendus Des Séances De L'année . . .- Académie Des Inscriptions et Belles-lettres Crai* 148, no. 2 (2004): 831–908.

————. "Le judaïsme de Ḥimyar," *Arabia* I (2003): 97–172.

Rodriguez, Amardo, and Robin Patric Clair. "Graffiti as Communication: Exploring the Discursive Tensions of Anonymous Texts." *Southern Communication Journal* 65, no. 1 (1999): 1–15.

Rosenblum, Jordan. *Food and Identity in Early Rabbinic Judaism*. Cambridge: Cambridge University Press, 2010.

————. *Jewish Dietary Laws in the Ancient World*. Cambridge: Cambridge University Press, 2016.

Rosenblum, Jordan, Lily C. Vuong, and Nathaniel DesRosiers, eds. *Religious Competition in the Third Century CE: Jews, Christians, and the Greco-Roman World*. Gottingen: Vandenhoek and Ruprecht, 2014.

Rosenfeld, Ben Zion. "The Title 'Rabbi' in Third- to Seventh-Century Inscriptions in Palestine Revisited." *Journal of Jewish Studies* 61, no. 2 (2010): 234–56.

Rosenfeld, Ben Zion, and Rivka Potchebutzky. "The Civilian-Military Community in the Two Phases of the Synagogue at Dura Europos: A New Approach." *Levant* 41, no. 2 (2009): 195–222.

Rostovtzeff, Michael Ivanovitch, Clark Hopkins, Carl H. Kraeling, Arthur Darby Nock, E. T. Silk, Henry T. Rowell, P.V.C. Baur, C. Bradford Welles, Alfred R. Bellinger, and Susan M. Hopkins, eds. *The Excavations at Dura-Europos; Preliminary Report of the 5th Season of Work, October 1931–March 1932: Conducted by Yale University and the French Academy of Inscriptions and Letters*. New Haven, CT: Yale University Press, 1934.

Rostovtzeff, Michael Ivanovitch, C. Bradford Welles, Clark Hopkins, Alfred R. Bellinger, Frank Edward Brown, Margaret Crosby, Charles Cutler Torrey, Carl H. Kraeling, Robert Du Mesnil Du Buisson, H.-F Pearson, Julian Obermann, Antonino Pagliaro, Robert Orwill Fink, and P.V.C. Baur, eds. *The Excavations at Dura-Europos; Preliminary Report of the 6th Season of Work, October 1932–March 1933: Conducted by Yale University and the French Academy of Inscriptions and Letters*. New Haven, CT: Yale University Press, 1936.

Rostovtzeff, Michael Ivanovitch, C. Bradford Welles, and Frank Edward Brown, eds. *Preliminary Report of the Seventh and Eighth Seasons of Work, 1933–34 and 1934–35*. New Haven, CT: Humphrey Milford, 1939.

Roth, Klaus. "Material Culture and Intercultural Communication." *International Journal of Intercultural Relations* 25 (2001): 563–80.

Rothenberg, B. "An Archaeological Survey of South Sinai: First Season 1967–1968. Preliminary Report." *PEQ* 102 (1970): 4–29.

Roth-Gerson, Lea. *The Jews of Syria as Reflected in the Greek Inscriptions*. Jerusalem: Merkaz Zalman Shazar Le-toldot Yiśra'el, 2001 [Hebrew].

Roueché, Charlotte. "Acclamations in the Later Roman Empire: New Evidence from Aphrodisias." *JRS* 74 (1984): 181–99.

———. "Inscriptions and the Later History of the Theatre." In *Aphrodisias Papers, 2* [JRA Monograph 2], edited by K. T. Erim and R.R.R. Smith, 99–108. Ann Arbor, MI: JRA, 1991.

———. "Metropolis." In *Late Antiquity: A Guide to the Postclassical World*, edited by Glen Warren Bowersock, Peter Brown, and Oleg Grabar, 577. Cambridge, MA: Harvard University Press, 1999.

———. *Aphrodisias in Late Antiquity: The Late Roman and Byzantine Inscriptions*, rev. 2nd ed., 2004. insaph.kcl.ac.uk/ala. 2004. Accessed August 16, 2016.

———. "Interpreting the Signs: Anonymity and Concealment in Late Antique Inscriptions." In *From Rome to Constantinople: Studies in Honour of Averil Cameron*, edited by Hagit Amirav and Haar Romeny R. B. Ter, 222–34. Leuven: Peeters, 2007.

Roueché, Charlotte, and J. M. Reynolds. *Aphrodisias in Late Antiquity: the late Roman and Byzantine inscriptions including texts from the excavations at Aphrodisias conducted by Kenan T. Erim*. London: Journal of Roman Studies Monograph, 1989.

Roueché, Charlotte, and Nathalie de Chaisemartin. *Performers and Partisans at Aphrodisias in the Roman and Late Roman Periods: A Study Based on Inscriptions from the Current Excavations at Aphrodisias in Caria*. London: Society for the Promotion of Roman Studies, 1993.

Rüpke, Jörg, and Wolfgang Spickermann, eds. *Reflections on Religious Individuality: Greco-Roman and Judaeo-Christian Texts and Practices*. Berlin: DeGruyter, 2012.

Rutgers, L. V. *The Jews of Late Ancient Rome: Evidence of Cultural Interaction in the Roman Diaspora*. Leiden: Brill, 1995.

Sanders, Seth L. *The Invention of Hebrew (Traditions)*. Urbana: University of Illinois Press, 2011.

Satlow, Michael. "Giving for a Return: Jewish Votive Offerings in Late Antiquity." In *Religion and the Self*, edited by David Brakke, Michael Satlow, and Steven Weitzman, 91–108. Bloomington: Indiana University Press, 2005.

———. "Beyond Influence: Toward a New Historiographical Paradigm." In *Jewish Literatures and Cultures: Context and Intertext*, edited by Anita Norich and Yaron Z. Eliav. Providence, RI: Brown Judaic Studies, 2008.

Schatzki, Theodore. *Social Practices: A Wittgenstinian Approach to Human Activity and the Social*. Cambridge: Cambridge University Press, 1996.

Schwabe, Moshe, and Baruch Lifshitz, *Beth She'arim. Volume 2: The Greek Inscriptions*. New Brunswick, NJ: Rutgers University Press, 1974.

Schwartz, Seth. "Language, Power, and Identity in Roman Palestine." *Past and Present* 148 (1995): 3–47.

————. *Imperialism and Jewish Society, 200 B.C.E. to 640 C.E.* Princeton, NJ: Princeton University Press, 2001.

————. "Rabbinization in the Sixth Century." In *The Talmud Yerushalmi and Graeco-Roman Culture III*, edited by Peter Schaefer, 55–69. Tübingen: Mohr Siebeck, 2002.

————. *Were the Jews a Mediterranean Society? Reciprocity and Solidarity in Ancient Judaism.* Princeton, NJ: Princeton University Press, 2010.

————. *The Ancient Jews from Alexander to Muhammad.* Cambridge: Cambridge University Press, 2014.

Scott, Sarah, and Jane Webster. *Roman Imperialism and Provincial Art.* New York: Cambridge University Press, 2003.

Shaw, Brent. "Social Science and Ancient History: Keith Hopkins in Partibus Infidelium." *Helios* 9 (1982): 34–8.

Sivan, Hagith. *Palestine in Late Antiquity.* Oxford: Oxford University Press, 2008.

Slootjes, Daniëlle. "Local Elites and Power in the Roman World: Modern Theories and Models." *Journal of Interdisciplinary History* 42, no. 2 (2011): 235–49.

Smith, Jonathan Z. *Imagining Religion: From Babylon to Jonestown.* Chicago: University of Chicago Press, 1982.

————. *To Take Place: Toward Theory in Ritual.* Chicago: University of Chicago Press, 1992.

Smith, Mark. *Traversing Eternity: Texts for the Afterlife from Ptolemaic and Roman Egypt.* Oxford and New York: Oxford University Press, 2009.

Smith, Morton. "Goodenough's Jewish Symbols in Retrospect." *JBL* 86 (1967): 53–68.

Smith, R.R.R. *The Marble Reliefs from the Julio-Claudian Sebasteion at Aphrodisias.* Darmstadt: Philipp von Zabern, 2013.

Smith, R.R.R., and A. Ertug. *Aphrodisias: City and Sculpture in Roman Asia.* Istanbul: Ertug and Kocabiyik, 2009.

Smoak, Jeremy, and Alice Mandell. "Reconsidering the Function of Tomb Inscriptions in Ancient Judah: Khirbet Beit Lei as a Test Case." *Journal of Near Eastern Religions* 16 (2016): 192–245.

Snyder, Gregory J. *Graffiti Lives: Beyond the Tag in New York's Urban Underground.* New York: New York University Press, 2009.

Sorek, Susan. *Remembered for Good: A Jewish Benefaction System in Ancient Palestine.* Sheffield: Sheffield Phoenix, 2010.

Sperber, Daniel. *Nautica Talmudica.* Bar Ilan: Ramat Gan, 1981.

Spigel, Chad. *Ancient Synagogue Seating Capacities.* Tübingen: Mohr Siebeck, 2012.

Squire, Michael. *Image and Text in Graeco-Roman Antiquity*. New York: Cambridge University Press, 2009.

Stephens, Michael Allen. *A Categorisation and Examination of Egyptian Ships and Boats from the Rise of the Old to the End of the Middle Kingdoms*. Oxford: Archeopress, 2012.

Stern, Karen B. *Inscribing Devotion and Death: Archaeological Evidence for Jewish Populations in North Africa*. Leiden: Brill, 2008.

———. "Limitations of 'Jewish' as a Label in Roman North Africa." *JSJ* 39 (2008): 307–36.

———. "Mapping Devotion in Roman Dura-Europos: A Reconsideration of the Synagogue Ceiling." *AJA* 114, no. 3 (2010): 473–504.

———. "Tagging Sacred Space in the Dura-Europos Synagogue." *JRA* 25 (2012): 171–94.

———. "Graffiti as Gift: Mortuary and Devotional Graffiti in the Late Ancient Levant." In *The Gift in Antiquity*, edited by Michael Satlow, 137–57. New York: Wiley-Blackwell, 2013.

———. "Vandals or Pilgrims? Jews and the Temple of Pan in Egyptian El-Kanaïs." In *The One Who Sows Bountifully: Essays in Honor of Stanley K. Stowers*, edited by Caroline Johnston Hodge, Daniel Ulucci, Saul Olyan, and Emma Wasserman, 177–88. Winona Lake, IN: Eisenbrauns, 2013.

———. "Celebrating the Mundane: Figural Graffiti and Daily Life among Jews in the Levant." In *Jewish Art in Its Late Antique Context*, edited by Uzi Leibner and Catherine Hezser, 237–60. Tübingen: Mohr Seibeck, 2016.

———. "Opening Doors to Jewish Life in Syro-Mesopotamian Dura-Europos." JAJ (2018, forthcoming).

Stone, Michael Edward, and Leslie Avital Kobayashi. *Rock Inscriptions and Graffiti Project Catalogue of Inscriptions*. Atlanta, GA: Scholars Press, 1992.

Strelan, Rick. *Paul, Artemis, and the Jews of Ephesus*. Berlin and New York: DeGruyter, 1996.

Strubbe, Johan H. M. "Curses Against Violation of the Grave in Jewish Epitaphs from Asia Minor." In *Studies in Early Jewish Epigraphy*, edited by Jan Willem van Henten and Pieter Willem van der Horst, 70–128. Leiden: Brill, 1994.

Sukenik, Eliezar Lipa. *The Synagogue of Dura Europos and Its Frescoes*. Jerusalem: Mossad Bialik, 1948.

Swenson, Edward. "Emotion Reified. Lessons from the Archaeology of Ritual." *Archaeological Dialogues* 17, no. 2 (2010): 176–83.

Swetnam-Burland, Molly. *Egypt in Italy: Visions of Egypt in Roman Imperial Culture*. Cambridge: Cambridge University Press, 2015.

————. "Encountering Ovid's Phaedra in House V.2.10–11, Pompeii." *AJA* 119, no. 2 (2015): 217–32.

Tambiah, S. J. "The Magical Power of Words." *Man* 3, no. 2 (1968): 175–208.

Taussig, Michael T. *Defacement: Public Secrecy and the Labor of the Negative.* Stanford, CA: Stanford University Press, 1999.

Taylor, Joan E. *Christians and the Holy Places: The Myth of Jewish-Christian Origins.* Oxford: Clarendon Press, 1993.

Tchekhanovets, Yana. "Early Georgian Pilgrimage to the Holy Land." *Liber Annuus* 61 (2011): 453–471.

Tepper, Yigal, and Yoram Tepper, *Beth She'arim: The Village and Nearby Burials.* Jerusalem: IAA, 2004 [Hebrew].

Testa, Emmanuele. *Nazaret Giudeo – Cristiana: Riti. Iscrizioni. Simboli.* Gerusalemme: Tipografia Dei Pp. Francescani, 1969.

Thomas, Rosalind. *Literacy and Orality in Ancient Greece.* Cambridge: Cambridge University Press, 1992.

Tilley, Christopher. *Phenomenology and Landscape I.* Oxford: Berg, 1993.

Tilley, Christopher, and Wayne Bennett. *Explorations in Landscape Phenomenology.* Oxford: Berg, 2004.

Tilley, Christopher Y., and Wayne Bennett. *Body and Image: Explorations in Landscape Phenomenology 2.* Walnut Creek, CA: Left Coast Press, 2008.

Trebilco, Paul. *Jewish Communities in Asia Minor.* Cambridge: Cambridge University Press, 1991.

Tzaferis, Vassilios. "A Monumental Roman Tomb on Tel 'Eitun." *'Atiqot* 8 (1982): 22–5 [Hebrew].

Ussishkin, David. *The Village of Silwan: The Necropolis from the Period of the Judean Kingdom.* Jerusalem: Israel Exploration Society, 1993.

Van der Horst, P. W. "Jews and Christians in Aphrodisias, in the Light of Their Relations in Other Cities of Asia Minor." *Nederlands Theologisch Tijdschrift* 43 (1989): 106–21.

————. *Ancient Jewish Epitaphs.* Leuven: Peeters, 1991.

————. *Jews and Christians in their Graeco-Roman Context.* Tübingen: Mohr Siebeck, 2006.

Van Minnen, P. "Drei Bemerkungen zur Geschichte des Judentums in der greischisch-römischen Welt." *ZPE* 100 (1994): 166–81.

Venit, Susan. *Monumental Tombs of Ancient Alexandria: The Theatre of the Dead.* Cambridge: Cambridge University Press, 2002.

Vitto, Fanny, "Byzantine Mosaics at Beit She'arim: New Evidence for the History of the Site," *'Atiqot* 28 (1996): 115-46.

Vivolo, Francesco Paolo Maulucci. *Pompei I graffiti figurati*. Foggia: Bastogi Editrice Italiana, 1993.

Volozny, Naama. "The Art of the Aramaic Incantation Bowls." In *Aramaic Bowl Spells: Jewish Babylonian Aramaic Bowls*, Vol. 1, edited by Shaul Shaked, Siam Bhayro, and James Nathan Ford, 29–37. Leiden: Brill, 2012.

"The Walled Off Hotel." www.bing.com/cr?IG=6B6E2380828241BDAA4E1A2 BC093EC35&CID=233804FC7DB96DB50A630FC07CBF 6C33&rd=1&h=iAeoYzisDPBr6n0hu2-R2AjKPp64pt3QYEnba3CGOGQ &v=1&r=http%3a%2f%2fwww.walledoffhotel.com%2f&p=DevEx,5066.1. Accessed November 15, 2017.

Webster, Richard, A. "Tomb of Marie Laveau, Voodoo Queen of New Orleans, Refurbished in Time for Halloween." NOLA.com/*The Times-Picayune*, 2014. www.nola.com/crime/index.ssf/2014/10/tomb_of_marie_laveau_voodoo _qu.html. Accessed August 11, 2016.

Weiss, Ze'ev. "Social Aspects of Burial at Beth She'arim: Archaeological Finds and Talmudic Sources." In *The Galilee in Late Antiquity*, edited by Lee I. Levine, 357–72. New York and Jerusalem: The Jewish Theological Seminary of America, 1992.

———. "Adopting a Novelty: Jews and the Roman Games in Palestine." In *The Roman and Byzantine Near East: Recent Archaeological Research, II [JRA Supplement 31]*, edited by J. H. Humphrey, 23–49. Portsmouth, RI: *JRA*, 1999.

———. "Burial Practices in Beit She'arim and the Question of Dating the Patriarchal Necropolis." In *"Follow the Wise": Studies in Jewish History and Culture in Honor of Lee I. Levine*, edited by Ze'ev Weiss, Oded Irshai, Jodi Magness, and Seth Schwartz, 207–31. Winona Lake, IN: Eisenbrauns, 2010.

———. *Public Spectacles in Late Antique Palestine*. Cambridge, MA: Harvard University Press, 2014.

Weiss, Ze'ev, and Ehud Netzer. *The Sepphoris Synagogue: Deciphering an Ancient Message through Its Archaeological and Socio-historical Contexts*. Jerusalem: Israel Exploration Society, 2005.

Welles, C. "'The Population of Roman Dura'." In *Studies in Roman Economic and Social History in Honor of Allan Chester Johnson*, edited by P. R. Coleman-Norton, 251–74. Princeton, NJ: Princeton University Press, 1951.

Wharton, Annabel Jane. *Refiguring the Post Classical City: Dura Europos, Jerash, Jerusalem, and Ravenna*. Cambridge: Cambridge University Press, 1995.

Wharton, Annabel. "Erasure: Eliminating the Space of Late Ancient Judaism." In *From Dura to Sepphoris: Studies in Jewish Art and Society in Late Antiquity [JRA Supplement 40]*, edited by Lee I. Levine and Ze'ev Weiss, 195–214. Portsmouth, RI: *JRA*, 2000.

White, L. Michael. *Building God's House in the Roman World: Architectural Adaptation among Pagans, Jews, and Christians.* Baltimore, MD: Johns Hopkins University Press, 1990.

Wightman, G. J. *Sacred Spaces: Religious Architecture in the Ancient World.* Leuven: Peeters, 2007.

Wilken, Robert. *The Christians as the Romans Saw Them.* New Haven, CT: Yale University Press, 1984.

Wilkinson, John. Egeria's Travels. 3rd ed. Liverpool: Liverpool University Press, 1999.

Williams, Ingrid K. "36 Hours in Rome." *The New York Times*, 2015. www.nytimes.com/2015/03/08/travel/what-to-do-in-36-hours-in-rome.html . Accessed August 03, 2016.

Williams, Margaret. "The Jews and Godfearers Inscriptions from Aphrodisias: A Case of Patriarchal Interference in Early Third Century Caria?" *Historia* 41 (1992): 297–310.

———. "The Contribution of the Study of Inscriptions to the Study of Judaism." In *The Cambridge History of Judaism III: The Early Roman Period*, edited by W. Horbury, W. D. Davies, and J. Sturdy, 75–93. Cambridge: Cambridge University Press, 1999.

———. "Jews and Jewish Communities in the Roman Empire." In *Experiencing Rome: Culture, Identity and Power in the Roman Empire*, edited by J. Huskinson, 305–33. London: Routledge, 2000.

———. "Jewish Festal Names in Antiquity—A Neglected Area of Onomastic Research." *Journal for the Study of Judaism* 36, no. 1 (2005): 21–40.

———. "The Use of Alternative Names by Diaspora Jews in Late Antiquity." *JSJ* 38 (2007): 307–27.

———. "The Menorah in a Sepulchral Context: A Protective, Apotropaic Symbol?" In *The Image and Its Prohibition in Jewish Antiquity*, edited by Sarah Pierce, 77–88. Oxford: Journal of Jewish Studies, 2013.

———. *Jews in a Greco-Roman Environment.* Tübingen: Mohr Siebeck, 2013.

Wilson, Stephen. *Related Strangers: Jews and Christians 70–170 CE.* Minneapolis: Fortress Press, 1995.

Wise, Michael Owen. *Language and Literacy in Roman Judaea.* New Haven /London: Yale University Press, 2015.

Wiseman, James. "Jews at Stobi." In *Miscellanea Emilio Marin Sexagenario Dicata*, edited by Hrvatin G. Jurišić, 325–50. Split: Zbornik Kačić, 2011.

Wiseman, J. and Mano-Zissi, Ð. "Stobi: A City of Ancient Macedonia." *JFA* 3 (1976): 269–302.

Yardeni, Ada. "The Decipherment and Restoration of Legal Texts from the Judean Desert: A Reexamination of the *Papyrus Starcky* (P. Yadin 36)." *SCI* 20 (2001): 121–37.

Yasin, Ann Marie. *Saints and Church Spaces in the Late Ancient Mediterranean.* Cambridge: Cambridge University Press, 2012.

Yasin, A. M. "Prayers on Site: The Materiality of Devotional Graffiti and the Production of Early Christian Sacred Space." In *Viewing Inscriptions in the Late Antique and Medieval World,* edited by A. Eastmond, 36–60. Cambridge: Cambridge University Press, 2015.

Zabin, Serena. "Iudaeae Benemerenti: Towards a Study of Jewish Women in the Western Roman Empire." *Phoenix* 50, no. 3/4 (1996): 262–82.

Zadorojni, Alexei. "Transcriptions of Dissent? Political Graffiti and Elite Ideology Under the Principate." In *Ancient Graffiti,* edited by J. D. Baird and Claire Taylor, 110–33. New York: Routledge, 2011.

Zissu, Boaz. "Horbat Egoz." *HA–ESI* 19 (1997): 85, fig. 173; 123–4.

———. "Horbat el 'Ein." *HA–ESI* 109 (1999): 87*–8*, 109.

———. "Horbat Lavnin." *HA–ESI* 113 (2001): 104, 153–4.

———. "A Burial Cave with a Greek Inscription and Graffiti at Khirbet el-'Ein, Judean Shephelah," *'Atiqot* 50 (2005): 27–36.

———. "Graffito of a Ship and a Boat." In *Herodium, Final Reports of the 1972–2010 Excavations, Directed by Ehud Netzer. Vol. 1: Herod's Tomb Precinct, Jerusalem,* edited by R. Porat, R. Chachy, and Y. Kalman, 511–4. Jerusalem: Israel Exploration Society, 2015.

———. "A Burial Cave with a Greek Inscription and Graffiti at Khirbet el-'Ein, Judean Shephelah," *'Atiqot* 50 (2005): 27–36.

Zlotnick, D. *The Tractate "Mourning" (Semahot): Regulations Pertaining to Death, Burial and Mourning.* New Haven, CT: Yale University Press, 1966.

INDEX

Byzantine Empire: Asia Minor, 1, 31, 32, 160, 161–62; burial sites in, 31, 86, 113, 132, 164, 210n14; Christians in, 73, 146, 165, 221n118; cities in, 142, 145; Greek language in epigraphy in, 189n101, 212n24; Jews in, xvi, 34, 141, 142, 161, 165, 168, 173; Palestine, 13, 31, 82, 86, 140, 141, 164, 212n24, 221n118

camels, 9, 12
Caracalla, 29
Caria, 145, 149
catacombs, xiii, xv, xix; Anfushi or Moustafa Pacha (Alexandria), 119, 121–22, 133, 224n150; Egypt, 133, 225n151; Malta or Naples, xiv, 121; Palestine, 1, 84; Villa Torlonia (Rome), 121, 123, 175, 215n67, 238n5. See also Beit Shearim
cemeteries: activities in, 11, 82–83, 126, 137, 139, 140, 175; epitaphs or formal inscriptions in, 10, 111, 164, 214n57; graffiti in, 31–32, 82, 83, 125, 143, 175; Jewish graves in, 188n92; lamellae placed in, 226n161; modern, 80–81, 135, 140; rabbinic views of, 138–39, 225n154. See also Beit Shearim
Chaniotis, Angelos, 15, 144, 151, 155–56, 159, 161, 182n34, 231n41, 234n81, 234n84
Chéhab, Maurice, 162
Christians, 188n90, 221n118, 227n6; in Aphrodisias or Sardis, 149, 152, 154, 156, 157, 159–60, 230n39, 233n65; in Dura-Europos, 25, 43, 53–54, 56, 200n74; in Elijah's Cave, 66–67, 69–70, 203n115; graffiti drawn by, 26, 35–36, 53, 73, 75, 76, 128, 152, 154, 157, 159–60, 204n123, 208n164, 233n65; graves or mortuary practices of, 128, 129,

132, 237n118; Jews' relations with (see Jews: Christians and); literature of, xv, 12, 22, 87, 126, 141, 144, 154, 161, 165, 167, 168, 173, 214n59, 220n111, 226n2, 228n15, 238n127; names of, 68, 205n126, 205n133, 236n114; pilgrimage routes of, 73, 208n164; worship spaces used by, 59, 60, 77, 197n50 (see also Church of the Holy Sepulchre; Elijah's Cave)
christograms, 39, 67–69, 75, 132
Chrysostom, John, 165, 228n15
Church of the Holy Sepulchre, 35–39, 58, 140
circuses, 152, 233n59, 236n110, 238n127
class, 9, 28–29, 59, 124, 149, 164, 166, 189n105
commercial graffiti, 155, 167, 172; religious symbols in, 157, 159, 166, 235n88. See also under Aphrodisias; Sardis; Tyre
contagion, 32, 83–84, 138
Crawford, John, 144
Croatia, 2, 42, 175
cross-shaped graffiti, 73, 75, 208n164, 222n127, 236n112; in Aphrodisias, 152, 157, 159, 234n85, 235n86, 235n88; in Church of the Holy Sepulchre, 35, 38; menorah graffiti and, 159–60, 164, 208n164, 235n88; in Sardis, 160; on tombs, 132, 135; in Tyre, 163–64
cryptograms, 35
curses: in Beit Shearim, 97, 99, 102, 103, 117–20, 134, 137, 219n93; of Māran, 51, 52, 197n49; as regional mortuary practice, 119, 213n37, 217n85, 217n87, 218nn90–92
Cyprus, 119, 218n90; map, 4

Damascus, xiii; map, 4, 5
Dead Sea Scrolls, xiii

scripts: Arabic, 37; Aramaic, 26, 57, 78, 117; Greek, 50, 57, 78, 117, 130, 146, 202n93; Hebrew, 26, 73, 78, 102, 130; illegible or esoteric, 131, 184n56, 223n139; large or clear, 53, 118; Latin, 37; Nabataean Arabic or Aramaic, 71, 72, 207n152; Pahlavi, Parthian, and Middle Persian, 54; Phoenician, 119; Semitic, 50; used by Jews, 26, 72, 75, 77, 78

Sebasteion. *See* Aphrodisias: Sebasteion in; Aphrodisias: commercial graffiti in

shalom graffiti, 72, 102, 129–31, 135

Shefelah, Judean. *See* Judean Shefelah

Sheikh Abreikh. *See* Beit Shearim

ship graffiti or dipinti: in Beit Shearim, 93–95, 102–5, 117, 120, 125–26, 134; in other places, 120–25; locations of, 120, 125; popularity of, 120–21; reasons for, 125, 134–35; types of ships in, 120

ships, xi, 123–25

shofar graffiti, 26, 102, 156, 234n77

shrouds, 126

signature graffiti: in Dura-Europos synagogue, 45, 46, 49, 51, 53, 56, 58, 194n28; "Ḥiya," 1, 46; locations of, 46, 53; "Mattenai," 46; in Nabataean Aramaic, 72; by pagans, 50–51; by Persian scribes, 54–56; as prayers, 51

Sinai Peninsula, 31, 39, 42, 71, 72, 75

skeleton graffiti, xiii, 101, 104, 111, 112

Souza, Solomon, 15, 16

Split, Croatia, 4, 175

statues: cult, 24, 53, 67, 196n45, 216n76; graffiti depicting, 107, 108, 117; in mortuary contexts,132, 133; votive, 51, 185n66,

Stobi synagogue, 192–93n15

street art, 2, 169, 170, 178n4; graffiti vs. 15

Sumaqa, 5, 132, 224n146

Susiya synagogue (West Bank), 14, 15, 195n38

synagogues, 12, 67, 85, 143, 149, 210n14, 228n15; activities in, 11, 36, 38, 57–59, 174; doorways, 54, 198n60; graffiti in, xiv, xv, 1, 2, 14, 26, 33, 39, 42, 58–60, 76, 143, 171, 175, 188n93, 194n26, 194n28, 195n38, 199n71; inscriptions in, 10, 14, 43–44, 49–50, 143, 164, 180n16, 195n37, 233n62; menorah graffiti in, 42, 192n15; mosaics or murals in, 10, 11, 14, 40, 43, 45, 47, 54–56, 58, 180n16, 180n20, 195n39; prayer in (*see under* prayer); remembrance graffiti in, 45, 46–48, 51–53, 58, 195n38; in Sardis, 143, 192n15, 235n93; scholars on, 59, 174, 194n24, 200n80; sensory experiences in, 38, 58, 173; in Stobi, 192–93n15; in Susiya (West Bank), 14, 15, 195n38; in Syria, 1, 42, 47, 195n38; urban locations of, 10, 143. *See also* Dura-Europos synagogue

Syracuse, 119, 213n37; map, 4

Syria, xvi, 141, 198n63, 205n134, 226n1; burial caves, catacombs, or mortuary graffiti in, 28, 84, 111, 140; cult-scene graffiti in, 117; devotional graffiti in, 57, 77; inscriptions from, 164; "public" graffiti in, 142, 166, 167, 168; remembrance graffiti in, 50, 195n38; Roman, 1, 31, 43, 84, 145, 162; synagogues or synagogue graffiti in, 1, 42, 47, 195n38. *See also* Dura-Europos; Tyre

Syriac, 35, 50, 191n2

Syrians, 34, 43, 44, 88, 123, 139